CHIAROSCURO

CHIAROSCURO

The Clair-Obscur Woodcuts by the German and Netherlandish Masters of the XVIth and XVIIth Centuries

A COMPLETE CATALOGUE WITH COMMENTARY BY

Walter L. Strauss

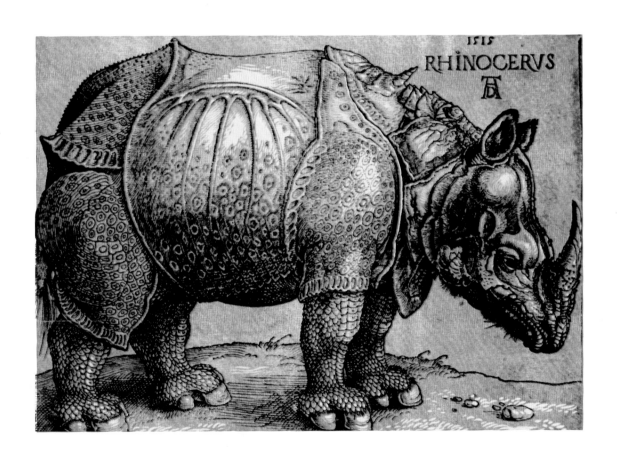

NEW YORK GRAPHIC SOCIETY LTD.
GREENWICH, CONNECTICUT

International Standard Book Number 0-8212-0501-3

Library of Congress Catalog Card Number 73-76179

Copyright © 1973 Walter L. Strauss
An Abaris Book

First published 1973 by New York Graphic Society Ltd.
140 Greenwich Avenue, Greenwich, Connecticut 06830

Manufactured in the U.S.A.
by Noble Offset Printers, Inc., New York, N. Y. 10003

Contents

CONTENTS

Introduction

When we think of the woodcuts by European masters of the sixteenth and seventeenth centuries, we usually think of them as printed in stark black lines on white paper; as strong, simple, pictorial statements which were exactly repeatable by means of the printing press. Similarly, although distinguished by more delicate lines and greater detail, engravings are generally visualized as representations in black and white.

There exists, however, a group of woodcuts, produced during these same centuries, which were printed from more than one block in order to add color and highlights. They resemble, in some respects, the wash drawings endowed with highlights and toned backgrounds which then enjoyed great popularity.

These woodcuts, strikingly different from ordinary ones, and remarkably effective, are known as *chiaroscuros*. (They are occasionally referred to as *clair-obscur* or *helldunkel* prints.) Their relative scarcity must be ascribed to inherent difficulties in the chiaroscuro technique for both the artist and the printer.

Chiaroscuro prints are not simply colored woodcuts where the colors are laid down side by side, but involve the superimposition of layers of colors to achieve fine shading and distinct highlights. A high degree of registration of the printing blocks is of course mandatory to attain satisfactory results.

Printing in more than one color dates back to the beginning of printing with movable type. As early as 1457, Fust and Schöffer's *Psalter* was embellished with red and blue initials. Erwin Ratdolt used varied colors in his edition of Euclid's works (Venice, 1482).[1] The woodcut illustrations of the patron saints of Passau, St. Valentine, St. Stephen, and St. Maximilian, in the *Passau Missal* of 1498 (issued by Ratdolt after he took up residence in Augsburg) are printed from four blocks: black, red, yellow, and brown. But the colors are not superimposed; they are laid down side by side in the manner of stained glass windows, without an attempt to achieve shading.

Because it is printed in white on a black background, a unique impression of Master E. S.'s engraving, "Madonna with a Bird" (L.70), dating from about 1470, has sometimes been described as a forerunner of chiaroscuro prints. It must, however, be considered strictly experimental because the shadows were clearly intended for black on white impressions.

Two engravings by Mair von Landshut, "Birth of Christ" (B.4), dated 1499, and "Samson and Delilah" (B.3, at the Albertina in Vienna) were formerly considered to be the earliest examples of chiaroscuro prints.[2] Both are, however, simply printed on dark grounded paper and then heightened with white by hand.

Apart from the rudimentary application of color in the printing process, as exemplified by Erwin Ratdolt's publications, it

[1] Campbell Dodgson, *Catalogue of Early German and Flemish Woodcuts in the British Museum,* vol. 1 (London, 1903), p. 36.
[2] John Jackson, *A Treatise on Wood Engraving* (London, 1839). There is also an impression on blue tinted paper of Mair von Landshut's "The Virgin and St. Ann" (B.8) at the Museum of Art in Cincinnati.

was customary in the fifteenth century to hand-color woodcuts and engravings. This practice seems to have come to a temporary halt during the time of Dürer.

Albrecht Dürer (1471-1528) was probably the greatest master of engraving and woodcut techniques of all time. He was fond of using gay colors in his paintings during his youth, although he later changed his view.[3] In some of his remaining manuscripts he actually used various colored inks on a single page to enhance their effectiveness.[4] But in his woodcuts and engravings he appears to have purposely avoided the use of more than one color. Although he was obviously familiar with it, he refrained from employing the chiaroscuro method of using tone blocks. In some instances, tone blocks were added to his works posthumously (see Plates 1, 2, and 3). Even when color was called for, as in "The Rhinocerus" (Plate 2), where Dürer himself mentions the required color in the accompanying legend, he resolutely restricted himself to black and white. Yet, he was by no means unaware of clair-obscur effects. His preparatory drawings for the painting "The Brotherhood of the Rosary" (1506) are on blue Venetian paper and heightened with white. He used a similar technique in the preparatory drawings for the *Heller Altarpiece* (1508-1509). Several of his sketches of human proportions, dating from 1503 to 1507, are endowed with a sepia background (W.424, 427, 428). He

had already experimented with a dark background in the engraving "Adam and Eve" (B.1) of 1504. A number of his engravings during the years 1508 to 1510 are decidedly of a clair-obscur quality (e.g., "The Crucifixion," B.24; dated 1508; see illustration opposite), but they are all printed from a single plate.[5]

Dürer's reluctance to employ the chiaroscuro method is in some ways surprising, for he continuously experimented with new techniques, both in painting and in the use of the burin. His graphic work is particularly distinguished by a new look, a new perspective, and a "rationalization of sight"[6] that must have had a striking effect on the eyes of the public of his time.

In the opinion of his contemporaries, the effectiveness of Dürer's prints was unquestionably based in large part on his singular use of black and white: "He pictures everything . . . and presents it in fortuitous lines, precisely those black lines to which it would be unjust to add color. While Apelles had the benefit of color, is it not wondrous to achieve effectiveness in its absence?" (Letter from Erasmus of Rotterdam to Dürer's friend, the humanist Willibald Pirckheimer, dated March 31, 1528.)[7]

This emphatic and exclusive use of black and white in his woodcuts and engravings can hardly be explained otherwise than as a counterreaction to traditional hand-colored woodcuts. Undoubtedly, Dürer was

[3] Letter from Philip Melanchthon to Georg von Anhalt, December 17, 1546 quoted in Hans Rupprich, *Dürers schriftlicher Nachlass,* vol. 1 (Berlin, 1956), p. 289.
[4] Sloane Manuscript No. 5230, Fol. 10, British Museum; quoted in Rupprich, *op. cit.,* vol. 2, p. 46.

[5] Erwin Panofsky, *Albrecht Dürer,* vol. 1 (Princeton, 1943), p. 134. J. D. Passavant, *Le Peintre Graveur,* vol. 3 (Leipzig, 1860), p. 226.
[6] William Ivins, Jr. *Metropolitan Museum of Art Papers,* No. 8 (New York, 1938).
[7] Rupprich, *op. cit.,* vol. 1, pp. 279, 296.

flattered by the compliments paid to him that his prints did not require any addition of color.

The sudden appearance of chiaroscuro woodcuts during the years 1508 to 1510 in several localities, by several artists, simultaneously, suggests in turn a revival of interest in color. But it was now added from inception during the printing process, not subsequently and often by amateurs, in the manner of children's coloring books. It is hardly a coincidence that Dürer's single plate "clair-obscur" engravings date from precisely this time, although he was then still engaged in completing his great "woodcut books," begun many years before but finally issued in 1511. However, instead of pursuing the possibilities of true chiaroscuro, Dürer turned to drypoint, etching, and attempts to further refine his engraving technique, while leaving the production of woodcuts, particularly chiaroscuro woodcuts printed from more than one block, to his erstwhile assistants and contemporaries.

During the very same year that Dürer issued his "clair-obscur" engravings, Dr. Conrad Peutinger, the renowned humanist and advisor to the Emperor, sent a communication from Augsburg to Frederick the Wise, Elector of Saxony in Wittenberg (November 24, 1508). In this letter, Dr. Peutinger makes reference to a *Kurisser* (equestrian), printed in gold and silver, that Frederick the Wise had sent him a year earlier. He goes on to say: "We have now likewise succeeded here in printing a *Kurisser* in gold and silver and I am sending you herewith a trial print of it on vellum." (See Plate 11) The print Frederick

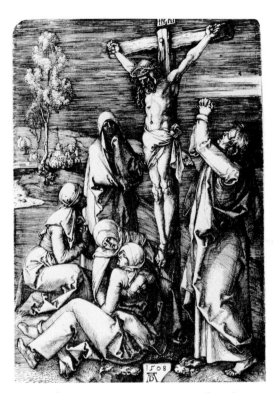

Albrecht Dürer: The Crucifixion [B.24]

the Wise had sent was the woodcut "St. George on Horseback" (See Plate 6) by his court painter, Lucas Cranach the Elder. It had presumably been printed in 1507, because early in 1508 Cranach had left for the Netherlands in order to paint a portrait of the future Emperor Charles V.

Printing in gold and silver cannot, of course, be considered chiaroscuro. Nor was it a new invention. Martin Weinberger[8] describes a "Virgin with Halo, Handing an Apple to the Infant Christ," printed in gold and silver, and dating from about 1430. Cranach had, however, used a dark blue

[8] Martin Weinberger, *Die Holzschnitte des Katherinenklosters zu Nürnberg* (Munich, 1925).

grounded paper for his print that lent it a chiaroscuro quality. He had not yet employed a printed tone background, nor was that the case with the print prepared at Augsburg by Hans Burgkmair the Elder upon Dr. Peutinger's instructions.

Very soon thereafter these same line blocks began to be used in conjunction with printed tone backgrounds. Some of these impressions bear the imprint of Jost de Negker, who has since been credited with the introduction of printed tone blocks. De Negker was famous for having added movable flourishes and colored adornments to movable type. He was therefore expert in the precise registration of printing plates. He had come to reside in Augsburg at Dr. Peutinger's request, sometime between 1508 and 1509, in order to help embellish the many publications planned by the Emperor. In a letter to Maximilian I, dated October 27, 1512, de Negker asserts that he was the first to employ this technique. He refers to the "Portrait of Hans Paumgartner" (Plate 18) as "my own work, in folio, printed from three blocks.[9] The portraits of Pope Julius II (Plate 16) and of Jacob Fugger the Rich (Plate 17), printed from only two blocks, obviously preceded that of Paumgartner. Both were undoubtedly cut and printed by Jost de Negker as well, based on Hans Burgkmair's design.

Lucas Cranach, in Wittenberg, presumably followed suit by adding printed tone blocks to his line blocks soon after intro-

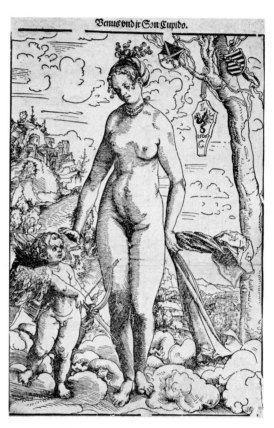

Lucas Cranach the Elder: Venus and Cupid
Printed from the line block only [III]
Compare to Plate 5

duction of the process in Augsburg. In "Venus and Cupid" (compare the illustration above to Plate 5), the tone block has already been incised to attain white highlights. The technique of achieving perfect registration during the printing process has not yet been fully mastered in Wittenberg. Later, dowels or pins were used to assure that the layers of color

[9] Anton Reichel, *Die Clair-Obscur Holzschnitte des XVI, XVII und XVIII Jahrhunderts* (Vienna, 1925), p. 19. De Negker's monogram still appeared on a woodcut designed by Lucas van Leyden, representing St. Martin, used for the *Utrecht*

Brevier, dated March 31, 1508. For the letter to the Emperor, see *Jahrbuch der Kunsthistorischen Sammlungen des allerhöchsten Kaiserhauses,* XIII/2, 1892, No. 8592.

would be correctly superimposed. Vasari mentions that the lighter tone block was usually printed first and the line block last, that is, in reverse order of their preparation.

The first artist to issue an extensive series of chiaroscuro prints and whose reputation rests on this technique was Hans Wechtlin. Born in Strassburg, he worked in Nancy in 1505 and in Wittenberg in 1506. It is possible that subsequently he passed through Augsburg and studied with Jost de Negker. According to the record of the city of Strassburg, Wechtlin became a citizen on November 16, 1514. He had probably returned to his birthplace several years before. His chiaroscuro prints are generally dated from 1510 to 1516.[10]

Wechtlin's artistic activity in Strassburg coincided with that of Hans Baldung Grien. Also a citizen of Strassburg, Baldung had returned shortly after 1508 from his travels as a journeyman which included a prolonged stay with Albrecht Dürer in Nuremberg. His first chiaroscuro print, "The Witches' Sabbath" (Plate 32), is dated 1510. Both artists were obviously familiar with the Augsburg chiaroscuros, but no evidence of a close collaboration between Wechtlin and Baldung has been discovered.

Jost Amman, Georg Mattheus, and Tobias Stimmer became temporarily interested in chiaroscuro later during the sixteenth century. Ludolph Büsinck issued no fewer than twenty-five chiaroscuro prints in the first half of the seventeenth century. But the flowering of chiaroscuro activity in Germany, best exemplified by Cranach, Burgkmair, Hans Baldung Grien, and Wechtlin, was of brief duration.

After hardly a decade interest in chiaroscuro shifted to Italy, where, on July 24, 1516, Ugo da Carpi (1455-1523) applied to the Signoria of Venice for the exclusive privilege to issue chiaroscuro prints, a technique he claimed to have invented.[11] Perhaps some of da Carpi's chiaroscuro prints are earlier, but none are dated in the plate before 1518. Ugo da Carpi had certainly had occasion to see examples of German chiaroscuro by the year 1516, especially in view of the fact that the merchants of Augsburg and Nuremberg maintained in Venice a large trading establishment, the Fondaco dei Tedeschi, next to the Rialto Bridge. The façade of that great edifice had been decorated by Titian and Giorgione in 1508.

The first artist to employ a tone block in the Netherlands was Cornelis Anthoniszoon (1507-1553) in Amsterdam. Only a single example of his use of this technique is known.

Frans Floris van Vriendt (1518-1570) followed with "David Playing the Harp before Saul" (Plate 101) in 1555. In 1557, Hubert Goltzius, a native of Würzburg, Germany, issued a book in Antwerp that was printed in line on a sepia background and pictured the Roman Emperors in the manner of antique coins. The actual cutting of the blocks has been attributed to Joos Gietleughen of Courtrai.

In 1558, Crispin van den Broeck (1524-1591) moved from Mechelen (Ma-

[10] Thieme-Becker, *Künstler Lexicon*, vol. xxxv, p. 233.

[11] Anton Reichel, *op. cit.*, p. 29. *La Xilografia a chiaroscuro italiana*, 2nd ed. (Lecco, 1932), p. 28.

lines) to Antwerp where he rented quarters from Hubert Goltzius. The ten chiaroscuros attributed to van den Broeck are all etched and endowed with a single tone block. One of these is dated in the plate 1571.

These early attempts to issue chiaroscuro prints in the Netherlands lean heavily on German examples. It was not until Hendrick Goltzius (1558-1617) began printing his graphic works in Haarlem, sometime after 1582, that Dutch chiaroscuro came into its own. The technique of employing swelling and diminishing lines gave Goltzius' works a special quality that was to be emulated later by the engravers after Rubens.[12] Carel van Mander mentions that, after settling in Haarlem in 1583, he showed a number of Bartholomäus Spranger's drawings to Goltzius.[13] Spranger (1546-1611), a native of Antwerp, was then Court Painter to Emperor Rudolph II in Prague. Previously, he had spent ten years in Rome, in the employ of Cardinal Alessandro Farnese and Pope Pius V. The drawings, van Mander showed to Goltzius were obviously from Spranger's "Viennese Period," before Prague. They reflect Italian influence, are charged with energy and movement, and employ washes, the effects of which the chiaroscuro technique particularly seeks to reproduce. In this respect, Spranger's drawings influenced not only Goltzius but also his contemporary, Abraham Bloemaert, and indeed may have caused both these artists to become interested in chiaroscuro printing.

Goltzius' early chiaroscuros are marked by a stress on the line block. The earliest impressions are printed only from the line blocks on blue paper, without tone blocks. Sometimes these are experimentally heightened with white by hand. They generally date from before his journey to Italy from 1490 to 1491. In his later works, the emphasis shifts to the tone blocks and to coloristic contrast, obviously influenced by the Italian chiaroscurists. At this point Goltzius approaches "pure" chiaroscuro in which the line block loses its importance altogether and a satisfactory image is achieved only if all blocks are used in conjunction with one another. From a stylistic point of view, Goltzius succeeds in fusing traditional Netherlandish coarseness with Italian Mannerism.

According to van Mander, Goltzius did not turn to painting until the year 1600, that is, long after his return from Italy. This underlines the fact that he must be considered primarily a graphic artist, familiar with the intricacies of printing and cognizant of the peculiar difficulties of the multiblock chiaroscuro process.

Abraham Bloemaert (1564-1651), six years younger than Hendrick Goltzius, issued only a limited number of chiaroscuro prints. Although these are based on his own designs, they were probably cut by others. One of his prints is, in fact, imprinted: *"A. Bloemaert inue, B. A. Bolswert fec. et excu."* (Plate 149)

Only two chiaroscuro prints are based on designs by Paulus Moreelse (1571-

[12] William M. Ivins, Jr., *Prints and Visual Communication* (Cambridge, 1953), p. 73.
[13] Carel van Mander, *Het Schilderboeck* (Haarlem,

1604). E. K. J. Reznicek, *Die Zeichnungen des Hendrick Goltzius* (Utrecht, 1961), p. 152.

1638), and three, executed by Christoffel Jegher (1596-1662), are based on designs by Peter Paul Rubens.

Jan Lievens (1607-1674) made use of a tone block in only one instance, the "Head of an Old Man." (Plate 162) His great contemporary, Rembrandt (1606-1669), never employed chiaroscuro, although Hercules Segher (c. 1589-c. 1638) experimented with etchings in color or printed on colored papers, all, however, printed from a single plate.[14]

When Frederick Bloemaert (1610-1669) issued a printed edition of his father's (Abraham Bloemaert's) *Tekenboek,* it served as a reminder of the possibilities of chiaroscuro. Among the more than one hundred line block illustrations, were several to which a sepia background was added, enhancing their effectiveness. But Bloemaert found no emulators. In the Netherlands too, the spurt of chiaroscuro activity was of short duration.

In each instance, the use of chiaroscuro technique in a given locality occurred during a relatively brief span of time. In every case the results were, nevertheless, startling in their novelty. There is only one plausible explanation for this phenomenon: Most artists shied away from the extraordinary difficulty of designing and then printing chiaroscuro works. It was practiced only by those who, endowed with a special skill and predilection for this medium, combined artistic talent with mechanical crafts-

manship and were patient enough to continue in that vein. It was for this reason that chiaroscuro activity, wherever it arose, was almost invariably associated with one principal artist and echoed by others to a limited extent.

As a consequence, the total number of chiaroscuro prints produced by the artists of the sixteenth and seventeenth centuries in Germany and the Netherlands is relatively small. They stand apart as specialized works by especially talented artists and continue to impress the viewer with a particular, unique effectiveness.

As far as the present state of research permits, a chronological sequence has been adopted in order to make it possible to follow the use and development of the chiaroscuro technique as a whole while following the work of individual artists.

With few exceptions, the illustrations are reproduced in *Duotone,* in shades of brown and sepia. Although it represents a compromise, this effect approximates that of the original to a considerably greater degree than can be achieved by black and white. Most chiaroscuro prints were issued in several color combinations at various times. These colors have been noted in the text whenever they could be ascertained.

In the commentary, conjecture and descriptive matter have purposely been kept to a minimum. The illustrations should be given first consideration, for these alone represent the manner in which the artist intended to address his audience.

W. L. S.

14 Jacob Rosenberg and Seymour Slive, *Dutch Art and Architecture, 1600-1800* (Baltimore, 1966), p. 147.

ACKNOWLEDGMENTS

This book could not have been written or illustrated without the help, cooperation, and many helpful suggestions of friends and colleagues to whom I am forever indebted and grateful: Mr. Robin Adèr, Museum Boymans-van Beuningen, Rotterdam; Dr. Fedja Anzelewski, Kupferstichkabinett, Berlin-Dahlem; Miss Inge Dürst-Bannier, Öffentliche Kunstsammlung, Basel; Mr. Leonard Baskin, Northampton; Mr. K. G. Boon, Rijksprentenkabinet, Amsterdam; Miss M. van Borssum Buisman, Prentenkabinet, Leyden; Mr. Fred Cain, Alverthorpe Gallery, Jenkintown; Mr. Douglas Dillon, Metropolitan Museum of Art, New York; Mr. Edward A. Foster, Institute of Arts, Minneapolis; Mr. Glaubrecht Friedrich, Print Room, Dresden; Miss I. M. de Groot, Rijksprentenkabinet, Amsterdam; Prof. Egbert Haverkamp-Begemann, Yale University; Prof. Julius S. Held, Bennington; Mr. J. Hofmann, Staatsbibliothek, Bamberg; Dr. Hanna Hohl, Kunsthalle, Hamburg; Miss B. L. D. Ihle, Museum Boymans-van Beuningen, Rotterdam; Mlle. Pierette Jean-Richard, The Louvre, Paris; Dr. Harold Joachim, Chicago Art Institute; Miss Caroline Karpinsky, New York; Dr. E. W. Kornfeld, Berne; Dr. Walter Koschatzky, The Albertina, Vienna; Dr. Dieter Kuhrmann, Graphische Sammlung, Munich; Prof. Ruth S. Magurn, Fogg Art Museum, Cambridge; Miss Charita Mesenzeva, The Hermitage, Leningrad; Miss Maria Naylor, Kennedy Galleries, New York; M. Maxime Préaud, Bibliothèque Nationale, Paris; Miss Louise Richards, Cleveland Museum of Art; Mr. Benjamin Rifkin, New York; Dr. Hella Robels, Wallraf-Richartz Museum, Cologne; Mr. Lessing Rosenwald, Jenkintown; Miss B. T. Ross, Princeton University Art Museum; Miss Elizabeth Roth, Public Library, Prints Division, New York; Mr. John Rowlands, Print Room, British Museum, London; Miss Elizabeth Sayre and her assistants, Clifford S. Ackley, Sue W. Reed, and Wendy S. Topkins, Boston Museum of Fine Arts; Dr. Werner Schade, Staatliche Museen zu Berlin; Dr. Werner Schmidt, Kupferstichkabinett, Dresden; Dr. R. Schwarzweller, Städelsches Kunstinstitut, Frankfurt; Mr. H. J. de Smedt, Centraal Museum, Utrecht; Miss Kristin L. Spangenberg, Cincinnati Art Museum; Prof. Wolfgang Stechow, Oberlin College; Dr. Alice Strobl, The Albertina, Vienna; M. Carlos van Hasselt, Institut Néerlandais, Paris; Dr. L. Voet, Stedelijk Prentenkabinet, Antwerp; Dr. Fritz Zink, Germanisches National Museum, Nuremberg.

The author also wishes to express his appreciation to Sara Pyle for many editorial suggestions, to Laurie Sucher for the index, and to Hermann Strohbach for the design of this book.

Abbreviations

A Andresen, Andreas. *Der deutsche Peintre-Graveur,* Berlin, 1866.

B Bartsch, Adam von. *Le Peintre-Graveur,* Vienna, 1808.

DM *Dutch Mannerism, Apogee and Epilogue,* Exhibition Catalogue, Vassar College Art Gallery, Poughkeepsie, 1970.

H Hollstein, F. W. H. *Engravings, Etchings, and Woodcuts,* Amsterdam, 1954-.

IN Institut Néerlandais. *Exposition Clair-Obscurs Gravures sur Bois, Imprimées en Couleurs de 1500-1800,* Paris, 1965.

LeB Le Blanc, Charles. *Manuel de l'Amateur d'Estampes,* Paris, 1854-90.

M Meder, Joseph. *Dürer-Katalog,* Vienna, 1932.

P Passavant, Johann David. *Le Peintre-Graveur,* Leipzig, 1862.

R Reichel, Anton. *Die Clair-Obscur Holzschnitte des XVI, XVII und XVIII Jahrhunderts,* Vienna, 1925.

St Stechow, Wolfgang. "Ludolph Büsinck, a German Chiaroscuro Master of the Seventeenth Century," *Print Collector's Quarterly,* vol. 25, 1938, pp. 393-419; vol. 26, 1939, pp. 349-59.

W Winkler, Friedrich. *Die Zeichnungen Albrecht Dürers,* Berlin, 1936-39.

Wu Wurzbach, A. von. *Niederländisches Künstler Lexicon,* 2 vols. and supplement, Vienna, 1906-11.

Bibliographical references appear on the first page devoted to each artist.
All sizes are stated in millimeters, height before width.
The references for watermarks are: C. M. Briquet, *Les Filigranes,* 2nd ed., Leipzig, 1923 and Joseph Meder, *Dürer-Katalog,* Vienna, 1932 (abbreviated: M).

Repositories

Amsterdam *Rijkprentenkabinct, Rijksmuseum*
Antwerp *Stedelijk Prentenkabinet*
Aschaffenburg *Schlossbibliothek*
Bamberg *Staatsbibliothek*
Basel *Öffentliche Kunstsammlung*
Berlin *Kupferstichkabinett, Staatliche Museen, Preussischer Kulturbesitz*
Berlin *Kupferstichkabinett, Staatliche Museen zu Berlin*
Boston *Museum of Fine Arts*
Bremen *Kunsthalle*
Brunswick *Herzog Anton Ulrich Museum*
Cambridge *Fogg Art Museum*
Cambridge (UK) *Fitzwilliam Museum*
Chicago *The Art Institute*
Cincinnati *Museum of Art*
Cleveland *Museum of Art*
Coburg *Sammlung der Veste*
Cologne *Wallraf-Richartz Museum*
Darmstadt *Hessisches Landesmuseum*
Dresden *Kupferstichkabinett*
Erlangen *University Library*
Frankfurt *Städelsches Kunstinstitut*
Göttingen *Kunstsammlung der Universität*
Haarlem *Museum Teyler*
Hamburg *Kunsthalle*
Hanover *Kestner Museum*
Jenkintown *Alverthorpe Gallery*
Karlsruhe *Staatliche Kunsthalle*
Kassel *Kupferstichkabinett*
Leningrad *The Hermitage*

Leyden *University Library*
London *British Museum*
Middletown *Wesleyan University, Print Room*
Minneapolis *Institute of Arts*
Munich *Staatliche Graphische Sammlung*
New Haven *Yale University Art Museum*
New York [MM] *Metropolitan Museum of Art*
New York [NYPL] *New York Public Library, Prints Division*
Nuremberg *Germanisches National Museum*
Oberlin *Allen Memorial Art Museum*
Oxford *Ashmolean Museum*
Paris [BN] *Bibliothèque Nationale*
Paris [IN] *Institut Néerlandais*
Paris [L] *Louvre, Collection Edmond de Rothschild*
Philadelphia *Museum of Art*
Princeton *Princeton Art Museum*
Providence *Museum of Art, Rhode Island School of Design*
Rotterdam *Museum Boymans-van Beuningen*
Stuttgart *Staatsgalerie*
Utrecht *Centraal Museum*
Vienna *Albertina*
Vienna [HB] *Nationalbibliothek*
Washington *National Gallery of Art*
Washington [L] *Library of Congress*
Weimar *Schlossmuseum*
Worcester *Museum of Art*

The locations listed for each print are indicative but not exhaustive. In each case, the collection in *italics* denotes the source of the illustration.

List of Plates

GERMAN ARTISTS

ALBRECHT DÜRER

1. Portrait of Ulrich Varnbüler
2. The Rhinocerus
3. Emperor Maximilian I
3A. St. Francis Receiving the Stigmata*

LUCAS CRANACH THE ELDER

4. St. Christopher
5. Venus and Cupid
6. St. George on Horseback
7. Rest on the Flight to Egypt
7A. Adam and Eve*
7B. David and Abigail*
7C. St. Jerome, Penitent*
8. The Sermon of St. John the Baptist
9. Frederick the Wise, Elector of Saxony

HANS BURGKMAIR THE ELDER

10. Madonna and Child
11. St. George on Horseback
12. Emperor Maximilian on Horseback
13. Lovers Surprised by Death
14. The Holy Roman Empire and Its Principalities
15. Coat of Arms of Cardinal Matthew Lang
16. Pope Julius II
17. Jacob Fugger the Rich
18. Hans Paumgartner

HANS WECHTLIN

19. Christ on the Cross
20. Madonna on a Grassy Bench
21. Virgin and Child Surrounded by a Renaissance Frame
22. St. Sebastian
23. Skull in a Renaissance Frame

*Not illustrated.

24. Pyramus and Thisbe
25. Orpheus Spellbinding the Wild Animals by His Music
26. Alcon Freeing His Son
27. Knight and Lansquenet
28. Pyrgoteles
29. St. Jerome, Penitent
30. St. Christopher

ALBRECHT ALTDORFER

31. The Beautiful Virgin of Regensburg

HANS BALDUNG GRIEN

32. The Witches' Sabbath
33. The Fall of Man
34. Madonna in a Landscape Surrounded by Angels
35. St. Jerome, Penitent
36. St. Christopher
37. Christ on the Cross with the Virgin, the Magdalen, and St. John
38. The Conversion of St. Paul
39. Lucretia

ERHARD ALTDORFER

40. Loving Couple in a Landscape

HANS WEIDITZ

41. Coat of Arms of Cardinal Matthew Lang, Coadjutor of Salzburg
42. Ecce Homo, Standing
42A. Ecce Homo, Seated

HANS SEBALD BEHAM

43. Head of Christ with Sudarium

*Not illustrated.

NETHERLANDISH ARTISTS

* Not illustrated.

* Not illustrated.

GERMAN ARTISTS

ALBRECHT DÜRER

1471-1528, Nuremberg. Dürer traveled to Italy in 1595-1496, and again in 1506-1507; to the Netherlands during 1520 to 1521.

1. Portrait of Ulrich Varnbüler

Imprinted: Albrecht Dürer. Dated 1522.
487 x 326 mm.
B. 155; P.I. p. 124; M.256; Panofsky 369; H.256.

I. Line block only.
II. Posthumous. Line only. A crack near the collar; the left eye damaged. Imprinted:
 Men vintse te coope by Hendrick Hondius, Plaetsnijder in s'Gravenhage.[1]
 Watermark: Crest of Cologne.
III. Posthumous. One line block; two tone blocks (light green/dark green or brown/sepia). Imprinted: *Ghedruckt t'Amsterdam by Willem Janssen in de vergulde Sonnwyser.*[2] Watermark: Circle with Two Arcs and a Flourish.

Varnbüler, a friend of Erasmus of Rotterdam and of Willibald Pirckheimer, was Pronotary of the Imperial Supreme Tribunal (Reichskammergericht).

The chiaroscuro version of this print is posthumous and served partly to hide the defects of the greatly used woodblock. States II and III are evidence of the "Dürer Renaissance" that occurred in the Netherlands late in the sixteenth century[3] when the child prodigies Jan and Jerome Wierix produced amazingly good copies of Dürer's prints. Hendrick Goltzius emulated Dürer's silverpoint technique in his early drawings and, for his amusement, issued very clever engravings which he passed off as "unpublished" Dürers,[4] supposedly withheld from publication until fifty years after Dürer's death. New editions of Dürer's theoretical works were published by Joh. Janssen at Arnhem in 1603.

I. Berlin, London, New York (MM), Paris (L).
III. Amsterdam, Berlin, Boston, London, Minneapolis, New Haven (Yale Art Musum), New York (MM), Nuremberg, Paris (L), Philadelphia, Washington.

[1] Hendrick Hondius (1573-1646). His imprint appears also on Plate 2 (cf. Pl. 152).
[2] The imprint of Willem Janssen [Blaeu] (1571-1638) appears also on Plates 2, 119, 124, 133, and 134. He was active as a printer in Amsterdam after 1620. In that year he published a "View of Amsterdam" (B. Hausmann, *Albrecht Dürer's Kupferstiche, Radirungen, und Holzschnitte,* Hanover, 1861, p. 88;

cf. F. G. Waller, *Biographisch Wordenboek van Nederlandsche Graveurs,* The Hague, 1938, p. 54).
[3] E. K. J. Reznicek, *Die Zeichnungen des Hendrick Goltzius,* Utrecht, 1961, p. 54.
[4] Carel van Mander, *Het Schilderboeck,* Haarlem, 1604; Hans Kauffmann, "Dürer in der Kunst und im Kunsturteil um 1600," *Vom Nachleben Dürers,* Nuremberg, 1954, p. 30.

2

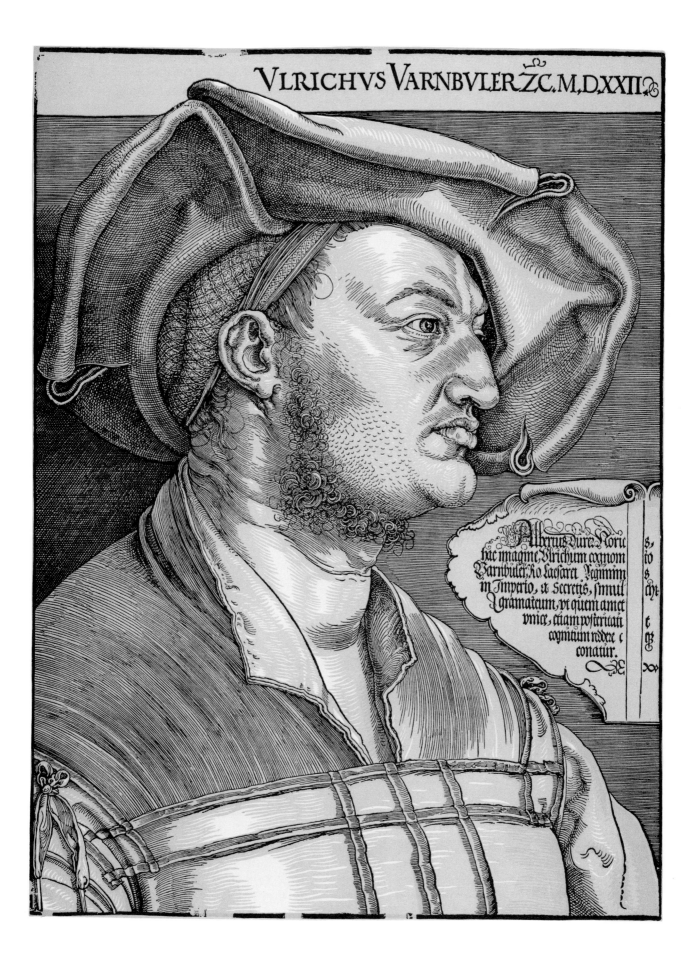

2. The Rhinocerus

With monogram. Dated 1515.
212 x 300 mm.
B.136; P. I, p. 124; M.273; Panofsky 356; H.273.

I. Line block only.
II. Posthumous. Line block only, with a crack through the legs. Imprinted: *Hendrick Hondius, Plaetsnijder in s'Gravenhage.* Text in Dutch.[1]
III. Posthumous. One line block; one tone block. Imprinted: *Ghedruckt t'Amsterdam by Willem Janssen in de vergulde Sonnwyser.*
The line block shows greater wear than in II,[2] although the defects are well camouflaged by the addition of the tone block.

Text of I translated from the German:

"After Christ's Birth, the year 1513, on May 1, this animal was brought alive to the great and mighty King Emanuel at Lisbon in Portugal from India. They call it Rhinocerus. It is here shown in full stature. Its color is that of a freckled toad and it is covered by a hard, thick shell. It is of the same size as an elephant but has shorter legs and is well capable of defending itself. On the tip of its nose is a sharp, strong horn which it hones wherever it finds a stone. This animal is the deadly enemy of the elephant. The elephant is afraid of it because upon meeting it charges with its head between the elephant's legs, tears apart his belly, and chokes him while he cannot defend himself. It is so well armored that the elephant cannot harm it. They say that the Rhinocerus is fast, cunning, and daring."

This rhinoceros was sent to King Emanuel of Portugal by King Muzafar of Cambodia. It arrived in Lisbon on May 29, 1513. The King then sent it to Pope Leo X, but the boat sank on the way. Later it was recovered and delivered to the Pope stuffed.[3]

Dürer did not use color in this print, although it would have been indicated to attain a lifelike impression. The tone block was added posthumously.

I. Berlin, Brunswick, Coburg, Dresden, Erlangen, Frankfurt, Hamburg, London, Munich, Paris (L), Schweinfurt, Stuttgart, Vienna, Weimar.
II. Vienna.
III. Berlin, *Boston,* Gotha, London, New York (MM), Paris (BN), Paris (L), Vienna.

[1] Joseph Heller, *Das Leben und die Werke Albrecht Dürer's,* Bamberg, 1827, No. 1904.
[2] B. Hausmann, *Albrecht Dürer's Kupferstiche, Radirungen, Holzschnitte und Zeichnungen,* Hanover, 1861, p. 81.

[3] Campbell Dodgson, "The Story of Dürer's Ganda," in A. Fowler, *The Romance of Fine Prints,* Kansas City, 1938, p. 45.

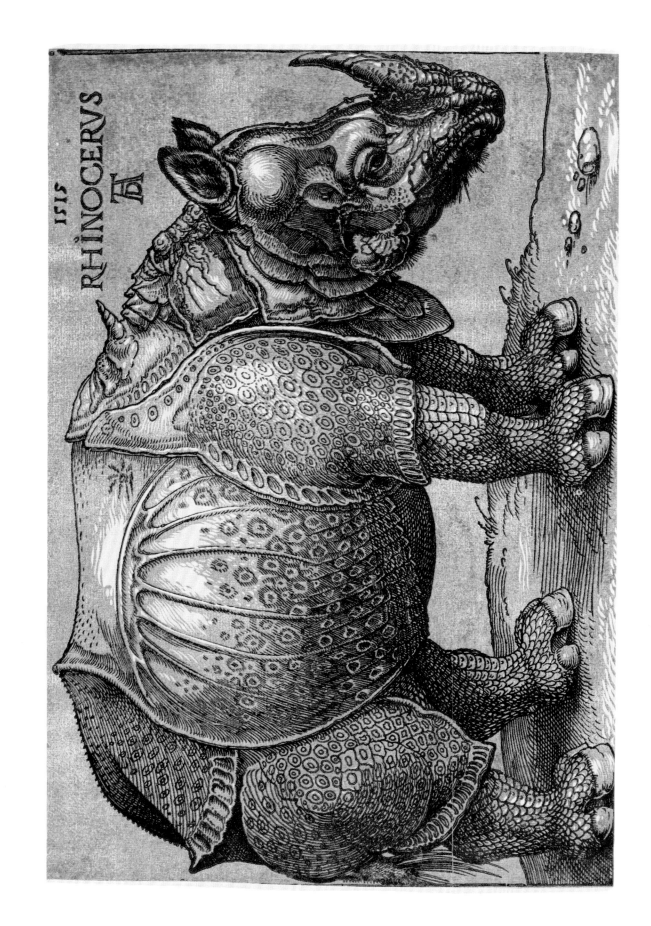

3. Emperor Maximilian I

Without monogram. 1519.
414 x 319 mm.
B.154; M.255; Panofsky 367/368; H.255.

ı. Line block only. Imprinted: *Imperator Caesar.*
ıı. Line block only, but printed in black and gold on a dark blue background, simulating chiaroscuro. Imprinted: *Imperator Cæsar.* According to Geisberg,[1] this revised block was cut by Jost de Negker in Augsburg.[2] Watermark: Anchor in Circle.
ııı. Third block. Line only. Similar to II but a small horizontal line added to the "p" of Imperator.
ıv. Fourth block. Line only. With an added ornamental frame, attributed by Röttinger[3] to Hans Weiditz (ca. 1495 to 1536). Size with frame: 544 by 378 mm. Watermark: Circle with Star (M.7) or Crest of Nuremberg (M.204) which Meder[4] dates about 1550. The attribution to Weiditz is therefore open to question. This woodblock was bought by the Earl of Arundel in 1623 and taken to England.[5]

This woodcut is based on a drawing by Dürer made during the Imperial Diet in Augsburg in 1518 (W.567, Vienna). It served as memorial sheet for the Emperor who, shortly after leaving Augsburg, died at Wels in Austria, on January 12, 1519.

ı. Berlin, London, Melbourne, Vienna.
ıı. *Bamberg,* Gotha (until 1945).
ııı. Paris (BN).
ıv. Bremen.

[1] Max Geisberg, "Holzschnittbildnisse des Kaisers Maximilian I," *Jahrbuch der preussischen Kunstsammlungen,* vol. 32, 1911.
[2] Cf. Introduction, p. ıx.
[3] Heinrich Röttinger, *Hans Weiditz, der Petrarka Meister,* Strassburg, 1904.
[4] Joseph Meder, *Dürer-Katalog,* Vienna, 1932.
[5] Joseph Heller, *Albrecht Dürer,* Bamberg, 1827, No. 1949; A. von Eye, *Albrecht Dürer, Leben und Wirken,* Nördlingen, 1869, p. 387.

3ᴀ. St. Francis Receiving the Stigmata

B.110; M.224; Panofsky 330; H.224.
Heller (No. 1829) mentions impressions in chiaroscuro. Location unknown.

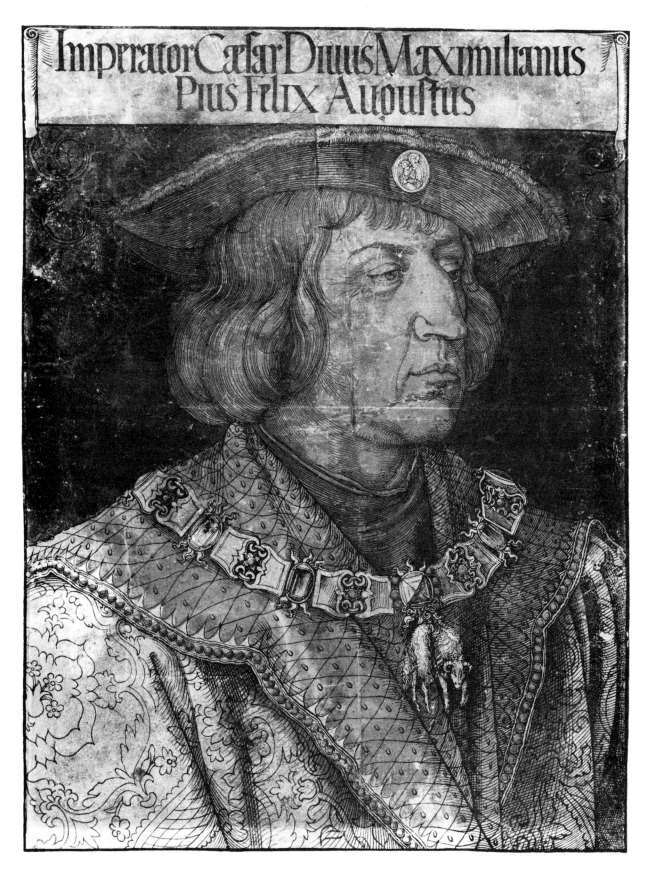

Imperator Cæsar Diuus Maximilianus Pius Felix Augustus

I

LUCAS CRANACH THE ELDER

Cronach, 1472-1553, Weimar. Named after his birthplace in Bavaria, he settled at Wittenberg in Saxony in 1505. He became Court Painter to the Elector, Frederick the Wise, and was a close friend of Martin Luther.

4. St. Christopher

With monogram. Dated 1506; removed in later impressions.
286 x 204 mm.
B.58; R.2; H.79.

I. Line block only.
II. One line block; one tone block (black/gray, brown/sepia, black/pink).

The tone block was probably added in 1509, after Cranach's return from his journey to the Netherlands where he had been commissioned to paint a portrait of the future Emperor Charles V (cf. Introduction, p. IX).

I. Amsterdam, Berlin, Cambridge, London (imprinted: *Ad imaginem divi Christophori*), Washington.
II. Amsterdam, Boston, Cambridge, Cleveland, Coburg, London, Minneapolis (pink), Munich, New York (MM), Nuremberg, Oxford, Paris (BN), Paris (IN), Paris (L), Philadelphia, Rotterdam, Vienna, *Washington* (Lessing Rosenwald Collection), Weimar.

Joseph Heller, *Lucas Cranach, Leben und Werk,* Bamberg, 1821, No. 79.

C. Schuchardt, *Lucas Cranach, Leben und Werke,* Leipzig, vols. 1, 2 (1851), and 3 (1871).

Georg K. W. Seibt, "Helldunkel," *Studien zur Kunst und Kunstwissenschaft,* vol. 5, Frankfurt, 1891, p. 26.

Friedrich Lippmann, "Farbholzschnitte von Lucas Cranach," *Jahrbuch der preussischen Kunstsammlungen,* Berlin, 1895, vol. 16, pp. 138-42.

Eduard Flechsig, *Cranachstudien,* Leipzig, 1900.

Campbell Dodgson, "Rare Woodcuts in the Ashmolean Museum, Oxford," II, *Burlington Magazine,* vol. 39, July 1921, p. 68.

Heinrich Röttinger, *Beiträge zur Geschichte des sächsischen Holzschnitts,* Strassburg, 1921.

H. S. Foote, "Lucas Cranach the Elder's St. Christopher," *Cleveland Museum Bulletin,* vol. 16, July 1929.

Heinz Lüdecke, *Lucas Cranach der Ältere,* Berlin, 1953.

Exhibition Catalogue, *Lucas Cranach Ausstellung,* Berlin, 1954.

Johannes Jahn, *Lucas Cranach als Graphiker,* Leipzig, 1955.

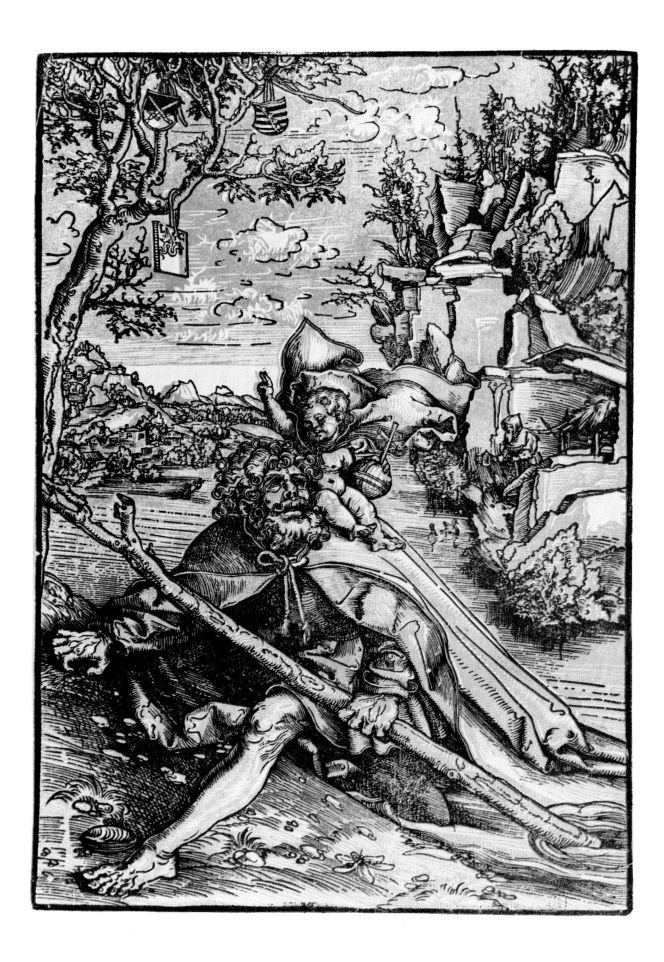

5. Venus and Cupid

With monogram. Dated 1506.
277 x 189 mm.
B.113; H.105.

I. Line only.
II. One line block; one tone block.
III. Second state: The shoulders of Venus in the line block are no longer drooping but square. Line only (cf. Introduction, p. x).

The tone block was probably added in 1509. A painting of the same subject by Cranach, dated 1509, is at The Hermitage in Leningrad.

The two crests of Saxony are suspended from a tree, customary for Cranach.

I. Berlin, Cambridge (U.K.), Frankfurt.M., Gotha, Hamburg, London, Oxford, Vienna, Weimar.
II. Berlin, *Dresden,* London.
III. Berlin, Göttingen, Nuremberg, Oxford, Vienna.

Campbell Dodgson, "Rare Woodcuts in the Ashmolean Museum, Oxford," II, *Burlington Magazine,* vol. 39, July 1921, p. 68.

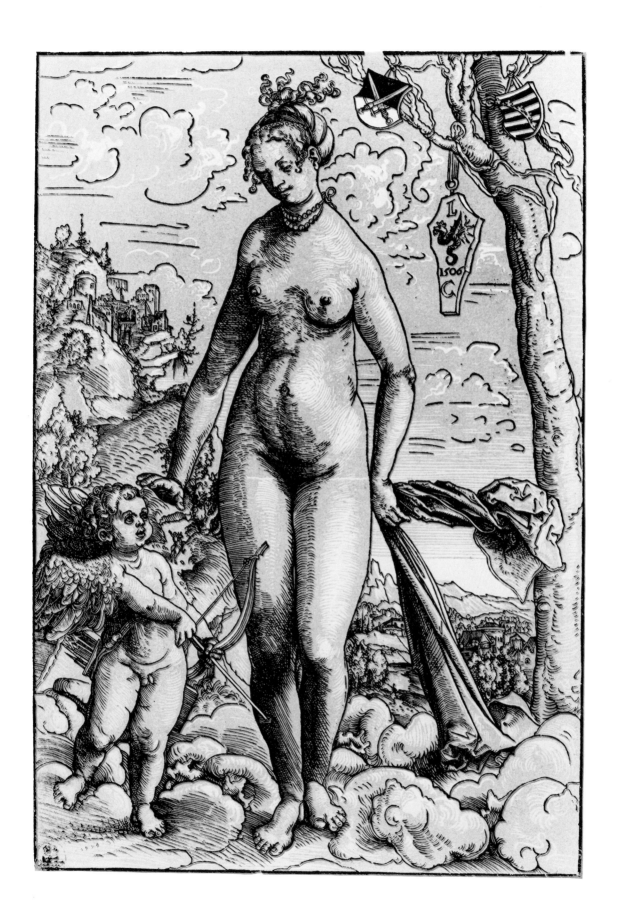

6. St. George on Horseback

With monogram. Dated 1507.
228 x 157 mm.
B.65; R.1; H.81.

 I. Line only; on paper tinted blue by hand.
 II. Printed from two blocks in black and gold on paper tinted blue by hand.

The two crests of Saxony, typical for Lucas Cranach, also appear suspended from a tree in this woodcut. According to Hind,[1] the imprint in gold was achieved by first blind-stamping the paper with paste and then dusting it with gold powder. Although the line blocks of the two preceding chiaroscuro prints are earlier, it is this subject which first was endowed with a tone background (cf. Introduction, p. IX).

 I. Dresden, London, New York (MM), Paris (L), Weimar.
 II. *London,* Munich, Paris (L).

[1] Arthur M. Hind, *An Introduction to a History of the Woodcut,* New York, 1935 and 1963, p. 51.

Campbell Dodgson, *Catalogue of Early German and Flemish Woodcuts in the British Museum,* vol. 2, pp. 74, 205.

Flechsig, 1900, p. 34.
Geisberg, 1924-30, vol. 9, Pl. 22.
Seibt, 1891, p. 26.
Campbell Dodgson, "Rare Woodcuts in the Ashmolean Museum, Oxford," II, *Burlington Magazine,* vol. 39, July 1921, p. 68.

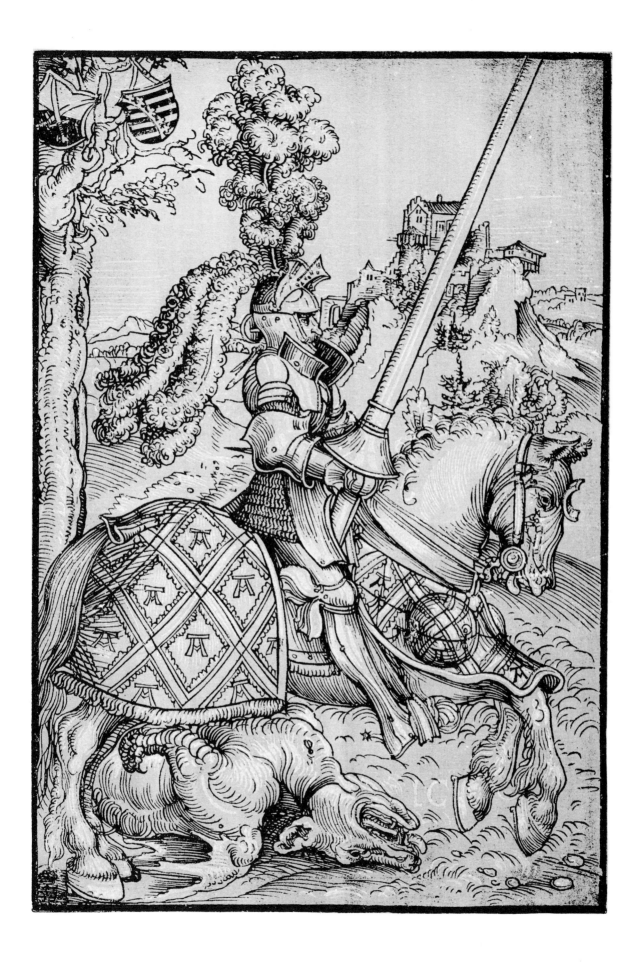

7. Rest on the Flight to Egypt

With monogram. Dated 1509.
284 x 185 mm.
B.3; Heller 3; Flechsig, pp. 31, 60; R.3; H.7.

 ɪ. Line block only.
 ɪɪ. One line block; one tone block (sepia).

 ɪ. New York (MM), London, Paris (L).
 ɪɪ. London, Munich, Nuremberg, Paris (L), *Vienna,* Weimar.

NOTE: The following woodcuts by Cranach exist also in chiaroscuro versions according to some commentators, but no examples could be located:

7A. Adam and Eve

Dated 1509.
333 x 230 mm.
B.1; Schuchardt 1; Geisberg 537; H.1.
Impressions from the line block at Aschaffenburg (with simulated tone block added by hand) and at Weimar.

7B. David and Abigail

Dated 1509.
243 x 172 mm.
B.122; Schuchardt 121; P.157; Geisberg 631; H.3.
The chiaroscuro impression is mentioned by Schuchardt.

7C. St. Jerome, Penitent

Dated 1509.
335 x 226 mm.
B.63; Schuchardt 77; Geisberg 600; H.84.
Impression from the line block at Weimar. The chiaroscuro impression is mentioned by Johannes Jahn, *Lucas Cranach als Graphiker,* Leipzig, 1955, p. 33.

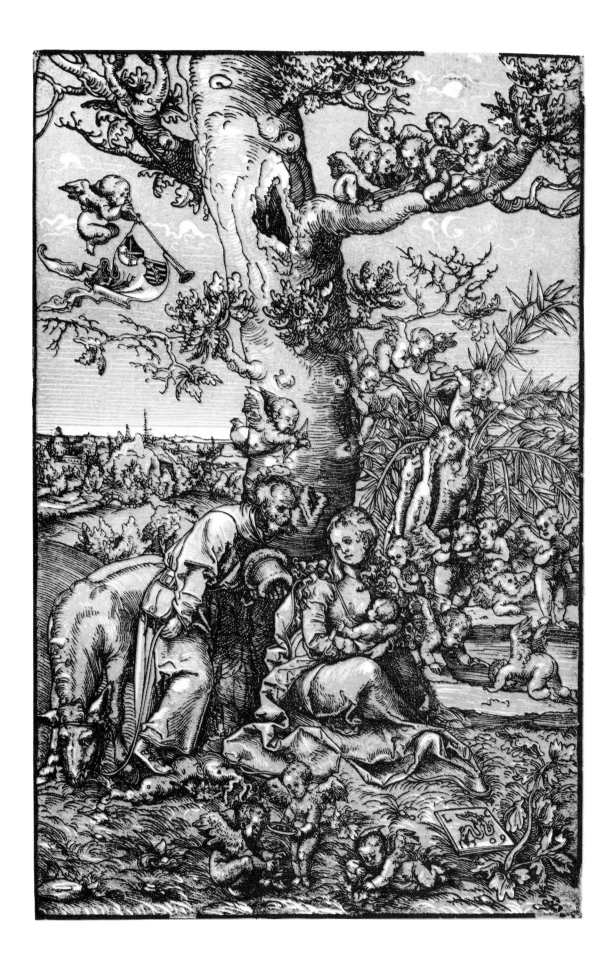

8. The Sermon of St. John the Baptist

With monogram. Dated 1516.
335 x 231 mm.
B.60; R.4; H.85.

 I. Line block only.
 II. One line block; two tone blocks.

According to Heller,[1] chiaroscuro impressions of this print are exceedingly rare.

 I. Amsterdam, New York (MM), Weimar.
 II. Amsterdam, Boston (W. G. Russell Allen Collection), *Vienna.*

[1] Heller, No. 85.

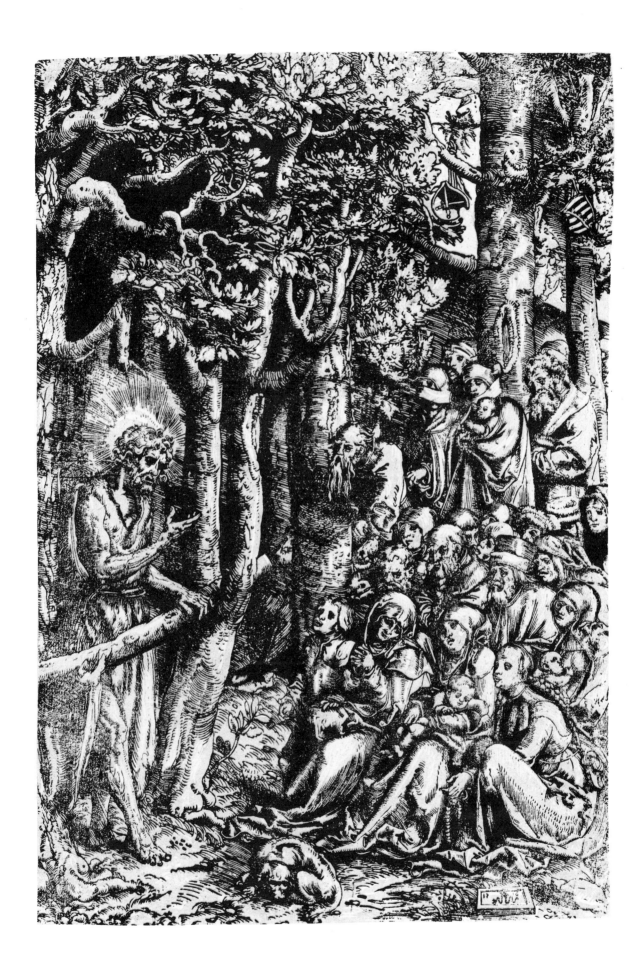

9. Frederick the Wise, Elector of Saxony

No monogram. Dated 1519, beginning with III.
295 x 269 mm.
B.43; Heller (Dürer) 2169; R.5; H.129.

 I. Line block only. Without monogram or date. Single borderline. The two
 crests of Saxony within the borderline. Watermark: Double Coat of Arms
 (Meder watermark No. 197).
 II. Copy with double borderline. The two crest of Saxony overlap the borderlines.
 III. Copy with double borderline and added tone block (sepia or orange).
 With the spurious monogram of Albrecht Dürer and dated 1519 in the
 tone block. Watermark: Arrow with the letter H (not known to Meder
 or Briquet).

Old impressions of I are accompanied by an inscription laudatory to Frederick the Wise, indicating that it was cut at the time of his death in 1525. The watermark of the impression in Boston indicates that this block was still in use late in the sixteenth century. Meder lists late impressions of Dürer's engraved portrait of Frederick the Wise on this same paper (M.102).

According to Reichel, II and III are later than I, obviously intended to deceive, in view of the spurious monogram, and backdated to 1519. Bartsch's assertion that this print portrays William of Saxony is incorrect.

 I. Bamberg (with Latin text on a tablet), Boston (W. G. Russell Allen
 Collection), Bremen (with German text on a tablet).
 III. Bamberg, *Boston* (W. G. Russell Allen Collection), Paris (L),
 Princeton, Vienna.

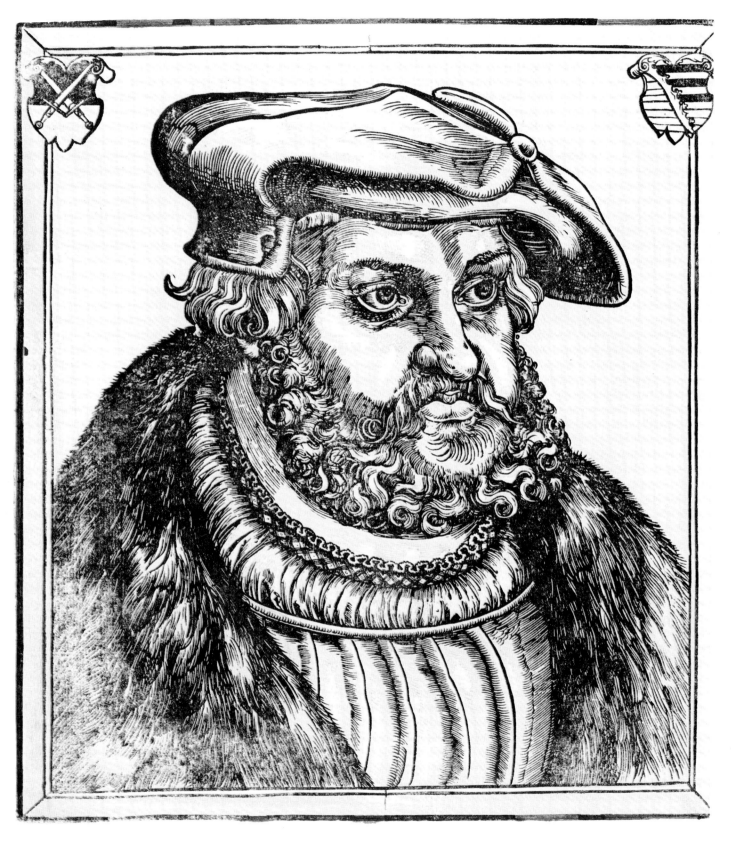

III

HANS BURGKMAIR THE ELDER

1473-1531, Augsburg. Son of the painter Thomas Burgkmair of Augsburg. Apprenticed to Martin Schongauer in 1488. Designed a canon page of "Christ on the Cross with the Virgin and St. John" as early as 1494, printed from four blocks in color, according to the method introduced by Erwin Radtolt.[1] Burgkmair provided many woodcut illustrations for the publications of Emperor Maximilian I. He collaborated with Jost de Negker in issuing the earliest chiaroscuro woodcuts (cf. Introduction, p. x).

10. Madonna and Child

Without monogram. Dated 1508.
295 x 160 mm.
P. III, p. 270, No. 84; R.6; H.67.

I. Line block only.
II. Line block with simulated tone block added by hand.

According to Reichel, the tone block was added experimentally by hand, in preparation for a projected printing block, Dodgson[2] terms it a clumsy forgery.

II. Amsterdam, Berlin, London, Oxford (heightened with white), Paris (L), *Vienna.*

[1] Cf. Introduction, p. x. See also Friedrich Winkler, *Dürer und die Illustrationen zum Narrenschiff,* Berlin, 1951, p. 81.
[2] Campbell Dodgson, *Burlington Magazine,* "Rare Woodcuts in the Ashmolean Museum, Oxford," II, vol. 39, July 1921, p. 68.

Arthur Burkhard, *Hans Burgkmair der Ältere,* "Meister der Graphik," Berlin, 1932.
H. Rupé, "Hans Burgkmair," *Print Collector's Quarterly,* vol. 10, 1923.
Friedrich Winkler, "Hans Burgkmairs früheste Holzschnitte," *Zeitschrift für Kunstwissenschaft,* vol. 1, 1947, p. 39.

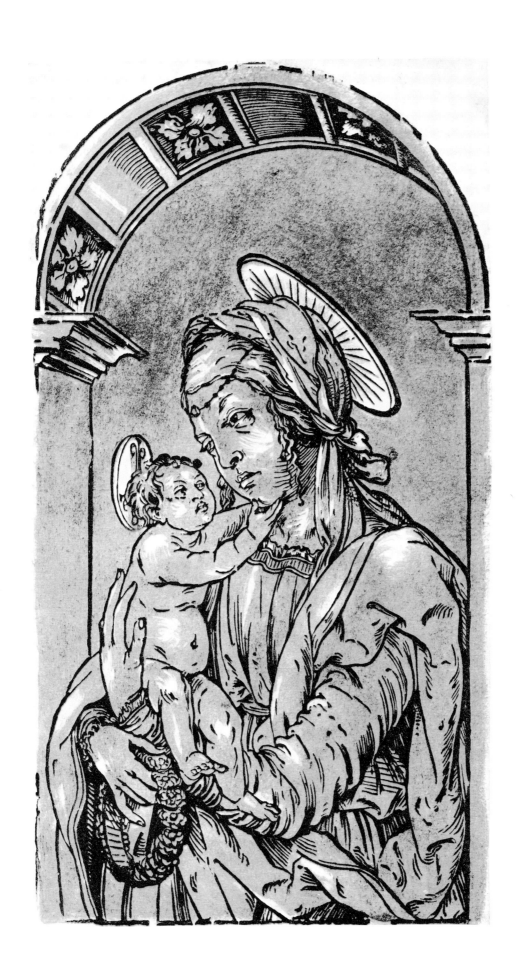

11. St. George on Horseback

Imprinted: *H. Burgkmair. 1508.*
320 x 231 mm.
B.23; R. p.15; Burkhard 15; H.253.

I. Line only.
II. Gold on prepared ground. Watermark: High Crown.
III. Line on gray tone.
IV. Line only. Imprinted, in addition, *Jost de Negker.*
V. One line block; one tone block. With de Negker's imprint.

St. George, according to legend,[1] saved Sabra, the daughter of the King of Lybia from being sacrificed to a vicious dragon. After he stabbed the beast, it "followed Sabra like a tame dog."

The Emperor Maximilian greatly expanded the Order of St. George as a means to promote a planned new Crusade against the Turks. (St. George was also credited as having aided both Godfrey de Bouillon and Richard Lionheart to attain victories over the infidels.) The Cross of St. George, emblem of the Order, serves to decorate the helmet and the cover of the stallion's armor.

Dr. Conrad Peutinger, the noted humanist and counsellor of the Emperor, referred to this print in his letter of September 24, cited in the Introduction (p. IX).

I. Dresden, Vienna.
II. Berlin, London, Oxford.
III. Cambridge, Innsbruck.
IV. Berlin, Karlsruhe, New York (MM), Paris (L).
V. Amsterdam, Cleveland, London (the date eliminated), Paris (L).

[1] Jacobus de Voragine, *Legenda Aurea;* E. Cobham Brewer, *A Dictionary of Miracles,* Detroit, 1966, p. 112.

Eduard Chmelarz, "Jost de Negkers Helldunkelblätter Kaiser Max und St. Georg," *Jahrbuch der kunsthistorischen Sammlungen des allerhöchsten Kaiserhauses,* vol. 15, Vienna, 1894, p. 392.

Campbell Dodgson, "Zu Jost de Negker," *Repertorium zur Kunstwissenschaft,* vol. 21, Berlin, 1898, p. 377.
Campbell Dodgson, *Catalogue,* vol. 2, p. 75.
Campbell Dodgson, "Rare Woodcuts in the Ashmolean Museum, Oxford," II, *Burlington Magazine,* vol. 39, July 1921, p. 68.

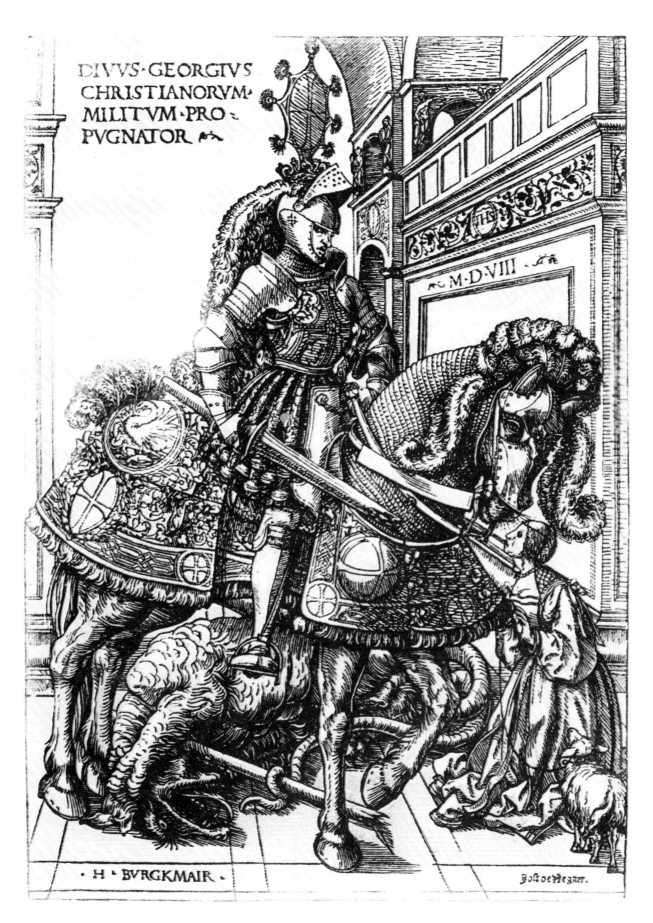

DIVVS·GEORGIVS
CHRISTIANORVM·
MILITVM·PRO=
PVGNATOR

M·D·VIII

·H·BVRGKMAIR·

12. Emperor Maximilian on Horseback

Imprinted: *H. Burgkmair.* Dated 1508.
325 x 228 mm.
B.32; R.7-8; Burkhard 14; H.323.

I. Line only. Watermark: High Crown. On white paper.
II. Two line blocks.
III. One line block only. Jost de Negker's signature added. Waterwark: Bull's Head.
IV. Same as III but date changed to 1518.
V. One line block; one tone block. Dated 1518. Watermark: Bull's Head.

The Emperor is wearing the Order of the Golden Fleece. The peacock feathers of the helmet symbolize the Archduchy of Austria. The year 1508 was significant for Maximilian I, for he was finally proclaimed Emperor at Trento on February 4, Cardinal Lang officiating (cf. Plate 15). Prior to this, his title had been "King of the Romans." Notwithstanding the coronation, Maximilan is here pictured without a crown, as a knight in armor, perhaps as a companion piece to "St. George on Horseback" (Plate 11).

I. London, Munich, Paris (L).
II. Chicago (black and gold on vellum), Cleveland (black and white on slate-blue paper, colored only on the recto. Watermark: Imperial Orb [Briquet 3069]),
Oxford (on reddish paper).
III. London, Paris (L).
IV. Berlin, Munich, Vienna (the numeral "1" added by hand [?] between 15 and 8).
V. Berlin, Boston, Dresden (dull green, a gap between 15 and 8),
London (brick red; gap as in Dresden), New York (MM),
Paris (L; gap as in Dresden), Vienna.

Chmelarz, 1894, No. 11.
Dodgson, *Catalogue*, vol. 2, p. 75.
Max Geisberg, "Holzschnittbildnisse des Kaisers Maximilian I," *Jahrbuch der preussischen Kunstsammlungen*, vol. 32, 1911.

Cleveland Museum Bulletin, vol. 29, 1952, p. 223.
Campbell Dodgson, "Rare Woodcuts in the Ashmolean Museum, Oxford," II, *Burlington Magazine*, vol. 39, July 1921, p. 68.

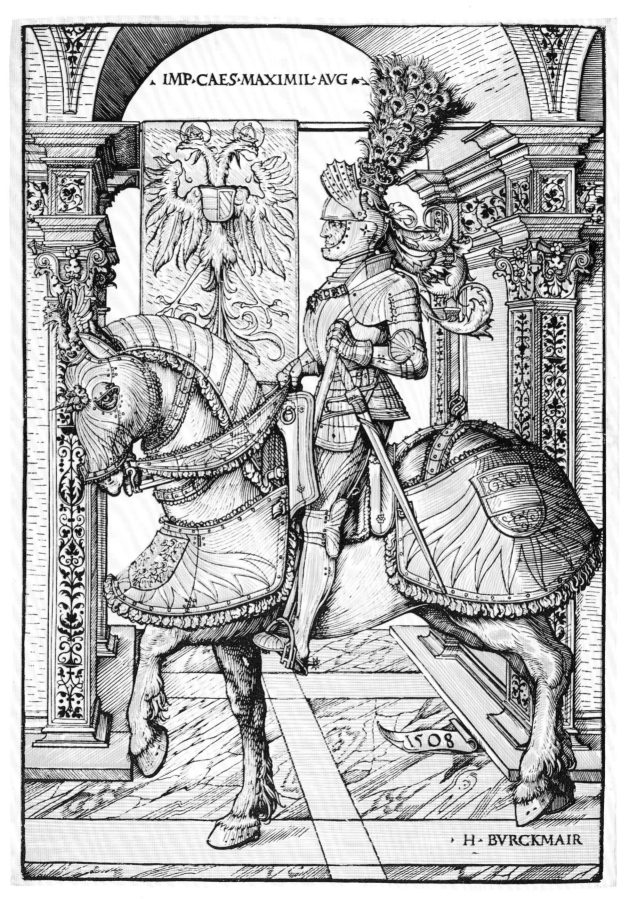

13. Lovers Surprised by Death

Inscribed: *H. Burgkmair*. Dated 1510.
214 x 153 mm.
B.40; R.9; Burkhard 20; Dodgson *(Catalogue)*, vol. II, 85, No. 46; H. 724.

 I. One line block; two tone blocks. Imprinted: *H. Burgkmair*.
 II. As I, with the date MDX added.
 III. As above, without date but with the additional imprint: *Jost de Negker*.
 IV. One line block; three tone blocks. Imprinted: *Jost de Negker zu Avgspvrg*.
 V. As above, but only two tone blocks.

The Italianate features of the architecture were noted by Reichel and ascribed to Burgkmair's familiarity with Venice. The theme of this print is not uncommon in the sixteenth century. Another example is Albrecht Dürer's "Promenade" (B.94). Rather than to signify disapproval of premarital love, the subject was intended to remind man of the brevity of life and its pleasures.

 I. London, Paris (L).
 II. Feldberg, Frankfurt, Karlsruhe.
 III. Berlin, Coburg, Cologne, Dresden, Paris (BN), Prague, *Vienna*.
 IV. Basel, Berlin, Cleveland, Coburg, London, Munich, Nuremberg, Paris, Vienna.
 V. Bautzen, Cleveland, Dresden, Hamburg, London, New York (MM)
 Oxford, Paris (L), Prague, Vienna, Washington.

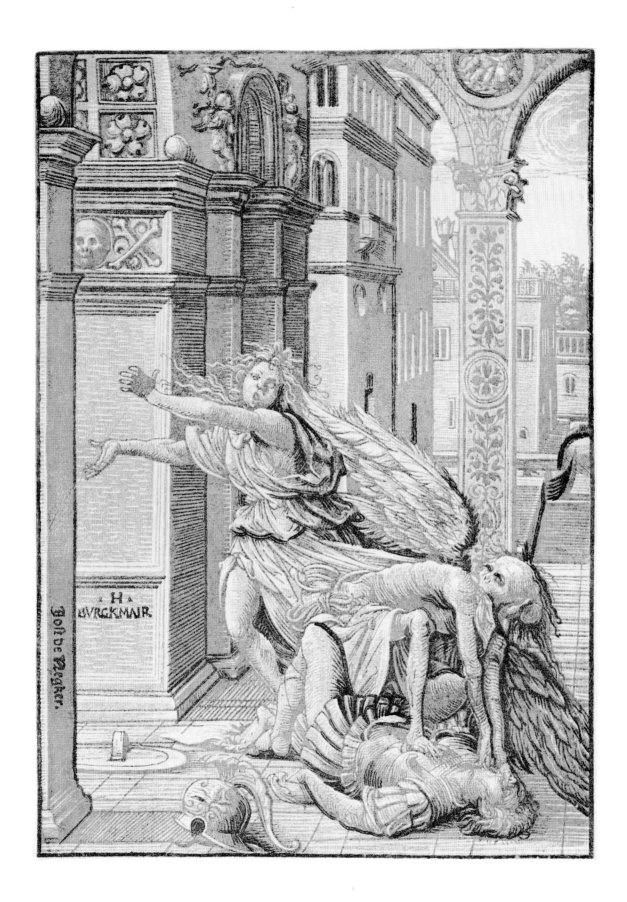

14. The Holy Roman Empire and its Principalities

Imprinted: *Das hailig römisch Reich mit sampt seinen Gliedern.* 1510.
285 x 387 mm.
Dodgson *(Catalogue),* vol. II, 206; Burkhard 19; Geisberg 520; H.829.

 I. Line only; dated 1510.
 II. Line only from a different block; dated 1511.
 III. One line block; two tone blocks (red and violet).
 Imprinted: *Jobst de Negker, Augspurg.*
 IV. Line only. Imprinted: *David de Negker in Augsburg.*
 V. Line only. Imprinted: *N F zu Leipzig.*

Although not a true chiaroscuro print—the colors are laid down side by side—it is here included because of the use of tone blocks, often augmented by additional hand coloring.

 I. Erlangen.
 II. Nuremberg.
 III. *Boston* (W. G. Russell Allen Collection), Dresden.
 IV. Gotha (until 1945).
 V. Berlin.

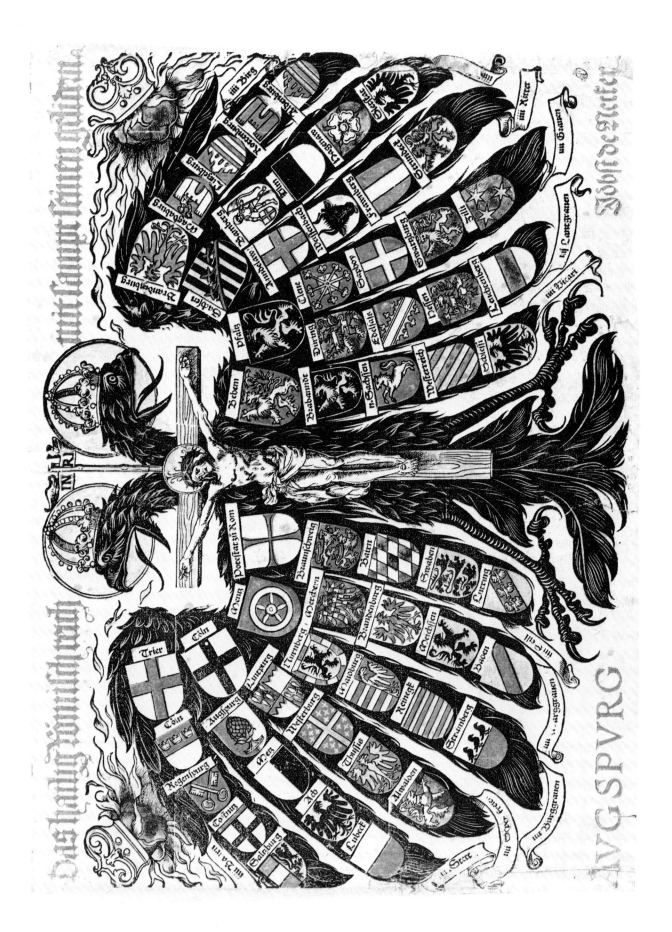

15. Coat of Arms of Cardinal Matthew Lang

Without monogram. Circa 1510.
415 x 325 mm.
B.325; Geisberg 528; Burkhard 42; H.816.
One line block; two tone blocks (black, red, yellow).

Not true chiaroscuro, the colors in this print are laid down side by side; less elaborate than the woodcut of the same subject attributed to Hans Weiditz (Plate 41). Matthew Lang was secretary and longtime confidant of the Emperor Maximilian I.

Berlin.

MATHEVS·M·D·Ạ·S·ANGLI·DIAC·CARD·
GVRCEN̄·COADIVT·SALTZBVRGEN̄·ƵC·

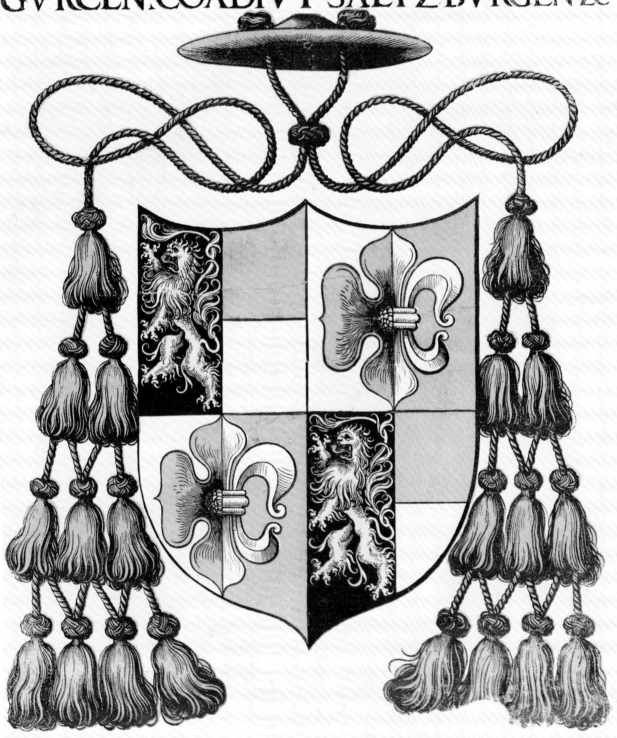

16. Pope Julius II

Imprinted: *H. BVRGKMAIR.* Dated 1511.
264 x 243 mm.
B.33; P.33; A.12; LeB.640; Burkhard 28; H.316.

 I. Line block only.
 II. One line block; one tone block. Imprinted, in addition,
 Jost de Negker zu Augspurg. Watermark: Bull's Head.

After a medal of Pope Julius II by Caradossa, dated 1506.

 I. New York (MM), Vienna.
 II. *Brunswick* (Herzog Anton Ulrich Museum), Dresden (incomplete),
 Oxford (incomplete).

 Campbell Dodgson, "Rare Woodcuts in the Ash-
molean Museum, Oxford," II, *Burlington Magazine,*
vol. 39, July 1921, p. 68.

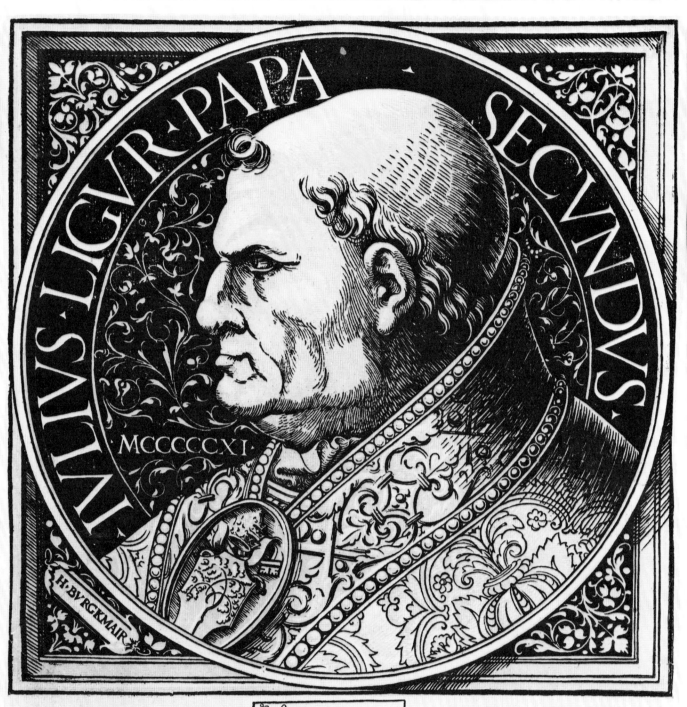

IVLIVS·LIGVR·PAPA SECVNDVS.

MCCCCCXI

H·BVRCKMAIR

Joſe de Neyker Zů Augſpurg

17. Portrait of Jacob Fugger the Rich

Without monogram. No date; circa 1511-1512.
180 x 120 mm.
P.119; R, p. 19; Burkhard 29; H.315.

I. Line block only.
II. One line block; one tone block.

The tone block consists in this instance of a fine grid. It is obviously experimental and was used only in this case. Also, this block was presumably cut by Jost de Negker.

Jacob Fugger (1459-1525) headed the wealthy Fugger Trading Company of Augsburg. He was a patron of the arts and himself excelled in painting landscapes.[1] Albrecht Dürer and Hans Holbein the Elder also did portraits of Jacob Fugger.[2]

I. Berlin (hand colored).
II. Boston, Leningrad, Munich, *Vienna*.

[1] Joseph Heller, *Das Leben und die Werke Albrecht Dürer's*, vol. 2, Bamberg, 1827, p. 61.

[2] Dürer: a drawing (W.571) and a painting (in Munich); Holbein: two drawings (in Berlin).

IACOBVS·FVGGER·CIVIS·AVGVSTÆ

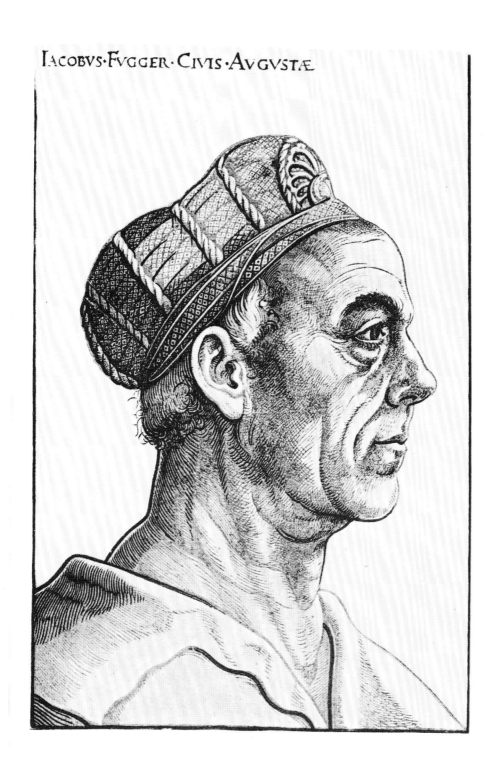

18. Portrait of Hans Paumgartner

Inscribed: *H. Burgkmair; ANN. SAL. MDXII. IOANES PAVNGARTNER.*
C. AVGVSTA AETAT SVAE ANN LVII. Dated 1512.
294 x 243 mm.
B.34; R.10; Burkhard 33; H.307.
Three tone blocks in shades of violet in the absence of black.
Watermark: Imperial Eagle with Crown.

In a letter addressed to the Emperor Maximilian I, dated October 27, 1512, Jost de Negker defends himself for having accepted commissions other than the Emperor's by referring to this portrait of Paumgartner as his own work, "done in folio and printed from three blocks."[1]

Berlin, Boston (W. G. Russell Allen Collection), Brunswick, Cambridge (UK), Coburg, Leyden, London, Oxford, Paris (L), *Vienna*.

[1] Anton Reichel, *Jahrbuch der Kunsthistorischen Sammlungen des allerhöchsten Kaiserhauses,* vol. 13, 1892, p.2.
 Sidney Colvin, "Le Portrait de Jean Baumgartner ou Paumgartner," *L'Art,* vol. 16, 1897, p. 221.
 Campbell Dodgson, vol. 2, p. 87, No. 50.
 Campbell Dodgson, 1921, p. 68.

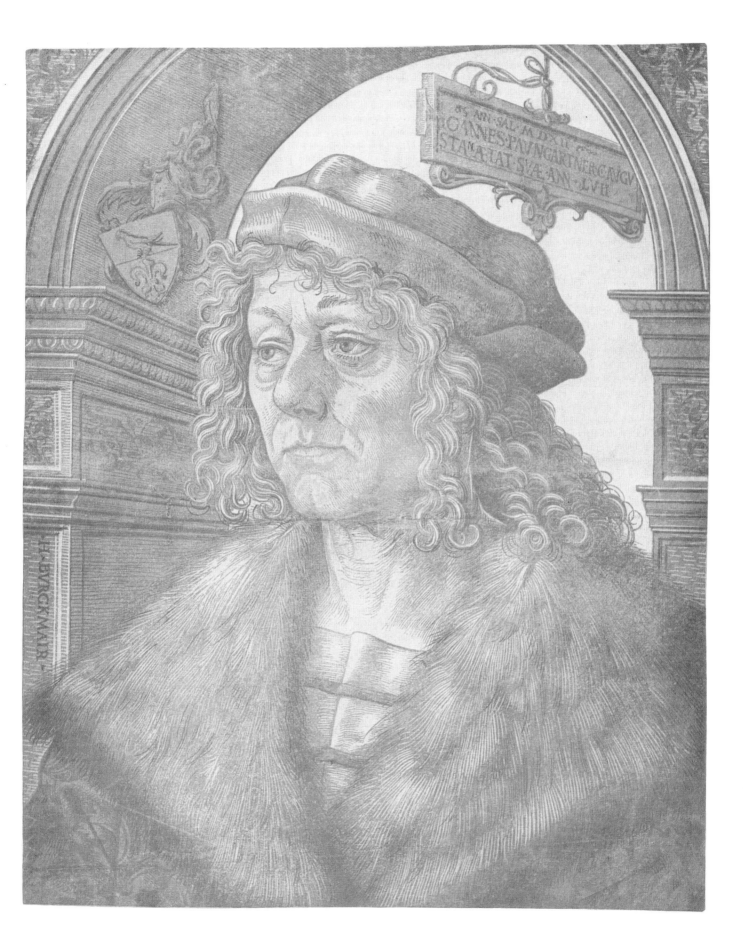

HANS WECHTLIN

[Joannes Vuechtelin, Johann Ulrich Pilgrim, Maître aux Bourdons Croisés]
Strassburg, 1480-85; still active there in 1526. Documentary information
about Wechtlin is scarce. Both his father and grandfather were citizens of Strassburg.
Wechtlin spent the year 1505 in Nancy. In 1506 and 1507 he was in Wittenberg
where he must have met Lucas Cranach the Elder. He became a registered
citizen of Strassburg on November 16, 1514, presumably having returned some time before.
Wechtlin's emblem, two crossed pilgim's staffs, was first identified by Murr.[1]
Bartsch[2] regarded Wechtlin as the inventor of chiaroscuro.

19. Christ on the Cross with the Virgin, the Magdalen, and St. John.

With Wechtlin's emblem on a tablet. About 1510.
272 x 186 mm.
B.1; R.19.
One line block; one tone block.

The skyline of Jerusalem is in the background. The ornamental frame is
printed from four separate blocks.

Boston, Munich, Paris (IN), *Vienna.*

[1] Christoph G. von Murr, *Journal zur Kunstgeschichte und Litteratur,* Nuremberg, vol. 4, 1777, p. 53.
[2] Adam von Bartsch, *Le Peintre-Graveur,* vol. 7, Vienna, 1808, p. 449.

Heinrich Lödel, *Johann Wechtlin, genannt Pilgrim, Holzschnitte in Clair-Obscur in Holz nachgeschnitten,* Leipzig, 1863.
Carl von Lützow, *Geschichte des deutschen Kupferstichs und Holzschnitts,* Berlin, 1891, pp. 164-69.
Heinrich Röttinger, "Hans Wechtlin und der Hell-dunkelschnitt," *Gutenberg Jahrbuch,* Mainz, 1942-43, pp. 107-13.

NOTE: The portrait of Philip Melanchthon, described by Passavant (vol. 3, p. 334, No. 58) as a chiaroscuro print, is, in fact a drawing. It is illustrated in Lödel (No. 13), who considered the drawing, as well as the inscription authentic. ("MELANTON ANNO DOMINI MDXIX XXXIII ANNOS HABVI. Jo. WECHTLIN FACIEBAT" with Wechtlin's emblem.) The authenticity is disputed by Röttinger (cf. Thieme-Becker, vol. xxxvi, p. 234).

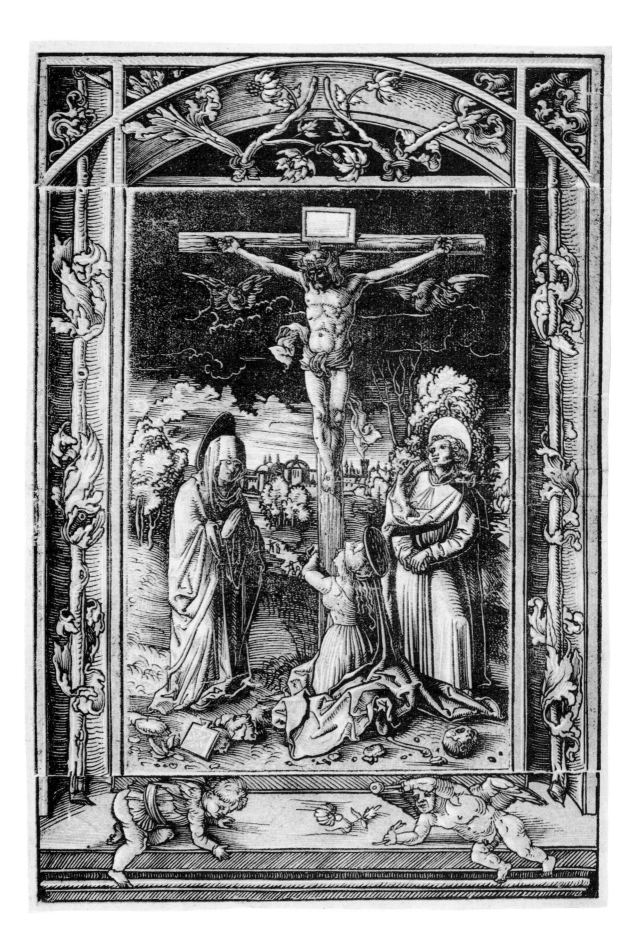

20. Madonna on a Grassy Bench

With Wechtlin's emblem and the initials Jo. V. About 1510.
269 x 181 mm.
B.2; R.21.
One line block; one tone block. Watermark: Small Bull's Head.

Based on Albrecht Dürer's woodcut "Holy Family with Three Rabbits" (B. 102).

Basel, Berlin, Boston (W. G. Russell Allen Collection), London, Munich,
New York (MM), Paris (IN), Paris (L), *Vienna* (Albertina and Nationalbibliothek).

21. Virgin and Child Surrounded by a Renaissance Frame

With Wechtlin's emblem on a tablet. About 1512.
272 x 185 mm.
B.3; R.18.
One line block; one tone block.

According to Winkler,[1] this print is based on Dürer's "Haller Madonna" (National Gallery of Art, Washington). The Renaissance frame of this woodcut is akin to those found on several of Burgkmair's prints (e.g., "Samson and Delilah").

The dating of Wechtlin's woodcuts is conjectural. Although he was active in Strassburg at the same time as Hans Baldung Grien, there is no evidence that one influenced the other. Both artists were obviously familiar with the Burgkmair-de Negker chiaroscuro technique. Although Hans Baldung Grien had been a member of Albrecht Dürer's workshop, it is Wechtlin who frequently used works by Dürer as models for his compositions.

Basel, Boston (W. G. Russell Allen Collection), Paris (L), Vienna.

[1] Friedrich Winkler, *Albrecht Dürer, Leben und Werk,* Berlin, 1957, p. 78.

22. St. Sebastian

With Wechtlin's emblem and initials on a tablet. About 1512.
234 x 184 mm.
B.5; P. vol. III, p. 329; Geisberg 1491; R.24.
One line block; one tone block.

Based on an anonymous engraving of the fifteenth century.[1] The ornamental frame is printed from separate blocks. The side panels are identical to those used for Plate 19.

London, New York (MM), *Vienna*.

[1] Heinrich Röttinger, "Hans Wechtlin und der Helldunkelschnitt," *Gutenberg Jahrbuch,* 1942-43, p. 108; illustrated in P. Kristeller, "Florentinische Zierstücke," *Graphische Gesellschaft,* vol. 10, 1909, Pl. 4.
Karl T. Parker, *Archives alsaciennes de l'Art,* Strassburg, 1923, p. 77.

23. Skull in a Renaissance Frame

With Wechtlin's emblem on a tablet. About 1512.
272 x 180 mm.
B.6
One line block; one tone block.

According to Karl T. Parker,[1] this woodcut dates from 1512 or before because the printer Jacob Köbel of Oppenheim copied the Renaissance frame and used it for a title page decoration. A second Renaissance frame with Wechtlin's emblem and initials, illustrated by Lödel (p. XIX) was first used in *Ottonis Phrisingensis Rerum ab Origine Mundi* in 1515.[2]

The worn line block was still used in 1545 as a book illustration by Cammerlander.[3]

Berlin, Boston (W. G. Russell Allen Collection), London, Paris (L),
Washington (Lessing Rosenwald Collection).

[1] *Archives alsaciennes de l'Art,* Strassburg, 1923, p. 76.
[2] Thieme-Becker, vol. XXXV, p. 233 (H. Röttinger).
[3] *Gutenberg Jahrbuch,* 1936, p. 126.

Lützow, 1891, p. 164.
Röttinger, 1942-43, p. 108.

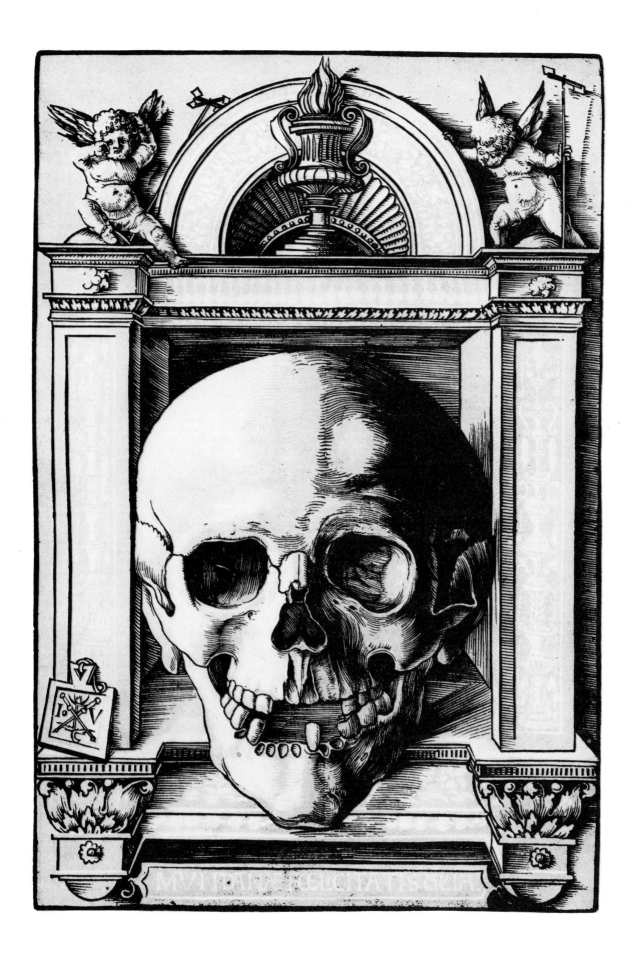

24. Pyramus and Thisbe

With Wechtlin's emblem and monogram on a tablet. About 1512.
272 x 190 mm.
B.7; IN.34.
One line block; one tone block.
Watermark: Small Bull's Head.

According to Heinrich Röttinger,[1] Wechtlin was the first to use true chiaroscuro technique. Röttinger thought that Marcantonio Raimondi copied this print in 1505. His assertion is difficult to accept in view of the early date of Raimondi's version and the obvious Italian influence that may be observed in Wechtlin's.[2]

The story of Pyramus and Thisbe derives from Ovid's *Metamorphoses,* Book IV, verses 55-166. Thisbe, arriving for a rendezvous with Pyramus, finds him near death, having committed suicide in the mistaken belief that Thisbe had been killed by a wild animal.

Evidence of the popularity of this subject, besides the engraving by Marcantonio Raimondi, are the painting by Lucas Cranach the Elder and the woodcuts by Altdorfer, Schäuffelein, Hans Baldung Grien, and Peter Flötner.

Cleveland (John L. Severance Fund), Leyden, London, Paris (L).

[1] Röttinger, 1942-43, p. 107.
[2] H. T. Musper, *Der Holzschnitt in fünf Jahrhunderten,* Stuttgart, 1944, p. 386.

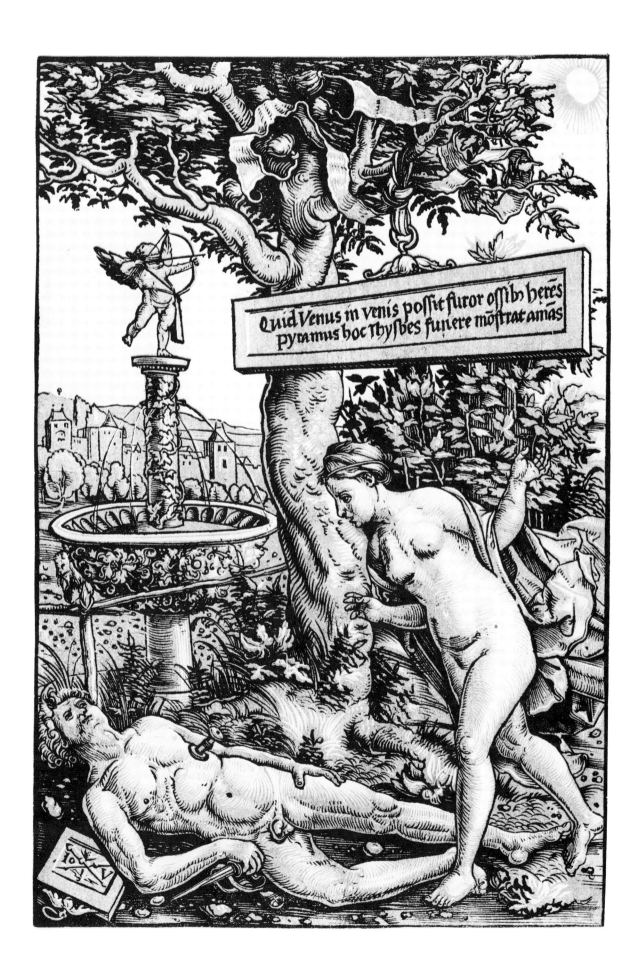

Quid Venus in venis possit furor ossib) heres
pyramus hoc Thysbes funere mostrat amas

25. Orpheus Spellbinding Wild Animals by His Music

With Wechtlin's emblem and initials on an oval tablet. About 1512.
268 x 179 mm.
B.8; R.20.
One line block; one tone block.

The subject of this print derives from the painting described in Philostratus' *Imagines.*[1] It is also mentioned in Ovid's *Metamorphoses* (X. 84-105; XI. 1-2). Wechtlin has taken a number of liberties with the text, for he pictures Orpheus playing a viola da braccio instead of a lyre, while a lute and a harp are shown on the ground beside him.

Interest in Orpheus was greatly stimulated toward the end of the fifteenth century by the repeated performances of Angelo Poliziano's lyrical drama, *La Favola di Orfeo,* a forerunner of opera.

The subject of Orpheus' charming animals also occurs in paintings by Giovanni Bellini and Hans Leu,[2] as well as in woodcuts by Virgil Solis and Tobias Stimmer. It recurs in a large engraving executed by Simon Wynouts Frisius in 1618 (W.1; H.104).

Basel, Boston, Munich, New York (MM), Paris (L), *Vienna.*

[1] Loeb Classical Library, London, 1931, p. 309.　　[2] A. Pigler, *Barockthemen,* Budapest, 1956, p. 186.

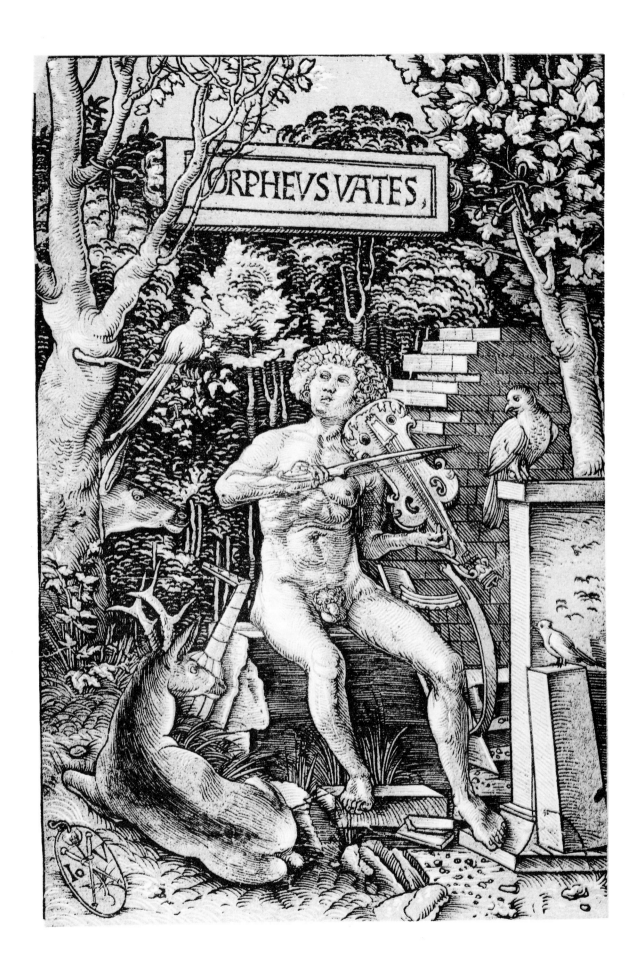

HANS WECHTLIN

26. Alcon Freeing His Son

With Wechtlin's emblem on a tablet. About 1512.
271 x 182 mm.
B.9; R.16, IN.35.
One line block; one tone block (sepia or greenish gray).
Watermark: Small Bull's Head with Flower.

The Story of Alcon of Crete freeing his son derives from Valerius Flaccus' *Argonautica* (vol. 1, p. 398): "When you were a young boy a serpent pounced upon you from the branch of a tree and coiled around you fourfold with its glistening body. Leaning forward, your father, in a fearful stance, aimed an uncertain blow."

Aschaffenburg, Boston (W. G. Russell Allen Collection), Dresden, London, Munich, New York (MM), Paris (BN), Paris (L), Paris (IN), *Vienna.*

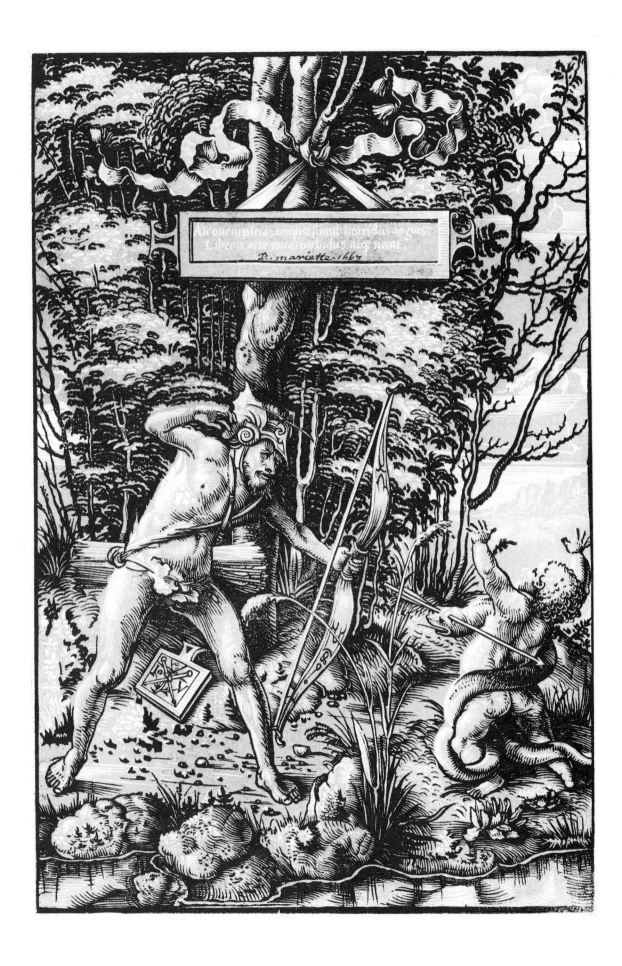

HANS WECHTLIN

27. Knight and Lansquenet

With Wechtlin's emblem and monogram on a tablet. About 1512.
270 x 183 mm.
B.10; R.22.
One line block; one tone block.
Watermark: Small Bull's Head with Tau Cross (Briquet 15174).

Based on Albrecht Dürer's woodcut of this same subject (B.131) of about 1497.

Boston (W. G. Russell Allen Collection), Cincinnati, Cleveland,[1] Dresden,
London, Munich, New York (MM), Paris (IN), Paris (L), *Vienna.*
(Albertina and Nationalbibliothek), Washington.

[1] *Bulletin of the Cleveland Museum of Art,* February 1953, No. 2.

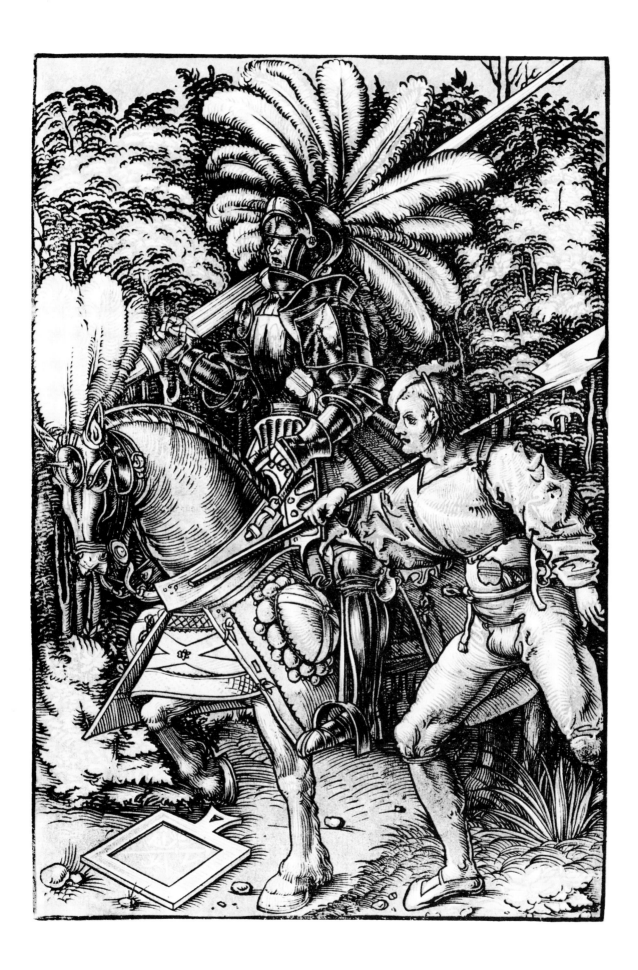

28. Pyrgoteles

Without monogram. About 1510.
190 x 125 mm.
P.57.
One line block; one tone block (grayish green).

Pyrgoteles[1] was a famous carver of cameos during the reign of Alexander the Great (ca. 400 B.C.). Only Pyrgoteles was permitted to carve Alexander's likeness into an emerald (Pliny, *Natural History,* VII. 125).

Amsterdam, Boston (W. G. Russell Allen Collection), Berlin, Hamburg, London, Munich, Paris (L), Washington (Lessing Rosenwald Collection).

[1] Cf. J. H. Krause, *Pyrgoteles,* Jena, 1856.

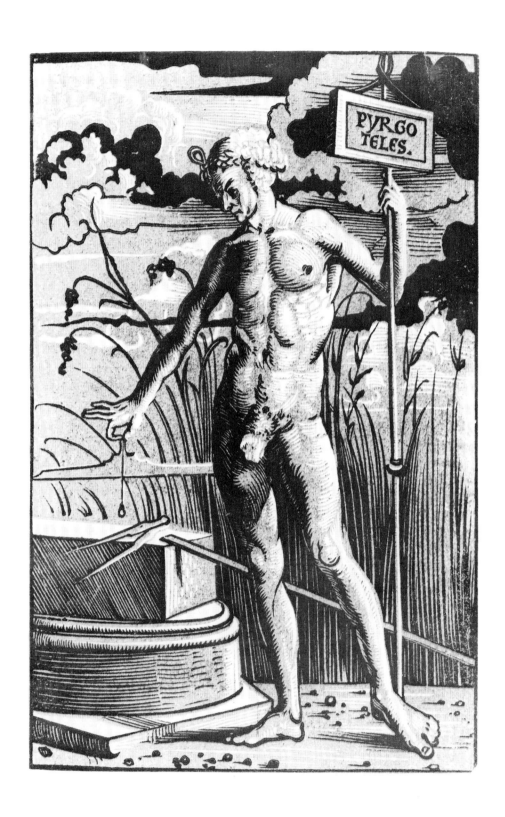

HANS WECHTLIN

29. St. Jerome, Penitent

With Wechtlin's emblem on a tablet. About 1516.
188 x 127 mm. ·
B.4; R.23.
One line block; two tone blocks (shades of gray).

Basel, *Vienna.*

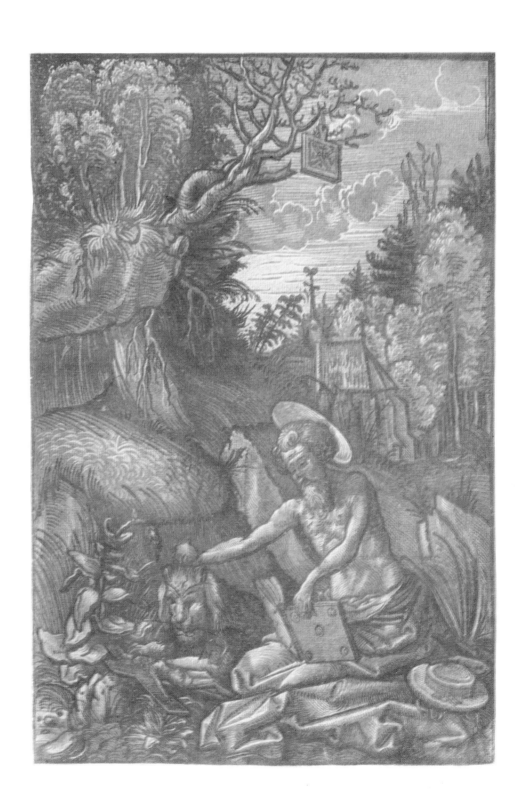

HANS WECHTLIN

30. St. Christopher

With the artist's emblem on a tablet, but without his initials. About 1512.
188 x 127 mm.
Geisberg 1487.
One line block; two tone blocks.

The windswept garment, the ripples in the water, and the plant in the foreground are closely akin to those of Dürer's "St. Christopher" (B.104). First described by Ernst Redlob.[1]

Berlin (formerly Redlob Collection.)

[1] "Ein neuer Helldunkelschnitt Wechtlins," *Mitteilungen der Gesellschaft für vervielfältigende Kunst,* No. 4, 1927, p. 53.

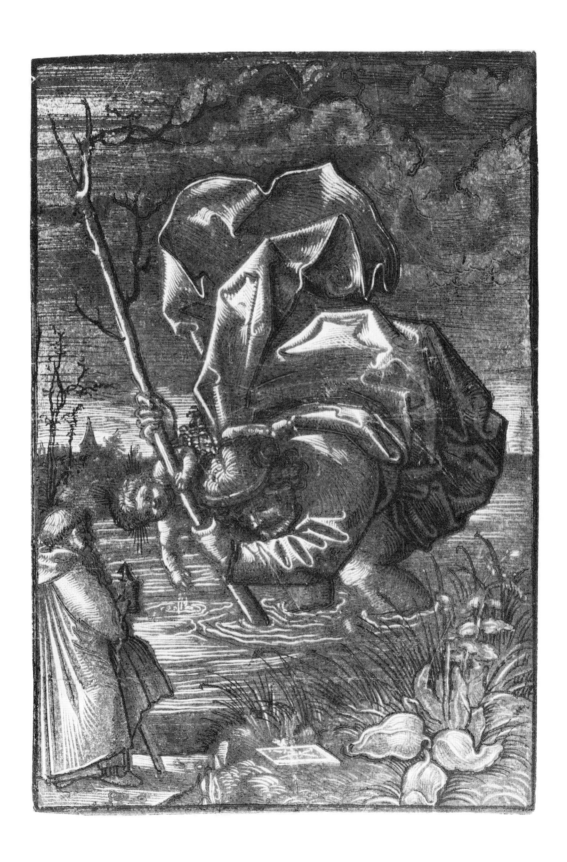

ALBRECHT ALTDORFER

1480-1558. Lived in Regensburg.

31. The Beautiful Virgin of Regensburg

With monogram. About 1519.
340 x 245 mm.
B.51; R.25; H.52.
Imprinted: *Gantz schön bistu mein frundtin und ein mackel is nit in dir. Ave Maria.*
(You are beautiful to perfection, my friend, and entirely without a blemish. Ave Maria.)

I. Printed from six blocks (black, red, green, sepia, brown, blue).
 Watermark: Bull's Head with Cross and Serpent.
II. Printed from five blocks. Watermark: Crest of Kaufbeuren (ca. 1620).
III. Printed from four blocks. The monogram reversed.
IV. Line block only.

This is Altdorfer's only multicolor print but it does not represent an advancement in chiaroscuro technique. Meant as a souvenir for the many pilgrims who visited the shrine of the "Beautiful Virgin," this print is based on a thirteenth-century Byzantine icon that graced the wooden chapel, erected in place of the synagogue after the expulsion of the Jews during the interregnum following the death of Emperor Maximilian I in 1519.[1] According to Ruhmer, the ornamental frame is based on a Venetian or Paduan model.[2]

I. Formerly in Wolfegg.
II. Munich. Later impressions from substitute blocks, except black and blue, in London, New York (MM), *Vienna,* Washington, Würzburg.
III. Berlin, Boston, Coburg, Erlangen.
IV. Hamburg.

[1] Franz Winzinger, *Albrecht Altdorfers Graphik,* Munich, 1963, p. 84.

[2] Eberhard Ruhmer, *Albrecht Altdorfer,* Munich, 1965, pp. 38, 53.

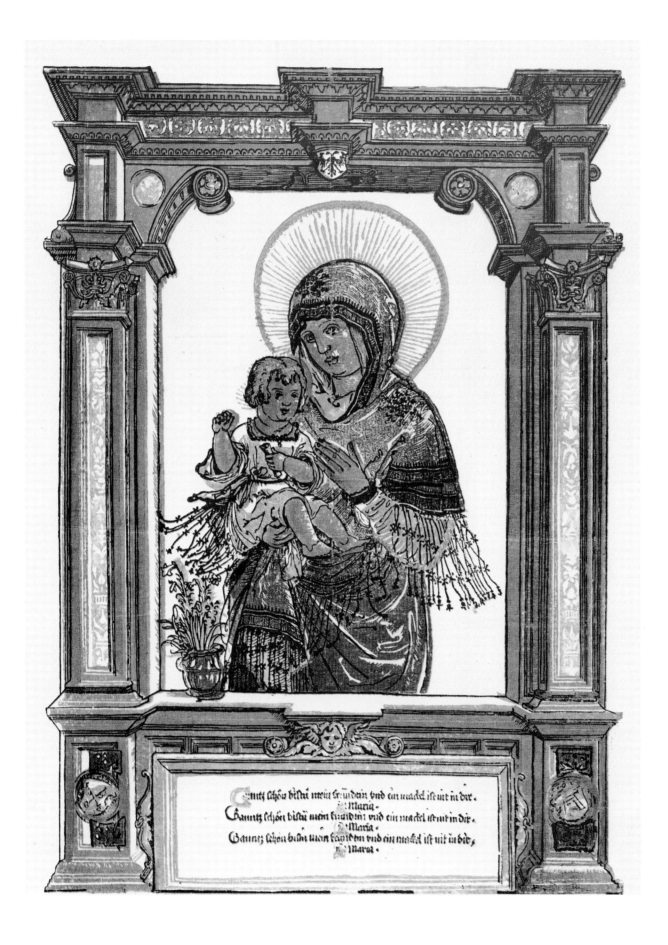

HANS BALDUNG GRIEN

Schwäbisch-Gmünd, 1484-1545, Strassburg. Hans Baldung Grien studied with Albrecht Dürer at Nuremberg intermittently from 1503 to 1508. Except for a stay at Freiburg i.B. during the years 1512 to 1516, he resided at Strassburg for the rest of his life.

32. The Witches' Sabbath

With monogram. Dated 1510.
368 x 255 mm.
B.55 R.11; Curjel 16; H.235.

 I. Line only.
 II. One line block; one tone block (brown or sepia).
 III. One line block; two tone blocks (brown/sepia).

This woodcut, the first of Baldung's chiaroscuros, dates from shortly after his return from Nuremberg to Strassburg. It is not beauty that is stressed, but a mood—in this case of mystery and witchcraft—underscored by highlights rather than by color, akin to Albrecht Altdorfer's drawing of this subject.[1] The witch rides backwards on a goat as in Dürer's engraving (B.29, circa 1500). A similar mood pervades Dürer's "Abduction on a Unicorn" (B.72) of 1516. Related drawing in Paris (L; inv. 1083).

 I. Amsterdam, Berlin, Boston, Brunswick, Darmstadt, London, New York (MM).
 II. Berlin, Coburg (with additional highlights in the tone block),
 London, Munich, New York (MM), Nuremberg, Paris (L), *Vienna*.
 III. Coburg.

[1] Dated 1506. Pen on brown paper, heightened with white. Becker No. 56; Winzinger No. 2.

H. Curjel, *Hans Baldung Grien,* Munich, 1923.
Friedrich Winkler, "Hans Baldung Griens drei Hexen," *Jahrbuch der preussischen Kunstsammlungen,* vol. 57, Berlin, 1936, p. 156.

O. Fischer, *Hans Baldung Grien,* Munich, 1939.
Jan Lauts, *Hans Baldung Grien Ausstellung,* Karlsruhe, 1959.
Karl Oettinger and K. A. Knappe, *Hans Baldung Grien und Albrecht Dürer in Nürnberg,* Nuremberg, 1963, No. 68.

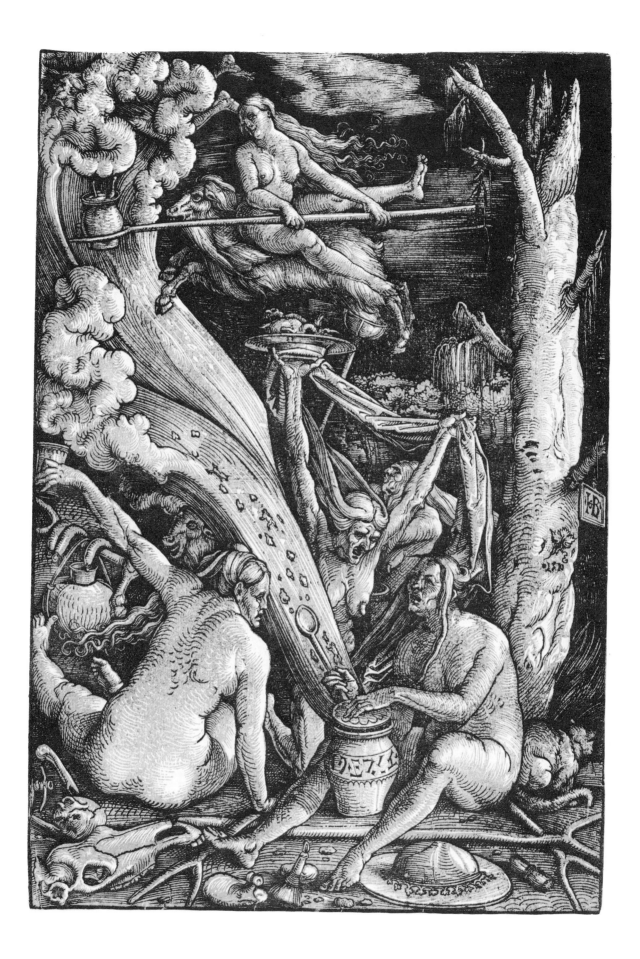

33. The Fall of Man

With monogram. Dated 1511.
375 x 256 mm.
B.3; R.12; H.3; Curjel 18.

 I. Line only.
 II. One line block; one tone block.

 I. Berlin, Bremen, London, New York (MM), Paris (IN).
 II. Amsterdam, Basel, Berlin, Dresden, Freiburg, Hamburg, London,
 New York (MM), Nuremberg, Paris (IN), *Vienna,* Washington.

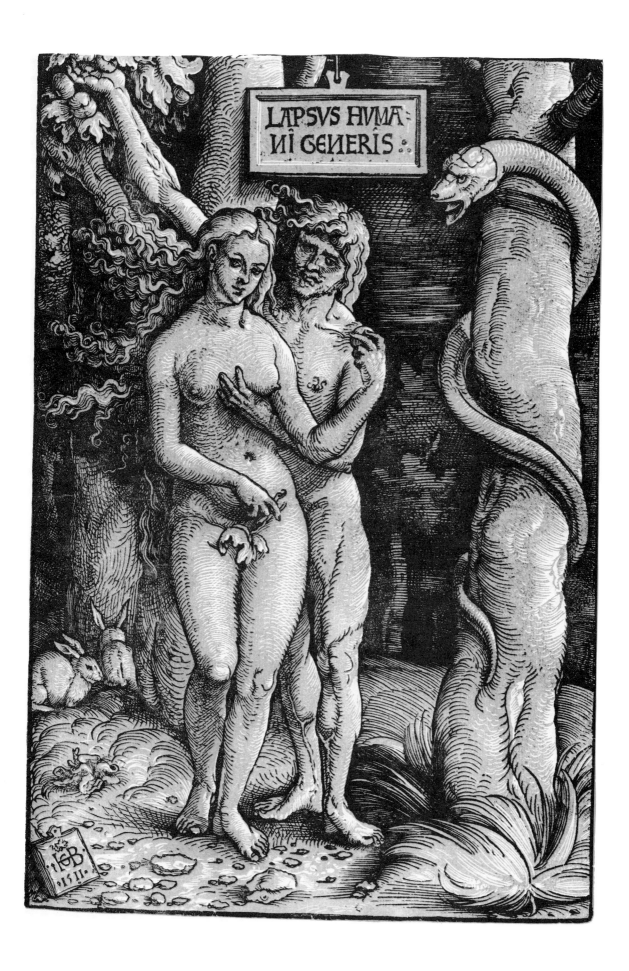

34. Madonna in a Landscape Surrounded by Angels

With monogram. About 1511.
328 x 265 mm.
P. 66; R.13; Curjel 21; H.62.

 i. Line only.
 ii. One line block; one tone block (grayish brown, red, or green).

Late impressions have a crack through the floating angel, extending down to
the angel playing the lute.

 i. Amsterdam, Berlin, London, New York (MM).
 ii. Amsterdam, Basel, Berlin, Boston, Copenhagen, Dresden, Karlsruhe, London, *Vienna*.

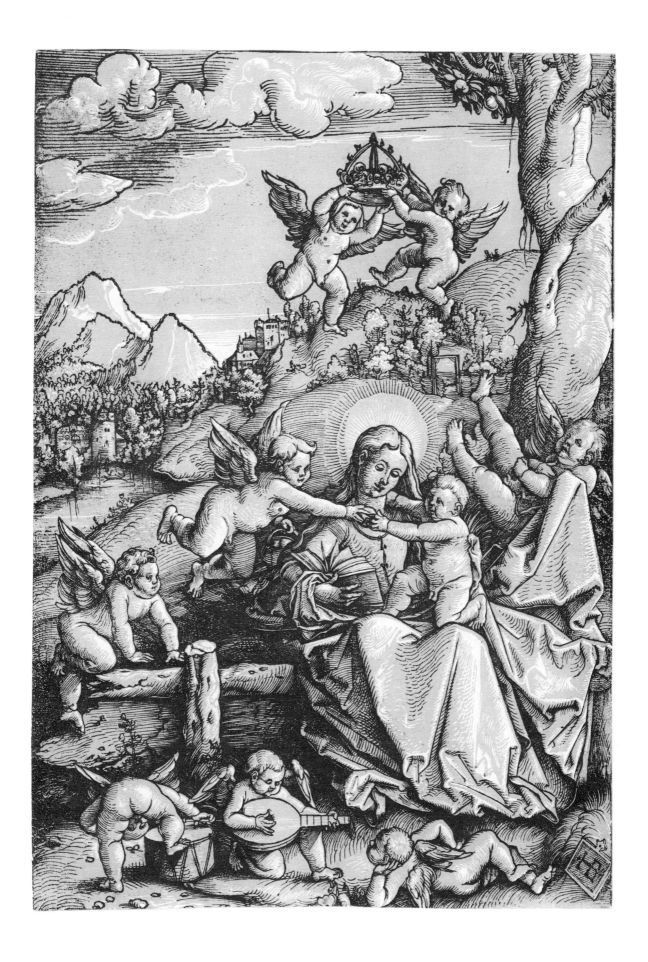

35. St. Jerome, Penitent

With monogram. About 1511.
195 x 140 mm.
P.70; R.14; Curjel 22; H.120.

I. Line block only.
II. One line block; one tone block (brown or sepia).

Bartsch[1] attributed this print to Hans Brosamer.

I. Berlin, Paris, Vienna.
II. Berlin, Darmstadt, Erlangen, Karlsruhe, New York (MM), Nuremberg, *Vienna*.

[1] Vol. 8, p. 468, No. 7.

36. St. Christopher*

With monogram. About 1511.
388 x 259 mm.
B.38; Curjel 20; H.116.

I. Line block only.
II. With tone block.

According to Curjel, this print was conceived to be printed in chiaroscuro, but no such impressions could be located.

I. Aschaffenburg, Berlin, Dresden, London, Paris (L).

Not illustrated.

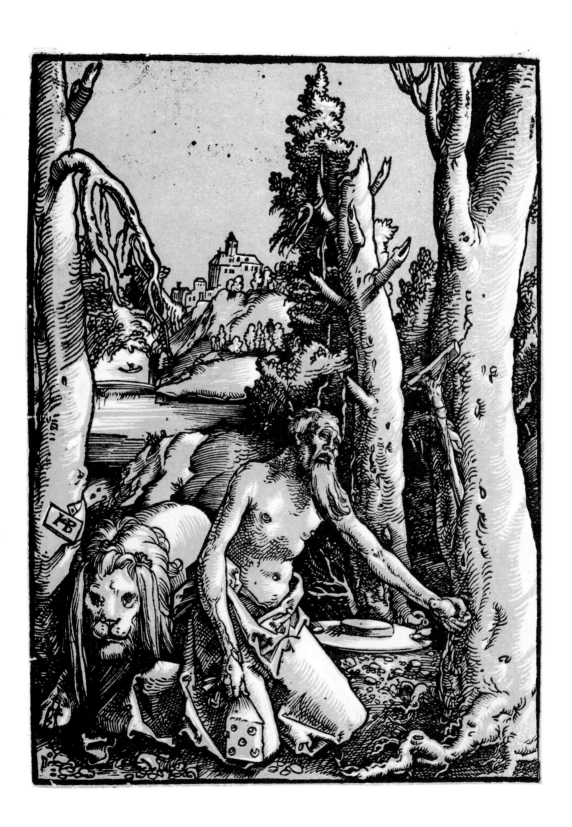

37. Christ on the Cross with the Virgin, the Magdalen, and St. John

With monogram. (On some impressions Dürer's monogram has been added.) 1512-1514.
374 x 262 mm.
B.57; R.15; Curjel 36; H.11.

I. Line only.
II. One line block; one tone block.
III. Copy by Georg Erlinger with his monogram.

I. London.
II. Amsterdam, Berlin, London, Paris, *Vienna*.
III. Erlangen.

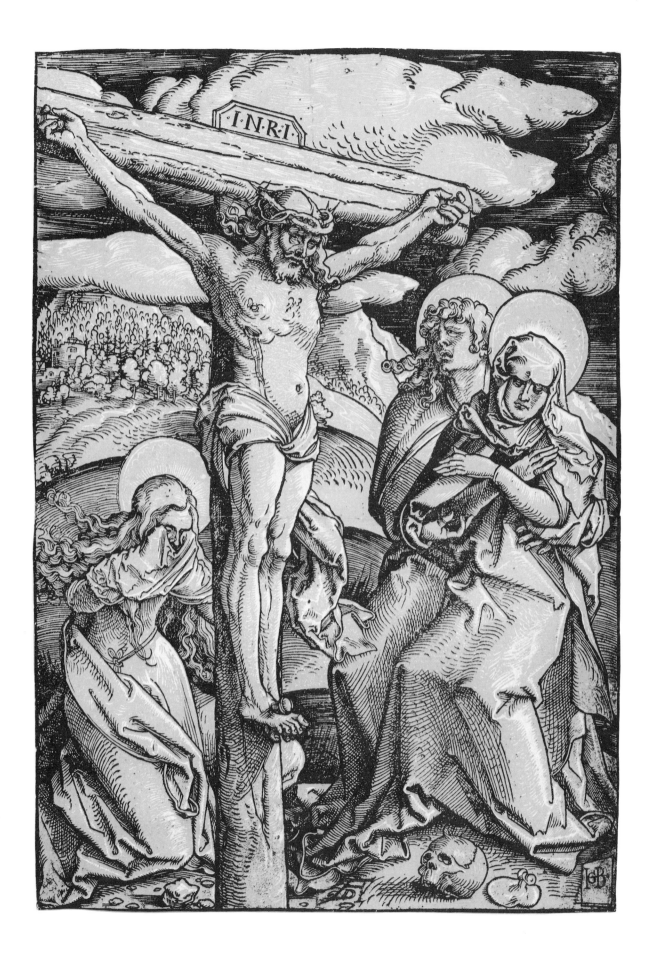

38. The Conversion of St. Paul

With monogram. About 1514.
294 x 195 mm.
B.33; Curjel 43; H.125.

 I. Line block only. Watermark: Gothic letter P.
 II. One line block; one tone block.

 I. Amsterdam, Basel, *Berlin,* Karlsruhe, Munich, New York (MM).
 II. Mentioned by Curjel, but location undetermined.

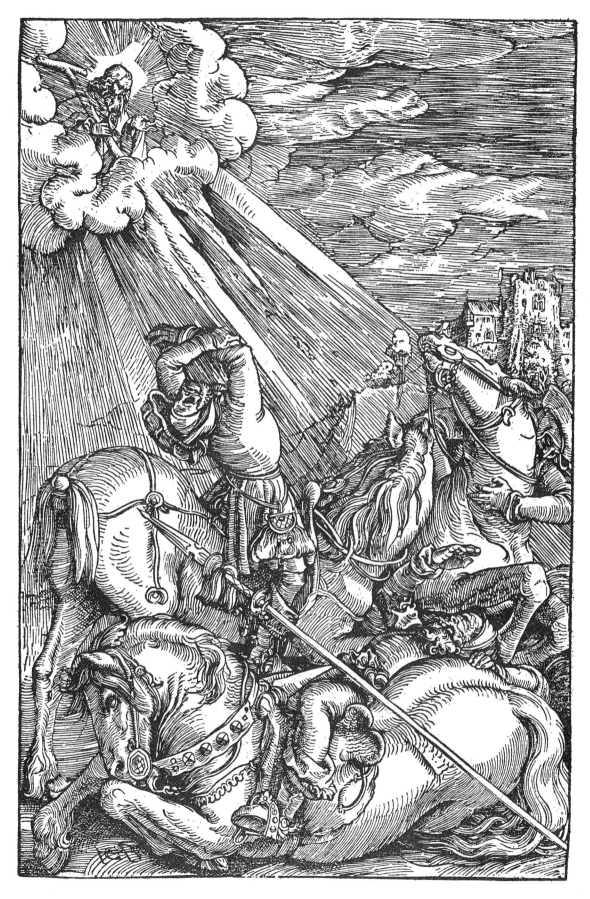

I

39. Lucretia

With monogram. About 1520.
128 x 88 mm.
P.73; Curjel 74; H.231.

 I. Line only.
 II. One line block; one tone block.

Akin in format to Albrecht Dürer's painting of this subject, dated 1518.

 I. Basel, Dresden, *New York* (MM).
 II. Mentioned by Curjel, but location undetermined.

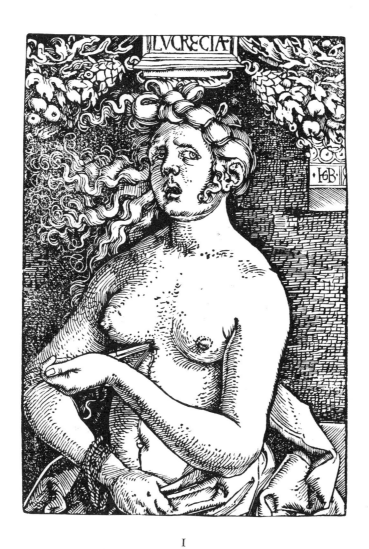

I

ERHARD ALTDORFER

Circa 1485 to 1562. Studied with his brother Albrecht Altdorfer at Regensburg.
After 1512, active as Court Painter at Schwerin, where he died in 1562.

40. Loving Couple in a Landscape

Monogram: *Al fe*. Dated 1538.
135 x 122 mm.
H.3a.
One etched line plate; one tone block.

The earliest example of an etching combined with a tone block.

Formerly in Wolfegg. Per kind communication of Messrs. Kornfeld & Klipstein, Berne
(letter dated May 8, 1972), this impression was acquired by Joseph Meder
at the Wolfegg Auction (H. G. Gutekunst, May 27-29, 1903) for the then
considerable sum of 540 Marks. Its present location could not be determined.
Photograph courtesy of Messrs. Klipstein & Kornfeld.

Campbell Dodgson, "Erhard Altdorfer als Kup-
ferstecher," *Mitteilungen der Gesellschaft für ver-
vielfältigende Kunst,* 1911, p. 21.
Thieme-Becker, I, p. 348.

W. Jürgens, *Erhard Altdorfer und seine Werke
und seine Bedeutung für die Buchillustration des 16.
Jahrhunderts,* Leipzig, 1931.

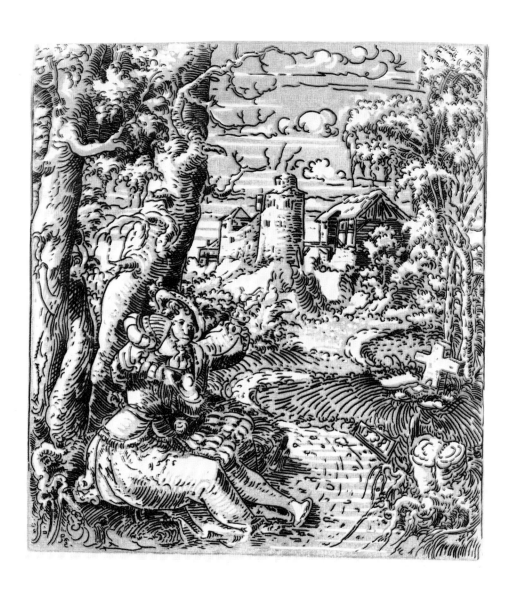

HANS WEIDITZ

Circa 1495 to circa 1536. Whatever we know about Hans Weiditz is conjecture. Röttinger[1] was the first to attribute a group of woodcuts to Weiditz, solely on similarities of style to illustrations in the Strassburg edition of Otto Brunfels' *Kräuterbuch* and the Augsburg edition of Cicero's *De officiis*. The illustrator of the former is referred to in the preface as "Hans Weyditz of Strassburg." In *De officiis* only the initials HW occur. According to Röttinger's hypothesis, Weiditz was active at Augsburg from about 1515 to 1522 and then moved to Strassburg. Jost de Negker's address appears on Weiditz' *Children's Alphabet* (Röttinger 39). Older commentators attributed Weiditz' works primarily to Hans Burgkmair. (Cf. Plate 3, IV.)

41. Coat of Arms of Cardinal Matthew Lang, Coadjutor of Salzburg.

Without monogram. About 1518.
271 x 206 mm.
Printed in four colors: gold, gray, red, orange.
Röttinger 22; Geisberg 1542.

This coat of arms is very similar to the one attributed to Hans Burgkmair the Elder (Plate 15), except for the added crucifix. Although not strictly a chiaroscuro print, it is included here because of the use of tone blocks in the printing process. This woodcut was published, printed in color, in Senfel's book of motets, *Liber Selectarum Cantionum quas Vulgo Mutetates Volant*, Augsburg, 1520.[2] Matthew Lang attended the Imperial Diet of Augsburg during 1518.

London, Stuttgart.

[1] Heinrich Röttinger, *Hans Weiditz, der Petrarca Meister*, Strassburg, 1904. (See Passavant, III, p. 275. The edition of Petrarca credited to Weiditz appeared in Augsburg, 1532; the edition of Cicero in Augsburg 1531; the *Children's Alphabet*, P.130, is dated 1521.)
[2] Campbell Dodgson, "Rare Woodcuts in the Ashmolean Museum, Oxford," II, *Burlington Magazine*, vol. 39, July 1922, p. 68.

Max Geisberg, "Holzschnittbildnisse des Kaisers Maximilian I," *Jahrbuch der preussischen Kunstsammlungen*, vol. 32, 1911, p. 236.
Max Friedländer, *Die Holzschnitte des Hans Weiditz*, Berlin, 1922.

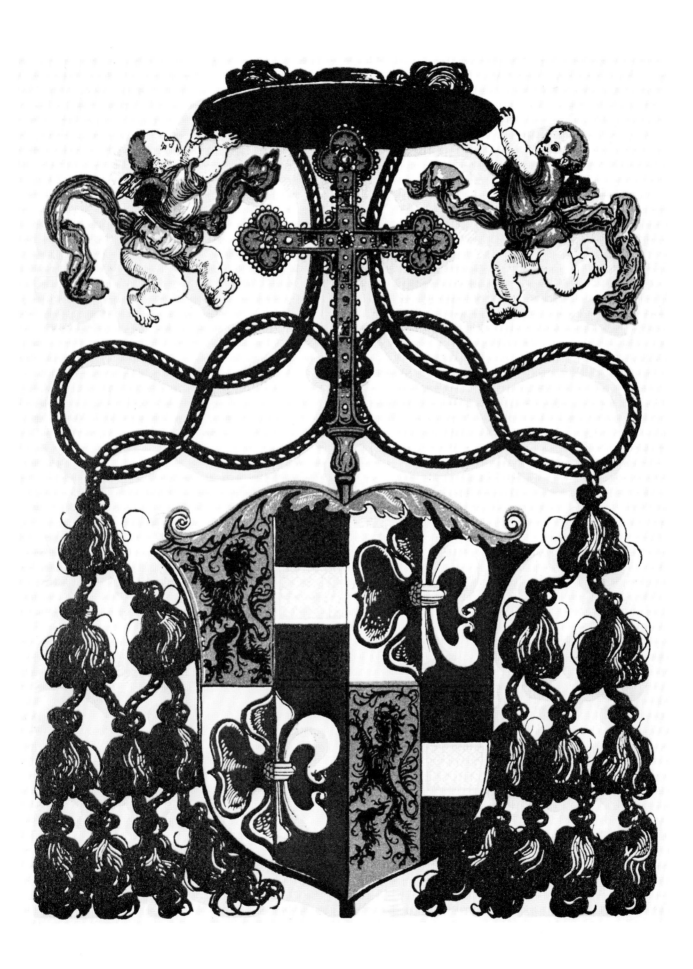

42. Ecce Homo, Man of Sorrows, Standing

Without monogram. Dated 1522.
294 x 224 mm.
P.III, p. 322, No. 64 (Hans Baldung Grien); R.27; Geisberg 1500.
One line block; one tone block.

The tone block is probably a later addition. The registration is not quite perfect. First attributed to Weiditz by Röttinger,[1] perhaps executed by Weiditz after his move to Strassburg in 1522. (See remarks for the following print.)

Amsterdam, Boston, Bremen (line block slightly altered), Cleveland, Coburg, Erlangen, Munich, *Vienna*.

[1] Heinrich Röttinger, *Mitteilungen der Gesellschaft für vervielfältigende Kunst,* 1911, p. 49.

42A. Ecce Homo, Man of Sorrows, Seated on the Cross

Without monogram. Probably 1522.
291 x 200 mm.
Heller (Dürer) 1980; P.III, p. 199, No. 231 (Dürer); Geisberg 1501.

I. Line only.

II. One line block; one tone block.

Heller is uncertain of the attribution to Albrecht Dürer. According to Passavant, some impressions are imprinted: *"O du unschuldiges lamb Gottes."* He attributes this print to the circle of Albrecht Dürer.

Röttinger ascribes it to Nicholas Nerlich.[1] Geisberg groups this sheet with the preceding one and a "Mater Dolorosa" (Geisberg 1502), thus attributing all three to Weiditz.

I. Bremen.
II. *Boston* (W. G. Russell Allen Collection), Hamburg.

[1] *Op. cit.* 1924, p. 35.

Illustrated in the Appendix.

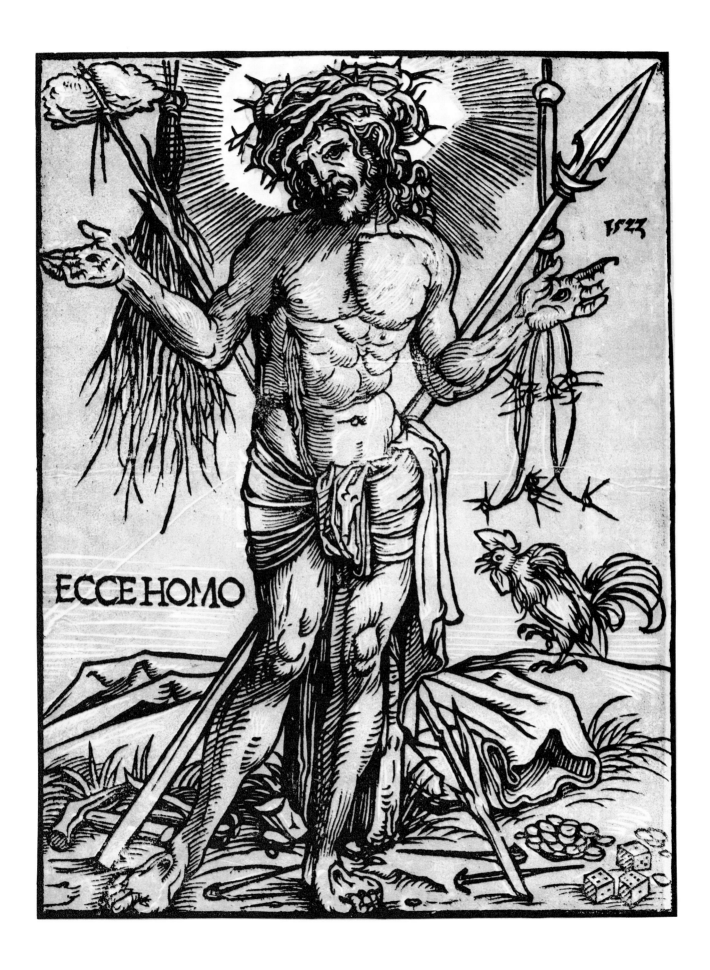

HANS SEBALD BEHAM

Born in Nuremberg, 1500. Died in Frankfurt, 1550. Student of Albrecht Dürer.
Expelled from Nuremberg for brief periods in 1525 and 1528 on account
of his anarchistic and atheistic pronouncements. Resided in Frankfurt after 1532.

43. Head of Christ Crowned with Thorns [The Holy Countenance]

Without monogram. Dürer's monogram appears on later impressions. No date.
435 x 330 mm. (With Sudarium: 478 x 362 mm.)
B. app. 26 (Dürer); Pauli 829-11a; H. vol. III, p. 184.

I. Line only.
II. One line block; one tone block.
III. Copy of the above with the Sudarium added. Line only.
IV. See Plate 43A.

Beham's authorship was first noted by Johann Hauer (died in 1660), as reported by C. Murr.[1] "The Holy Countenance" is certainly based on Albrecht Dürer's engraving "Sudarium Held by Two Angels" (B.25). Wölfflin[2] calls this woodcut "extraordinarily grandiose; it will always be identified with Dürer, even if it should have been cut by someone else."

I. *Amsterdam,* Berlin, London.
II. Vienna.
III. Location undetermined.
IV. See Plate 43A.

[1] Christoph G. von Murr, *Journal zur Kunstgeschichte,* vol. 14, Nuremberg, 1787, p. 97.
[2] Heinrich Wölfflin, *Die Kunst Albrecht Dürers,* Munich, 1905, p. 239.

Adolf Rosenberg, *Sebald und Barthel Beham,* Leipzig, 1875.

Gustav Pauli, *Hans Sebald Beham, ein kritisches Verzeichnis seiner Kupferstiche,* Strassburg, 1901.
Emil Waldmann, *Die Nürnberger Kleinmeister,* Leipzig, 1910.
Heinrich Röttinger, *Hans Sebald Beham, Nachträge zu Paulis Verzeichnis,* Strassburg, 1911.

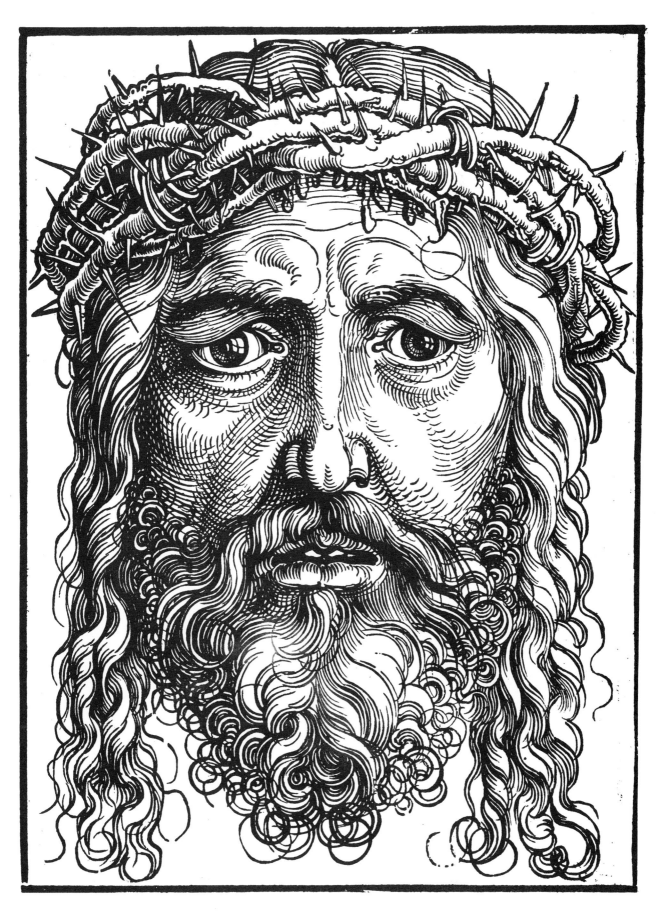

I

43A. Head of Christ Crowned with Thorns [The Holy Countenance]

IV. As State III, with one tone block added. (Sudarium added.)

Amsterdam, Paris (L).

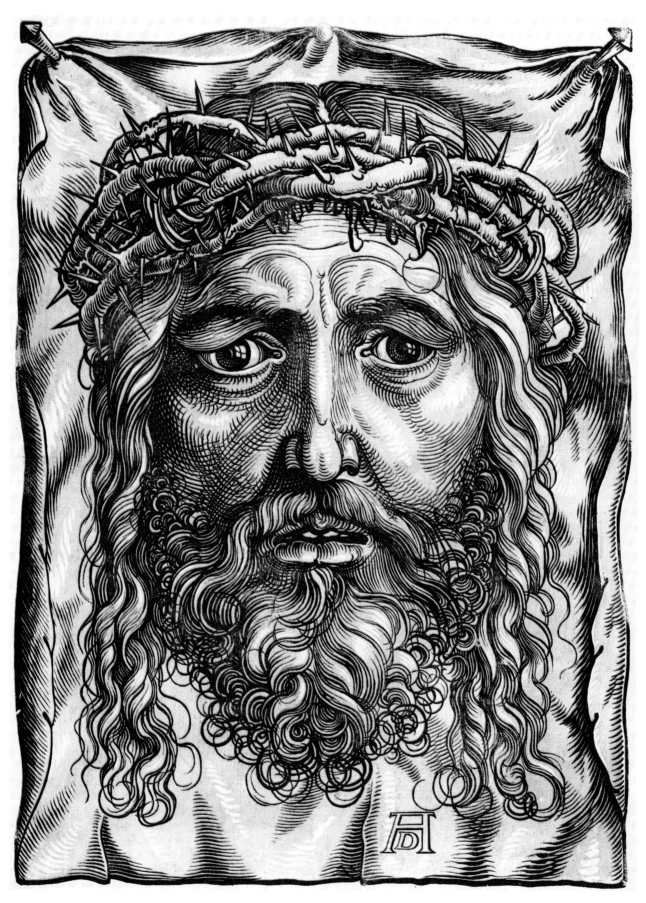

IV

44. St. Apollonia

Without monogram. No date.
311 x 233 mm.
Pauli 302; H. vol. III, p. 213; Geisberg 812 (Erlinger).

ı. Line only.
ıı. One line block; one tone block.

St. Apollonia is mentioned only in passing in the *Legenda Aurea* as having buried St. Anastasia after her martyrdom and then erecting a church on the site of the burial plot. According to St. Francis of Sales,[1] Apollonia refused to flee Alexandria during the persecution of the Christians in A.D. 249. She was burned in a bonfire by a mob.

ı. Erlangen.
ıı. *Amsterdam* (black/sepia).

[1] *Treatise on Divine Love,* vol. 10, ch. 8.

45. Loving Couple before a Vase.

Without monogram. About 1525.
77 x 67 mm.
B.162; Pauli 1231; H. p. 245.

 I. Line only.
 II. One line block; one tone block; heightened with white by hand.

 I. Darmstadt, Hamburg, London.
 II. *Nuremberg* (unique).

46. The Hour of Death

Imprinted: *Niclas Meldeman zu Nvrmberg.* Dated 1522.
392 x 284 mm.
Pauli 1901, 1122; Dodgson *(Catalogue),* vol. I, p. 473; H. vol. III, p. 235.

 I. Line only. Watermark: Serpent Staff with the letters H.S.
 II. Line only. No date.
 III. Line only. With Dürer's monogram added.
 IV. COPY. Line only; without Meldeman's signature. Five large nails in the ceiling.
 V. COPY. One line block; one tone block. No date.
 VI. COPY. One line block; one tone block. With Dürer's monogram.
VII. COPY. In mirror image. Line only.

Nicolas Meldeman was active at Nuremberg as a printer and publisher during the years 1520-40. It is very possible that Beham left some of his woodblocks with Meldeman while ostracized from Nuremberg.

 I. Berlin, Boston, London.
 II. Dresden.
 III. Munich (no watermark).
 IV. Amsterdam, Dresden, London, Vienna.
 V. *Amsterdam,* Cambridge, Dresden, London, Paris (IN), Stuttgart.
 VI. Coburg.

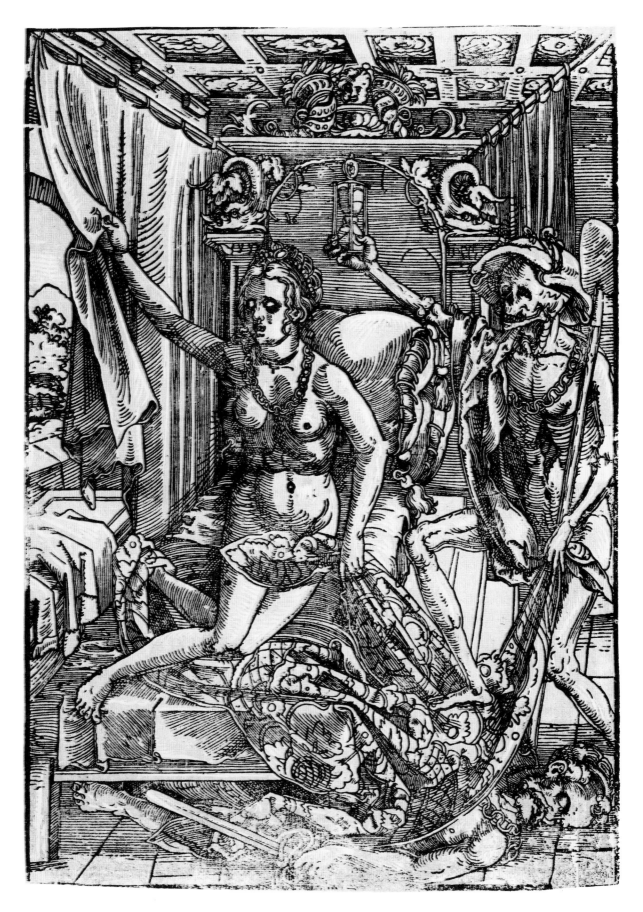

V

47. Adam and Eve

No monogram. No date.
349 x 255 mm.
P. IV, p. 78, No. 172; Pauli 687; H. p. 172.

I. Line block only. Imprinted: *Gott der Herr, ein schöpffer der hiemeln vnnd erdenn. Gedruckt zu Nürnberg durch Hans Weygel formschneider.*

II. Line block only. Inscription changed to: *Adam vnd Eva im Paradeyss.*

III. Deceptive copy. Line block only. Without the seven pebbles in the right lower corner.

IV. Deceptive copy. Line block only. With only one shading line instead of two next to the stone beneath Adam's right foot.

V. Deceptive copy, as IV, but with a tone block added. Watermark: Gothic letter P or Small Coat of Arms with a Diagonal Stripe (Crest of Kaufbeuren) as used for Nos. 51 and 56.

In this large woodcut the stance of Adam and Eve is patterned after Dürer's engraving (B.1). Adam, however, now grasps the apple from Eve's hand, while she receives a second one from the serpent. The skull denotes the newly gained knowledge of transcience and mortality. The animals below do not correspond entirely to those of Dürer's rendering, in which they represent the four human temperaments. The wise and benevolent parrot and the elk, representing melancholy gloom, are taken over almost exactly. But the lizard occurs not in Dürer's "Adam and Eve" but in his "Knight, Death, and Devil" (B.98). It often serves to warn the unaware of the danger of the approaching serpent (Pliny, 2. p. 635).

I. Berlin.
II. London, Nuremberg.
III. Dresden.
IV. Amsterdam, Berlin, Boston, Prague, Sigmaringen.
V. Berlin, Donaueschingen, Frankfurt, London, Paris (BN), Paris (L), *Munich,* Vienna.

Heinrich Röttinger, *Hans Sebald Beham, Nachträge zu Paulis Verzeichnis,* Strassburg, 1911; there is a further impression from a copy of the line block with the monogram CS added, dated 1552 (No. 687k).

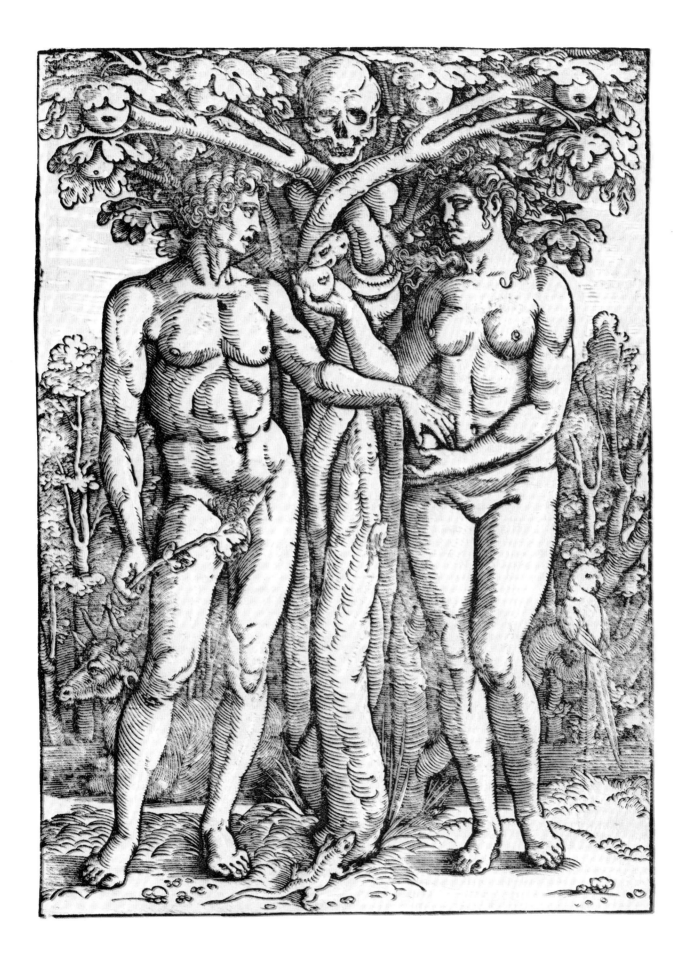

48. Old Man Caressing a Young Woman

Without monogram. No date.
245 x 246 mm. (With text: 350 x 248 mm.)
P. III, p. 211, No. 281; Pauli 1236; Geisberg 901; H. p. 249.
Watermark: Crowned Double-headed Eagle with a Small Crest on Its Chest.

 I. With text; line block only. Imprinted: *gedruckt bey Hanns Adam.*
 II. Line block only; no text.
 III. One line block; one tone block.
 IV. Line block only; Albrecht Dürer's monogram added.

Companion piece of the following print. Röttinger,[1] followed by Geisberg, attributed this woodcut to Jacob Lucius of Cronstadt. Lucius was active at Wittenberg about 1550, at Rostock during the years 1564-78, and later at Helmstedt as printer for the university.[2] The attribution to Lucius seems unconvincing in view of Hans Adam's imprint. Adam was active at Nuremberg, where he died in 1567.[3] The subject of this print is identical to that of Albrecht Dürer's engraving (B.93).

 I. Erlangen.
 III. Berlin, Boston, Bremen, Brunswick, London, Munich, Paris (BN), Vienna.
 IV. Berlin, Boston.

[1] Heinrich Röttinger, *Beiträge zur Geschichte des sächsischen Holzschnitts,* Strassburg, 1921, p. 92, No. 28.
[2] W. Eule, *Helmstedter Universitätsdrucker,* Helmstedt, 1921.
[3] Joseph Heller, *Lexicon für Kupferstichsammler, Berichtigungen und Zusätze,* Bamberg, 1838, p. 99.

49. Old Woman Caressing a Young Man

Without monogram. No date.
246 x 250 mm. (With text: 350 x 248 mm.)
Heller (Dürer) 2073; P.III, p. 211, No. 280; Pauli 1235; H. p. 249.
Watermark: Crowned Double-headed Eagle with a Small Crest on Its Chest.

I. With text; line block only. Imprinted: *gedruckt bey Hanns Adam.*
II. Line block only; no text.
III. One line block; one tone block.
IV. Line block only; Albrecht Dürer's monogram added.

Companion piece of the preceding print.

I. Erlangen.
II. Berlin, Brunswick, Dresden, London, Munich, Oxford, Vienna.
III. Bremen, *Munich.*
IV. Berlin.

50. Christ on the Cross Between the Virgin and St. John

Without monogram. No date.
297 x 210 mm.
Heller No. 1974; P.175; Panofsky 426; H.5.

I. One line block; one tone block. Watermark: Bull's Head. Imprinted on the bottom:
 Gedruckt durch Hans Guldenmund brieffmaler zu Nürnberg A.

II. COPIES:
 A. Without the lines between the Virgin's halo and the left border.
 Woodblock in Berlin (Derschau Collection).
 B. Without the sun and the moon.
 C. The crucifix only; the skull directly beneath the cross.

Both Dodgson[1] and Winkler[2] credit Dürer with the design of this woodcut. Panofsky[3] disagrees because the design reverts to an earlier type in the figure of Christ, while the composition is apparently based on the drawing by Dürer (W. 880) of 1521. Hans Goldenmund is known to have reprinted some of Dürer's woodcuts.[4]

I. Hamburg (black and pink); *New York* (black and green).

[1] Campbell Dodgson, *Print Collector's Quarterly,* vol. 24, 1937, p. 173.
[2] Friedrich Winkler, *Albrecht Dürer, Leben und Werk,* Berlin, 1957, p. 288.

[3] Erwin Panofsky, *Albrecht Dürer,* vol. 2, Princeton, 1943, No. 426.
[4] Hans Rupprich, *Dürers schriftlicher Nachlass,* vol. 1, Berlin, 1956-70, p. 243.

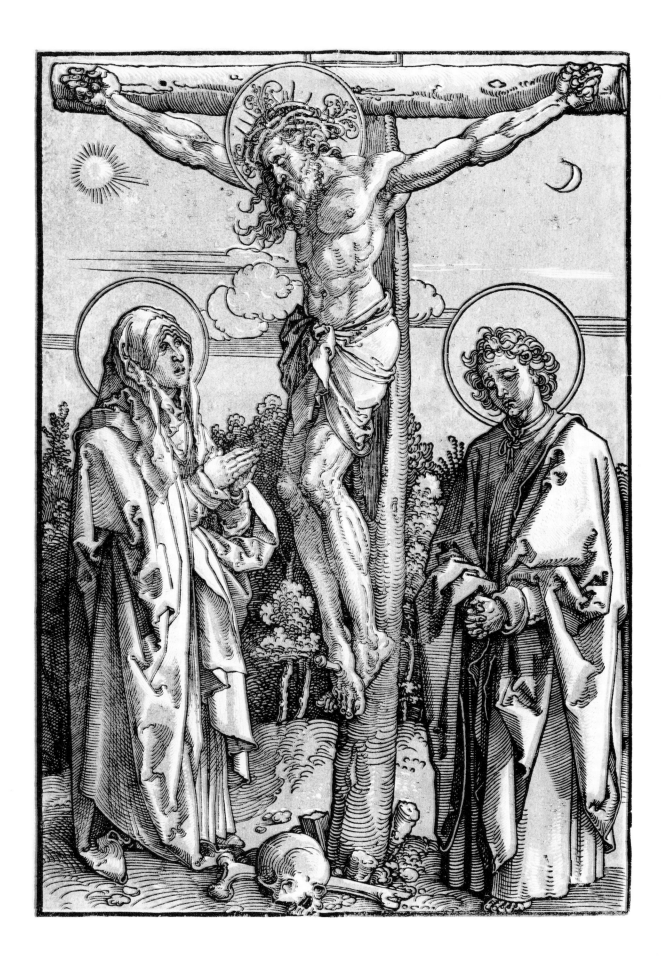

51. The Holy Kinship with St. Ann and St. Joachim

No monogram. Dated 1519.
303 x 220 mm.
B. vol. VII, p. 176, No. 10; Heller 1936; P.178.

I. Line block only.
II. One line block; one tone block.
III. COPY:
 A. Line block only. Imprinted on top: *Sancta Anna.* On the bottom:
 Hans Glaser, Brieffmaler auff S. Lorentzen Platz.
 B. As above, but with one tone block added.
 C. Line block only, with Dürer's monogram added spuriously.
 D. As C, but with a tone block added. No date. Watermark:
 Coat of Arms with Diagonal Stripe (Briquet 1008, ca. 1550).

Röttinger attributes this woodcut to Peter Vischer the Elder.[1] Both this and the following woodcut (Plate 52) are, however, closely akin to the style of Hans Springinklee, circa 1519,[2] and both occur with the imprint of the Nuremberg printer Hans Glaser. Glaser's imprint is found too on woodcuts by Springinklee's pupil, Niklas Stoer,[3] and on some impressions of the five illustrations for *Freydal*[4] of 1516. The *Freydal* illustrations were prepared for a projected book about the Emperor Maximilian I while Hans Springinklee was in Dürer's workshop. It is therefore indicated that this and the following woodcut may be the work of Hans Springinklee, and the copy by Niklas Stoer.

IIIA. Bamberg.
IIID. *Boston* (W. G. Russell Allen Collection), Cambridge, Paris (L).

[1] Heinrich Röttinger, *Dürers Doppelgänger,* Strassburg, 1926, Pl. XVIII.
[2] Geisberg Nos. 1338, 1341.
[3] Geisberg Nos. 1354, 1355.
[4] Joseph Meder, *Dürer-Katalog,* Vienna, 1932, p. 203.

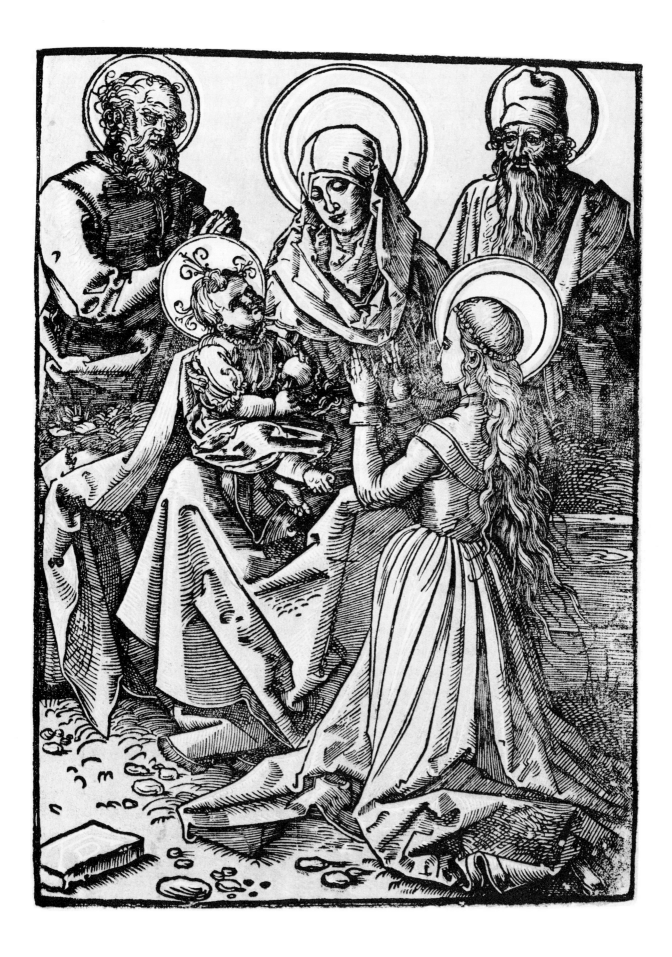

52. The Fall of Man

No monogram. No date.
305 x 245 mm.
Dodgson *(Catalogue)*, vol. I, p. 549, No. 2a.

 I. Line block only. Imprinted: *Zu Nürnberg bey Hans Glasser Brieffmaler zunächst dem Ochsenfelder.*
 II. One line block; one tone block. Without Glaser's imprint.

Dürer's influence is manifest. The four animals, representing the four human temperaments, do not coincide with those of Dürer's engraving entitled "Adam and Eve" (B.1) but are taken from his woodcut (B.17). The boar is taken from the workshop copy of his painting of the same name in Florence (Uffizi), in which the lion and the elk are added. (They do not appear on the original panels in Madrid.)

Röttinger[1] attributed this print to Jacob Lucius of Cronstadt (School of Lucas Cranach the Elder), but Glaser's imprint (as on the preceding print) points to a Nuremberg artist.

 I. London.
 II. Berlin, *Boston* (W. G. Russell Allen Collection; no watermark), Bremen, Minneapolis, Paris (BN), Vienna.

[1] Heinrich Röttinger, *Beiträge zur Geschichte des sächsischen Holzschnitts,* Strassburg, 1921, p. 84, No. 11.

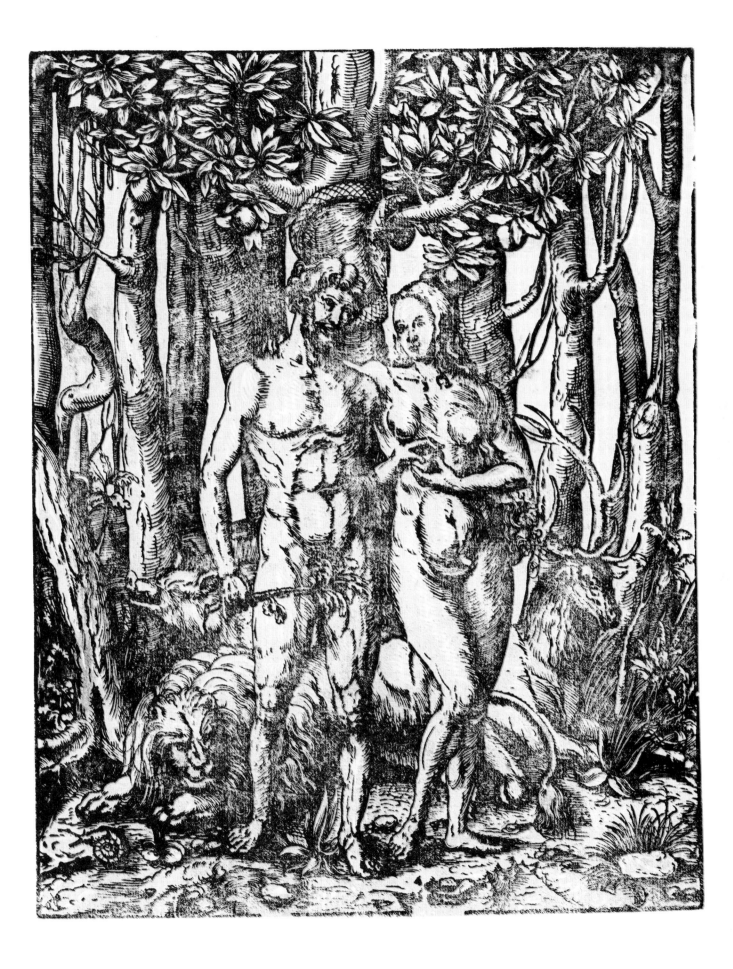

53. Reclining Child and a Skull in a Landscape

No monogram. No date.
240 x 330 mm.
One line block; two tone blocks.
Watermark: Gothic letter P with Orb and the letters HH (akin to Meder 327).

Anzelewski[1] notes Dürer's influence but ascribes this woodcut to either the School of Lucas Cranach the Elder or the Danube School. The background, except for the vegetation, is reminiscent of Dürer, but lacks Dürer's typical bulbous verdure. The head of the child bears some resemblance to Dürer's drawing, "Head of a Child," (W.577) of 1520. Pose and subject, however, are more reminiscent of the work of Barthel Beham, while the shading with concentric lines of the face may be found in some of the woodcuts of his brother, Hans Sebald Beham (e.g., "The Holy Family," Pauli 989, 1521). The watermark does not appear in any of Dürer's prints, except a posthumous impression of the "Crowning of Christ with Thorns" of the *Albertina Passion*, where the orb is on an escutcheon. A positive identification of the author of this woodcut must await a thorough study of the papers used by the Beham brothers and other artists of the Dürer School. The inscription reads, in translation: "Today I, tomorrow you."

Boston (Parker Collection).

[1] Fedja Anzelewski, *Albrecht Dürer, das malerische Werk,* Berlin, 1971, p. 280.

Horst W. Janson, "Putto mit dem Todenschädel," *Art Bulletin*, vol. 19, 1957, p. 423.

Watermark:

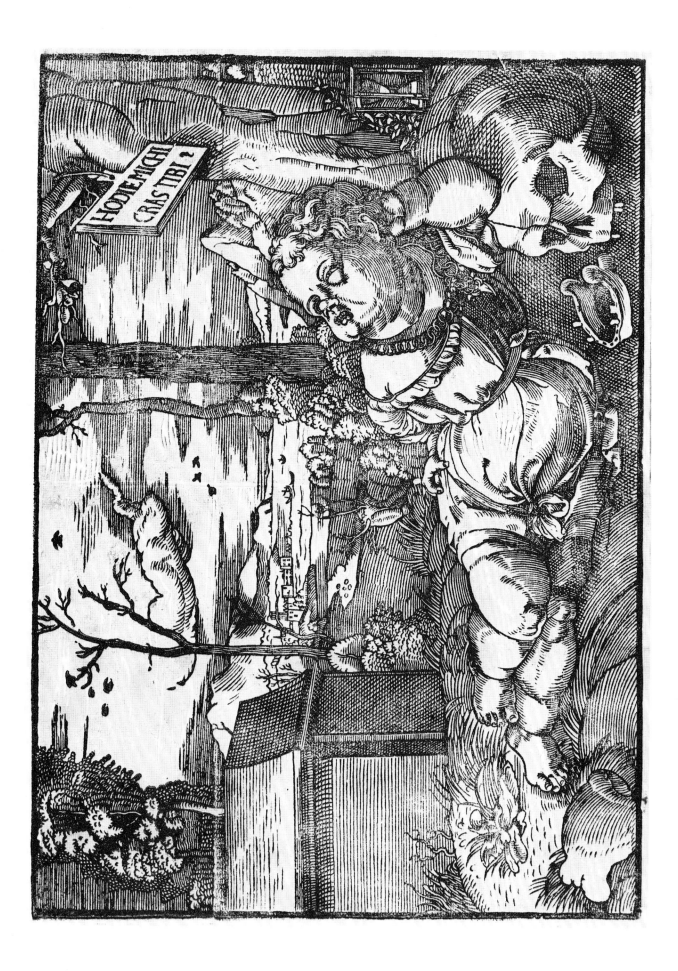

54. Altarpiece

No monogram. About 1515.
342 x 272 mm.
Heller (Dürer) 2054; P.268; R.26.

I. Line block only.
II. One line block; one tone block.

Composite altarpiece, based partly on works by Dürer ("Trinity," B.122; "Man of Sorrows," B.3; "Ascension of the Virgin," B.94). According to Reichel, this work may be based on a drawing by Erhard Schön. The frame is reminiscent of Hans Springinklee.

II. *Vienna.*

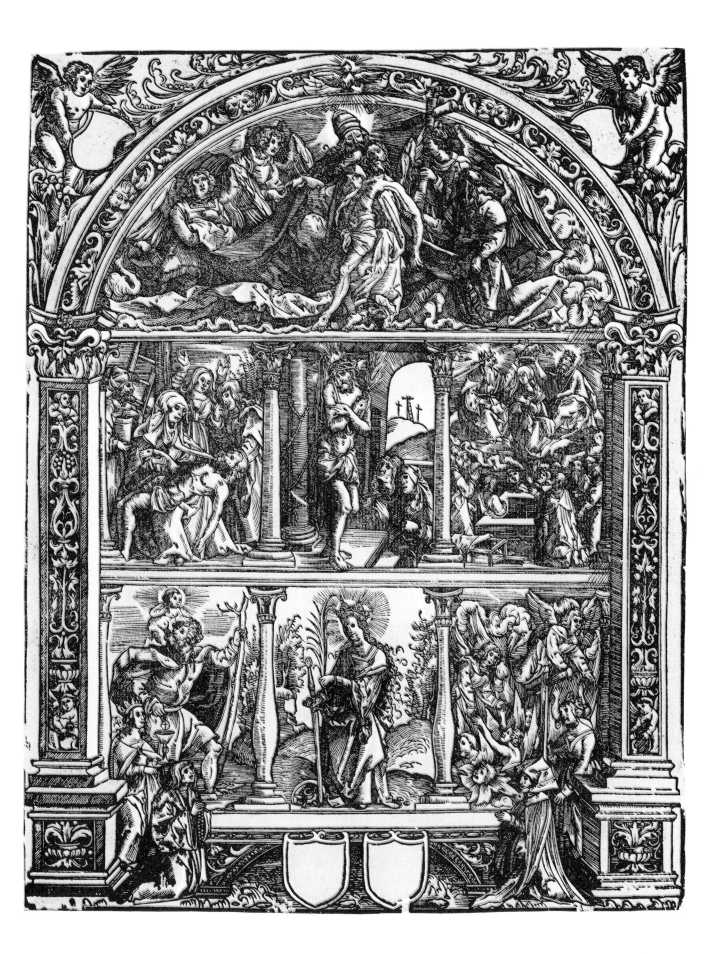

55. Coronation of the Virgin

No monogram. No date.
185 x 162 mm.
No watermark.
Dodgson *(Catalogue),* vol. I, p. 354, No. 15.

 I. Line block only.
 II. One line block; one tone block.

Nuremberg School. According to Dodgson, it is perhaps an early work by Hans Baldung Grien.

 I. Boston (W. G. Russell Allen Collection).
 II. *London.*

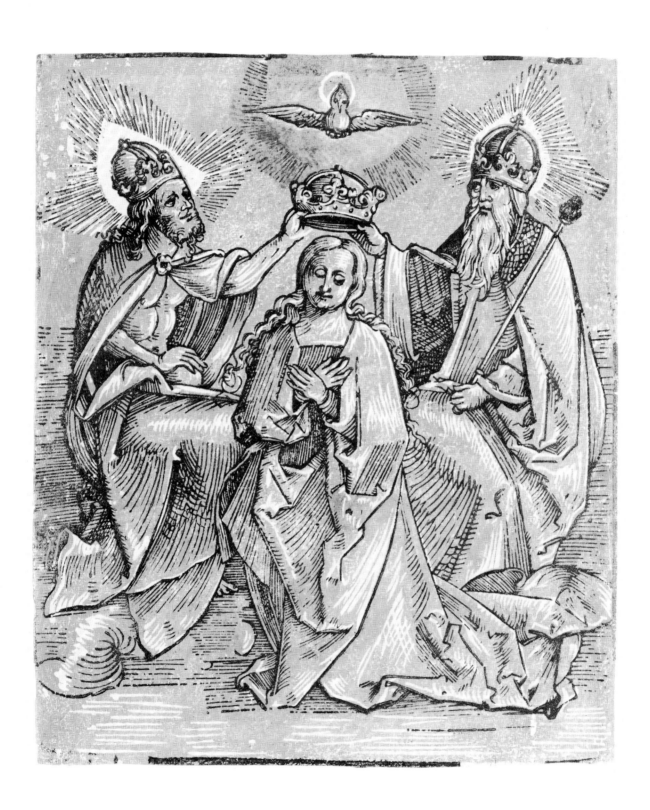

56. Christ Blessing the Children

Without monogram. No date. Second half of the sixteenth century.
214 x 273 mm.

I. Line block only. Watermark: Posthorn.
II. One line block; one tone block. The birds and most of the clouds eliminated.
Watermark: Coat of Arms with Diagonal Stripe (as in Nos. 47 and 51; Boston);
Gothic letter P (London).

Dodgson[1] attributes this print to the Master of the Adoration of the Shepherds. Röttinger[2] ascribes it to Jacob Lucius von Cronstadt (School of Lucas Cranach the Elder).

Based on the passage from Matthew 19:13-14: "Then there were brought to him little children, that he should put *his* hands on them, and pray: and the disciples rebuked them. But Jesus said, Suffer little children, and forbid them not, to come unto me; for such is the kingdom of heaven."

I. Amsterdam, Boston, London.
II. Amsterdam, *Boston* (W. G. Russell Allen Collection), Innsbruck, London, Paris (BN).

[1] Dodgson, *Catalogue,* vol. 2, p. 397, No. 3a.; Thieme-Becker, XXXVII, pp. 16, 455 (Master WS).

[2] Heinrich Röttinger, 1921, p. 87, No. 19.

Watermark:

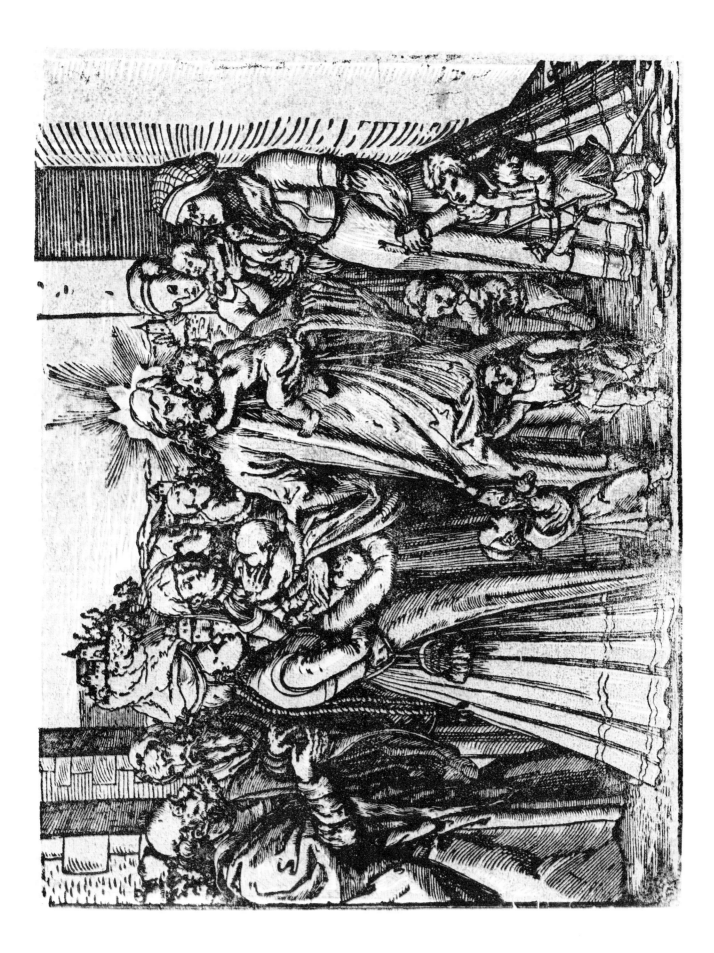

57. Ecce Homo [half-length]

With Dürer's monogram beginning with II. Dated 1521.
328 x 250 mm.
B. app. 5; Heller (Dürer) 1626, 1627; P.174; H.2.

I. Line only.
II. Copy in reverse with Dürer's monogram added; without the date. Line only.
III. Copy in reverse with Dürer's monogram, without date. One line block,
one tone block.

In the chiaroscuro impression (III), Pilate appears on the left, his left hand extended to protest Christ's innocence. On the right are two attendants, one only partly visible behind Christ's shoulder.

Some early impressions are imprinted *Sehet welch ein Mensch* (Look, what a man).[1] Retberg[2] called this print "one of the most excellent products of Dürer's workshop, Christ's head perhaps drawn by Dürer himself; very rare."

I. Bamberg (on vellum), Boston, Coburg, London, Stuttgart.
II. Boston (W. G. Russell Allen Collection).
III. *Bamberg* (brown), Boston (brown), London (green), Paris (L; brown).

[1] C. H. von Heinecke, *Verzeichnis von Dürers Holzschnitten,* Dresden, 1786.
[2] R. von Retberg, *Dürers Kupferstiche und Holzschnitte, ein kritisches Verzeichnis,* Munich, 1871, No. A. 23.

Campbell Dodgson, *Catalogue,* vol. 1, p. 351, No. 6a.

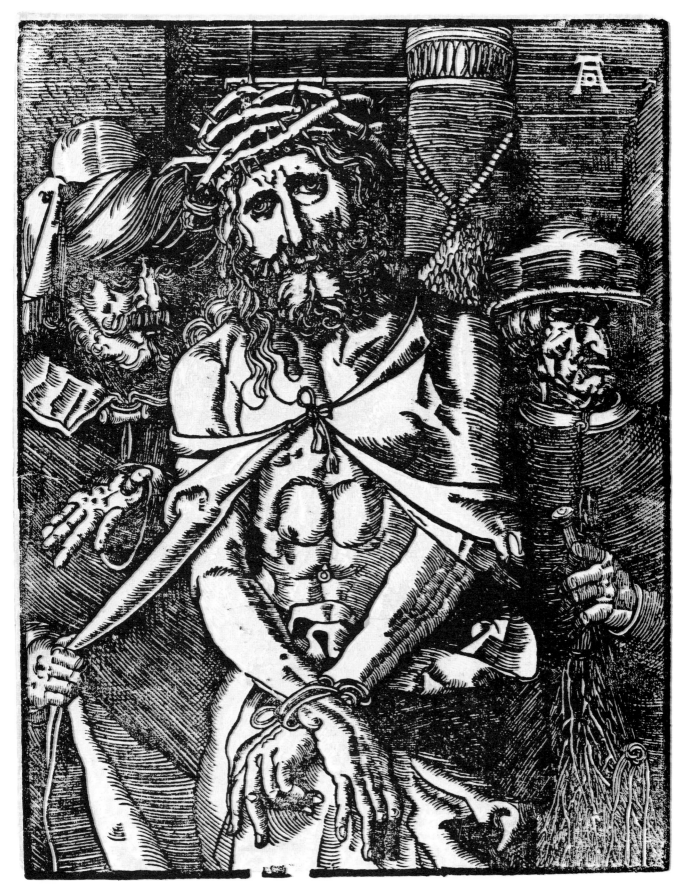

III

58. Queen Anne Maria of Hungary

No monogram. About 1515.
202 x 197 mm.
Geisberg 1529.
One line block; one tone block.

Geisberg attributes this print to Weiditz, Lützow[1] calls it "Swabian,"
while Musper[2] suggests Wechtlin.

Berlin.

[1] Carl von Lützow, *Geschichte des deutschen Kupferstichs und Holzschnitts,* Berlin, 1891, p. 222.
[2] H. T. Musper, *Der Holzschnitt in fünf Jahrhunderten,* Stuttgart, 1944, p. 389.

V. von Loga, "Ein Jugendbildnis der Maria von Ungarn," *Jahrbuch der preussischen Kunstsammlungen,* vol. 10, Berlin, 1889.

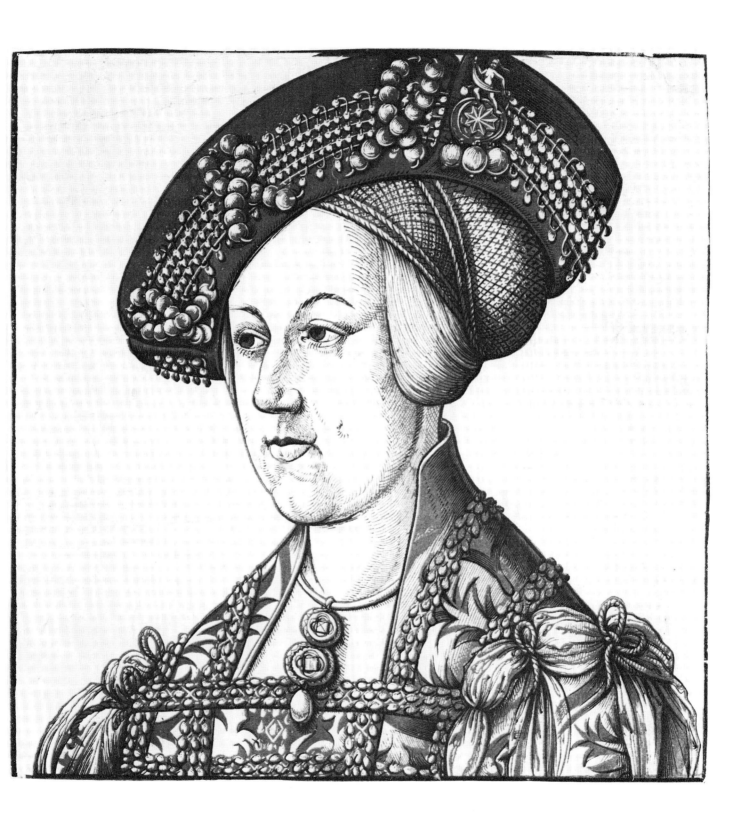

ERASMUS LOY

1520-1570, Regensburg. Erasmus Loy was granted the Imperial Privilege
to print multicolored wallpaper. These papers, although not true chiaroscuros, are
counted among the earliest examples of color printing. All are printed from two blocks
and are stamped: *Mit Ko: Kay: und Khu; May freyhait: nit Nachzudruckhen*
(With Royal, Imperial, and Electoral Majesty's Privilege: not to be reprinted).[1]

59. Renaissance Plaza

With monogram: E L. No date.
144 x 226 mm.
R.28.

Vienna (black/orange).

[1] Georg Kaspar Nagler, *Die Monogrammisten,*
vol. 2, Munich, 1879, p. 1663; LeB. p. 575.

59A. Renaissance Structures Connected by a Wall

With monogram: EL. No date.
158 x 292 mm.
Watermark: Escutcheon with Key and attached letter R (Briquet 1139).

Boston (sepia/dark brown).

Illustrated in the Appendix.

60. Medallion Paper

With monogram: E L. No date.
325 x 425 mm.

London (sepia/dark brown).

61. Escutcheon Paper

With monogram: E L. No date.
425 x 305 mm.

London (sepia/dark brown).

61A. Renaissance Structure with Guard

Without monogram. No date.
432 x 360 mm.

Boston (W. G. Russell Allen Collection; sepia/dark brown).

Illustrated in the Appendix.

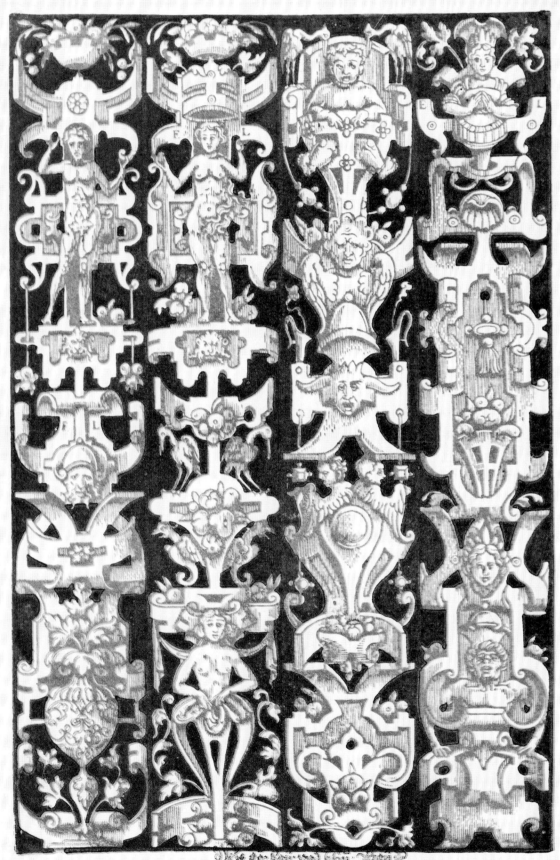

62. Courtyard

Without monogram. No date.
280 x 204 mm.

London (sepia/dark brown).

62A. Renaissance Street with Flight of Birds

Without monogram. No date.
293 x 168 mm.

Boston (W. G. Russell Allen Collection; sepia/dark brown).

Illustrated in the Appendix.

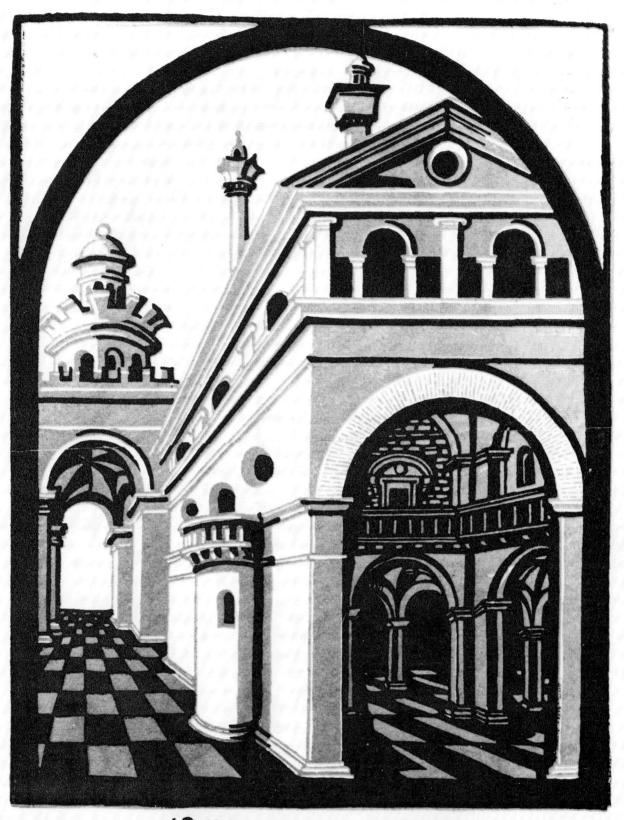

Mit rö: Kay: vnd khü: May: &
freyhait: nit Nachzudrucken

63. Courtyard with Fountain

Without monogram. No date.
374 x 312 mm.

London (sepia/dark brown).

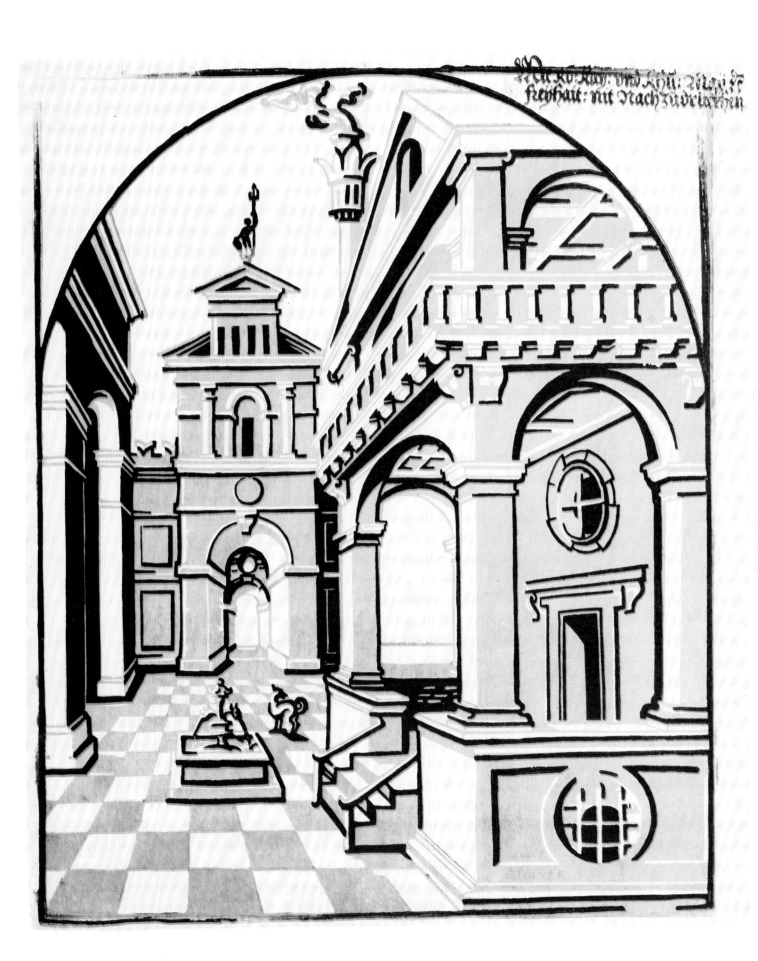

63A. Courtyard with Church Steeple

Without monogram. No date.
427 x 358 mm.
Watermark: Escutcheon with Key and attached letter R (Briquet 1139; ca. 1555-67, Regensburg.)

Frankfurt (H. H. Rumbler Gallery; reddish-brown and black).

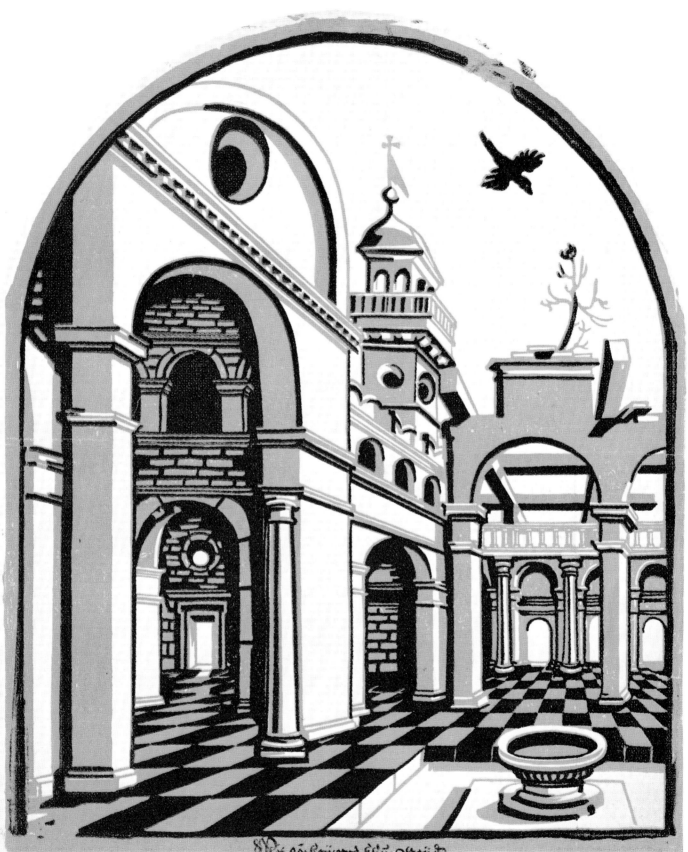

Mit Ro: Kay: vnd Khü: May: &
freyhait: nit Nachzudruckhen

GEORG MATTHEUS

Circa 1521 to 1572, Lyons. Active in Augsburg about 1554.

64. The Holy Family in Flight to Egypt

Imprinted: *IORG MATHEIS FVRMSCHNEIDER VA. AUGSPURG.* No date.
190 x 178 mm.
B.1; R. p. 21; P. IV, p. 312, No. 1.
One line block; one tone block.

Vienna.

Georg Kaspar Nagler, *Künstler Lexicon,* vol. 8, Thieme-Becker, xxiv, p. 261.
p. 434.

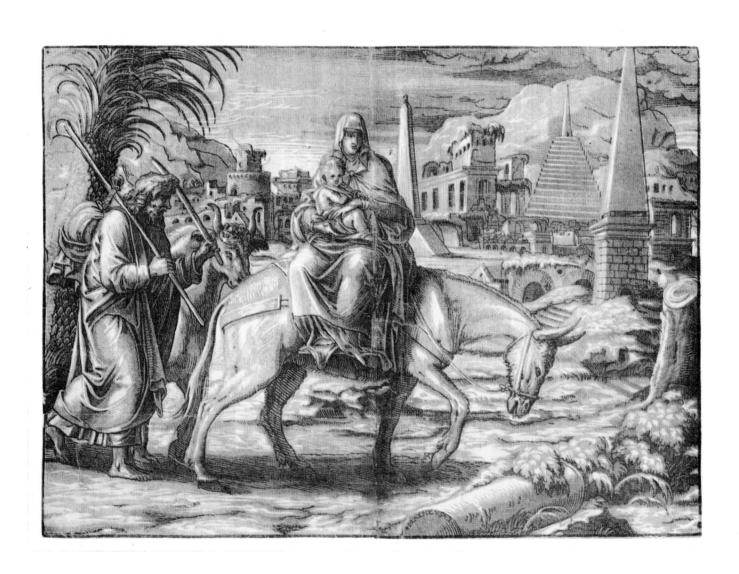

65. St. Martha Leading the Magdalen to the Temple

With monogram: M. No date.
237 x 348 mm.
B. vol. XII, No. 37; P.2; IN.27.
One line block; one tone block (sepia or terra cotta).
Watermark: Head of an animal in a circle (not in Briquet).

Copy of an engraving by Marcantonio Raimondi (B. 12), which in turn is based on Raphael.

Boston, London, New York (MM), *Nuremberg,* Paris (IN), Vienna.

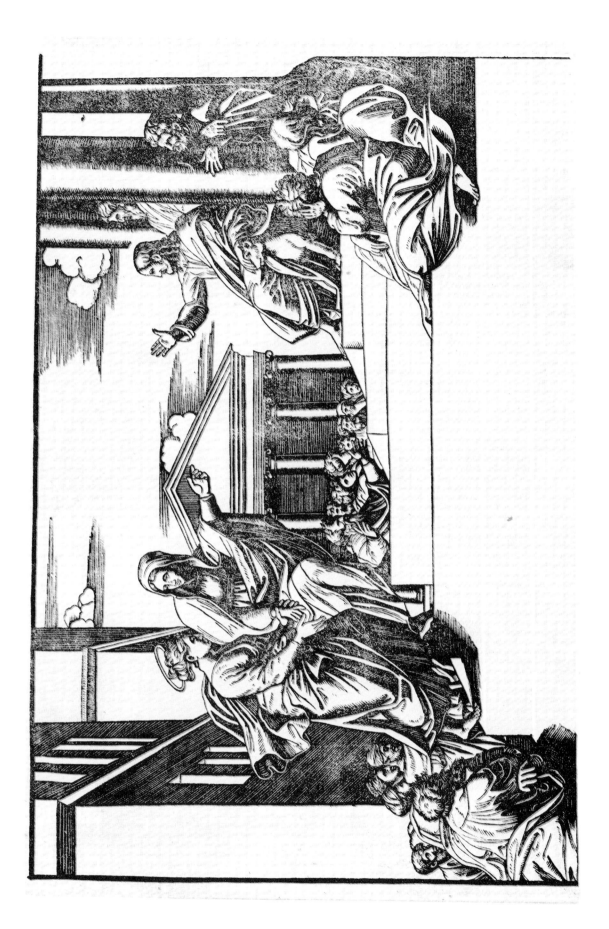

66. Actaeon Transformed into a Stag

Imprinted: IORG MATHEVS. No date.
B. vol. XII, No. 106; P.3.
343 x 482 mm.
One line block; two tone blocks.

This woodcut was executed by Georg Mattheus in collaboration with his daughter Anna. It is based on an engraving by Lucas Penni. Actaeon, a famous hunter, surprised the goddess Artemis (Diana) while bathing. In punishment for having boasted of being a superior hunter he was changed into a stag and devoured by his own hounds who failed to recognize him. (Ovid, *Metamorphoses* III. 138-253). There are two related drawings at Rennes.

Prints of this subject by the Master I. B. with the Bird, Georg Pencz, Tobias Stimmer, Virgil Solis, School of Marcantonio Raimondi, etc., attest to its popularity.

Boston (W. G. Russell Allen Collection), Paris (BN), *Vienna* (two impressions).

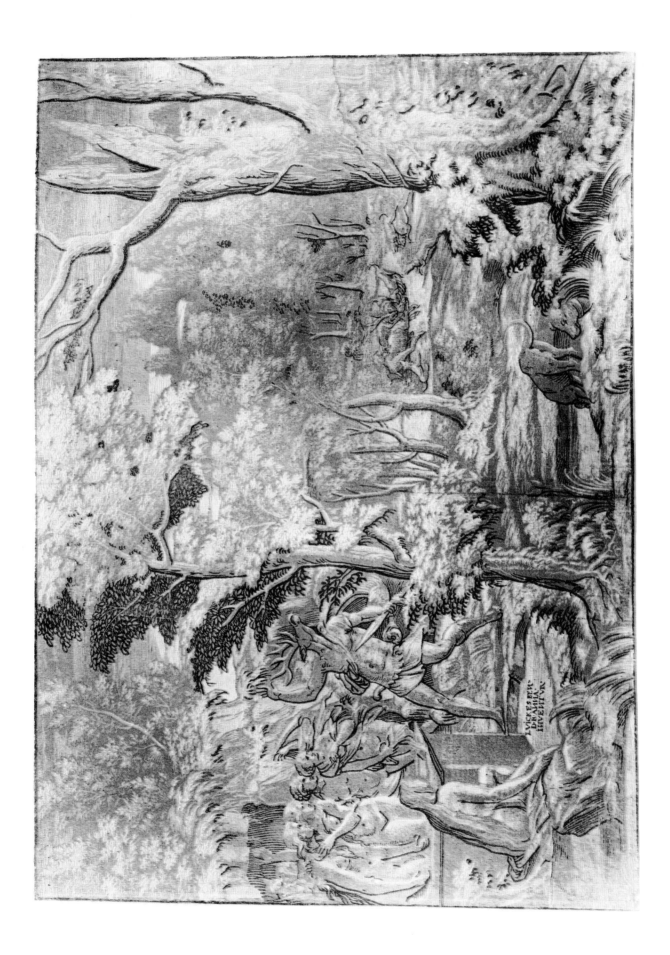

TOBIAS STIMMER

Schaffhausen 1539-1584, Strassburg. After a trip to Northern Italy as a journeyman, Tobias Stimmer began painting frescoes and portrait commissions at Schaffhausen, Basel, and Zürich. About 1569 he established his own workshop at Strassburg, where in 1570 he is recorded as godfather of a son of the printer Bernhard Jobin. He provided numerous woodcut illustrations for printed books, among these: *The History of Martyrs* (L. Rabus, 1571); *Till Eulenspiegel* (1572); *The History of the Popes* (B. Jobin, 1573); *Livy* (1574); Josephus Flavius' *History of the Jews* (1575). From 1577 to 1579 he was active decorating the new palace at Baden-Baden.

67. The Synagogue [The Old Faith]

With monogram. Imprinted: *B. Jobin execud.* No date. About 1572.
350 x 268 mm.
R. p. 25; Andresen, vol. III, p. 37, No. 41.
One line block; two tone blocks.

Text translation:

This very blood, it's dazzling to my eyes.
Gospels and law, no matter how sound
It is our Faith that holds the ground.
Stronger than old worldly law
Forever it forces sin to withdraw.
For art and teaching's sake, they say,
Such pictures are still preserved today.

This print, and the following companion piece, are based on sculptures in the Cathedral of Strassburg. The Old Faith is shown with a broken staff. During the years 1572-73 Stimmer was engaged in designing the housing and decoration of the great astronomical clock for that edifice. Although authorized in 1547, work had been interrupted on it because of an edict by the Emperor Charles V permitting the use of the cathedral for Catholic services for a period of ten years. Work on the clock was resumed only in 1571.

Basel, Boston, Cambridge, London (without text), New York (NYPL).

Christoph G. von Murr, *Journal zur Kunstgeschichte und Litteratur,* Nuremberg, 1777, p. 19.
Friedrich Thöne, *Tobias Stimmers Handzeichnungen,* Freiburg/B, 1936.

Max Bendel, *Tobias Stimmer, Leben und Werke,* Zürich-Berlin, 1940.

68. Ecclesia [The New Faith]

With monogram. No date.
350 x 268 mm.
R. p.25; Andresen, vol. III, p. 37, No. 42.
One line block; two tone blocks.

Companion piece of the preceding print.
Text translation:

With Christ's blood I'll conquer you.
Two ancient pictures of this kind

In the City of Strassburg you will find.
On the cathedral's gate in the rear
Whence the Fronhof is quite near,
This will show what ancient art
Believed and pictured on its part.

Basel, Boston (W. G. Russell Allen Collection; without text), Cambridge, London (without text).

Murr, 1777, p. 19.

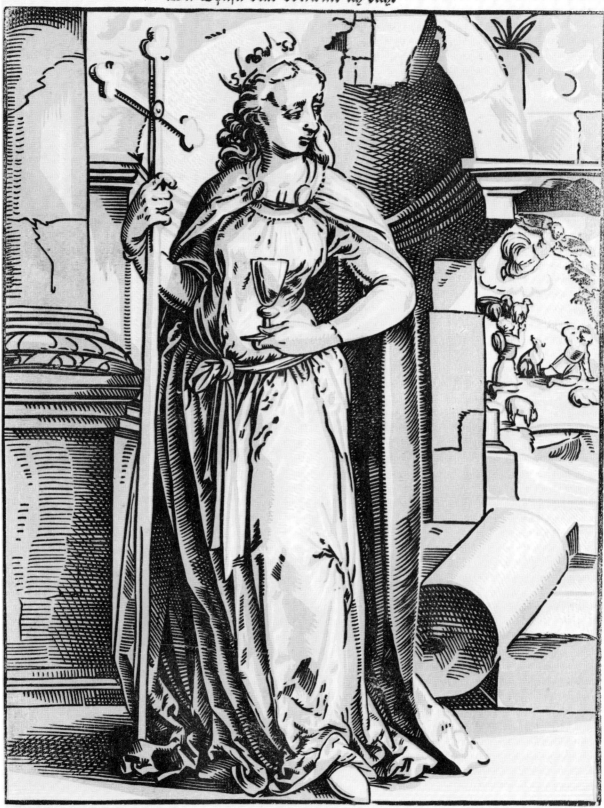

Mit Chꝛiſti blůt vberwind ich dich.

Diſſe zwey Alte bilder ſchön Am Münſter/in dem hindern thoꝛ Darauß man ſicht der alten kunſt
Find man zů Straßburg alſo ſtehn Wan man geht auff dē Fronhof voꝛ: Vnd was ſie han geglaubet ſunſt

JOST AMMAN

Zürich, 1539-1591, Nuremberg. Jost Amman, painter, woodcutter, and etcher, was the youngest son of the canon and professor of rhetoric and ancient languages at Zürich. He came to Nuremberg in 1560 to study with the famous book illustrator, Virgil Solis. After Solis' unexpected death in 1562 from the Plague, Amman became his artistic heir. The majority of his works are also book illustrations. Amman became a citizen of Nuremberg in 1577, where he continued to reside, except for brief stays at Augsburg (1578), Frankfurt and Heidelberg (1583), and Würzburg (1587).

69. Old Woman with an Owl

Without monogram. No date.
142 x 121 mm.

 i. Line block only.
 ii. One line block; one tone block.

Perhaps an experimental print. No other impressions with tone background are known.

 i. Illustration in *Jost Amman, Kunst und Lehrbüchlein,* Frankfurt, 1578, pp. 78,[1] 135.[2]
 ii. *Paris* (BN; vol. Ea.26). Not previously described.

[1] Carl Becker, *Jobst Amman,* Leipzig, 1854, p. 100.
[2] Reprint, New York (Dover Publications), 1968, p. 135.

 Johann David Passavant, *Le Peintre-Graveur,* vol. 2, Leipzig, 1862, pp. 463-65.
 Andreas Andresen, *Der deutsche Peintre-Graveur,* Berlin, 1866.
 Thieme-Becker, I, p. 410 (T. Hampe).
 K. Pilz, "Die Zeichnungen und das graphische Werk Jost Ammans," *Dissertation,* Munich, 1933; *Anzeiger für schweizerische Altertumskunde,* NF, vol. 35, 1933, p. 25; *Mitteilungen des Vereins für Geschichte der Stadt Nürnberg,* 1940, p. 203.

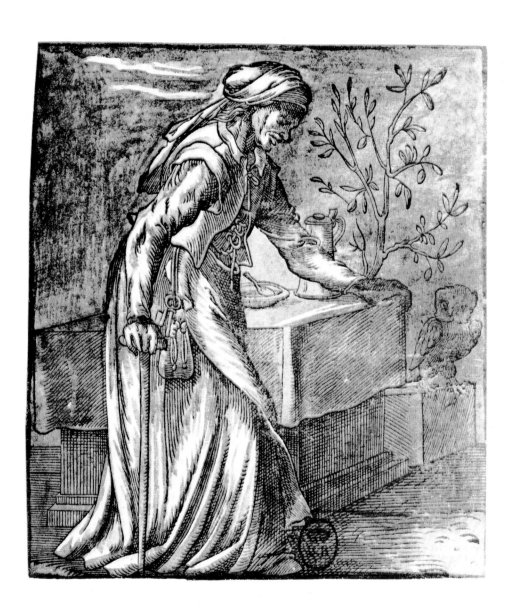

70. The Story of Adam and Eve

With monogram: IA. No date.
275 x 190 mm.
A.25; B.15; Becker, p. 14; H. p. 25.

I. Line block only.
II. One line block; one tone block.
III. Line block printed on colored paper.

The original line block is preserved in the Prince Oettingen-Wallerstein collection at Maihingen.

I. *Berlin,* Hamburg.
II. Location undetermined.
III. In Martin Luther, *Biblia, das ist die gantze Heylige Schrift Teutsch,* Frankfurt, 1589. Exists also in impressions of the eighteenth century.

71. Venus and Cupid*

With monogram: IA. No date.
120 x 95 mm.
A.59; H. p. 26.
One line block; one tone block.
Imprinted: *Chr. rest.*
Location undetermined.

*Not illustrated.

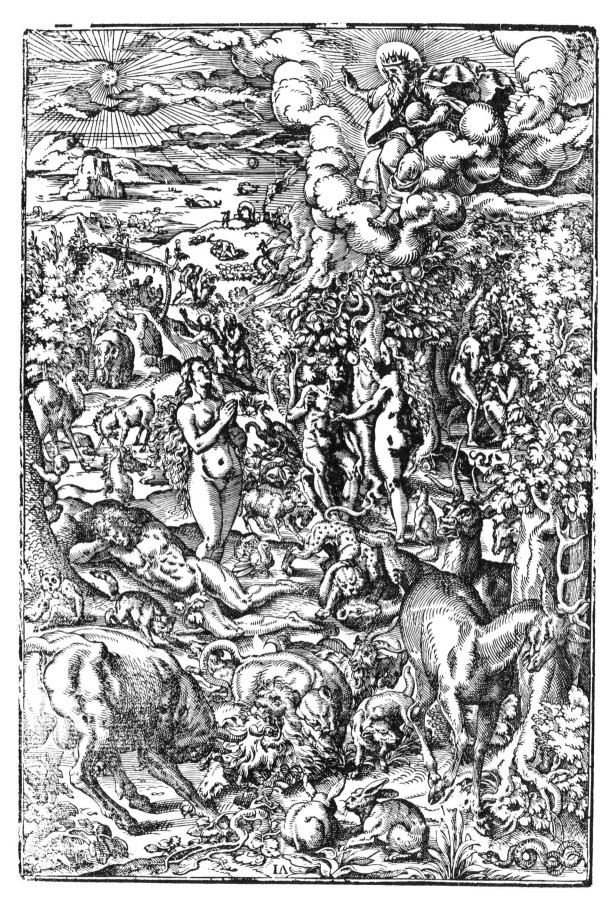

LUDOLPH BÜSINCK

1599/1602-1669 Münden. Active in Paris from 1623 to 1629, where he worked
with the printer and publisher Melchior Tavenier,[1] mostly after drawings
by Abraham Bloemaert and George Lallemand.[2] The latter, a painter from Nancy,
expended a large sum for the construction of a special press for chiaroscuro prints.
His style was somewhat coarse and provincial[3] and in this respect influenced
Büsinck to some extent. Büsinck was obviously familiar with the technique
of using swelling lines of Hendrick Goltzius. His prints are all pulled from three blocks
with the single exception of "Aeneas Saving His Father from Troy" (Plate 94).
During 1630 Büsinck returned to his native city of Münden to resume his activities
as a painter. In 1647 he was appointed Inspector of Customs which seems
to mark the end of his recorded activities as an artist.

72. The Holy Family

Imprinted: *A. Bloem inv. L. Büsi sc.* No date.
240 x 178 mm.
LeB.4; St.4; H.4.
One line block; two tone blocks.

 I. Signature in white. Watermark: Flask with Crescent (Briquet 12803).
 II. See Plate 72A.

Probably the earliest of Büsinck's chiaroscuro prints.

 I. Amsterdam, *Bamberg*, Basel, Berlin, Boston, Bremen, Brussels (grayish),
 Cambridge, Dresden, London, New York (NYPL), Philadelphia, Rotterdam.
 II. See Plate 72A.

[1] F. van Ortroy, *Biographie Nationale de Belgique,*
vol. 24, Brussels, 1926-29, p. 639.
[2] J. M. Papillon, *Traité de la Gravure en Bois,*
vol. 2, Paris, 1766, p. 372.
[3] Wolfgang Stechow, "Ludolph Büsinck, a German

Chiaroscuro Master of the Seventeenth Century,"
Print Collector's Quarterly, vol. 25, 1938, pp. 393-
419; "Catalogue of the Woodcuts by Ludolph Bü-
sinck," *Print Collector's Quarterly,* vol. 26, 1939,
pp. 349-59.

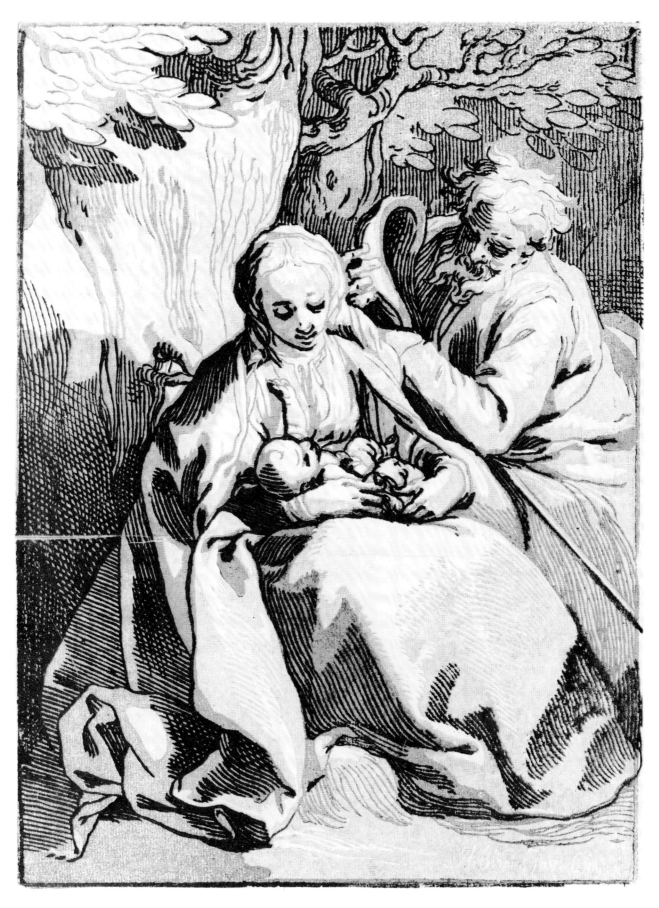

LUDOLPH BÜSINCK

72A. The Holy Family

II. Signature in brown. Tone block slightly narrower.

Amsterdam, New York (MM).

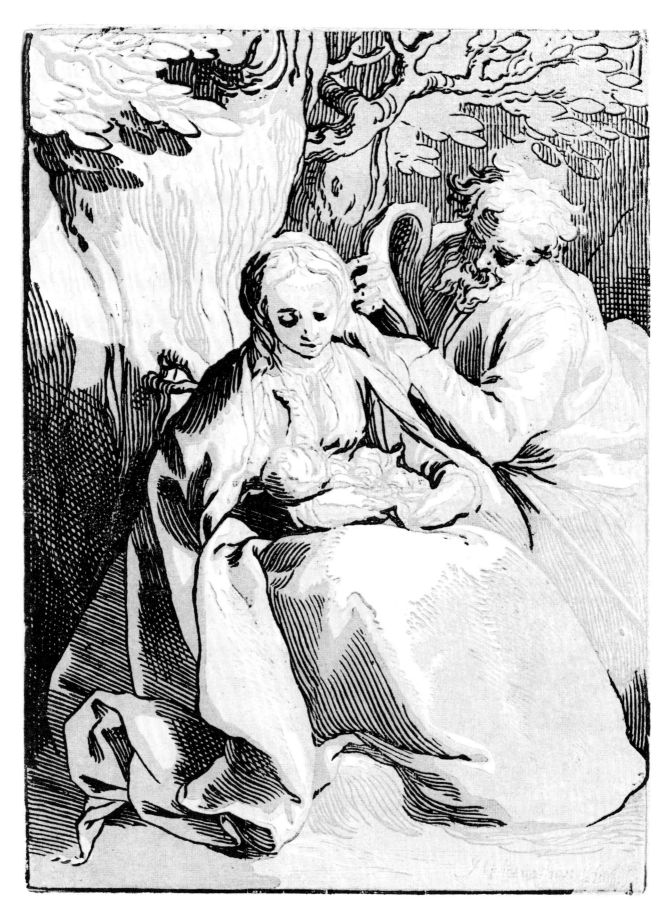

II

LUDOLPH BÜSINCK

73. The Holy Family with the Infant St. John Riding a Lamb

Imprinted: *G. Lallemand inv. L. Büsinck scul. 1623.* Dated 1623.
295 x 205 mm. (oval frame).
LeB.3; St.3; H.3.
Watermark: Grape.
One line block; two tone blocks.

Only this chiaroscuro print by Büsinck and Plates 80 and 97 bear dates.

Basel, Berlin, Boston, Bremen, Cincinnati, Coburg, Cologne, Göttingen,
Hamburg, London, New York (MM), Paris (BN), Paris (IN), Paris (L), Vienna, Warsaw.

74. The Holy Family with St. John and a Saint Holding a Candle*

H.4a.
One line block; two tone blocks.

Ascribed to Büsinck in Thieme-Becker,[1] based on the opinion of C. de Mandach.

Stechow[2] denies authenticity and terms this print "undoubtedly Italian."

Paris (L).

[1] Vol. V, p. 199.
[2] Wolfgang Stechow, 1939, p. 359, IV.

*Not illustrated.

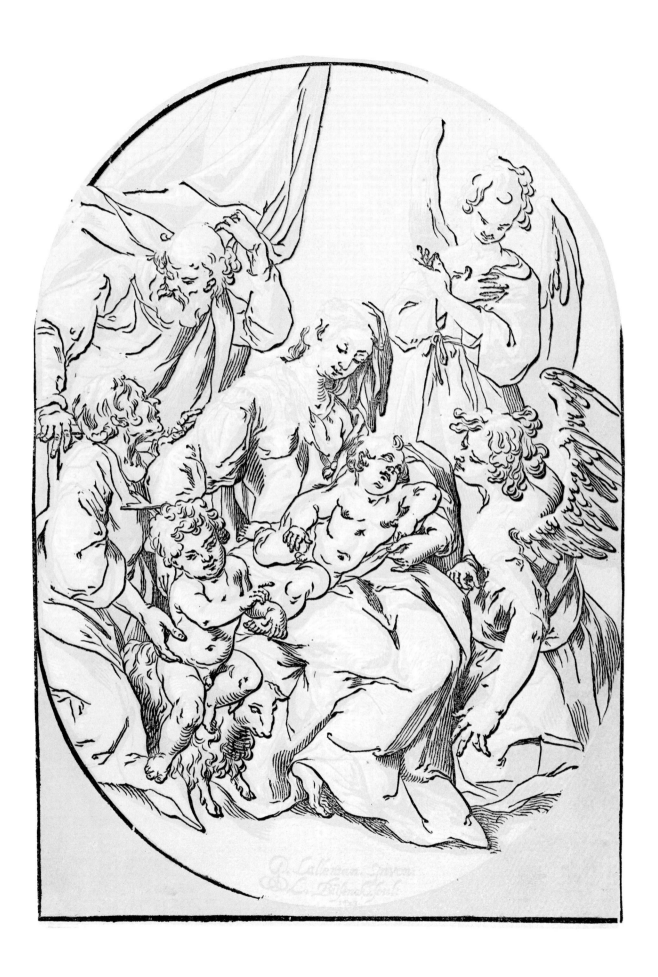

75. Moses with the Tablets of the Law

Imprinted: *G. Lalleman inv. L. Büsinck scu. à Paris chez Melchior Tavenier,
graveur et imprimeur du Roy pour tailles douces, en l'isle du Palais
sur le quai qui regarde la Magisserie, à l'Espice d'or. Avec privilège du Roy.* No date.
388 x 283 mm.
LeB.1; R. p. 29; St.1; H.1.
Watermark: Grape.
One line block; two tone blocks.

Based on the design of Abraham Bloemaert (cf. Plate 142).

Amsterdam, Berlin, Boston, Cambridge, Chicago, Dresden, London, Munich,
New York (MM), New York (NYPL), Nuremberg, Paris (BN),
Paris, (IN), *Vienna,* Warsaw.

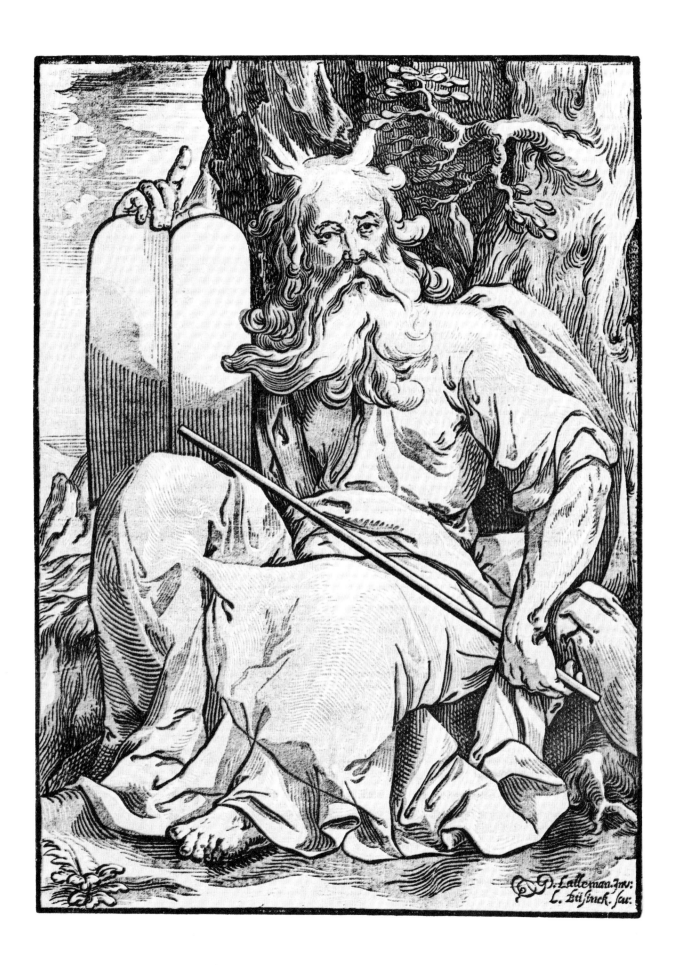

LUDOLPH BÜSINCK

76. Judith with the Head of Holofernes

Imprinted: *G. Lalle. in. L B sc.* No date.
208 x 138 mm.
LeB.2; St.2; H.2.
Watermark: Flask with Crescent.
One line block; two tone blocks.

The contours of the line block are broken to a minimal degree, while the tone block serves primarily as a colored background in this early chiaroscuro print by Büsinck.

Berlin, Boston (W. G. Russell Allen Collection), Dresden, Hamburg, London, *Northampton (Mass.),* Nuremberg, Paris (BN), Paris (IN), Paris (L), Rotterdam.

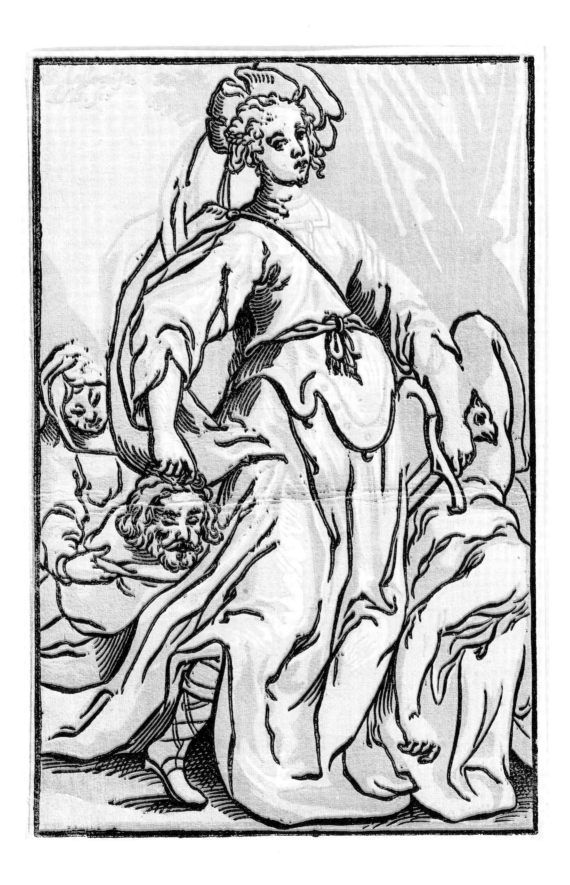

77. Christ, Salvator Mundi

Imprinted: *G. Lallemand inv. St. 14 à Paris chez Melchior Tavenier.* . . . No date.
238 x 160 mm.
LeB.5; St.5; H.5.
Watermark: Flash with Crescent; Grape.
One line block; two tone blocks.

The first of a series comprising Christ and the twelve Apostles. A date appears only on Plate 80.

The line blocks are interrupted more drastically in this series, particularly along the hairline, while the tone blocks take on greater importance.

Complete sets in: Amsterdam, Basel, Berlin, Dresden, Boston (W. G. Russell Allen Collection), Göttingen, London, Munich, *Nuremberg,* New York (MM), Paris (BN), Paris (L), Philadelphia, Vienna, Warsaw.

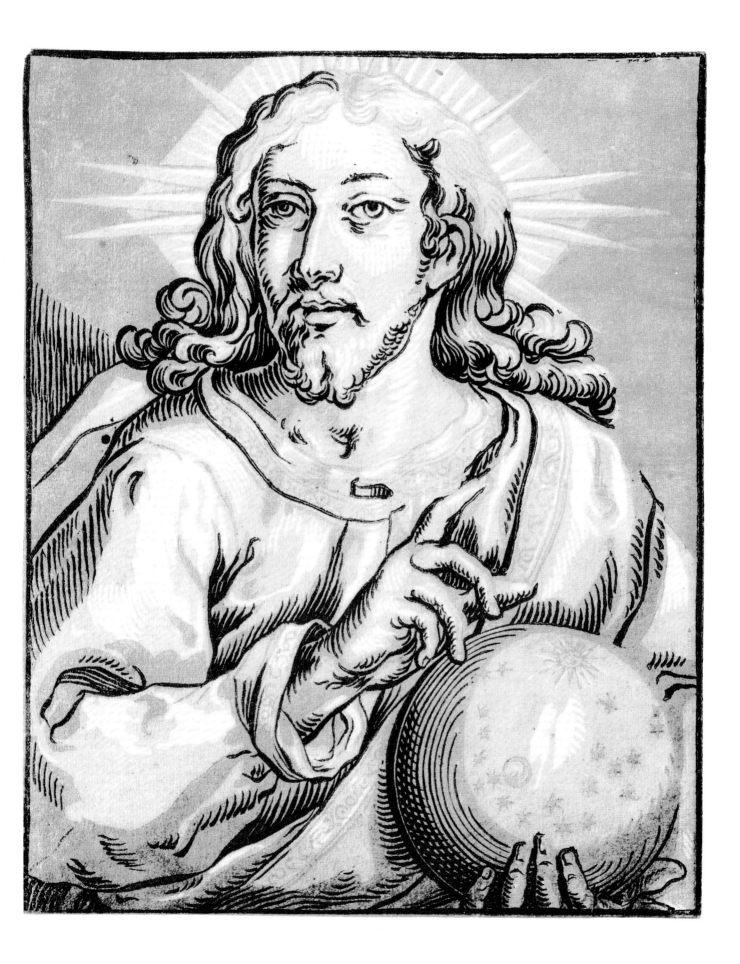

LUDOLPH BÜSINCK

78. St. Andrew

Without signature. No date.
210 x 160 mm.
LeB.6; St.6; H.6.
Printed from three blocks.

With his symbol, St. Andrew's Cross.

Locations: see Plate 77.

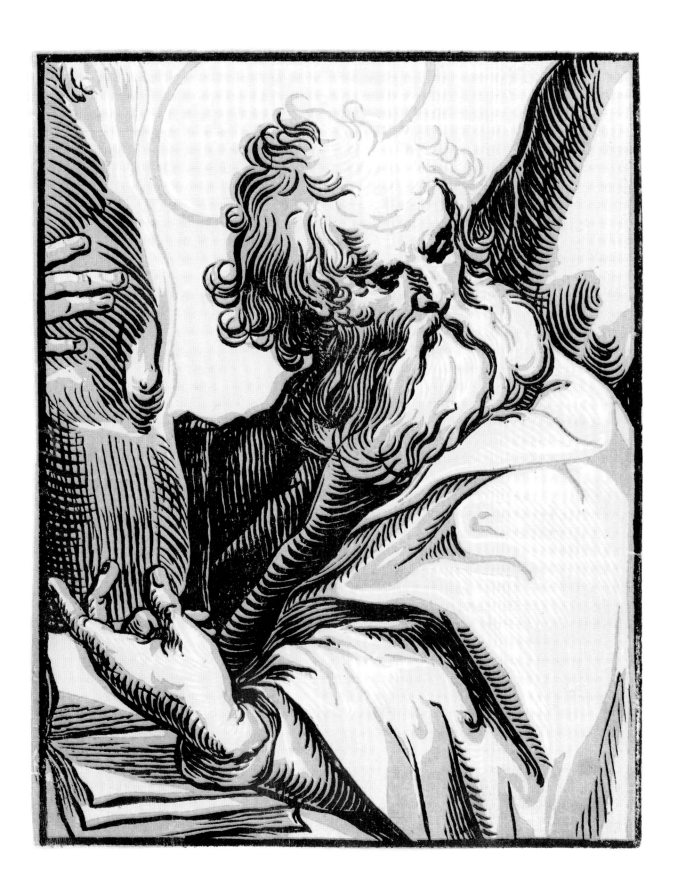

79. St. James the Greater

Without signature. No date.
210 x 160 mm.
LeB.7; St.7; H.7.
Printed from three blocks.

With pilgrim's staff and shell.

Locations: see Plate 77.

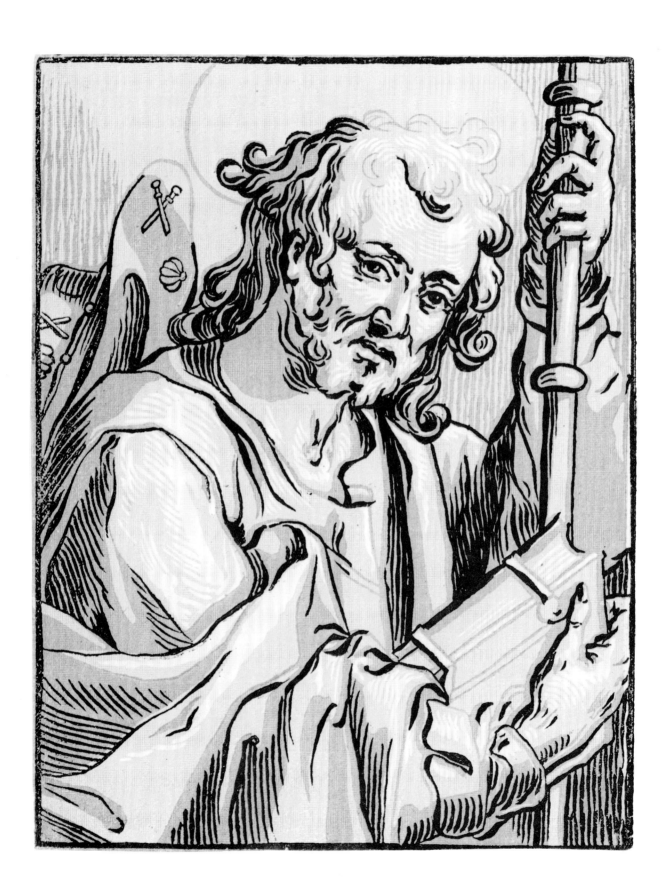

LUDOLPH BÜSINCK

80. St. James the Lesser

Imprinted: *Paris 1625, G. Lalleman in. L. Büsinck sc.* Dated 1625.
210 x 160 mm.
LeB.8; St.8; H.8.
Watermark: Grape.
Printed from three blocks.

With fuller's stake.

Locations: see Plate 77.

Wolfgang Stechow, "On Büsinck, Ligozzi, and an Ambiguous Allegory," *Essays in the History of Art Presented to Rudolf Wittkower,* London, 1967, p. 193, note 4.

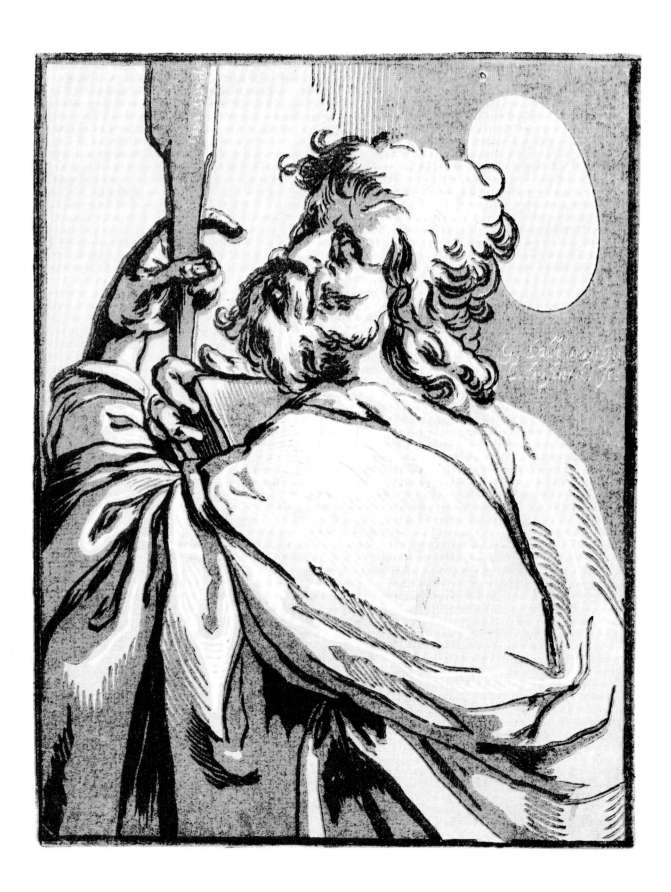

LUDOLPH BÜSINCK

81. St. John the Evangelist

Without signature. No date.
210 x 160 mm.
LeB.9; St.9; H.9.
Printed from three blocks.

With chalice.

Locations: see Plate 77.

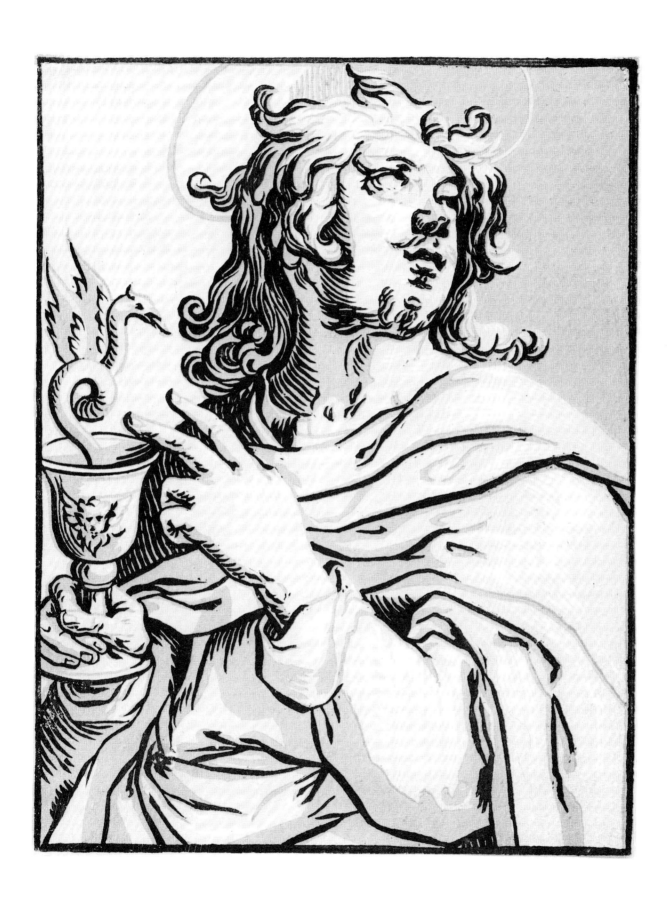

82. St. Jude Thaddaeus

Without signature. No date.
210 x 160 mm.
LeB.10; St.10; H.10.
Printed from three blocks.

With a club.

Locations: see Plate 77.

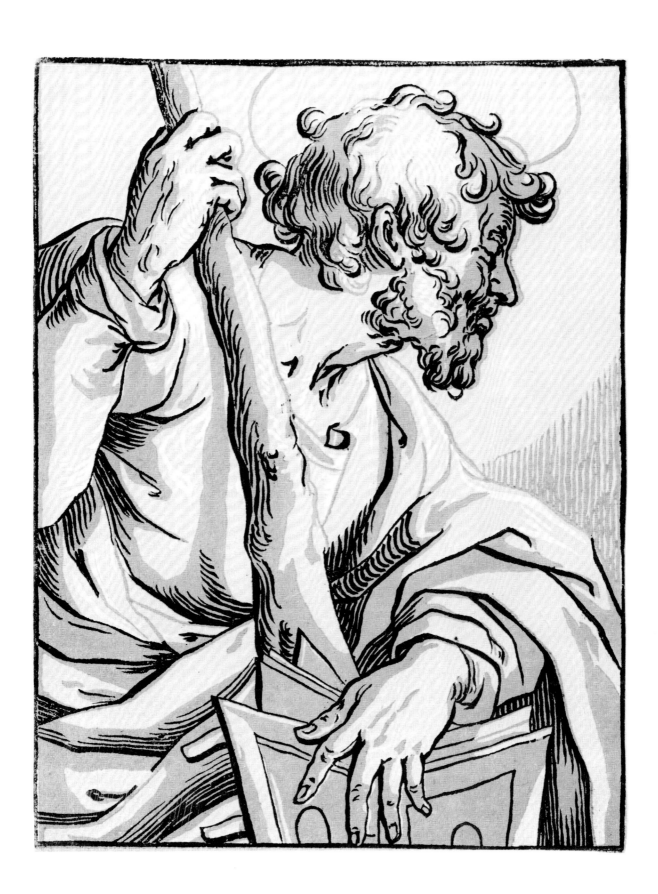

83. St. Matthew

Imprinted: *G. Lalleman in. Paris. L. Büsinck scu.* No date.
210 x 160 mm.
LeB.11; St.11; H.11.
Printed from three blocks.

With staff.

Berlin (gray with green). For other locations (usually sepia), see Plate 77.

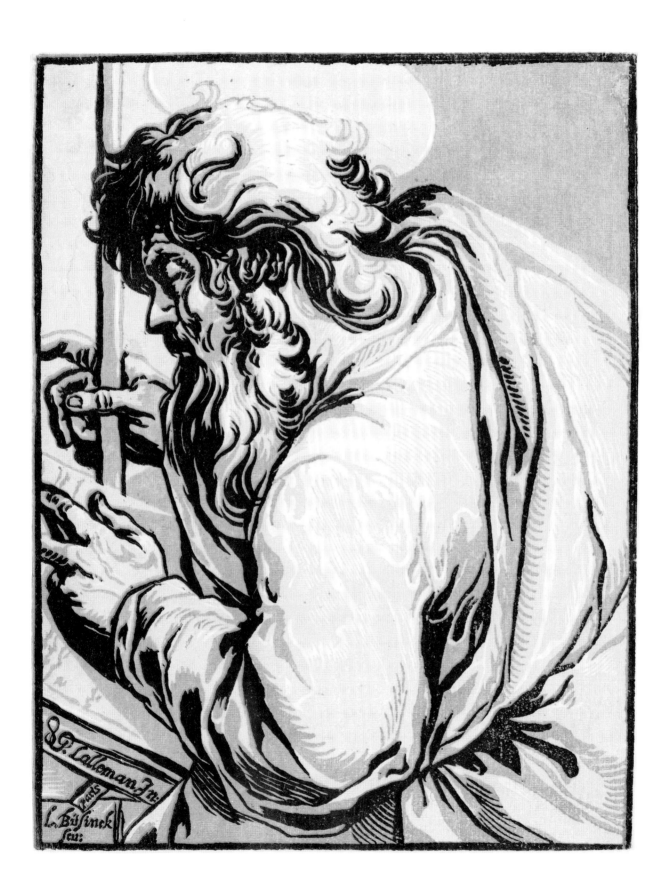

84. St. Matthias

Without signature. No date.
210 x 160 mm.
LeB.12; St.12; H.12.
Printed from three blocks.

With an axe, the instrument of his martyrdom.

Locations: see Plate 77.

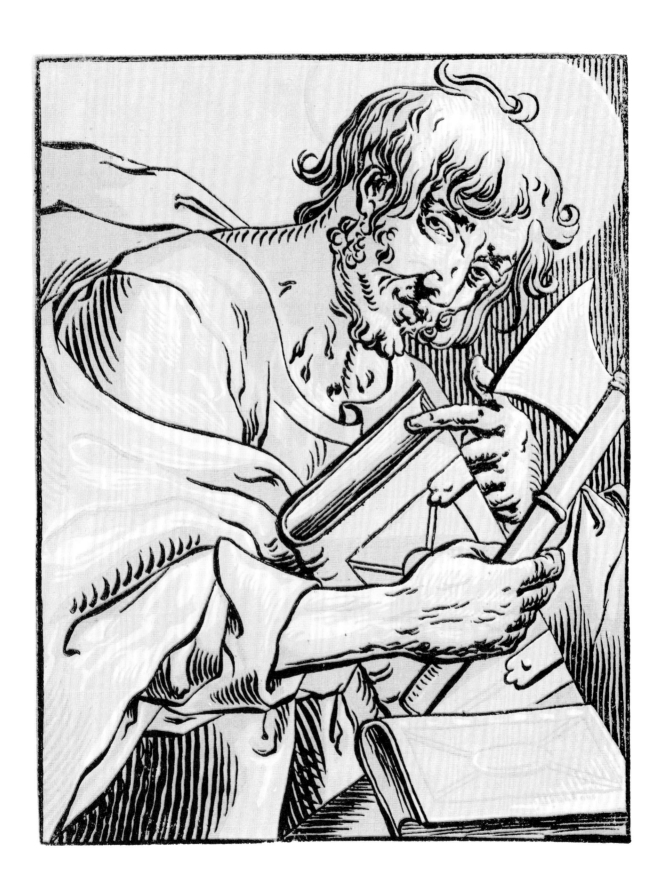

LUDOLPH BÜSINCK

85. St. Paul

Without signature. No date.
210 x 160 mm.
LeB.13; St.13; H.13.
Printed from three blocks.

With his emblem, a sword.

Locations: see Plate 77.

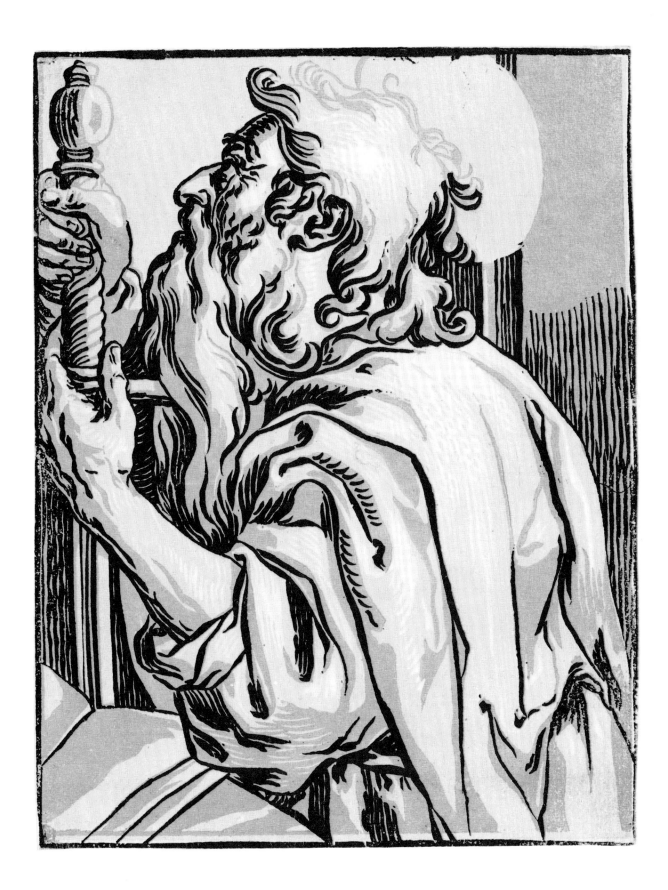

86. St. Peter

Without Büsinck's signature, but imprinted: *A Paris, chez Melchior Tavenier.* . . . No date.
210 x 160 mm.
LeB.14; St.14; H.14.
Printed from three blocks.

With his keys.

Locations: see Plate 77.

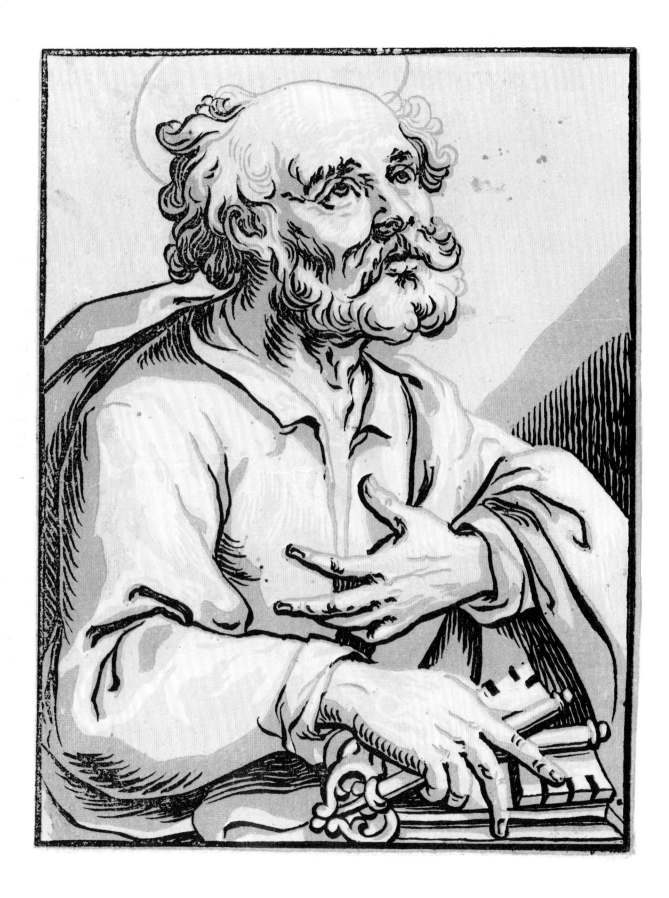

LUDOLPH BÜSINCK

87. St. Philip

Without signature. No date.
210 x 160 mm.
LeB.15; St.15; H.15.
Printed from three blocks.

With his staff and a little flag near the top.

Locations: see Plate 77.

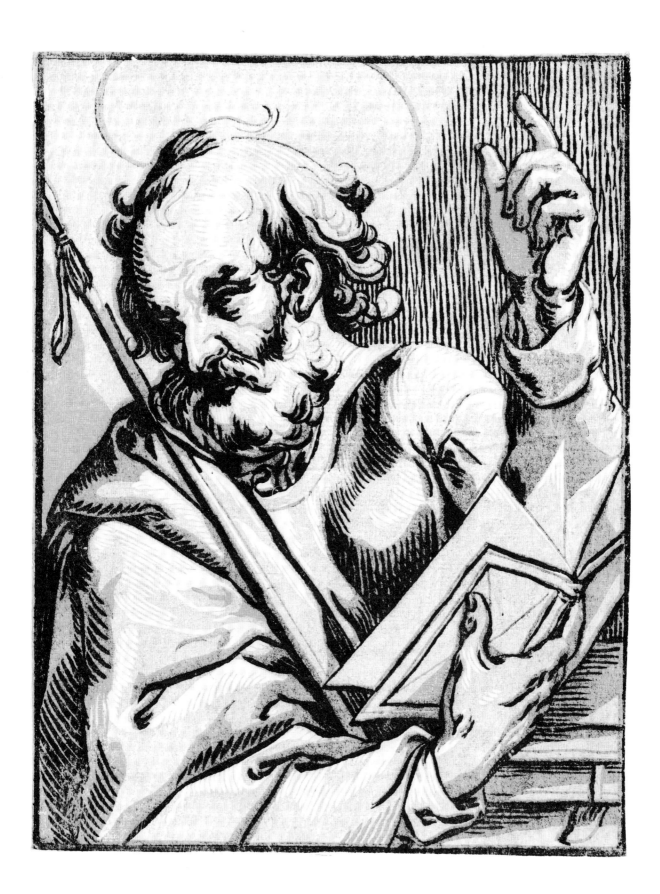

LUDOLPH BÜSINCK

88. St. Simon

Without signature. No date.
210 x 160 mm.
LeB.16; St.16; H.16.
One line block; two tone blocks.

The saint is pictured with his symbol, a saw, the instrument of his martyrdom.

Locations: see Plate 77.

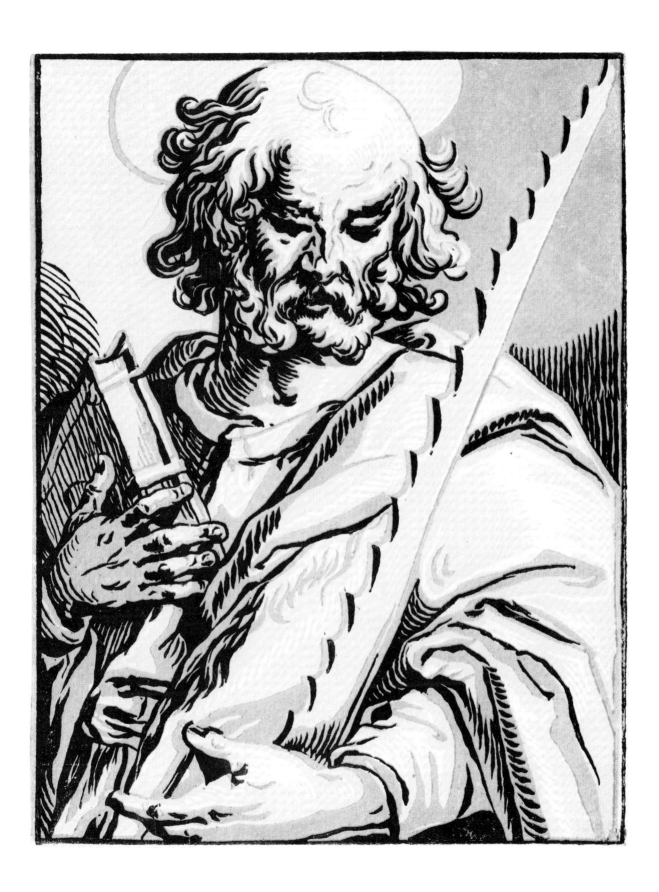

89. St. Thomas

Without signature. No date.
210 x 160 mm.
LeB.17; St.17; H.17.
Printed from three blocks.

With his symbol, a square.

Locations: see Plate 77.

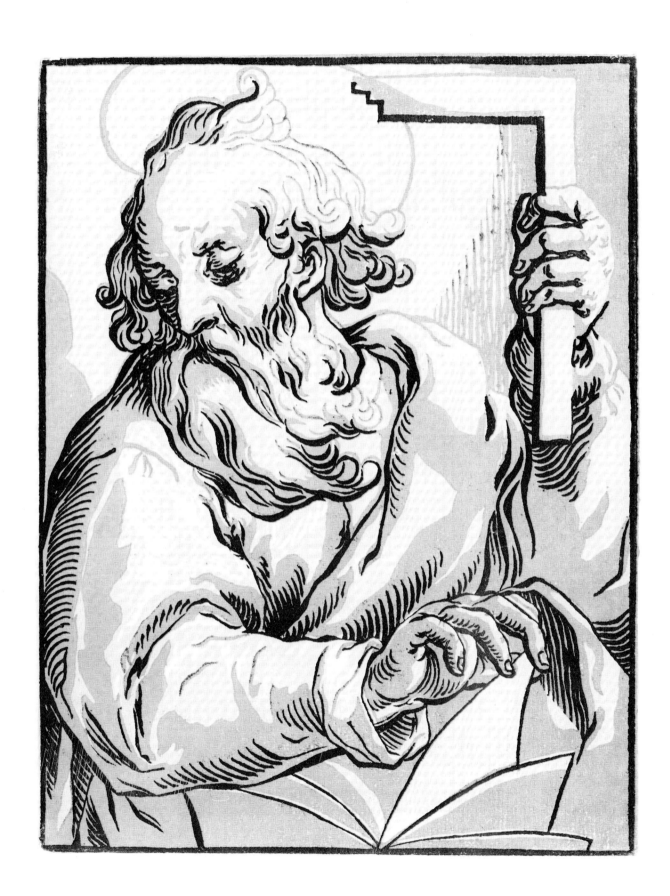

90. St. James the Greater

Imprinted: *Lallemand inv. L. Büsinck scu.* No date.
115 x 102 mm.
St.18; H.18.
One line block; two tone blocks (olive and brown).

Vienna (unique).

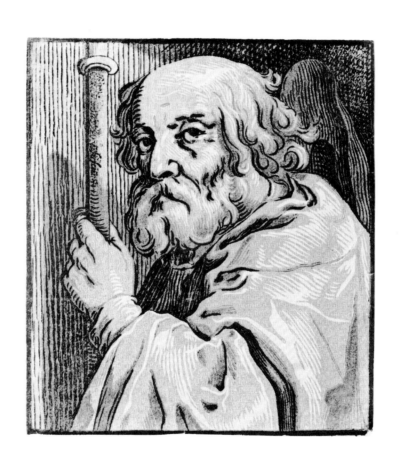

LUDOLPH BÜSINCK

91. St. Peter, Repentant

Imprinted: *G. Lallemand inv. L. Büsinck sc.* No date.
210 x 182 mm.
St.19; H.19.
One line block; two tone blocks.
Watermark: Flask with Crescent.

Berlin, Boston (W. G. Russell Allen Collection), Cambridge, Coburg,
Dresden, Göttingen, London, Paris (BN), Vienna.

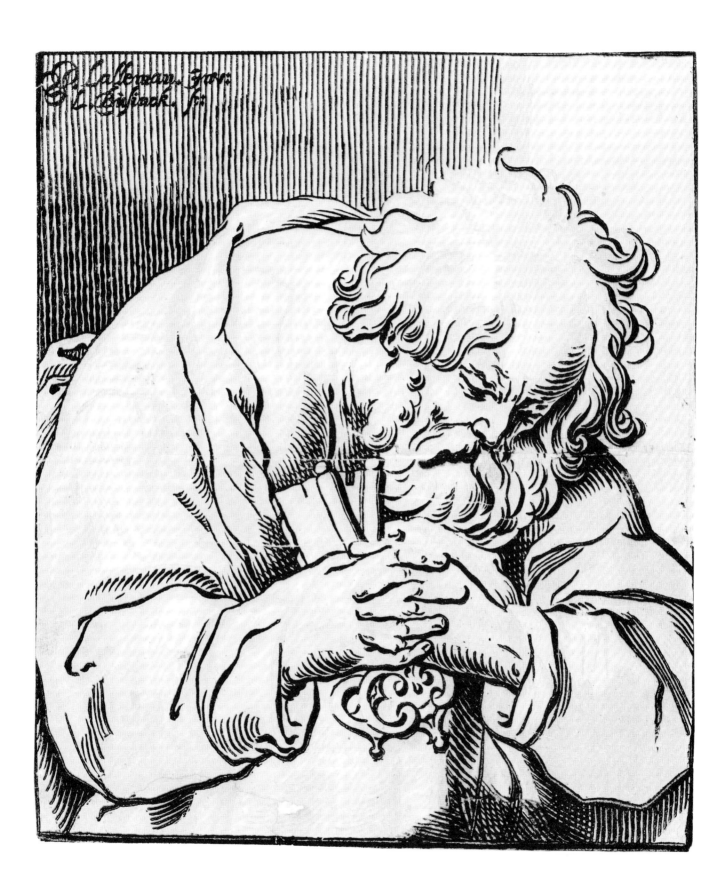

LUDOLPH BÜSINCK

92. St. Mark and St. Luke

Imprinted: *A Paris chez Melchior Tavenier*. . . . No date.
255 x 323 mm.
H.20; St.20.
One line block; two tone blocks.

Amsterdam, *Berlin,* Boston (W. G. Russell Allen Collection), Coburg, Dresden, Hamburg, London, New York (MM), Paris (BN), Paris (L), Paris (IN), Vienna, Warsaw.

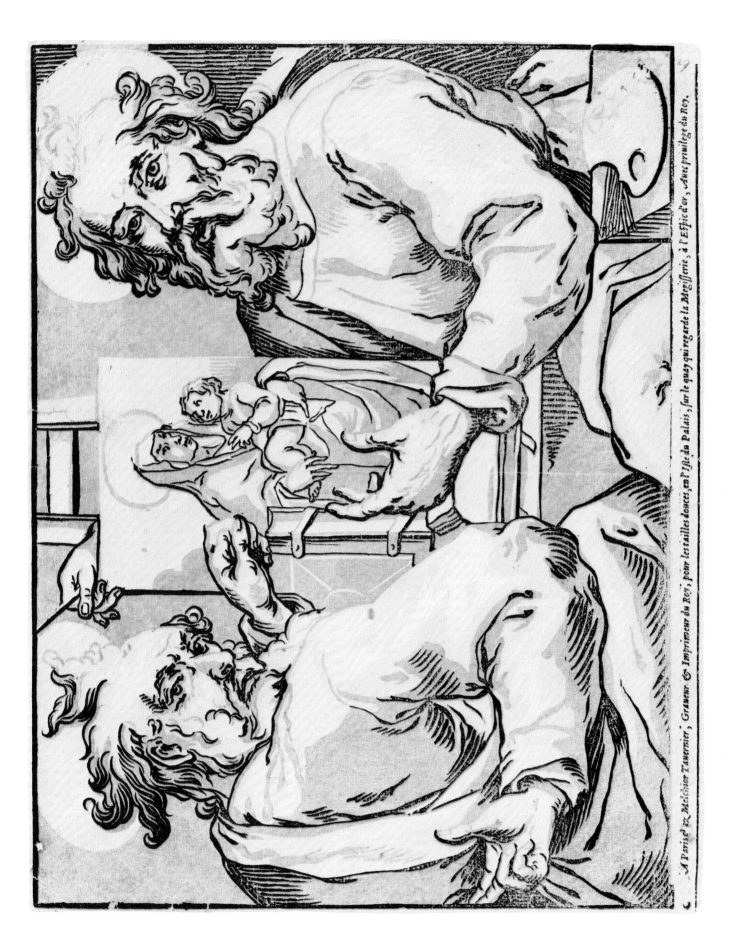

A Paris de Melchior Tavernier, Graveur & Imprimeur du Roy, pour les tailles douces, en l'Isle du Palais, sur le quay qui regarde la Megisserie, à l'Espic d'or, Avec privilege du Roy.

LUDOLPH BÜSINCK

93. St. Matthew and St. John

Imprinted: *G. Lalleman in. Büsinck sc. à Paris chez Tavenier.* . . . No date.
245 x 320 mm.
H.21; St.21.
One line block; two tone blocks.

Amsterdam, *Berlin,* Boston (W. G. Russell Allen Collection), Coburg, Dresden,
London, New York (MM), Paris (BN), Paris (IN), Stuttgart, Vienna.

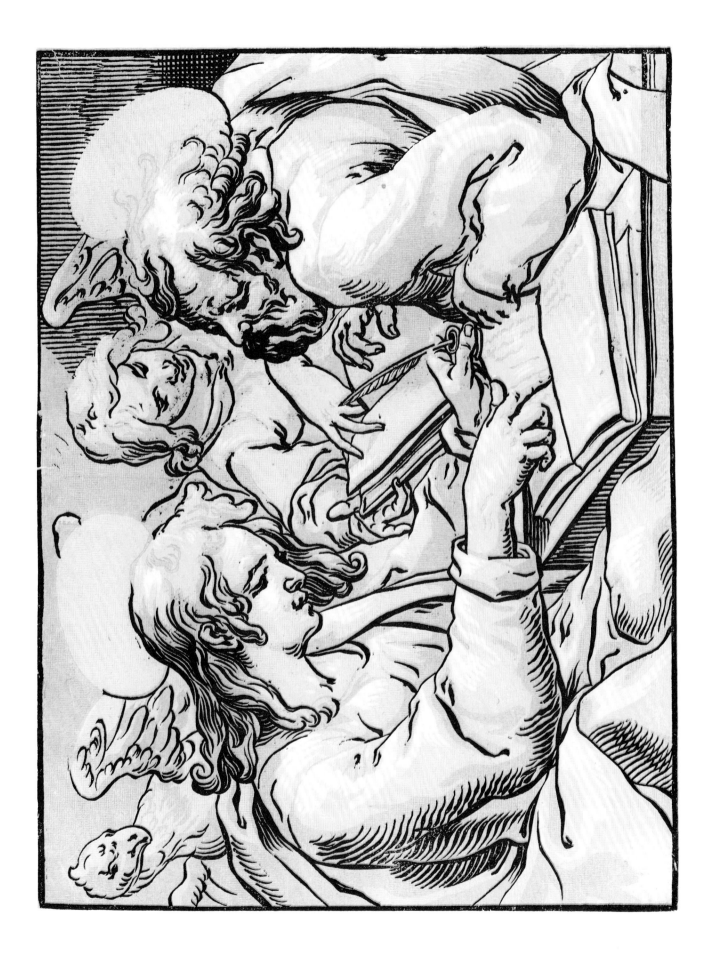

94. Aeneas Saving His Father from Troy

Imprinted: *G. Lallemand in. L. Büsinck fe.* No date.
344 x 214 mm.
LeB.20; St.22; H.22.
One line block; one tone block.

This is the only one of Büsinck's chiaroscuro prints from two instead of three blocks. According to W. Stechow, this print is perhaps later than "The Flute Player" (Plate 95). Ugo da Carpi had issued a chiaroscuro print of this same subject, based on Raphael, early in the sixteenth century (B. vol. 12, 104.13).

Amsterdam, Basel, Berlin, Boston (W. G. Russell Allen Collection), Bremen, Cambridge, Coburg, Cologne, Dresden, Hamburg, London, *New York* (MM),[1] Nuremberg, Paris (BN), Paris (L), Philadelphia, Rotterdam, Stuttgart, Vienna.

[1] Gift of Paul J. Sachs, 1922.

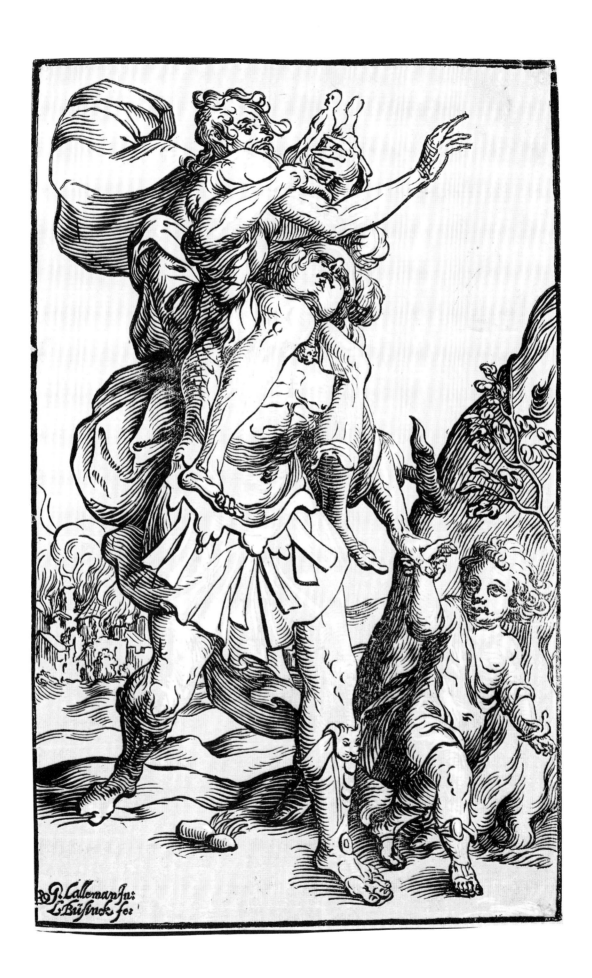

LUDOLPH BÜSINCK

95. The Flute Player

Imprinted: *G. Lalleman inven. L. Büsinck scul. à Paris chez Melchior Tavenier.* . . .
No date.
278 x 210 mm.
LeB.24; St.23; H.23.
One line block; two tone blocks.

According to Stechow, this print betrays a more modern stylistic element of the north, akin to the drawings of G. Hondthorst and his circle.

Amsterdam, Basel, Berlin, Boston (W. G. Russell Allen Collection), Brussels, Cambridge, Cologne, Dresden, London, Munich, New York (MM), Paris (BN), Paris (IN), Paris (L), Philadelphia, Rotterdam, Stuttgart, Vienna.

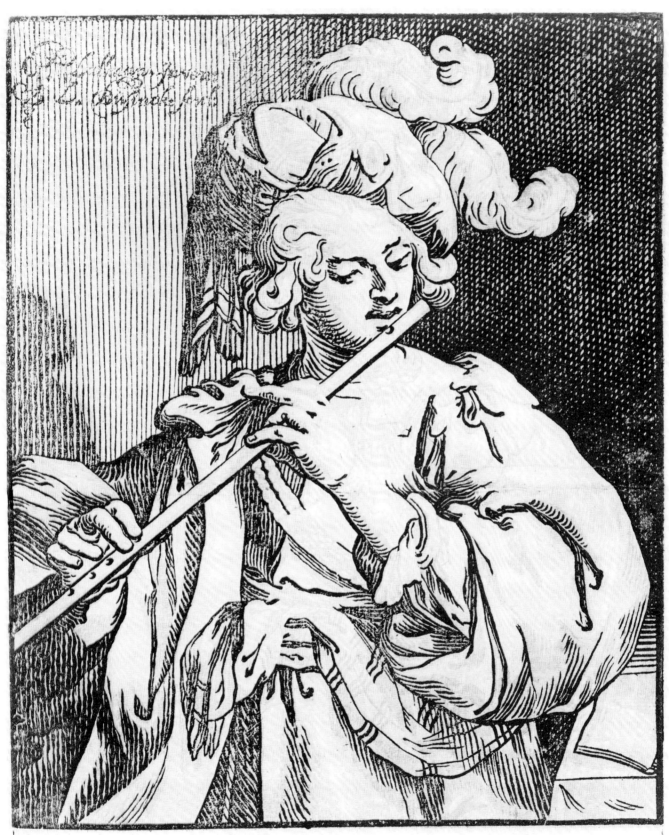

A Paris chez Melchior Tauernier, graueur & Imprimeur du Roy, pour les tailles douces, en l'isle du Palais, sur le quay qui regarde la Megisserie, à l'Espic d'or Auec priuilege du Roy

96. The Procuress

Imprinted: *L. B. fe. G. Lallemand in.* No date.
218 x 338 mm.
LeB.22; St.24; H.24.
One line block; two tone blocks (brown/sepia or shades of gray).

I. Without the name of the artist.
II. With his imprint in the lower right hand corner. Watermark: Grape.

Wolfgang Stechow discovered that the figure of the old woman in this print corresponds to one in an album of engravings by Crispin van der Passe, entitled *Minicarum aliquot facutiarum Icones* and published about 1612. This album is based on a series of drawings attributed to the Lorrainian artist Jacques Bellange, depicting scenes from the life of strolling Italian actors.

Amsterdam, Basel, Berlin, Boston (W. G. Russell Allen Collection), Coburg, Dresden, London, Munich, New York (MM), New York (NYPL), Paris (BN), Paris (IN), Paris (L), Philadelphia, Rotterdam, Vienna, Warsaw.

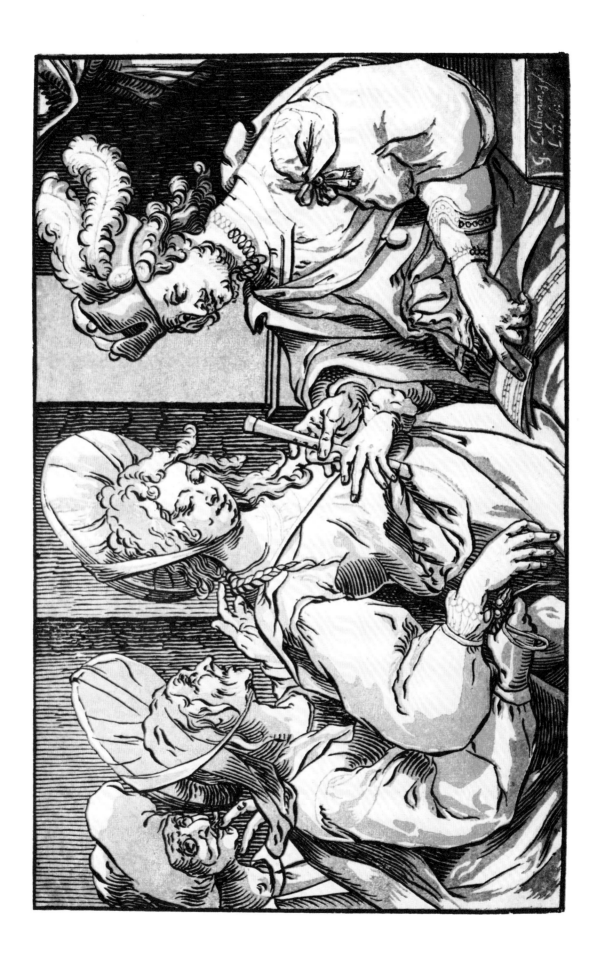

LUDOLPH BÜSINCK

97. Virtue Conquered by Vice

Imprinted: *Illustrissimo Principi ac Domino, Domino Wilhelmo Landgravio Hassiae Cassell. Jacobus Ligotius Veronensis inven. 1565, de nove tagliato in legne oper Ludolf Büsinck Mündensem Anno 1646.*
470 x 328 mm.
One line block; two tone blocks (shades of brown).

The last of Büsinck's prints and the only one signed with his full name. It is based on the chiaroscuro print by Andrea Andreani dated 1585 (one line block; three tone blocks), which in turn is based on a painting (or drawing?) by Jacopo Ligozzi dated 1565. Virtue is being attacked by the five vices: Amore, Errore, Ignoranza, Opinione, and Volgarita(?), whose initials AEIOU correspond to the five vowels of the alphabet. This symbolic use was not uncommon and had become especially fa-mous on account of the motto of Emperor Frederick III *(All Erd ist Oesterreich unter-tänig).*[1]

It may not be entirely coincidental that this print appeared in 1646 after a long hiatus. In this same year, a certain Moses Goldschmidt (alias Wilhelm Friedstadt from Frankfurt) was appointed instructor of drawing to the court at Münden. In 1647 Büsinck's artistic activities ceased altogether.[2]

Kassel (unique).

[1] Stechow, 1967, p. 193.
[2] Rudolf Hallo, *Das Kupferstichkabinett und die Bücherei der staatlichen Kunstsammlungen zu Kassel,* Kassel, 1931, p. 11.

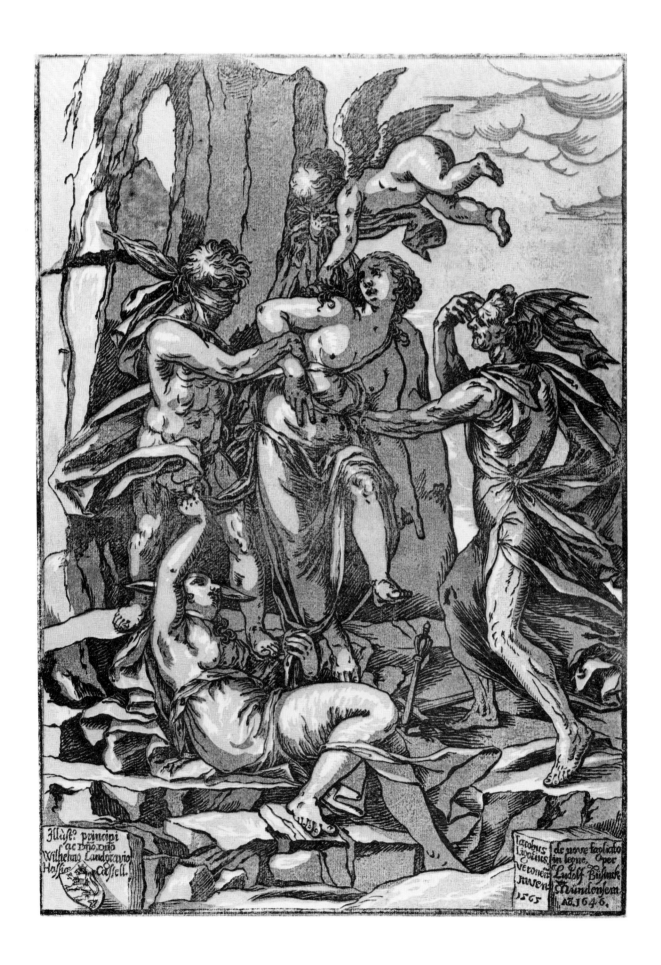

98. The Virgin with a Halo

Without monogram. No date.
225 x 182 mm.
One line block; two tone blocks.
Watermark: I S beneath a Crown.

According to Stechow,[1] "too slipshod and doughlike" to be attributed to Büsinck.

The impression at Berlin bears an annotation in ink: *Simon p./ S. de la Haye.*

Berlin (No. 591-54; attributed to Büsinck).

98A. Young Woman Sewing Near a Fireplace*

Inscribed: *L. Büsinck inven. E. Ecqman sculpt.* No date.
285 x 224 mm.
Chiaroscuro.

According to Stechow,[2] formerly at Basel and so listed in Renouvier, *Des Types et des Manières des Maîtres Graveurs des 16 et 17 siècles,* 2ème partie, Montpelier, 1856, p. 91.

[1] *Print Collector's Quarterly,* 1939, vol. 26, p. 357.
[2] *Ibid.,* p. 359.

*Not illustrated.

JOHANN KEYLL [Keil]

Active at Nuremberg during the second half of the seventeenth century.

99. St. Jerome

Imprinted: *Joh. Keyll fecit.* No date.
213 x 140 mm.
LeB.1; A.2; Thieme-Becker, XX, p. 70.
One line block; one tone block.

London, Rotterdam.

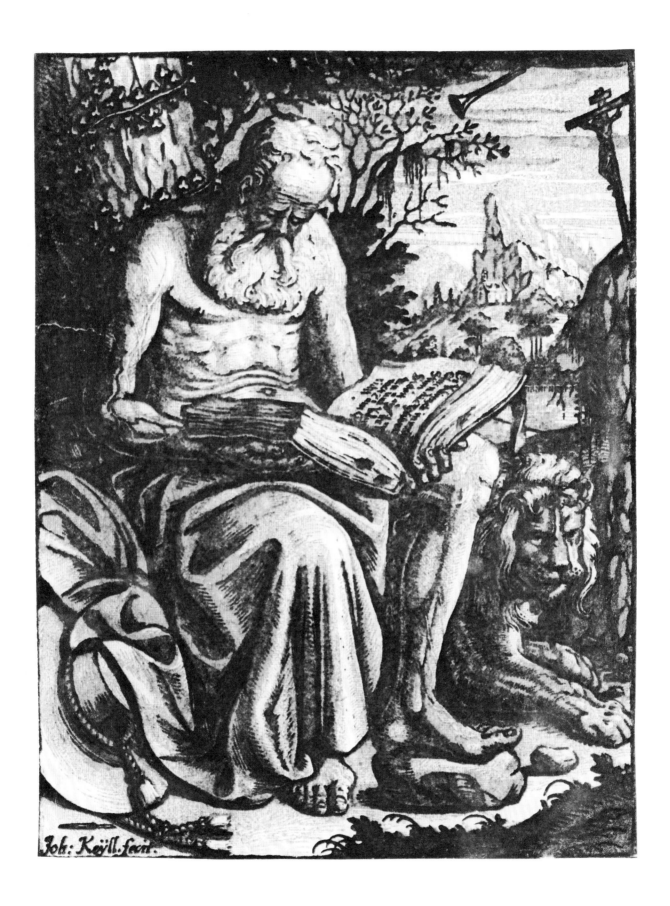

Joh: Keyll. fecit.

JOHANN KEYLL [Keil]

99A. Chronos or Saturn

Imprinted: *J. Keyll, 1672, 5. Feb*. Dated 1672.
64 x 92 mm.
Thieme-Becker, XX, p. 70.
One line block; two tone blocks.

Dresden.

NETHERLANDISH
ARTISTS

CORNELIS ANTHONISZOON [Cornelius Teunissen; Master C. T.]

1507-1553. Active at Amsterdam as a map-maker, portraitist, and satirist.
According to Heller,[1] he was thought to be a son of Anton of Worms.
His satirical prints are akin to those of Peter Flötner. The emblem between his initials
represents St. Anthony's cross and bell. Curiously, his name is not mentioned
in Carel van Mander's *Schilderboeck* (Haarlem, 1604).[2]

100. The Last Supper

With monogram. No date.
335 x 552 mm.
B. IX, p. 152; P. III, p. 30; Wu. I, p. 23, No. 2; Nagler, *Küstler Lexicon,* II, p. 725.

 I. Line block only.
 II. One line block, one tone block.

This print, probably the earliest chiaroscuro print produced in the Netherlands, corresponds in several respects to Dürer's woodcut of the same subject, dated 1523 (B.53). Although all twelve disciples are pictured in this instance, Anthoniszoon seems to be equally aware of Luther's support of the laymen's claim to partake of both the host and the chalice. This matter had been the subject of an extensive controversy when Dürer issued his print.[3]

 I. Rotterdam, New York (NYPL).
 II. Amsterdam, *Berlin,* Paris (BN), Vienna.

[1] Joseph Heller, "Berichtigungen und Zusätze," *Lexicon für Kupferstichsammler,* Bamberg, 1838, p. 11.
[2] F. J. Dubiez, *Cornelis Anthoniszoon, zijn Leven en Werken,* Amsterdam, 1968.
[3] Erwin Panofsky, *Albrecht Dürer,* vol. 1, Princeton, 1943, pp. 222-23.

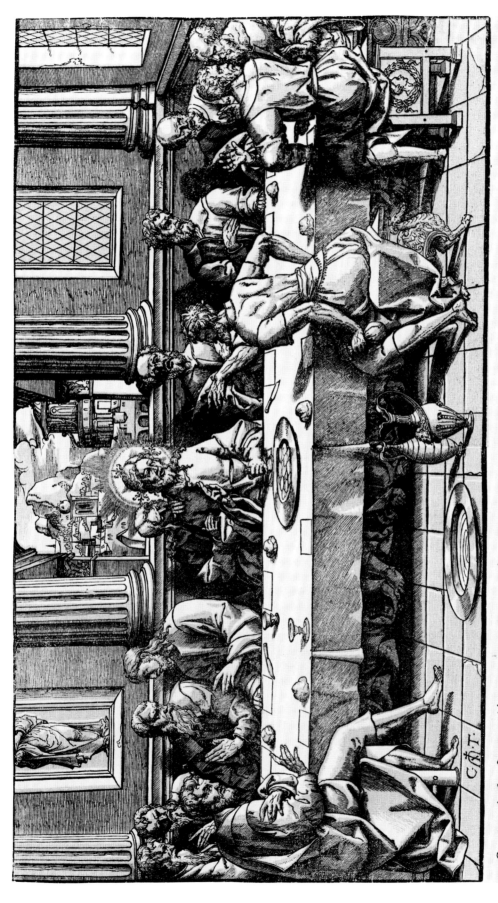

Quisquis ades sacræ spectator candide mensæ
Respice quid referat ista tabella tibi
Scena salutaris graphice sic sculpta videtur
Arte Viri clari Cornely Antony

Hic seruatorem Videas mitissimum Iesum
Fortis amicitiæ mutemosynori
Vltima dum celebrat lætus conuiuia nobis
Corporis hic epulum et sanguinis instituit

Fœlix qui hoc oculis dum externis afpicit intus
Internis oculis, quod indicatur, habet
Dat tibi se Christus suum, tu fratris Vt ipsa
Esse queas, nqua ne te otia artificiant

Impendit tibi se totum, tu proximo adesto
Qua tu cunq queas, Viribus, Ingenio,
Nil frustra facies, cum fœnore cuncta rependet
Hoc vbi depositum est corporis & animum.

FRANS FLORIS VAN VRIENDT

Antwerp, circa 1518-1570, Antwerp. Student of Lambert Lombard at Liège
from 1538 to 1540. In Italy during the years 1541-1547. Subsequently at Antwerp.

101. David Playing the Harp before Saul

Inscribed: *Franciscus Floris inventor, Judoce de Curia excudebat 1555*. Dated 1555.
330 x 485 mm.
H.1; IN.191-92.
One line block; three tone blocks (shades of gray or brown/sepia/orange).
Watermark: Crowned Two-headed Eagle.

Judoce de Curia may be identical with Joos Gietleughen of Courtrai (cf. Plate 113).

Amsterdam, Boston (W. G. Russell Allen Collection), Dresden, Leyden,
Paris (BN), Paris (L), Vienna.

Thieme-Becker, XII, pp. 123-25.
Dora Zuntz, *Frans Floris,* Strassburg, 1929.

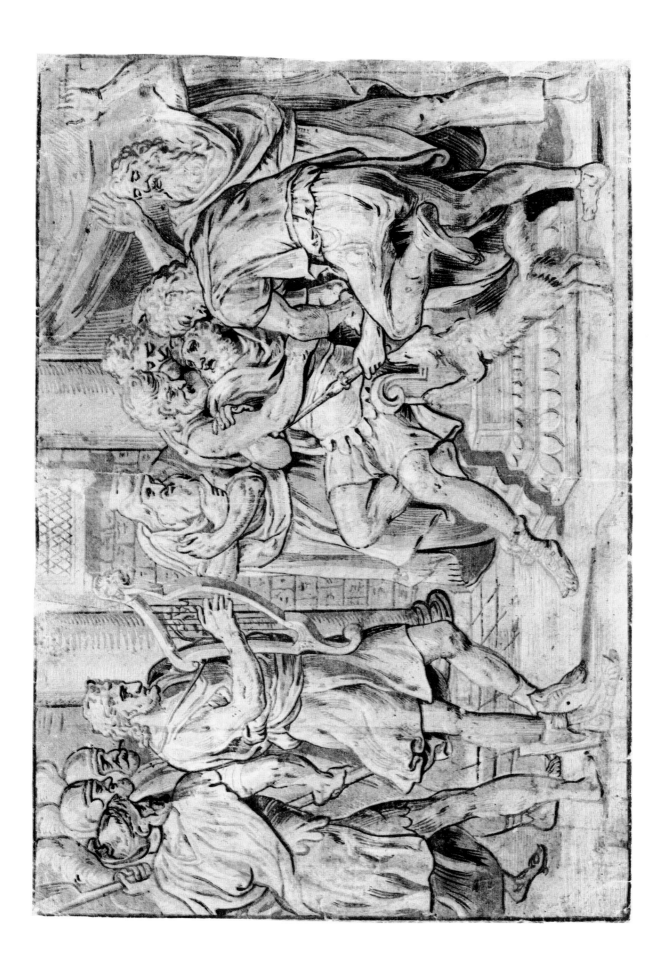

102. Christ Washing the Feet of St. Peter

Imprinted: *F. Floris in.* No date.
310 x 510 mm.
Nagler, *Künstler Lexicon,* IV, p. 384; Wu.2; Thieme-Becker, XII, p. 125; H.2.

I. Line only.
II. One etched plate; one tone block. (Not previously described.)

The signature appears near the bottom and is often trimmed off. The author's attention was called to this unique chiaroscuro impression by Dr. Dieter Kuhrmann of the Staatliche Graphische Sammlung in Munich. His contribution is gratefully acknowledged.

I. Illustrated by Hollstein.
II. *Munich* (top and bottom trimmed; tone block: greenish gray).

102A. Galloping Rider*

Without monogram. No date.
Large folio.
Thieme-Becker, XII, p. 125; H.3.

Formerly at Berlin.

*Not illustrated.

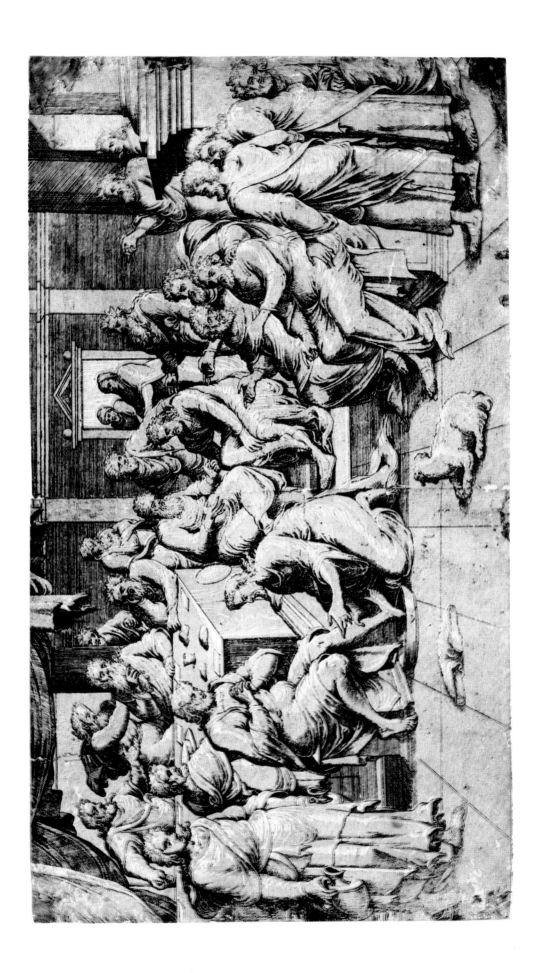

102B. Martyrdom of Hannah and Her Seven Sons

Without monogram. No date.
315 x 418 mm.
Not previously described.
One line block; two tone blocks (brown and green).

The scene is the martyrdom of Hannah and her seven sons, as described in chapter seven of II Maccabees, and is the main subject of this book. The event probably occurred during the religious persecutions of the years 167-166 B.C. under Antiochus IV Epiphanus. Voicing refusal to partake of swine meat, shown being proffered on a plate in the background, the spokesman for the sons is about to have his tongue cut out on the right. In the foreground, "when he [the son] had been reduced to a completely useless hulk, he [the King] ordered them to bring him, while still breathing, to the fire and to fry him in a pan."[1] Books I and II of Maccabees were declared canonical by the Council of Trent in 1546 and were incorporated in the Vulgate. The martyrs were venerated, according to the Roman Catholic Calendar, on August 1.[2] The attribution to Floris must remain tentative. The technique is also not unlike that found in the "Judgment of Solomon" (Plate 117) by Adriaen Thomasz Key, particularly the ruler-straight lines of the pedestral. The absence of accessories, such as the dogs favored by Floris, is noteworthy in this regard.

Vienna.

[1] Solomon Zeitlin, ed., *"The Second Book of the Maccabees,"* New York, 1954, p. 161.

[2] I am indebted to Miss Maria Naylor for suggesting Maccabees as the possible source of this subject.

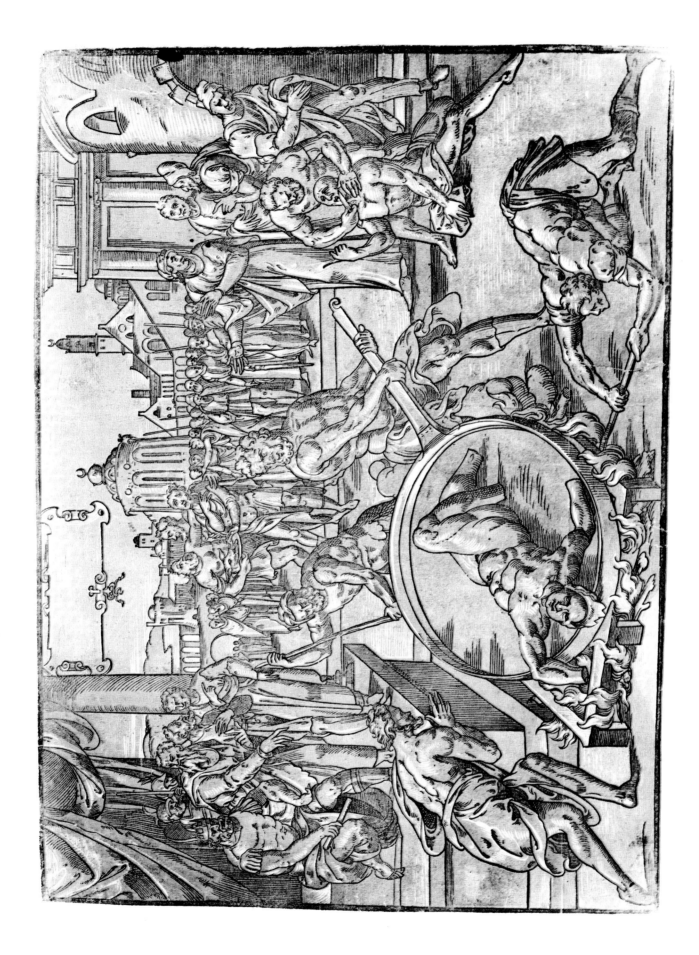

CRISPIN VAN DEN BROECK

Mechelen, 1524-1591, Antwerp. Sometimes called Paludanus, Crispin van den Broeck moved from Mechelen (Malines) to Antwerp in 1558. He became a citizen of Antwerp in 1559. At the same time he rented a house from Hubert Goltzius (cf. Plate 113). He is known to have studied with Frans Floris van Vriendt. During 1566 he traveled in Italy.

103. Annunciation

With monogram in the tone block (very faint). 1571.
235 x 233 mm.
LeB.38; H.37.
One etched plate; one tone block.

First of a series of six subjects from the life of Christ. Preliminary drawing in Paris (Louvre; Inv. 21240). The round frame and the size are reminiscent of the series of nine subjects from the Passion of Christ by Lucas van Leyden (B.57-B.65), executed in 1509.

Antwerp.

P. III, p. 124.
Thieme-Becker, v, p. 44.
A. von Wurzbach, *Niederländisches Künstler Lexikon,* Leipzig-Vienna, 1906-11.
A. J. J. Delen, *Histoire de la Gravure des Pays Bas et dans les Provinces Belges,* Paris, 1934-35.
Max Rooses, "Notes sur Crespin van den Broeck," *Journal des Beaux Arts et de la Littérature,* vol. 20, 1878.

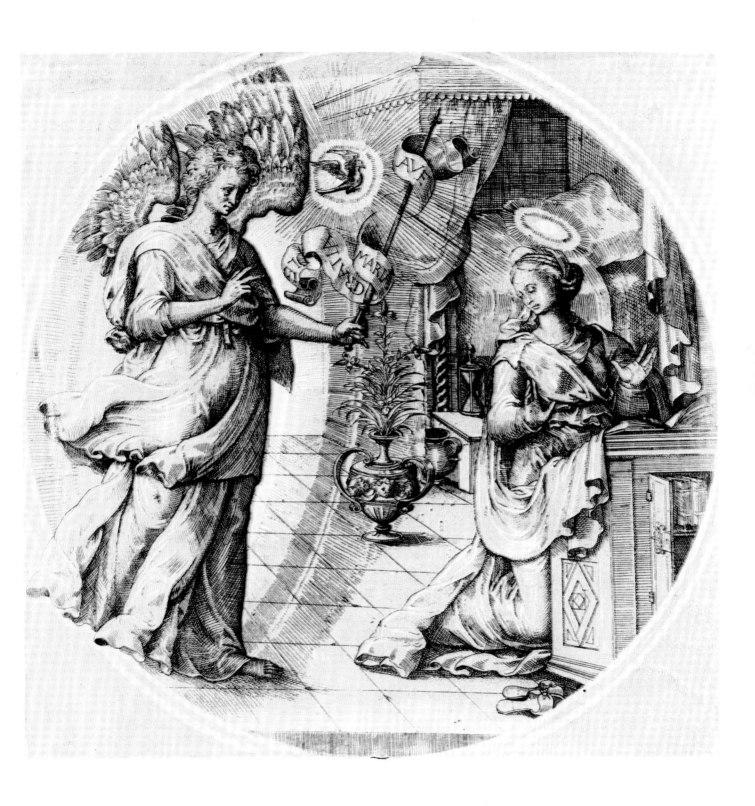

104. Visitation

With monogram (in the tone block). About 1571.
235 x 235 mm.
LeB.39; Wu.5; H.38.
One etched plate; one tone block.

Amsterdam, Boston (W. G. Russell Allen Collection), Munich, *Rotterdam,* Vienna.

Cf. Plate 103.

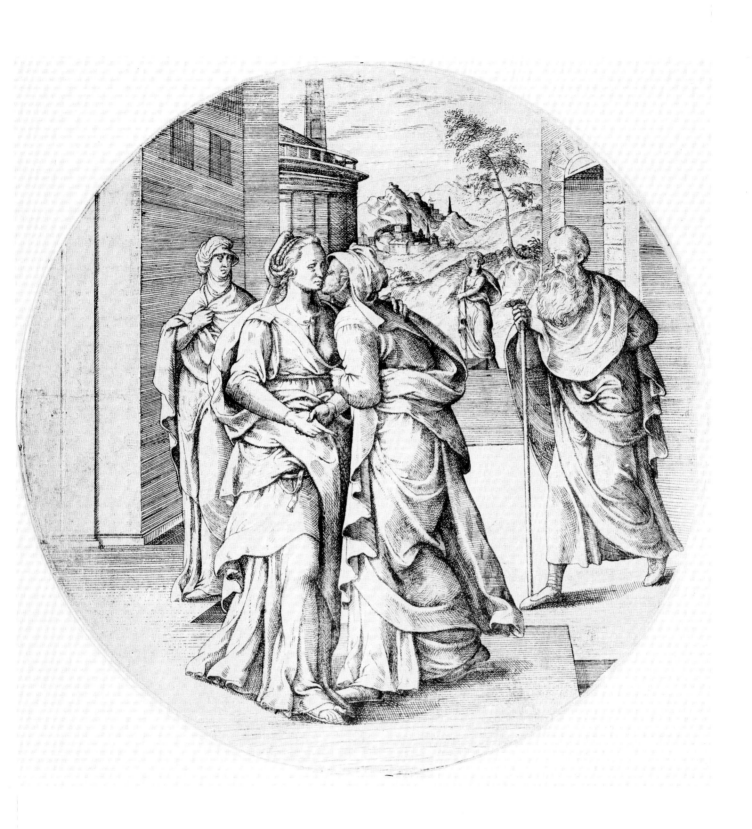

105. Adoration of the Shepherds

With monogram (in the tone block). Dated 1571.
235 x 233 mm.
LeB.38-41; H.39.
One etched plate; one tone block.

Amsterdam.

Cf. Plate 103.

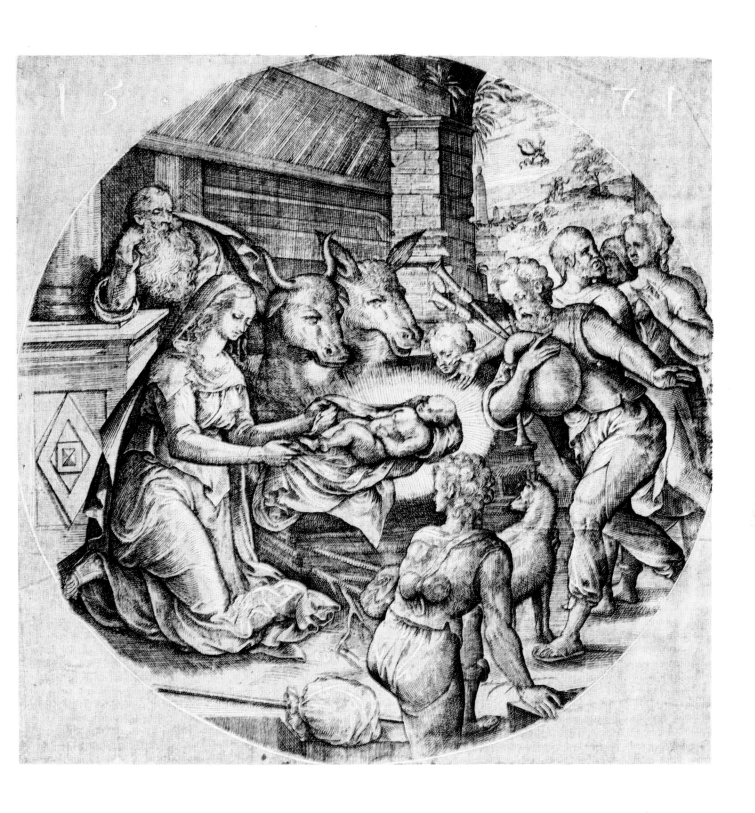

CRISPIN VAN DEN BROECK

106. Adoration of the Magi

With monogram (in the line block). About 1571.
235 x 233 mm.
LeB.38-41; H.40.
One etched plate; one tone block.

Antwerp.

Cf. Plate 103.

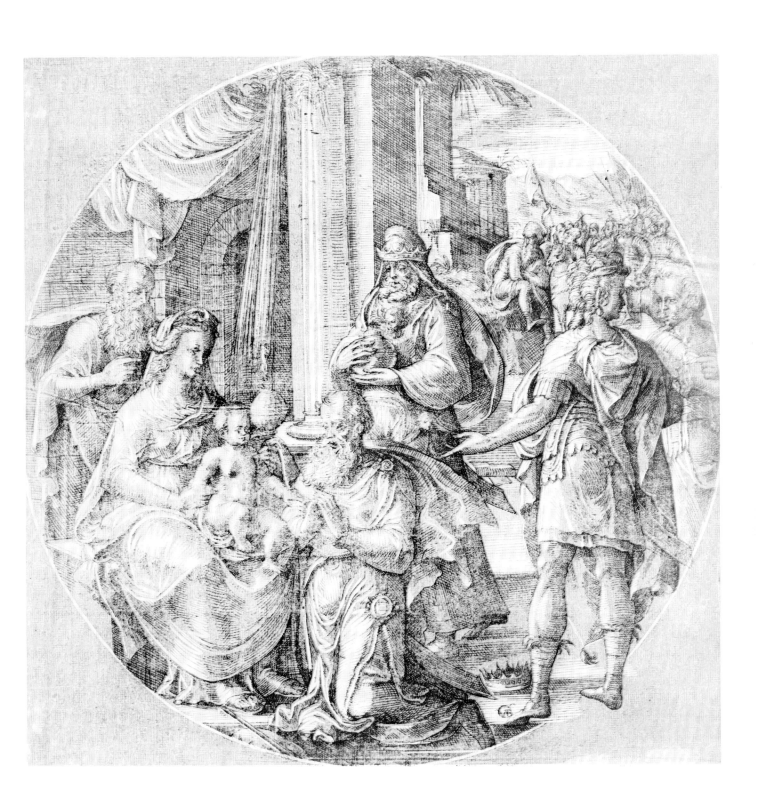

107. Circumcision of Christ

With monogram (in the line block). 1571.
235 x 233 mm.
LeB.38-41; H.41; Wu.I, p. 187, No. 9.
One etched plate; one tone block (sepia or slate gray).

Amsterdam, *Boston* (W. G. Russell Allen Collection), Dresden, London.

Cf. Plate 103.

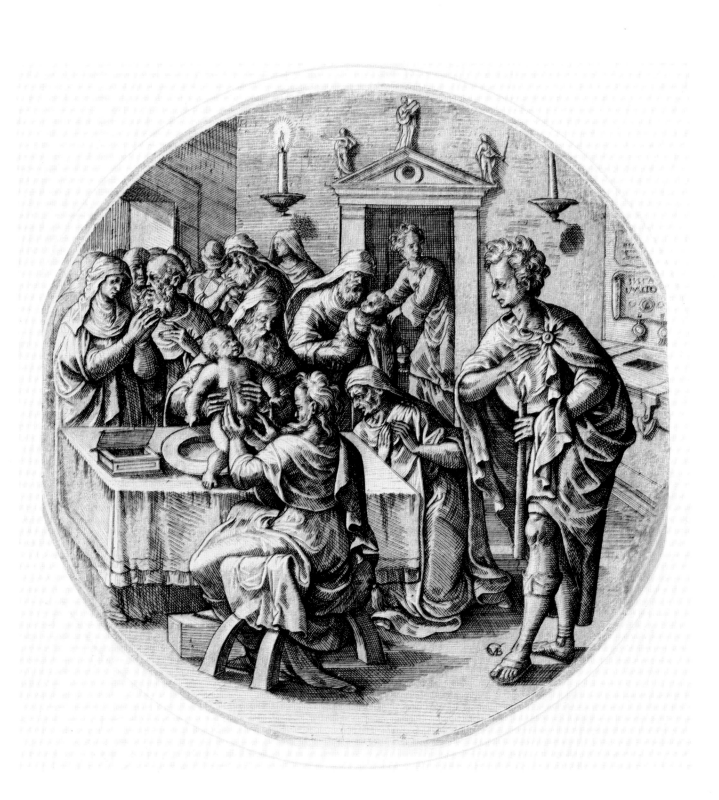

108. Agony in the Garden

With monogram (in the line block). 1571.
235 x 233 mm.
LeB.38-41; H.42.
One etched plate; one tone block (sepia).

Portions of this print are based on works by Albrecht Dürer. The position of Christ before a rocky formation, the cup, the angel, and the covered gate in the background derive from Dürer's etching of 1515 (B.19). The stance of the sleeping disciples is akin to that of Dürer's engraving of 1508 (B.4).

Amsterdam, London.

Cf. Plate 103.

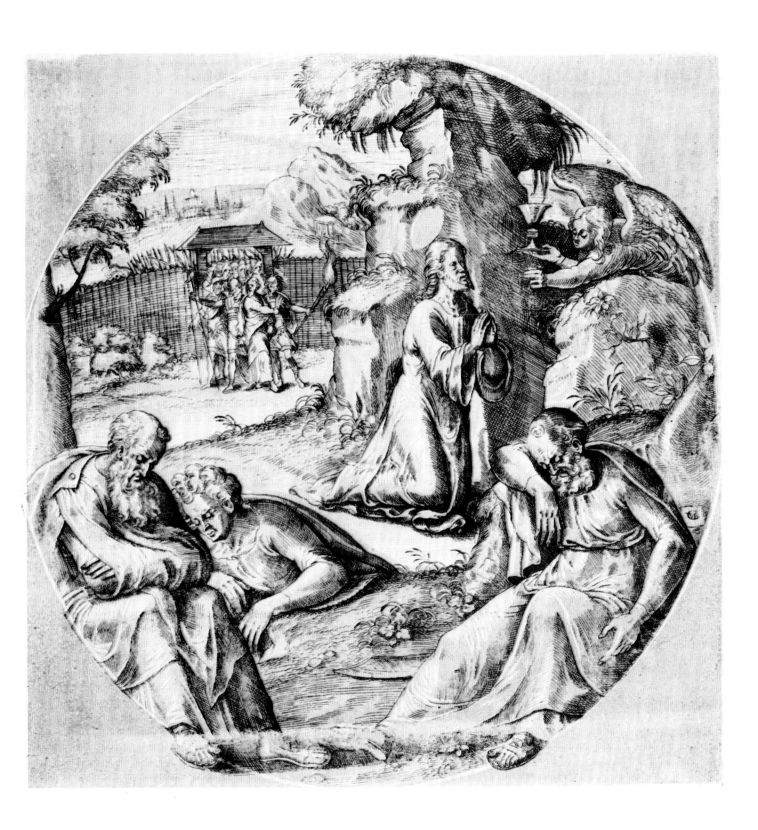

109. Christ Dining with Simon the Pharisee

Without monogram. No date.
227 x 233 mm.
Wu.1; P.7; H.43.
One etched plate; one tone block (sepia).

The first of a series entitled "Four Meals of Christ" which, according to Delen,[1] is based on a design by Frans Floris van Vriendt.

"And one of the Pharisees desired him that he would meat with him. And he went into the Pharisee's house, and sat down to meat." (Luke 7:36)

Boston (W. G. Russell Allen Collection), London, Vienna.

[1] Vol. 2, part 2, 1934-35, Pl. XVII.　　　　Cf. Plate 103.

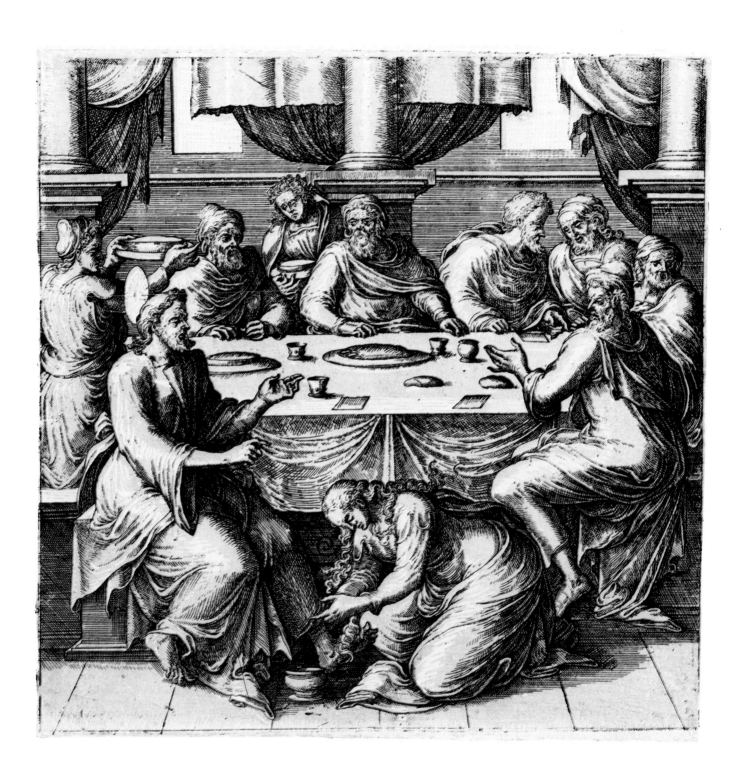

110. The Wedding Feast at Canae

Without monogram. No date.
227 x 233 mm.
H.44.
One etched plate; one tone block (sepia).
Watermark: Coat of Arms.

The second subject of the series "Four Meals of Christ" beginning with Plate 109.

Boston (W. G. Russell Allen Collection), London, Rotterdam.

Cf. Plate 103.

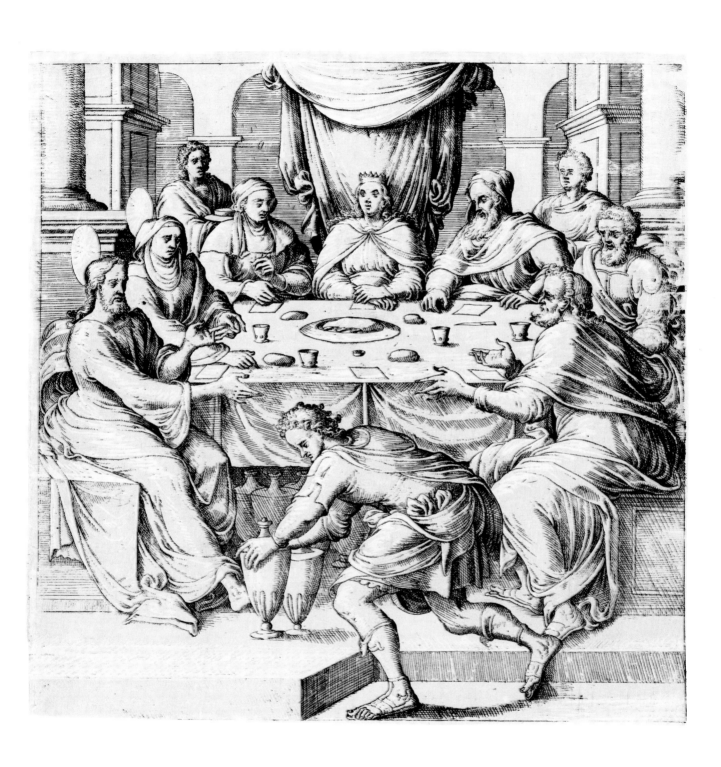

CRISPIN VAN DEN BROECK

111. The Last Supper

With monogram. No date.
227 x 233 mm.
H.45.
One etched plate; one tone block (sepia).

Part of the series "The Four Meals of Christ."

Boston (W. G. Russell Allen Collection), *Cincinnati* (Gift of Herbert Greer French),
London, New York (MM), Rotterdam.

Cf. Plate 103.

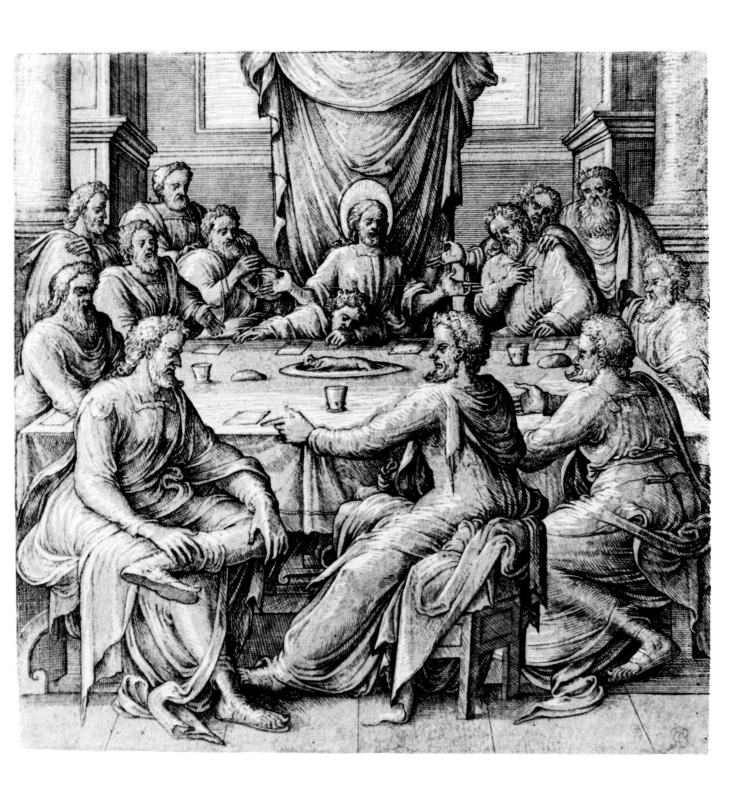

CRISPIN VAN DEN BROECK

112. Christ at Emmaus

Without monogram. No date.
227 x 233 mm.
H.46.
One etched plate; one tone block (sepia).

Last of the series "The Four Meals of Christ."

"And, behold, two of them went the same day to a village called Emmaus, which was from Jerusalem *about* threescore furlongs. And they talked together of all these things which had happened. And it came to pass, that, while they communed together and reasoned, Jesus himself drew near, and went with them. But their eyes were holden that they should not know him." (Luke 24:13-16). "But they constrained him, saying, Abide with us; for it is toward evening, and the day is far spent. And he went in to tarry with them. And it came to pass, as he sat down at meat with them, he took bread, and blessed *it*, and brake, and gave it to them. And their eyes were opened, and they knew him." (Luke 24:29-31).

Amsterdam, London.

Watermark of the impression in London:

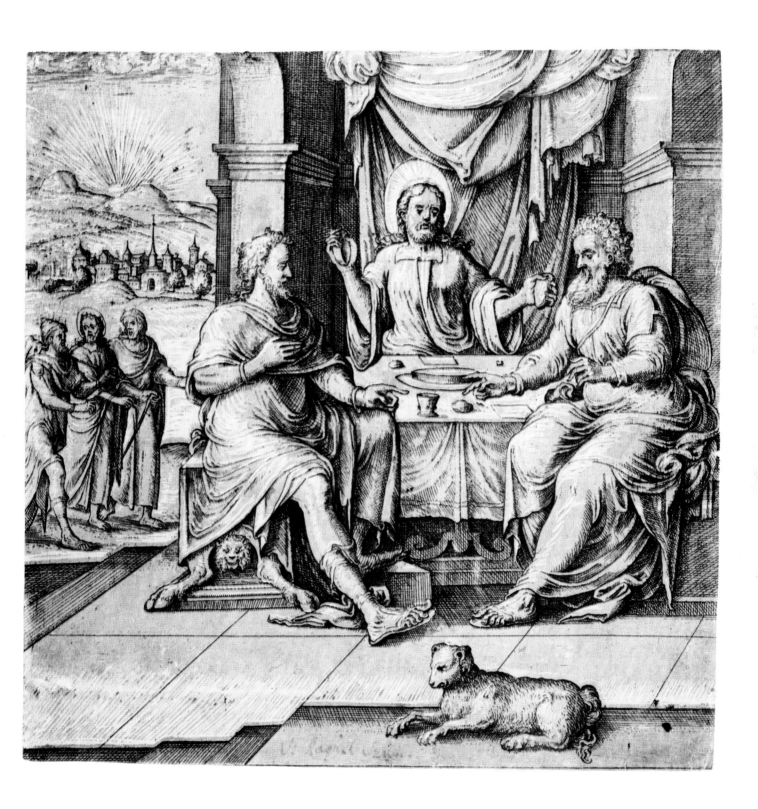

HUBERT GOLTZIUS

Venloo, 1526-1583, Bruges. Son of the painter Hubrecht Goltz (Holtz) who had come to the Netherlands from Würzburg in southern Germany. Goltzius studied with his father and with Lambert Lombard in Liège. From 1546 to 1558 he resided at Antwerp. Subsequently, he moved to Bruges where he established his own printing press.

113. Emperor Constantine

1557.
Diameter: 136 mm.
R.p.43; H.201.
One line block; one tone block.

Example of the 149 illustrations of antique coins in Hubert Goltzius' *Vitae et Vivae Omnium fere Imperatorium Imagines ex anitiquis numismatibus adumbratae,* Antwerp (Ag. Coppens van Diest), 1557. Some of the illustrations are marked with the initial G, attributed to the engraver Joos Gietleughen of Courtrai (cf. Plate 101). Although not true chiaroscuro, this early use of tone blocks is evidence of the effectiveness of this technique and its early use in the Netherlands.

Apart from the portraits of all Roman Emperors up to Charles V, this book includes a brief history of the Roman Empire. The French edition (1559) also contains portraits of Charlemagne and Henry IV (Plates 113 and 131 of the French edition) omitted from the Latin version. A second edition was issued in 1645 with the plates copied by Christoffel Jegher (cf. Plate 158). A third edition was published in 1708, printed by Hendrick and Corneel Verdussen.

Vienna.

Felix van Hulst, *Hubert Goltzius,* Liège, 1846. Marc Hoc, "Hubert Goltzius, éditeur et imprimeur," *Annuaire de Flandre,* vol. 67, 1925, pp. 21-34.

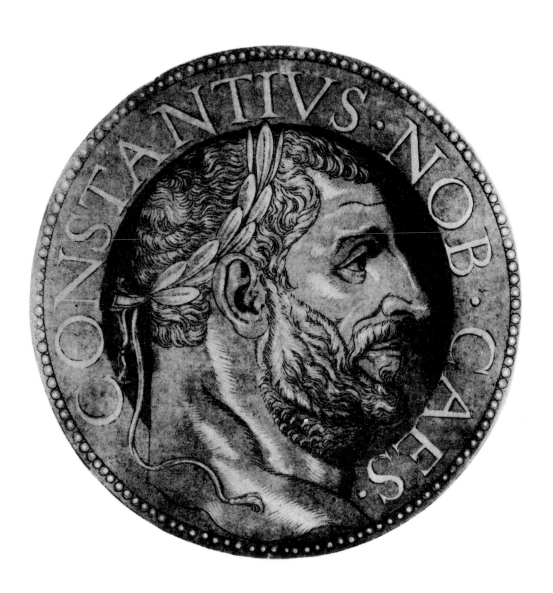

HANS VREDEMAN DE VRIES

Leeuwarden, 1527-1604(?), Hamburg(?). De Vries was a student of the glass painter R. Gebrants of Leeuwarden in Frisia. He subsequently worked in Kampen, Malines, and Antwerp (1549), and then in Malines (1561) and Antwerp again (1564-1570) before going to Aachen (1571) and Liège (1573). He returned to Antwerp for ten years (1575-1585) and then went to Wolfenbüttel (1585-1589), Hamburg (1591), Danzig (1592-1595), Prague (1598), Hamburg (1599), Amsterdam and The Hague (1601). De Vries spent his last years in Hamburg. Beginning in 1555, he illustrated a great many books on architecture and ornamentation which went through many editions. His publishers included H. Cock, G. de Jode, J. J. and P. Galle, P. Balten, H. Hondius, J. Janssen, and J. and L. Deutecum.

114. Renaissance Street

Without monogram. No date.
202 x 278 mm.
Watermark: High Crown.
One line block; two tone blocks.

Hans Vredeman de Vries' woodcut illustrations are usually printed in black and white. In this impression, typical of his style, a tone block was added. Another impression of the same print was sold at the Joseph Wünsch auction[1] in 1927. It bears an annotation with the artist's name and his year of birth.

[1] C. G. Boerner, Joseph Wünsch Auction Catalogue, May 4, 1927, Leipzig.

Wurzbach, vol. 2, 1906-11, p. 830.
Thieme-Becker, XXXIV, p. 575 (Irmgard Koska).

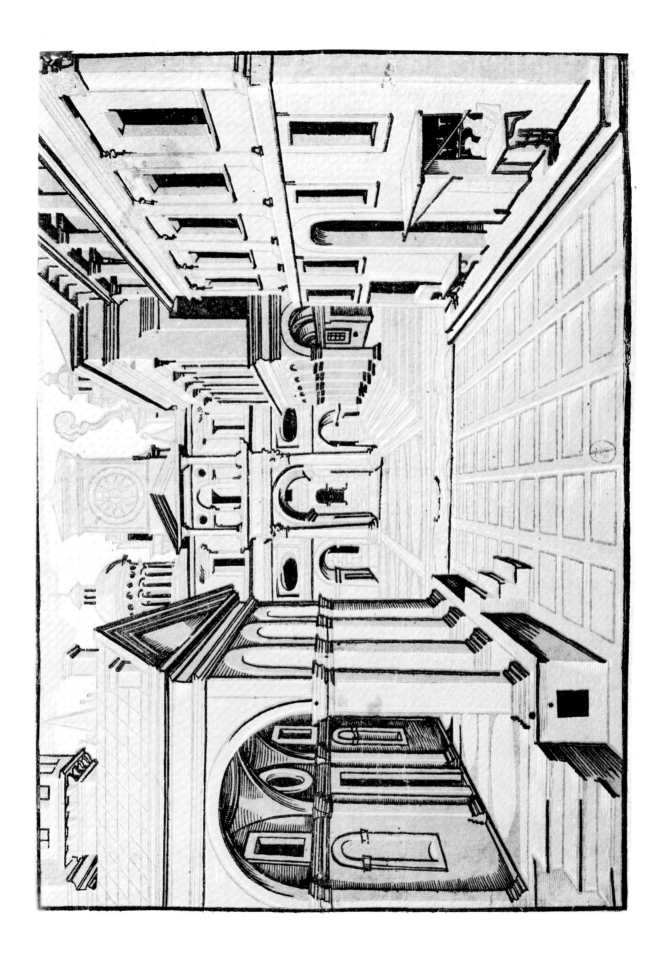

ADRIAEN THOMASZ KEY [Keij]

Antwerp, 1544-1589, Antwerp. Son of Thomasz and nephew of Willem Key.
Studied with Jan Hack at Antwerp in 1558. He became a Master of Painting in 1568
and is noted especially for his portraits. Key's woodcuts reflect the influence
of Frans Floris van Vriendt.

115. Joab Killing Absalom

With monogram: ATK. No date.
309 x 477 mm.
Wu.1; H.1; R. p. 23.
One line block; one tone block.

Amsterdam, Boston (W. G. Russell Allen Collection), Paris (L), Paris (BN), *Vienna*.

Thieme-Becker, xx, p. 228 (F. Winkler).
A. J. J. Delen, *Histoire de la Gravure de Pays Bas et dans les Provinces Belges,* Paris, 1934-35.

Leo van Puyvelde, *La Peinture flamande au siècle de Bosch et Brueghel,* Paris, 1953.

116. The Three Young Jews in the Furnace

With monogram: ATK. No date.
315 x 474 mm.
H.2.
One line block; one tone block.
Watermark: Crowned Double-Headed Eagle.

The monogram is identical to that appearing on Key's paintings. The well-known theme of this print is found in Daniel 3:15. Nebuchadnezzar, King of Babylon (ca. 600 B.C.) ordered Shadrach, Meshach, and Abednego, three young Jews who had refused to adore false images, to be cast into a fiery furnace. They emerged from the furnace unscathed.

Amsterdam, Munich, Paris (BN), Paris (L), Vienna.

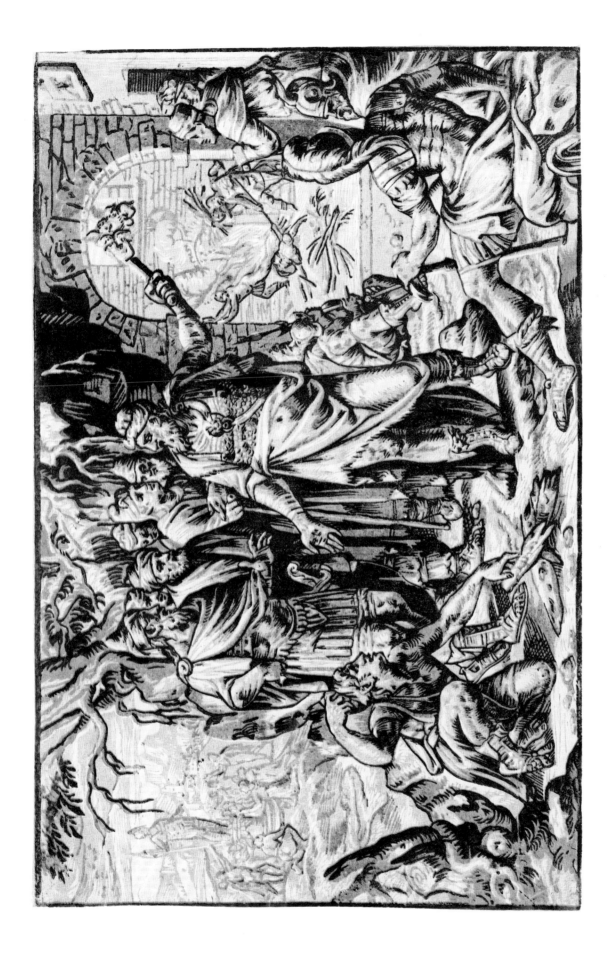

ADRIAEN THOMASZ KEY [?]

117. The Judgment of Solomon

Without monogram. No date.
285 x 420 mm.
Nagler, *Künstler Lexicon,* I, p. 141, No. 5.
One line block; two tone blocks (brown/sepia).

Although Nagler ascribes this print to Frans Floris van Vriendt, it is closer in technique and gestures to Adriaen Thomasz Key. The absence of the monogram and of a background scenery may indicate that it preceded Key's other chiaroscuro prints. A positive identification may be possible after X-ray examination of the watermarks used by both artists.

Boston, Paris (BN).

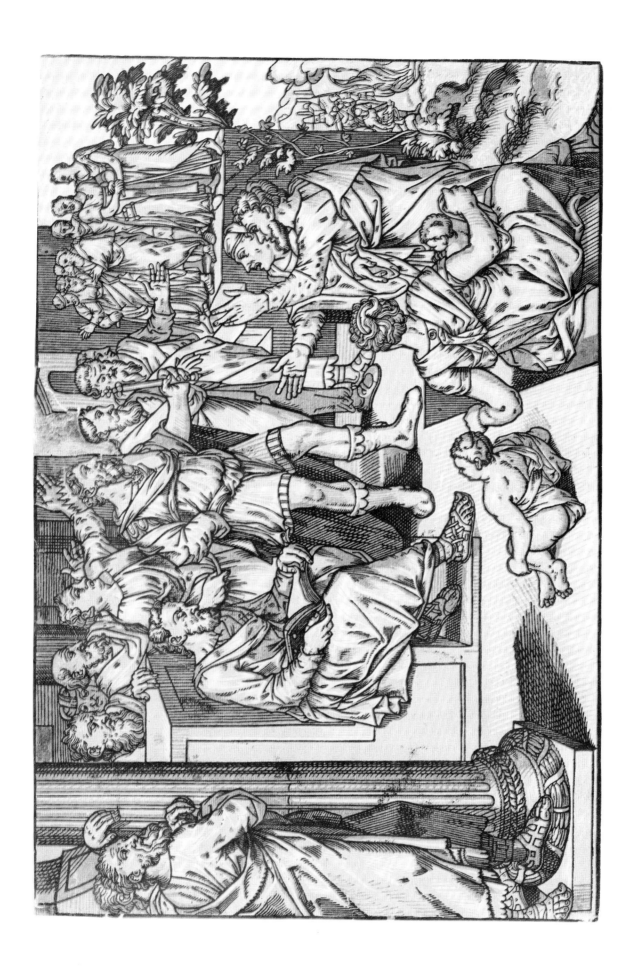

HENDRICK GOLTZIUS

Mühlbracht, 1558-1617, Haarlem. After studying painting with his father, Johann Goltzius, in Duisburg, Germany, Hendrick Goltzius began to learn the art of engraving from Dirck Volckertsz Coornhert in Xanten. In 1577 he moved with Volckertsz to Haarlem and began to print his own graphic works. The influence of Frans Floris is discernible in his earlier works. A remarkable change has been noted after 1583 when Carel van Mander took up residence at Haarlem and showed some of Bartholomäus Spranger's drawings to Goltzius.[1] Spranger's works were charged with a peculiar energy and movement that is reflected in Goltzius' output of that period. The early states of Goltzius' chiaroscuros, printed on blue paper, must be dated from that time. Their borderlines generally show fewer gaps due to wear than do their colored counterparts. In 1590 Goltzius traveled to Germany and to Italy, where he remained until 1591. This visit to Italy, where he saw prints after Parmegianino and by Andreani, apparently intensified his interest in the chiaroscuro technique. Most, if not all, of Goltzius' multicolor chiaroscuros probably date therefore from the years after his return from Italy. According to van Mander, Goltzius took up painting only in 1600.

118. Pike Bearer

Without monogram. No date.
147 x 133 mm.
H.376a; IN.229,230.
Line block printed on blue paper.

Probably Goltzius' earliest print on blue paper.

Amsterdam (a second impression in Amsterdam shows corrections by Goltzius' hand and his monogram added by brush), Rotterdam.

[1] Carel van Mander, *Het Schilderboeck,* Haarlem, 1604 (cf. Plate 164); E. K. J. Reznicek, *Die Zeichnungen des Hendrick Goltzius,* Utrecht, 1961, p. 155.

Otto Hirschmann, *Hendrick Goltzius, Meister der Graphik,* Leipzig, 1919; *Verzeichnis des graphischen Werks von Hendrick Goltzius 1558-1617,* Leipzig, 1921. (Hirschmann's catalogue numbers correspond to those used by Hollstein.)

Winslow Ames, "Some Works by Hendrick Goltzius and their Program," *Gazette des Beaux Arts,* 1949, p. 425.

Irina V. Linnik, "A New Interpretation of a Set of Prints by Hendrick Goltzius," The Hermitage, Leningrad, 1964, p. 3.

Exhibition Catalogue, *Graphicka Gendrika Goltziusa,* The Hermitage, Leningrad, 1968.

Exhibition Catalogue, *Hendrick Goltzius and the Printmakers of Haarlem,* Storrs, Connecticut, 1972. (University of Connecticut.)

Walter L. Strauss, "The Chronology of Hendrick Goltzius' Chiaroscuro Prints," *Les Nouvelles de l'Estampe,* No. 5, 1972, pp. 9-13.

119. John the Baptist

Without monogram. No date.
238 x 142 mm.
B.226; R.85; IN.193,194; H.362.

 I. Line on blue paper.
 II. One line block; two tone blocks (shades of yellowish green or brown/sepia).
III. Late impressions of this print bear the imprint: *Amsterdam, ghedruckt by Willem Jansen.*[1]

 I. Berlin, New York (MM), Paris (IN), *Rotterdam* (heightened with white by hand).
 II. Amsterdam, Boston (brown/sepia), Cambridge (brown/sepia), London (on reddish paper), Middletown (shades of green), Munich, New York (MM), New York (NYPL), Paris (BN), Philadelphia, Princeton, Vienna.

[1] Impressions with Jansen's imprint are probably posthumous. Cf. Strauss, 1972, p. 12; see also Plate 1.

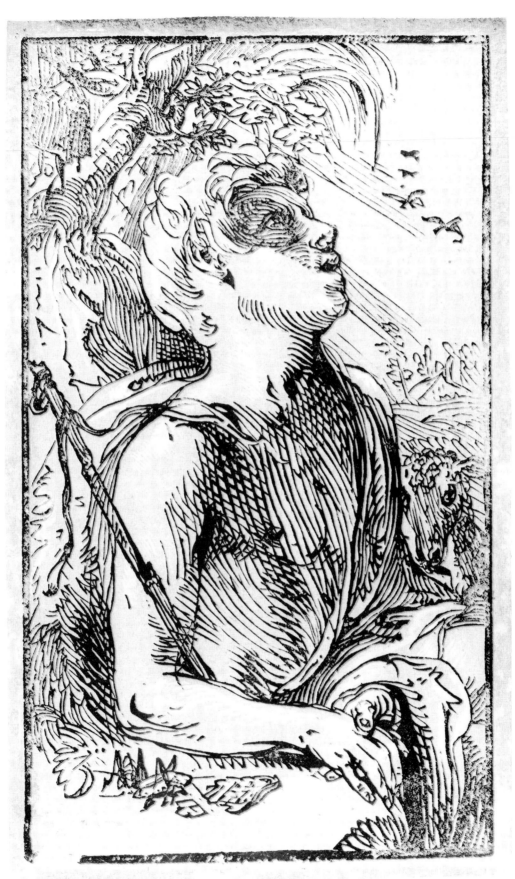

120. The Prophet Elijah

Without monogram. No date.
149 x 129 mm.
B.add.226a; R.86a; H.363a.

 I. Line on blue paper.
 II. See Plate 120A.

Formerly referred to as St. Benedict (Hirschmann 363a). Identified by Ames[1] as relating to the passage in I Kings 17:4 concerning Elijah: "And it shall be, *that* thou shalt drink of the brook; and I have commanded the ravens to feed you there."

Some doubt has been expressed recently[2] concerning the attribution of this print to Goltzius, on account of dissimilarities in lines and the type of figure. Begemann has noted a resemblance to drawings by Buytewech. A note on its mat in Boston by Clifford S. Ackley suggests the possibility of an attribution to another artist of the Haarlem School. The only other artist who produced prints both on blue paper and also with tone blocks is Christoffel van Sichem II (cf. Plate 154) whose Mennonite belief may have caused him to become particularly interested in Old Testament subjects. Nevertheless any attribution other than to Goltzius is highly conjectural.

There are also some striking similarities of details of this print to others by Goltzius, such as the arc-shaped branch with hangings near the top and the bulbous vegetation, features found, for example, in the "Arcadian Landscape" (Plate 127).

A conclusion might be reached once the watermark of the paper of this print, not heretofore described, is found in other prints by Goltzius or those of another artist.

 I. Berlin, *Princeton,* Stockholm.
 II. See Plate 120A.

[1] Winslow Ames, "Some Works by Hendrick Goltzius and their Program," *Gazette des Beaux Arts,* 1949, p. 425.

[2] Direct communications by Leonard Baskin and E. H. Begemann.

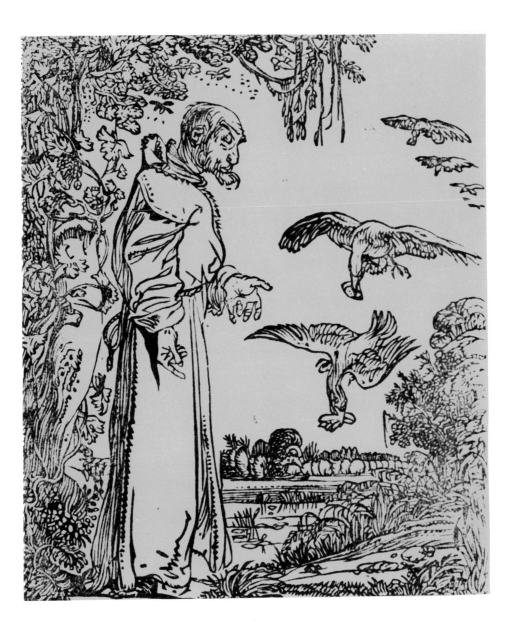

I

120A. The Prophet Elijah

II. One line block; two tone blocks (shades of yellowish green or sepia).
Watermark: Leaf with attached letter R (not in Briquet).

Boston (W. G. Russell Allen Collection), New Haven (Yale Art Museum),
Northampton (Mass.), Paris (BN), Paris (IN), Philadelphia, *Vienna*.

Watermark:

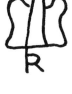

II

121. Portrait of Gillis van Breen

With monogram: HG.f. (in the tone block). No date.
206 x 142 mm.
B.239; R.84; H.375; IN.223-225.

 I. Line on blue paper. No monogram.
 II. One line block; two tone blocks. No monogram.
 III. See Plate 121A.

The impression in Amsterdam bears an annotation in a hand of the seventeenth century as follows: Gillis de Vreen, Kunstdrucker van H. Goltzius. A drawing by Goltzius at Frankfurt, dated 1588, portrays the same person. It is inscribed "——llis van Breen." Goltzius also engraved a portrait of van Breen (H.178).

 I. *Amsterdam,* Berlin, the Hague, Paris (IN).
 II. London (early impression with full border), Rotterdam.
 III. See Plate 121A.

I

HENDRICK GOLTZIUS

121A. Portrait of Gillis van Breen

III. One line block; two tone blocks (brown/sepia or shades of green). With monogram.

Amsterdam, Boston (W. G. Russell Allen Collection), London, Rotterdam, Vienna.

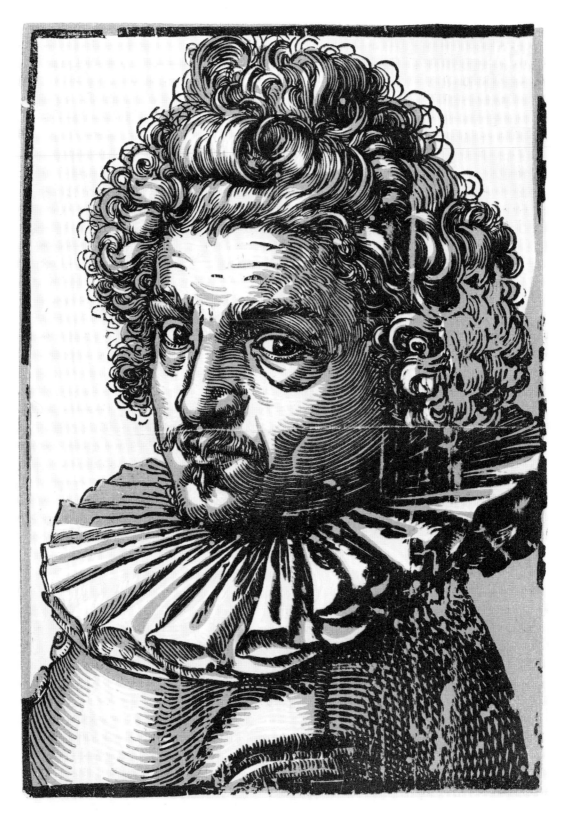

III

122. Young Man with a Cane

With monogram: HG. No date.
110 x 63 mm.
B.240; H.376.

 I. Line on white paper.
 II. Line on blue paper.
III. One line block; one tone block.
IV. One line block; two tone blocks.

 I. Amsterdam, London.
 II. *Boston* (W. G. Russell Allen Collection), Cleveland, London, Minneapolis, Paris (IN; heightened with white by hand), Princeton, Rotterdam.
III. *Amsterdam,* Boston (W. G. Russell Allen Collection), Cologne, London, Northampton (Mass.).
IV. Rotterdam.

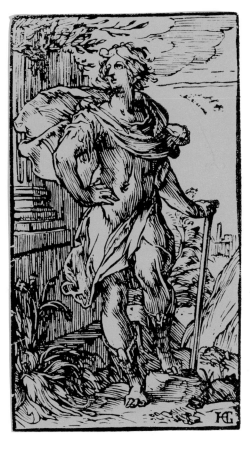

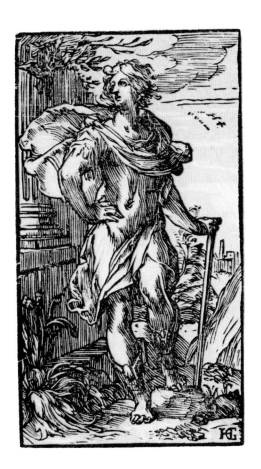

II III

123. The Magdalen

With monogram: HG. f. (in the tone block). No date.
139 x 113 mm.
B.227; R.86b; H.363.

 I. Line on blue paper.
 II. One line block; one tone block.
 III. One line block; two tone blocks (brown/sepia or shades of green).

 I. Berlin, Boston (W. G. Russell Allen Collection).
 II. London (green), Utrecht, Vienna.
 III. *Boston* (W. G. Russell Allen Collection), Cincinnati, London, New York (MM), Paris (BN), Paris (IN), Philadelphia, Providence.

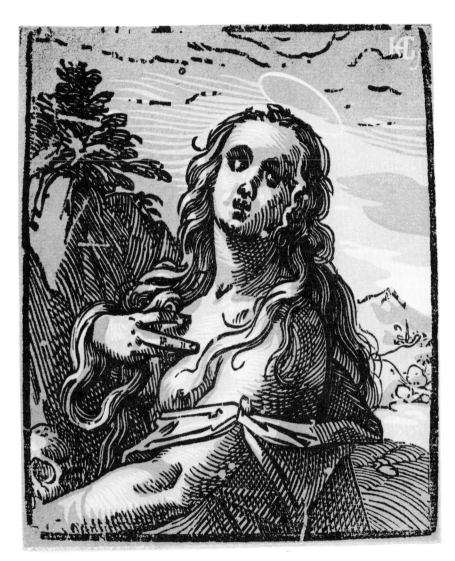

III

124. Mars [half-length]

With monogram. No date.
247 x 176 mm.
B.230; H.366; IN.200-202.

 I. Line only on blue paper.
 II. One line block; one tone block. Without monogram.
 III. One line block; one tone block. With monogram HG (reversed).
 IV. See Plate 124A.
 V. One line block; two tone blocks. Imprinted: *Ghedruckt t'Amsterdam by Willem Jansen in de vergulde Sonnewyser.*[1]

Compared to the later representation of this subject (Plate 125), this print still reflects a strong reliance on the line block.

The monogram was cut in both tone blocks. The earlier one, in reverse, was later removed.[2]

 I. Cologne (heightened with white by hand), London.
 II. *Amsterdam.*
 III. Berlin (olive green), Boston (sepia), Leningrad, Paris (BN).
 IV. See Plate 124A.
 V. Boston (W. G. Russell Allen Collection).

[1] Probably posthumous. Cf. Plates 1, 119.

[2] Hirschmann, 1919, p. 132.

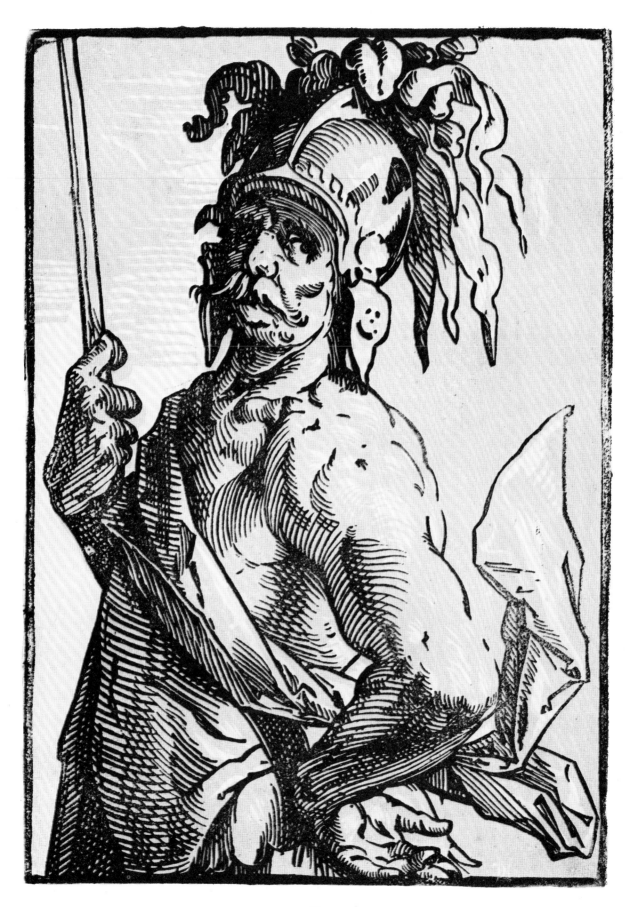

II

124A. Mars [half-length]

IV. One line block; two tone blocks. With monogram HG.f.

Amsterdam, Cambridge, London (sepia/olive), Munich (brown/sepia),
New York (MM), Philadelphia, Rotterdam.

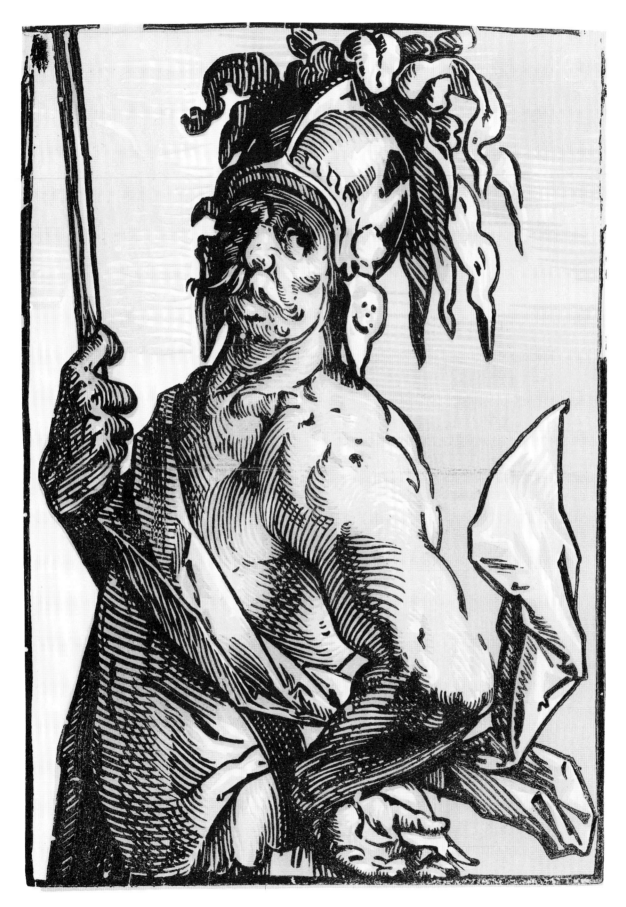

IV

125. Mars [full-length]

With monogram in the tone block: HG. No date.
237 x 143 mm.
B.229; H.365; IN.199.

I. One line block; two tone blocks. With monogram.
II. One line block; one tone block. Without monogram. The borderlines
with many gaps, indicating that these impressions, lacking the second tone block,
must be dated later.

In a circle at the upper left, Aries, "the Ram," denotes the astrological sign for March. Its astrological symbol appears in the opposite corner. "Mars" may have been intended for a projected series of calendar illustrations that, except for Plate 126, was left incomplete. The contours of the line block are frequently interrupted, thus lending greater emphasis to the tone blocks than in the earlier rendering (Plates 124 and 124A). Akin to Goltzius' illustrations of Ovid's *Metamorphoses* of 1589.[1]

Mars has been traditionally associated with both Aries and Scorpio in astrology. In this instance, Scorpio has, however, been assigned to Bacchus (cf. Plate 126). According to Ptolemy, the sun was in Aries at the time of the creation. Aries, the sign of the Ram, thus marks the beginning of the year. Placed in the heavens by Zeus after having been sacrificed by Phrixus, the son of Nepele. The Ram's Golden Fleece was later captured by Jason the Argonaut.

I. *Amsterdam*, Boston (W. G. Russell Allen Collection), Brussels, Cambridge, Cologne, London, Munich (WM: Coat of Arms with Fishes), New York (MM), Nuremberg, Paris (IN), Providence, Rotterdam.
II. Frankfurt (H. Rumbler Gallery; no watermark), London.

[1] Hirschmann, 1919, p. 132; vol. 3, p. 104, 31-82.

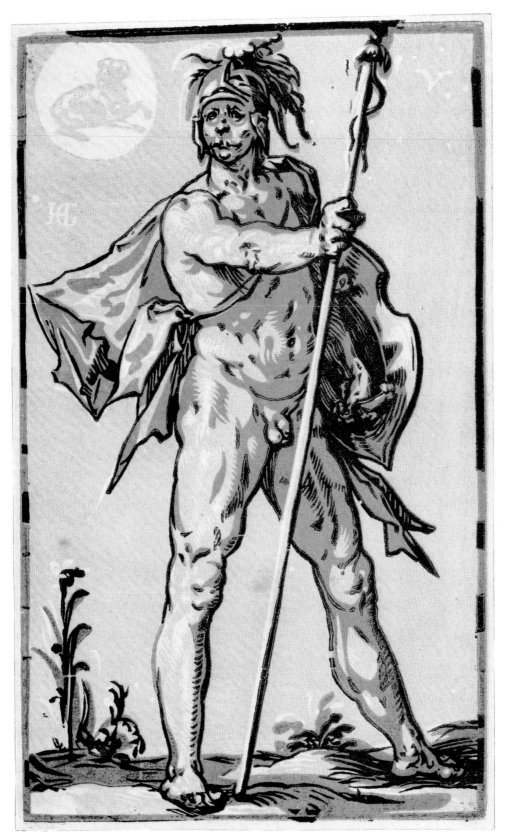

I

126. Bacchus

With monogram in the tone block. No date.
239 x 143 mm.
B.222; R.89; H.364.

I. One line block; one tone block (sepia). With monogram.
II. One line block; two tone blocks (brown/sepia). With monogram.
 Watermark: Small Lily.

At the upper left, Scorpio in a circle denotes October. The corresponding astrological symbol appears on the upper right. "Bacchus" is a companion piece of Plate 125.

In astrology, Mars traditionally rules both Scorpio and Aries. Men born under Scorpio are supposedly self-indulgent in revolt against the dullness of life. These attributes suggest the uncommon association of this sign with Bacchus in this instance.

I. Hague, Paris (IN), Vienna.
II. London, Munich, New York (MM), Paris (IN), Providence, Rotterdam, *Vienna*.

Watermark:

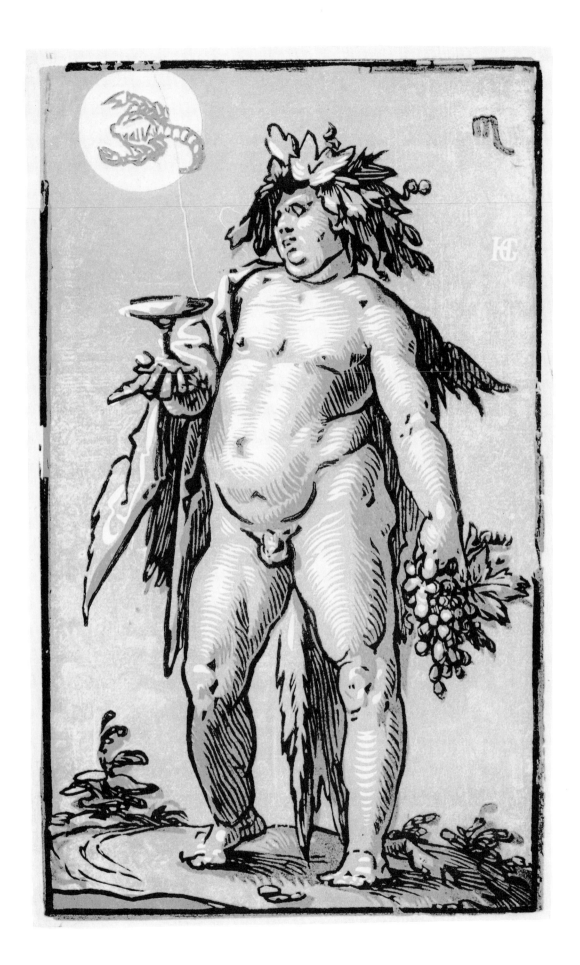

127. Arcadian Landscape

No monogram. No date.
180 x 249 mm.
B.241; R.91; H.377.

I. Line block printed on blue paper.
II. See Plate 127A.
III. See Plate 127B.

The earliest and largest of Goltzius' chiaroscuro landscapes, it is heavily dependent on the line block, as may be noted from the impressions of state I.[1] There is a drastic shift of emphasis to the tone blocks in the third state of this print. The upper portion of the line block was removed, in this instance, when the tone blocks were introduced. This radical change suggests that impressions on blue paper are considerably earlier than those with tone blocks, predating Goltzius' Italian journey, while those in color date from after 1591. Hirschmann[2] calls this print primitive, overstuffed with detail, and further ruined by the introduction of the tone blocks. In contrast, Oberhuber[3] terms it magnificent and perhaps inspired by Hercules Segher.[4]

I. *New York* (NYPL; with diagonal rays of the sun and clouds beneath the tree).
II. See Plate 127A.
III. See Plate 127B.

[1] Walter L. Strauss, "The Chronology of Hendrick Goltzius' Chiaroscuro Prints," *Les Nouvelles de l'Estampe*, No. 5, 1972, pp. 9-13.
[2] Hirschmann, 1919, p. 136.
[3] Konrad Oberhuber, *Zwischen Renaissance und Barock, Die Kunst der Graphik IV*, Vienna, 1967, No. 323.
[4] Wolfgang Stechow, *Dutch Landscape Painting in the 17th Century*, London, 1966, p. 131.

127A. Arcadian Landscape

II. Line block, upper portion removed, printed on blue paper.

Amsterdam (heightened with white by hand), London, New York (MM), Princeton.

II

127B. Arcadian Landscape

III. One line block; two tone blocks (yellow/green or shades of green).

Amsterdam, Boston (W. G. Russell Allen Collection), Cleveland, London, *New York* (NYPL), New York (MM), Paris (IN), Rotterdam, Vienna.

III

128. Landscape with Peasant Dwelling

With monogram: HG. No date.
112 x 146 mm.
B.244; R.90b; H.380.

 I. Line block printed on blue paper.
 II. One line block; two tone blocks (brown/sepia or shades of green).
 Watermark: Small Lily.

The scene is less crowded and the style more advanced than in the "Arcadian Landscape" (Plate 127). It is of a simplicity that abandons the theatrical landscape concept of the period and already suggests those of Jan van Goyen and Peter Molyn.[1]

 I. Boston (W. G. Russell Allen Collection), Cambridge, Chicago, Cologne, Leningrad, London, Paris (IN; heightened with white by hand, probably preparatory for the tone block), *Princeton,* Rotterdam.
 II. Chicago, Minneapolis, New York (MM), Oberlin, Paris (BN), Paris (IN), Philadelphia, Providence, *Rotterdam,* Vienna.

[1] Hirschmann, 1919, p. 137.

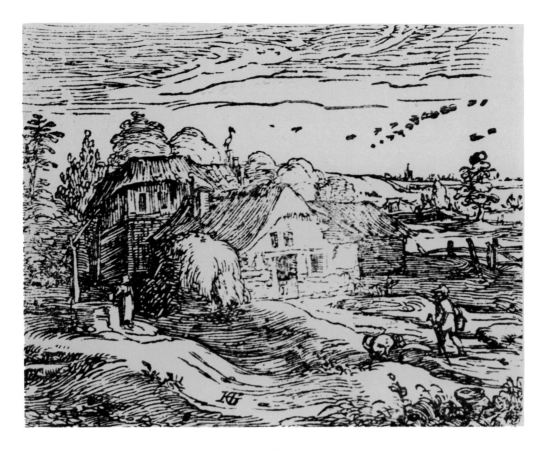

I

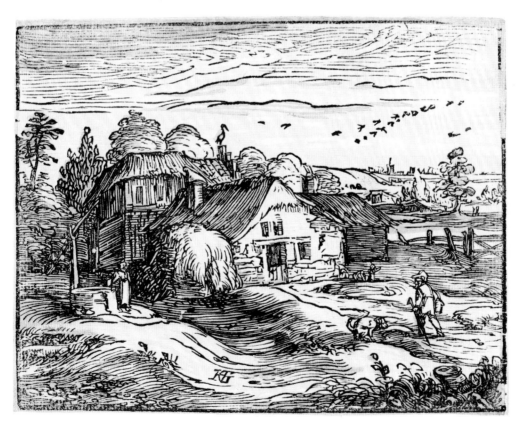

II

129. Landscape with Waterfall

With monogram: HG. No date.
112 x 146 mm.
B.242; R.90a; H.378.

I. One line block; printed on blue paper.
II. One line block; two tone blocks (brown/sepia or shades of green).
Watermark: Caduceus with a Small Coat of Arms (akin to Briquet 13847).

Still further advanced in technique than Plate 128 and more complicated in concept. According to Hirschmann,[1] it resembles Venetian landscapes and is close to some of Goltzius' drawings in the style of Titian. Several of these landscape drawings, however, date from later years.

I. *Amsterdam* (heightened with white by hand), Boston (W. G. Russell Allen Collection), Cambridge, Chicago (heightened with white by hand), Leningrad, London, Middletown, Minneapolis, New York (MM), Northampton (Mass.), Rotterdam. (The impressions heightened with white by hand were probably preparatory for the tone blocks.)
II. *Amsterdam*, Boston (W. G. Russell Allen Collection), Chicago, Minneapolis, Munich, New York (MM), Paris (BN), Paris (IN), Philadelphia, Vienna.

[1] Hirschmann, 1919, p. 136; he makes reference to Goltzius' drawings in Dresden, Haarlem, and Stockholm.

Watermark:

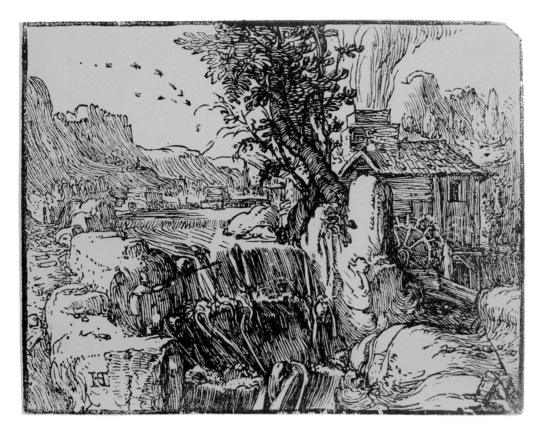

I

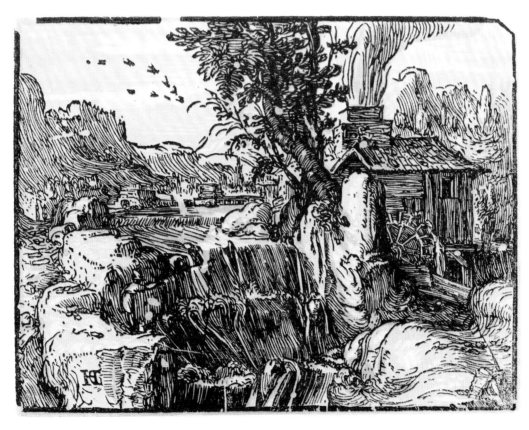

II

130. Landscape with a Seated Couple and Shepherds

With monogram: HG. No date.
113 x 146 mm.
B.243; H.379.

I. One line block; printed on blue paper.
II. One line block; two tone blocks (brown/sepia or shades of green).
Watermark: Caduceus with a Small Coat of Arms (cf. Plate 129).

Hirschmann[1] calls this the most advanced of Goltzius' chiaroscuro landscapes. He calls attention to the sweeping view, almost Venetian in style, and the kinship to engravings of Cornelius Cort after Muziano.

Even if this chronological order is correct for the line blocks, the tone block version of the "Arcadian Landscape" (Plate 127) is probably later than the one of this landscape (cf. remarks for Plate 127).

I. *Amsterdam* (heightened with white by hand), Boston (W. G. Russell Allen Collection; heightened with white by hand), Cambridge, Leningrad, London, New York (MM), Northampton (Mass.), Philadelphia, Princeton, Rotterdam. (The impressions heightened with white by hand were probably preparatory for the tone blocks.)
II. Boston (W. G. Russell Allen Collection), Minneapolis, Munich, New York (MM), Paris (BN), Paris (IN), New York (NYPL), *Oberlin,* Washington.

[1] Hirschmann, 1919, p. 136.

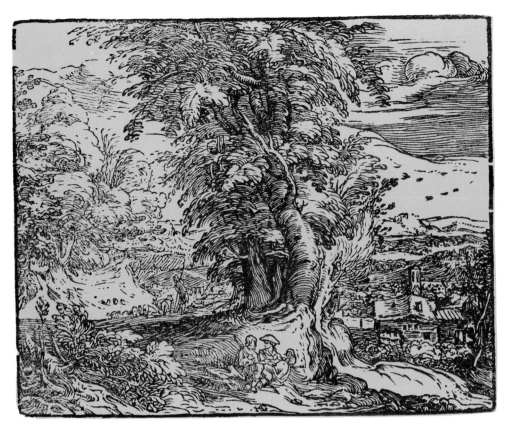

I

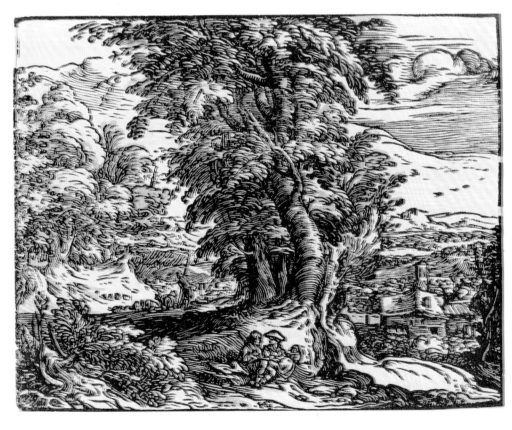

II

131. Cliff on the Seashore

With monogram: HG. No date.
113 x 146 mm.
B.245; H.381; DM.67.

I. Line block only printed on white paper.
II. Line block only printed on blue paper.
III. One line block; two tone blocks (ochre/sepia or shades of green).
 Watermark: Caduceus with a Small Coat of Arms (cf. Plate 129).

Mannerist influence is manifest in the imaginary seascape and the high vantage point. The sparse sky of the line block appears to have been designed with a view of being complimented by tone blocks.

I. Paris (IN).
II. Amsterdam (heightened with white by hand), Cleveland, Cologne, Leningrad, London, New York (MM), Northampton, (Mass. [heightened with white by hand]) Princeton, *Rotterdam*. (The impressions heightened with white by hand were probably preparatory for the tone blocks.)
III. Boston (W. G. Russell Allen Collection), *Cambridge,* Chicago, Cleveland, London, Minneapolis, Munich, New Haven (Yale Art Museum), New York (MM), Paris (BN), Paris (IN), Philadelphia, Providence.

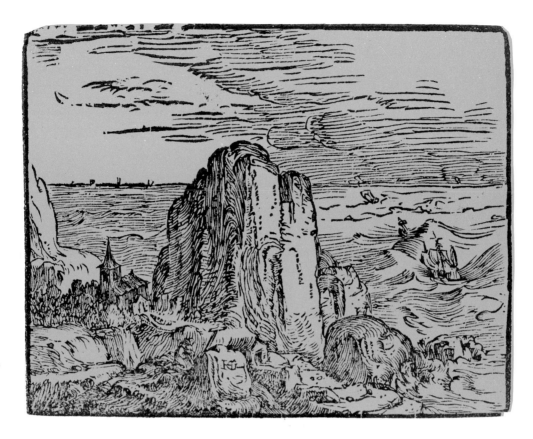

II

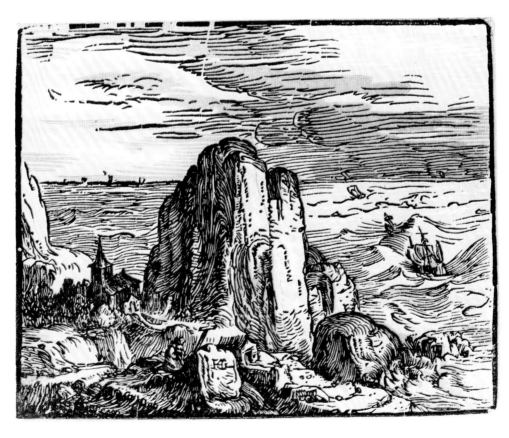

III

132. Seascape with Two Sailing Vessels

Without monogram. No date.
92 x 144 mm.
H.383.

I. Line block printed on blue paper.
II. One line block; two tone blocks (brown/sepia or shades of green).

Probably experimental, preceding the "Seascape with Three Sailing Vessels" (Plate 133), this work is presumably also based on a design of Cornelius Claesz van Wieringen, whose initials appear on the following print.

I. *Amsterdam,* Boston (W. G. Russell Allen Collection), London, Paris (BN), Philadelphia.
II. *Amsterdam,* Boston (W. G. Russell Allen Collection), Paris (BN), Paris (IN), Princeton, London, Washington.

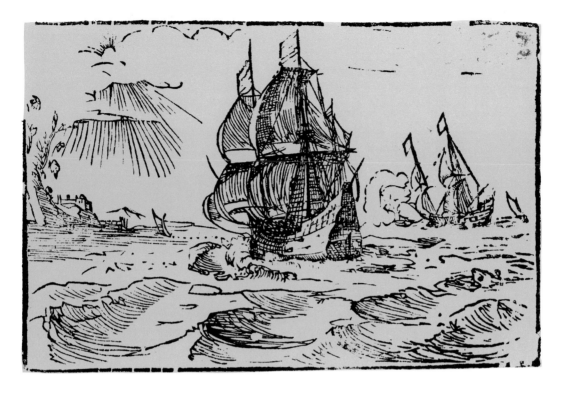

I

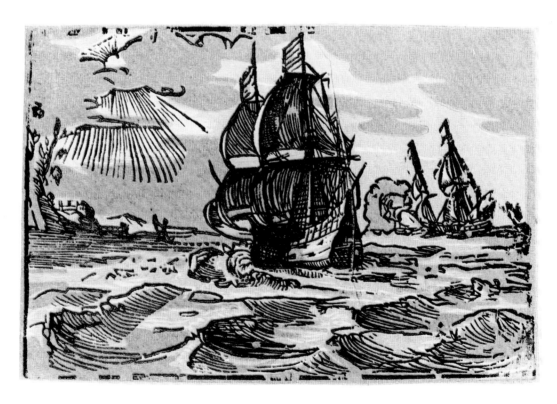

II

133. Seascape with Three Sailing Vessels

With monogram: CW. No date.
135 x 215 mm.
B.246; H.382.

 I. Line block printed on blue paper.
 II. One line block; two tone blocks.

Based on a design of Cornelis Claesz van Wieringen (1580-1633), a friend of Hendrick Goltzius, who was active in Haarlem. Van Wieringen was a pupil of Hendrick Cornelisz Vroom, who is known as the father of Dutch seascape painting.

The vessel in front is armed with cannons. Late impressions with the tone blocks (posthumous?) are imprinted: *Ghedruckt by Willem Iansen.*[1]

 I. *Amsterdam* (with corrections by hand by the artist), Munich, New York (MM).
 II. Amsterdam, Bamberg, London, New York (NYPL), Nuremberg, Philadelphia, *Rotterdam.*

[1] See remarks for Plates 1 and 119. The spelling of Janssen's name is not always consistent.

Reznicek, 1961, p. 179.

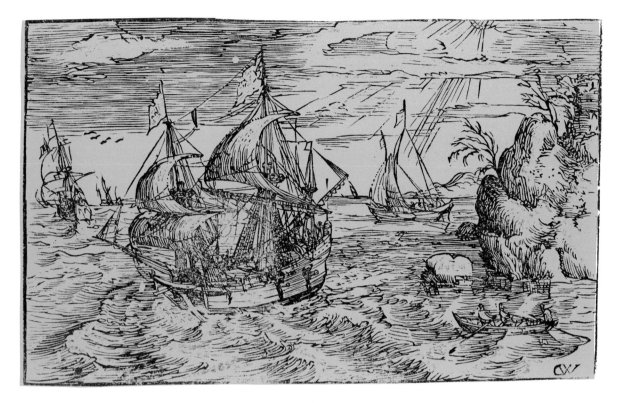

I

t' Amsterdam, Ghedruckt by Willem Iansen.

II

134. Hercules and Cacus

Imprinted: *H. Goltzius Inue. Ao. 88.* (in the tone block). Dated 1588 (beginning with III).
407 x 334 mm.
B.231; H.373; IN.217-220.

 I. Line only; on white paper.
 II. One line block; one tone block (sepia).
III. One line block; two tone blocks (brown/sepia).
IV. Imprinted: *Ghedruckt t'Amsterdam by Willem Janssen in the vergulde Sonnewyser.*[1]

This is Goltzius' largest chiaroscuro print and the only one bearing a date. In 1587 Bartholomäus Spranger had sent two drawings to Goltzius from Prague, where he was Court Painter to the Emperor Rudolph II, with the specific request that Goltzius engrave them ("The Dead Christ Supported by Angels" [H.320] and "Psyche's Wedding" [H.322]).[2] It must remain conjecture whether Spranger's designs induced Goltzius to add tone blocks. Early impressions are on white paper. The heavy reliance on the line block would seem to indicate that the tone blocks were added at a later date, perhaps even after Goltzius' return from Italy in 1591. The fact that the date and signature are cut into the tone block instead of the line block tends to corroborate this theory.

 I. Amsterdam, Düsseldorf, New York (MM), Paris (IN).
 II. Amsterdam, Boston, Cambridge, Cologne, Leningrad, New Haven (Yale Art Museum), New York (MM), New York (NYPL), Nuremberg, Paris (IN), Washington, Worcester.
III. New York (MM), London, Munich, Paris (BN), Paris (IN), Philadelphia.
IV. *Amsterdam,* Boston (W. G. Russell Allen Collection), London, New York.

[1] Probably posthumous. Cf. Plates 1 and 119. [2] Reznicek, 1961, p. 155.

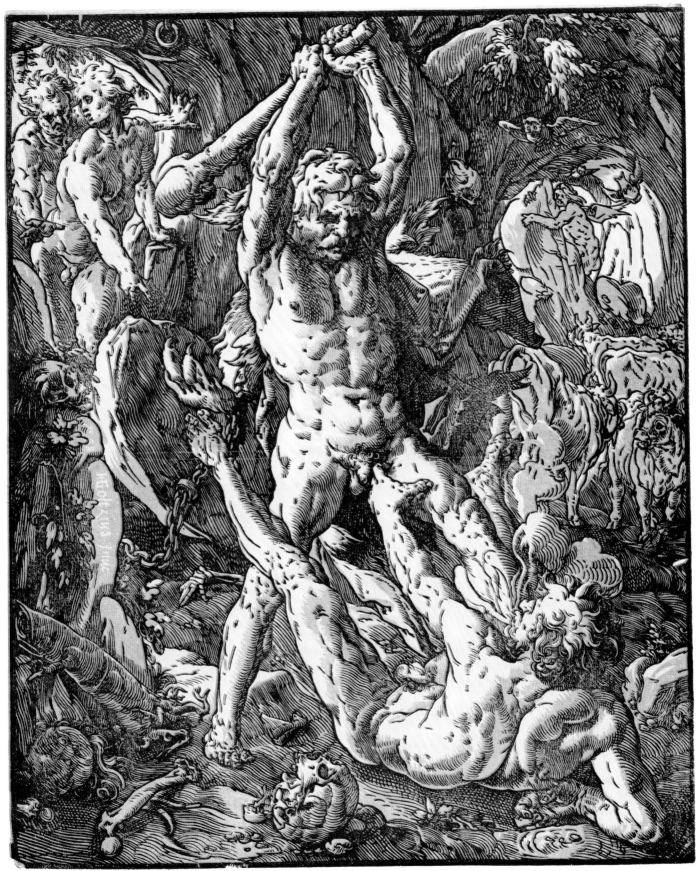

Ghedruckt t Amsterdam by Willem Ianssen in de vergulde Sonnewyser.

IV

135. The Magician [The Cave of Eternity]

With monogram (in the tone plate). No date. Probably 1591.
350 x 261 mm. (oval).
B.238; H.374; DM.64.
One line block; two tone blocks (olive/sepia, pale green/beige, or shades of gray).

Wolfgang Kemp[1] recognized the subject as the *Cave of Eternity* which Spenser describes in *The Faerie Queene* (1596) as follows:

Downe in the bottom of the deepe Abysse
where Demogorgon in full darkness pent
Farre from the view of Gods and heavens blisse
The hideous Chaos keeps, their dreadful dwelling is.
(Book 4, canto 2, stanza 47.)

The classical source for this subject is Claudian's *De Consolatu Stilichonis*:

Far away, at an unknown place, inaccessible to human thought, and difficult to reach even for the Gods, is the Cave of Eternity, inhospitable mother of centuries, whose lap serves both as cradle and grave of time. The cave is encircled by a serpent that, with inevitable force, devours everything. Its scales have a greenish hue. It bites its tail, being at once the beginning and the end. Dame Nature watches its entrance, ancient, yet beautiful; fleeing souls cling to her breast. A venerable old man is writing down ironclad laws. He determines the number, order, and the orbits of Mars, of Jupiter, and their bearing on the world. He defines the rapid transit of the Moon, the slow journey of Saturn, and the gleaming paths of Venus and of Mercury, the companion of Apollo. When Sol enters the cave, Dame Nature rushes to greet him, while the old man bows before the proud beam of light. The steelen gates swing open, exposing the spacious interior, the seat and secret of Eternity.
(Chapter II, verses 424-48)

This legend is retold by Boccaccio, followed by Vincenzo Cartari.[2] It is also described by Cesare Ripa in his *Iconologia* (Rome, 1593), based here on Francisco Barberini. Carel van Mander too became interested in this subject. It served to decorate the title page of Ovid's *Metamorphoses* that he illustrated.[3]

The "Cave of Eternity" is obviously the earliest of the oval chiaroscuros. The line block is still predominant. The use of small hooks in the musculature of the seated figure and the abrupt foreshortening are akin to "Hercules and Cacus" (Plate 134). The contorted pose has been cited as a typical "Sprangerism,"[4] but there are strong indications that Goltzius became acquainted with this subject matter during his sojourn in Italy during the years 1590-91, and that this print should be dated from the period following his return (cf. remarks for Plates 139 and 141).

Amsterdam, Boston, Cambridge, Chicago, Cincinnati, Cleveland, Leningrad, Middletown, London, Minneapolis, Munich, New York, Paris (BN, IN), Philadelphia, Rotterdam.

[1] Wolfgang Kemp, "Die Höhle der Ewigkeit," *Zeitschrift für Kunstgeschichte*, vol. 32, 1969, pp. 133-52.
[2] Vincenzo Cartari, *Imagini*, Florence, 1556. First illustrated edition, 1571.
[3] *Utlegghing op den Metamorphosis Pub. Ovidii Nasonis*, Haarlem, 1604.
[4] DM, p. 49.

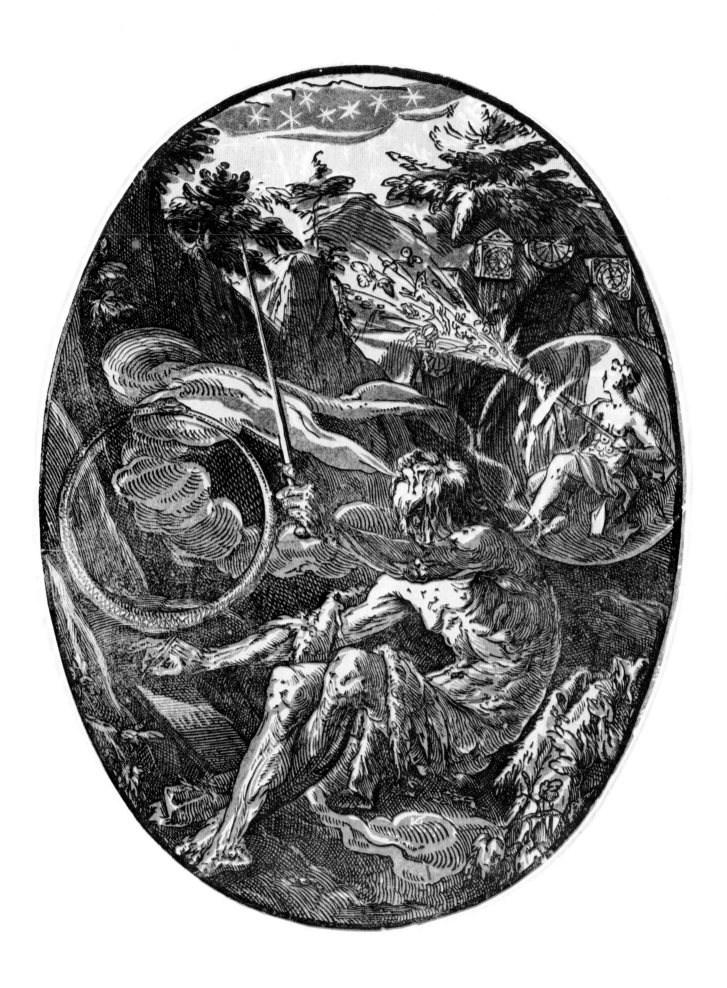

136. Neptune

With monogram: HG. f. No date.
349 x 264 mm. (oval).
B.232; H.367.
One line block; two tone blocks (brown/sepia or sepia/ochre).
Watermark: Fortuna on a Sphere with two Lions.

"Neptune" is the first of six oval prints (three pairs) picturing classical deities. By all indications, this series must be dated after Goltzius' return from his Italian journey (1590-91). They are Mannerist in concept and are distinguished by a greater measure of tone with lesser emphasis on the linear quality than his earlier works in this medium. Perhaps they were inspired by the famous "Parade of Deities," a Carnival display at Florence in 1565.[1] (Compare remarks for Plate 141.)

Boston (W. G. Russell Allen Collection), Chicago, Cincinnati, Leningrad, London, Munich, New York (MM), New York (NYPL), Paris (BN), Paris (IN), *Princeton,* Rotterdam, Vienna, Washington.

[1] Kemp, 1969, p. 137 (cf. Pl. 135).

J. Seznec, "La mascerade des dieux à Florence en 1565," *Mélange d'archéologie et d'histoire,* 1935, p. 224.
Ames, 1949, p. 425.

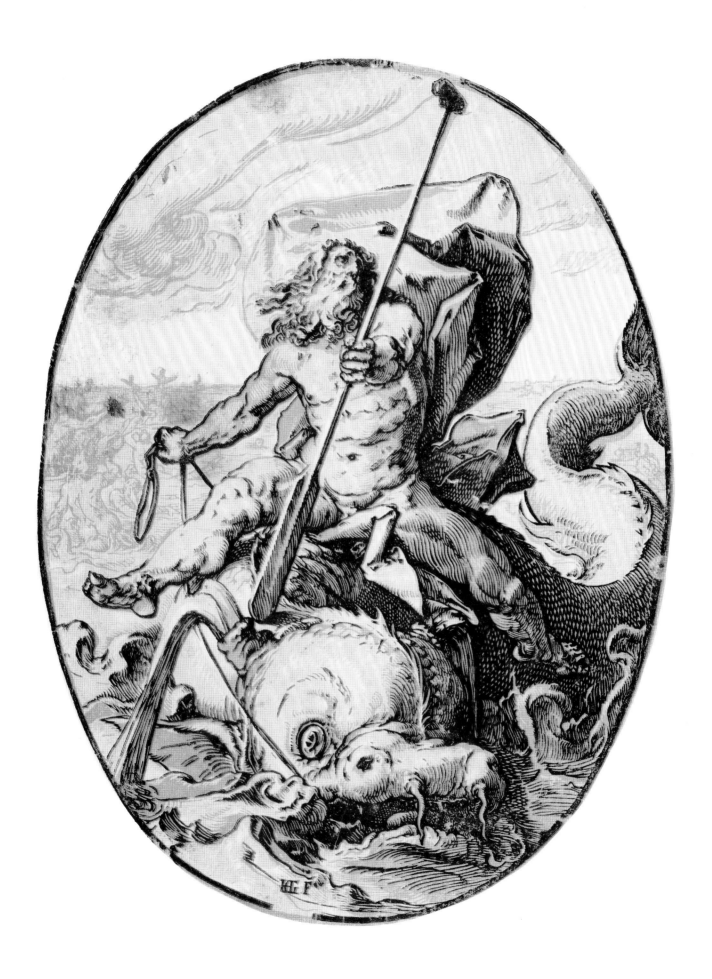

137. Galatea

With monogram: HG. fe. No date.
352 x 265 mm. (oval).
B.235; R.87; H.368.

I. One line block; one tone block (black/maroon).
II. One line block; two tone blocks (sepia/ochre, brown/sepia, shades of gray).

Hirschmann[1] finds a resemblance of this print to Raphael's rendering of the same subject (B.270).

Galatea was a sea nymph loved by the Cyclops Polyphemus. Spurning his love, she became enamored of Acis, a Sicilian shepherd. In revenge, Polyphemus crushed Acis in Galatea's arms. Galatea was also the name of Pygmalion's statue that was brought to life.

According to both Hirschmann and Hollstein, only this subject of the series of deities occurs in a single tone block version.

I. Haarlem (Museum Teyler).
II. Boston (W. G. Russell Allen Collection), Chicago, Leningrad, London, Munich, New York (MM), Paris (BN), Paris (IN), Princeton, Philadelphia, Rotterdam, Vienna.

[1] Hirschmann, 1919, p. 133.

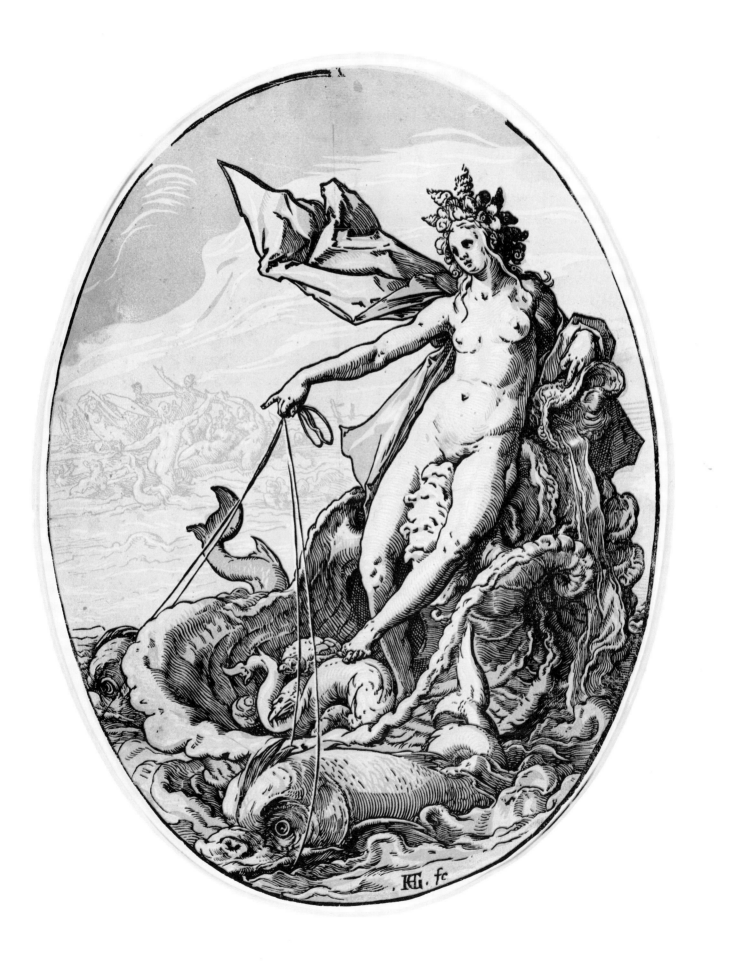

138. Pluto

With monogram: HG. fe. No date.
347 x 262 mm. (oval).
B.347; H.369; DM.62.
One line block; two tone blocks (brown/sepia, dark green/olive, pale green/beige).

In the background the "lost souls" are passing in judgment before the gods of the underworld. The four rivers of Hades spill from the urn at the lower right. Hirschmann[1] remarks that Pluto's pose is identical to that of Goltzius' "Hercules" (B.142) but seen from behind and that it is akin to No. 7 of his series of illustrations for Ovid's *Metamorphoses* (1589).[2] For the dating of this print see Plates 136 and 141.

Boston (W. G. Russell Allen Collection), Cambridge, Chicago, Cincinnati, Leningrad, London, Munich, New Haven (Yale Art Museum), New York (MM), New York (NYPL), Oberlin, *Princeton,* Paris (BN), Paris (IN), Rotterdam, Vienna.

[1] Hirschmann, 1919, p. 133.

[2] B. vol. 3, p. 104, Nos. 31-2.

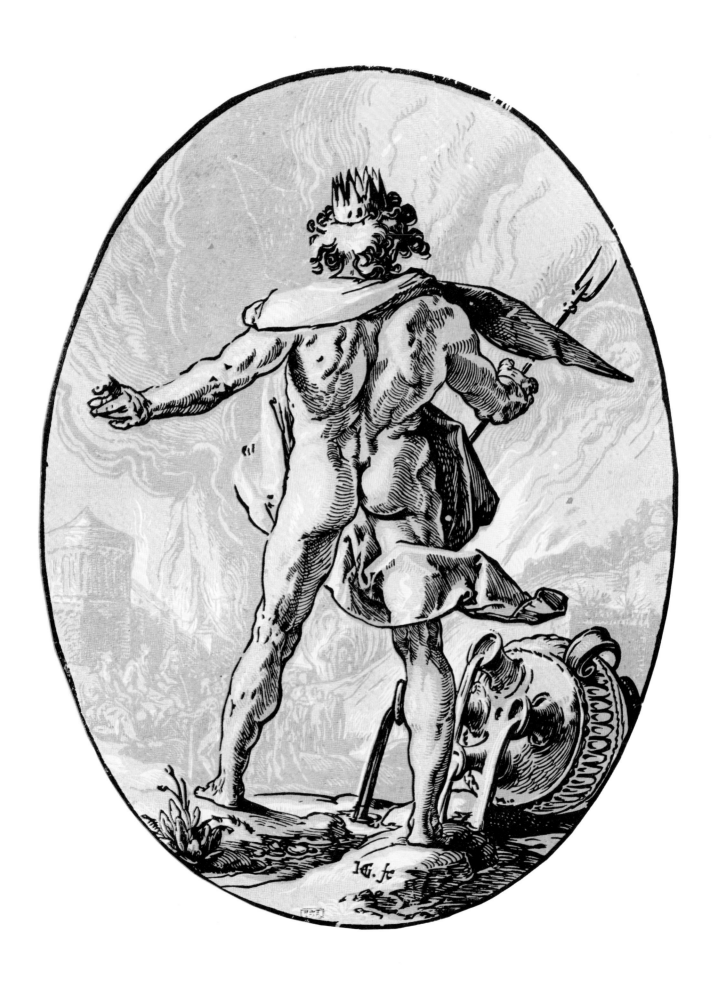

139. Proserpine

Without monogram. No date.
347 x 262 mm. (oval).
B.236; H.370; DM.63.
One line block; two tone blocks (brown/sepia, sepia/ochre).

Like the "Cave of Eternity" (Plate 135), the classical source for this subject is found in a work by Claudian, *The Rape of Proserpine (Il ratto di Proserpina,* editio princeps, Vincenza, 1482).

Hirschmann[1] calls this print the most magnificent of the series. The authors of *Dutch Art and Architecture, 1600-1800*[2] single it out to comment:

Goltzius' bold design, freedom in cutting, and sure use of tone blocks to describe forms without relying upon the black line block is seen in his colored print of Proserpine. The figure still has Mannerist proportions—the print can be dated around 1588, a few years before he went to Rome—and it is difficult to determine how the seated goddess manages to keep her balance, or to give a rational explanation for the position of the fluttering draperies; but these liberties delighted the artist and his public during this phase.

The predominance of the tone blocks in this print, as in others of this series of oval subjects, is quite in contrast to the technique of "Hercules and Cacus" (Plate 134), dated 1588. The subject matter unquestionably derives from Italian sources. A date subsequent to Goltzius' Italian journey from 1590 to 1591 seems therefore indicated for these classical deities (compare remarks for Plates 127 and 136).

Proserpine (Persephone), a daughter of Zeus and Demeter, was abducted by Pluto while she was gathering flowers on a hillside in Sicily. He carried her down to Hades and made her his queen. Upon Demeter's plea, Zeus agreed to bring Proserpine back to earth, provided she had eaten nothing in Hades. But Ascaphalus revealed that she had eaten a few pomegranate seeds. For this betrayal he was turned into an owl. Proserpine was permitted to spend six months of each year on earth, the remainder with Pluto.

Amsterdam, Berlin, Boston, (W. G. Russell Allen Collection), Cambridge, Chicago, Cincinnati, Cleveland, Leningrad, Leyden, London, Munich, New York, (MM), Paris (BN), Paris (IN), Philadelphia, *Princeton,* Providence, Rotterdam, Vienna.

[1] Hirschmann, 1919, p. 134.
[2] Jacob Rosenberg and Seymour Slive, *Dutch Art and Architecture, 1600-1800,* The Pelican History of Art, Baltimore, 1966, p. 15.

HENDRICK GOLTZIUS

140. Helios

With monogram: HG. fe. No date.
352 x 261 mm. (oval).
B.234; H.371.
One line block; two tone blocks (brown/sepia, sepia/ochre).

Helios, the Greek god of the Sun, was the son of Hyperion and the father of Phaeton. Hirschmann[1] noted that the stance resembles that of "Apollo" (B.141) of 1588. (For dating of this print, see Plates 136 and 141.)

Boston (W. G. Russell Allen Collection), Cambridge, Chicago, Leningrad, London, New York (MM), New York (NYPL), Nuremberg, Paris (BN), Paris (IN), Philadelphia, Princeton, Providence, Rotterdam.

[1] Hirschmann, 1919, p. 133.

141. Nox [Queen of Night]

With monogram: HG. f. No date.
350 x 265 mm. (oval).
B.237; R.88; H.372.
One line block; two tone blocks (yellow/green, brown/sepia, shades of gray).

A famous Carnival parade that included twenty-one floats featuring the gods of the ancients is described by B. Baldini in his *Discorso sopra mascherata della genealogia degl-iddei dei gentili* (Florence, 1565). The lead cart of this famous procession was devoted to Demogorgon, who is sitting on the *Cave of Eternity* (cf. Plate 135). The other carts showed deities and allegories referred to by Boccaccio as "Children of Demogorgon," specifically including Nox.[1] The importance attached to representations of the ancient deities in Italy during this period points to Goltzius' having become acquainted with this subject during his Italian journey. (See also Plate 136.)

Boston (W. G. Russell Allen Collection), Cambridge, Chicago, Cincinnati, Cleveland, Leningrad, London, Munich, New York (MM), New York (NYPL), Paris (BN), Paris (IN), Providence, Rotterdam, Washington.

[1] Kemp, 1969, p. 137 (cf. Pl. 135).

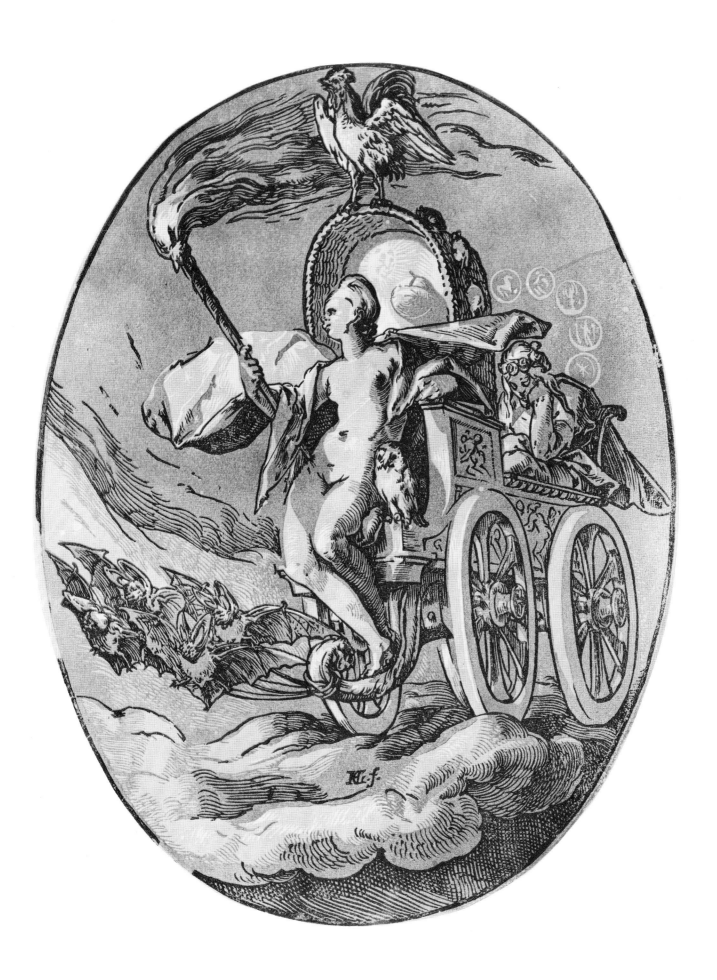

ABRAHAM BLOEMAERT

Dordrecht, 1564-1651, Utrecht. Bloemaert's family moved to Utrecht during his childhood. He first studied with his father, Cornellis Bloemaert, and later with Joos de Beer. From 1580 to 1583 Bloemaert lived in Paris. He then returned to Utrecht, where he remained until the end of his life, except for a brief stay in Amsterdam from 1591 to 1593. Together with Paulus Moreelse he founded St. Luke's Guild, the guild of the painters of Utrecht, in 1611.

Bloemart was primarily a painter. The chiaroscuro prints attributed to him may all, in fact, have been cut by others, upon his instructions, and based on his designs. Like Goltzius, he was influenced by the works of Bartholomäus Spranger.[1] In 1633, for the sum of 3,400 thalers,[2] Bloemaert purchased a number of items from the estate of Albrecht Dürer which had come into possession of Hans Hieronymus Imhof of Nuremberg. In this connection, it is interesting to note that a painting of "Adam and Eve," signed "B" and dated 1576, has been attributed to Bloemaert's teacher, Joos de Beer.[3] This painting is an almost exact copy of Dürer's engraving of the same subject (B.1).

142. Moses

Imprinted: *A. Bloemart inuen.* No date.
311 x 228 mm.
LeB.1; H.5.
One line block; two tone blocks (brown/sepia).
Watermark: Grape.

Basel, Boston (W. G. Russell Allen Collection), Leyden, Munich, New York (MM), New York (NYPL), Paris (BN).

[1] E. K. J. Reznicek, *Die Zeichnungen des Hendrick Goltzius,* Utrecht, 1961.

[2] A. von Eye, *Leben und Wirken Albrecht Dürer's,* Nördlingen, 1869, p. 487; Moritz Thausing, *Albrecht Dürer und seine Kunst,* vol. 1, Leipzig, 1884, p. 189. (Thausing mistakenly writes 34,000 thalers and quotes Imhof's diary entry: "Praise and thanks to God to have made such a good sale. There was not one major work among all the items sold, mostly small ones and watercolors, some of doubtful authenticity.")

[3] H. Kauffmann, "Dürer in der Kunst und im Kunsturteil um 1600," *Vom Nachleben Dürers,* Nuremberg, 1954, p. 38.

Gustav Delbanco, *Der Maler Abraham Bloemaert,* Strassburg, 1928.

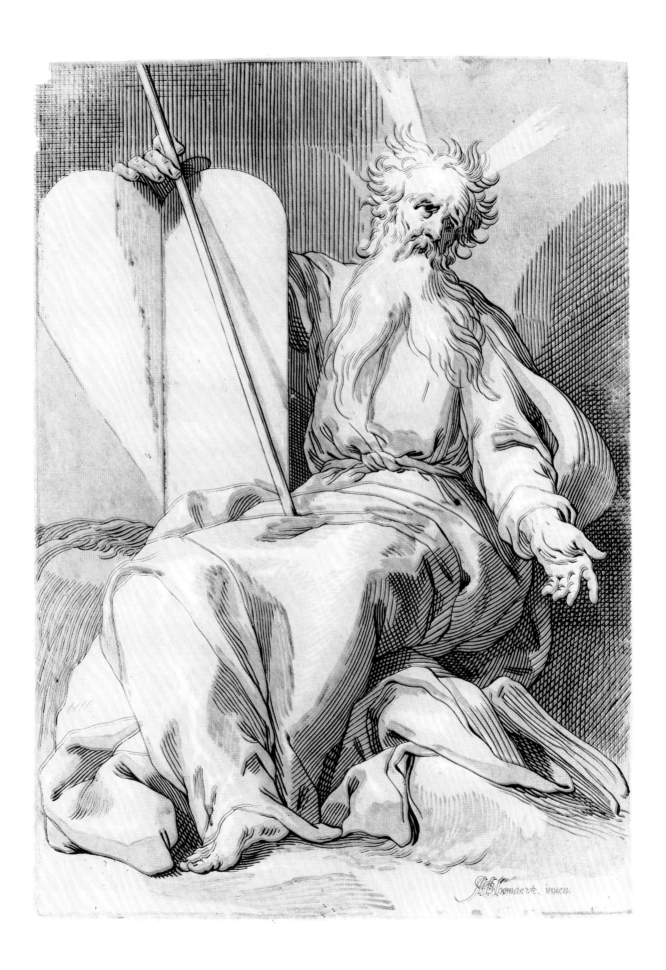

143. Aaron

Imprinted: *A. Bloemaert inuen.* No date.
311 x 228 mm.
P. p. 124; LeB.2; R.93; H.6; DM.27b.
One etched line plate; two tone blocks (oche/sepia).

Preparatory drawing in Boston (Museum of Fine Arts, No. 56.610; illustrated in DM.19a, Plate 46). A drawing of the same subject is in Paris (Bibliothèque Nationale, Lugt, F. 1936, No. 197).

This print was prepared by an anonymous artist, based on Bloemaert's invention.

Amsterdam, Boston (W. G. Russell Allen Collection), New Haven (Yale Art Museum), Munich, New York (MM), New York (NYPL), Paris (BN), Vienna.

144. The Holy Family in Half-Length

With monogram: AB. No date.
90 x 76 mm.
H.7.
One line block; two tone blocks (brown/sepia, tan/beige).

S. R. Koehler, in his notes in Worcester,[1] attributed this print to Büsinck. Stechow[2] terms the attribution to Büsinck incorrect. However, this print probably served as a model for Büsinck's "Holy Family" (Plate 73). Joseph is holding a cloth behind Mary. The work is closely related to an early drawing by Bloemaert at the Albertina in Vienna (*Catalogue,* 1928, No. 419).

Amsterdam, *Berlin* (Inv. 588-54, Büsinck), Boston (W. G. Russell Allen Collection), Leyden, London, New York (MM; Büsinck), Paris (L), Paris (BN), Philadelphia.

[1] Cf. Bibliography.

[2] Wolfgang Stechow, *Print Collector's Quarterly,* vol. 26, 1939, p. 359, III.

145. The Three Maries

With monogram: AB. No date.
95 x 82 mm.
H.8.
One line block; two tone blocks.

Boston (W. G. Russell Allen Collection), Leyden, London, New York (MM),
Paris (BN), *Rotterdam*.

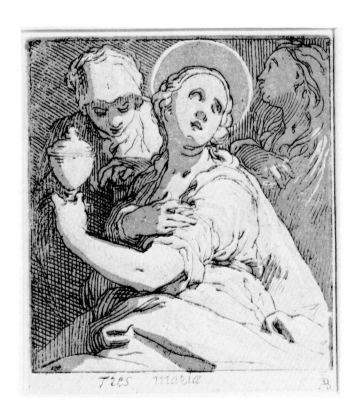

Tres mariae

146. St. Jerome, Reading

With monogram: AB. No date.
70 x 60 mm.
LeB.9; H.9.
One line block; two tone blocks.
Watermark: Jug with two handles.

London (united on one sheet with "Virgin and Child," Plate 147), Munich,
New York (MM), *Rotterdam*.

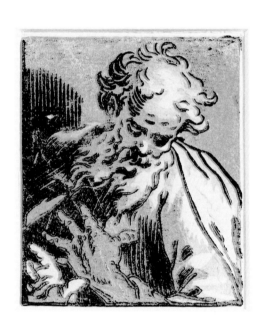

ABRAHAM BLOEMAERT

147. Virgin and Child

With monogram: AB. No date.
68 x 54 mm.
IN.190; DM.27a.
One line block; two tone blocks.

Amsterdam, *Boston* (W. G. Russell Allen Collection), London (united on one sheet with "St. Jerome," [Plate 146]), Northampton (Mass.), Paris (BN), Philadelphia.

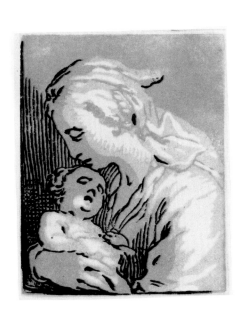

148. The Magdalen in a Cave [facing left]

With monogram. No date.
145 x 111 mm.
LeB.15; H.10.
One line block; one tone block.

Berlin, Boston (W. G. Russell Allen Collection), Cincinnati, Paris (BN), *Rotterdam*.

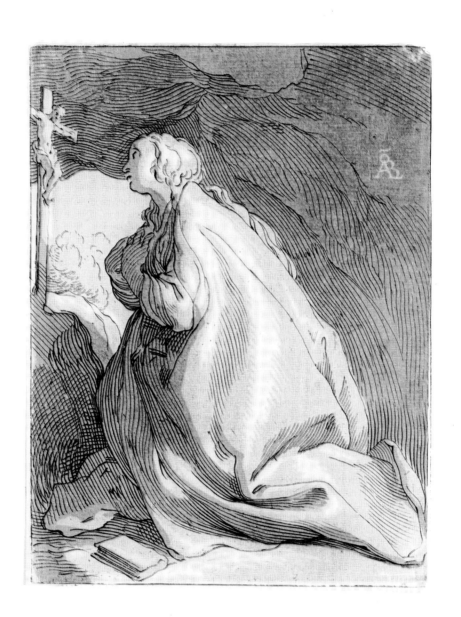

149. The Magdalen [facing right]

Imprinted: *A. Bloemaert inue. B.A. Bolswert fec. et excu.* No date.
137 x 86 mm.
LeB.14; H.354.
One line block; one tone block.

B. A. Bolswert (1588-1633), a student of Bloemaert, was active in Haarlem in 1612. After 1620 he resided in Antwerp. He engraved several of Bloemaert's and Rubens' works. "The Magdalen" is the only one of Bloemaert's chiaroscuro prints with Bolswert's imprint, although there are a number in black and white (e.g., Juno [H.4]) with the same signature.

Amsterdam, Boston (W. G. Russell Allen Collection), London, Munich, New York (before the imprint), Paris (BN).

150. The Holy Family Resting on the Flight to Egypt*

Imprinted: *Bloemaert inv.* No date.
H.596. (By an anonymous artist after Abraham Bloemaert.)
One line block; one tone block.

151. Elephant*

Large Folio.
One line block; one tone block.

Listed in Joseph Heller, *Lexicon der vorzüglischsten Kupferstecher und Lithographen,* Bamberg, 1823, p. 103; but omitted in the second edition, Leipzig, 1850.

*Location unknown. Not illustrated.

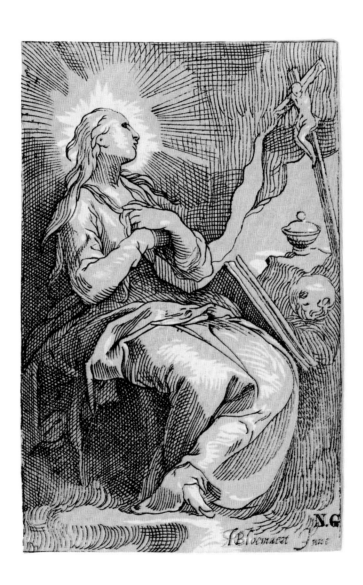

J Bloemaert fecit

PAULUS MOREELSE

1571-1638. Born in Utrecht, Moreelse traveled to Italy in 1600. He returned to his native city in 1602. In 1611, together with Abraham Bloemaert, he became the co-founder of St. Luke's Guild, the guild of the painters of Utrecht. Only two chiaroscuros bear his name. Both are Mannerist in style. The initial H beneath his signature on one of these suggests that the actual cutting was attended to by another artist.

152. Death of Lucretia

Imprinted: *P. Moreelse In/ 1612/ H*. Dated 1612.
292 x 357 mm.
P. I, p. 124; R. p. 45; H.1; IN.258-260.

I. Line block only.
II. One line block; one tone block. Watermark: Three Crowns above an Escutcheon.
III. See Plate 152A.

The initial H was attributed by Nagler, followed by Passavant (vol. 1, p. 124), to Hendrick Hondius (1573-1646), an engraver active in The Hague. Hondius had been a student of J. Wierix. There is no evidence that he ever issued chiaroscuros. The assertion is perhaps based on the mistaken notion that it had been Hondius who added the tone blocks to Albrecht Dürer's woodcuts "Ulrich Varnbühler" (Plate 1) and "The Rhinocerus" (Plate 2).

I. Amsterdam.
II. Amsterdam, Boston (W. G. Russell Allen Collection), Cambridge, *New York* (MM; Rogers Fund), Paris (BN), Rotterdam.
III. See Plate 152A.

Nagler, *Künstler Lexicon*, vol. 9, p. 457; *Monogrammisten*, vol. 3, p. 554; vol. 4, p. 313.
LeB. vol. 3, p. 46.
Wurzbach, vol. 2, p. 186.

Thieme-Becker, xxv, p. 131.
C. H. de Jonge, *Paulus Moreelse, Portret en Genreschilder te Utrecht, 1571-1638*, Assen, 1938.

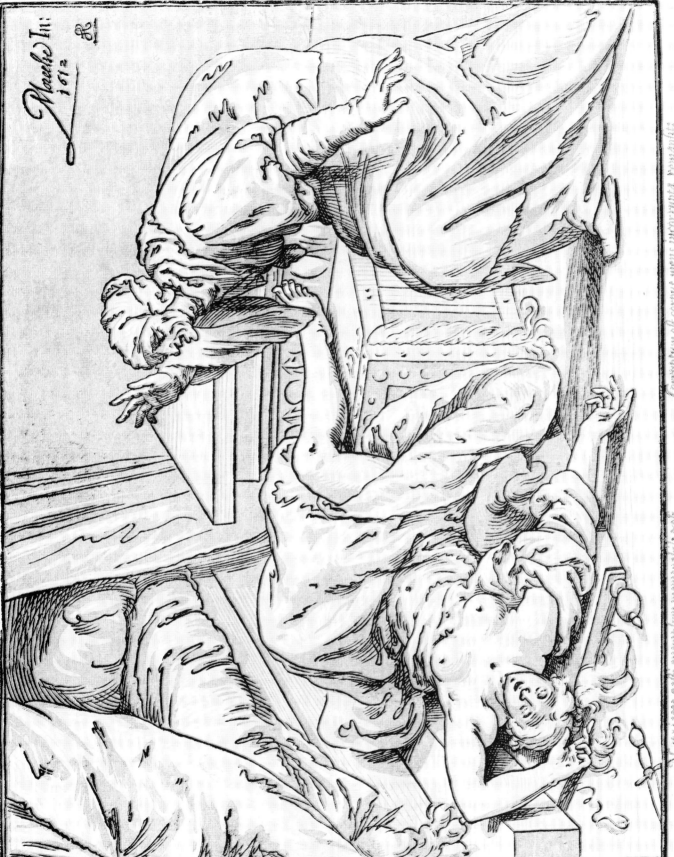

"Noemb III:" "1612"










Corruptum est corpus, mens incorrupta remansit,
In te damnasti, cur scelus alterius?

Natu vices, casti exemplum memorabile Leti,
Nata taces, gemino sed superata malo.

II

152A. Death of Lucretia

III. One line block; one tone block (gray). The letter H obliterated by vertical lines added to the background in the line block. Watermark: Emblem of Basel (akin to Briquet 1309; Meder 212). The same paper was used for the 1603 reprint of Dürer's *Unterweisung der Messung* by Joh. Janssen, Arnhem.

Boston (W. G. Russell Allen Collection), Munich, *New York* (MM; gift of Janos Scholtz), Paris (IN), Philadelphia, Princeton.

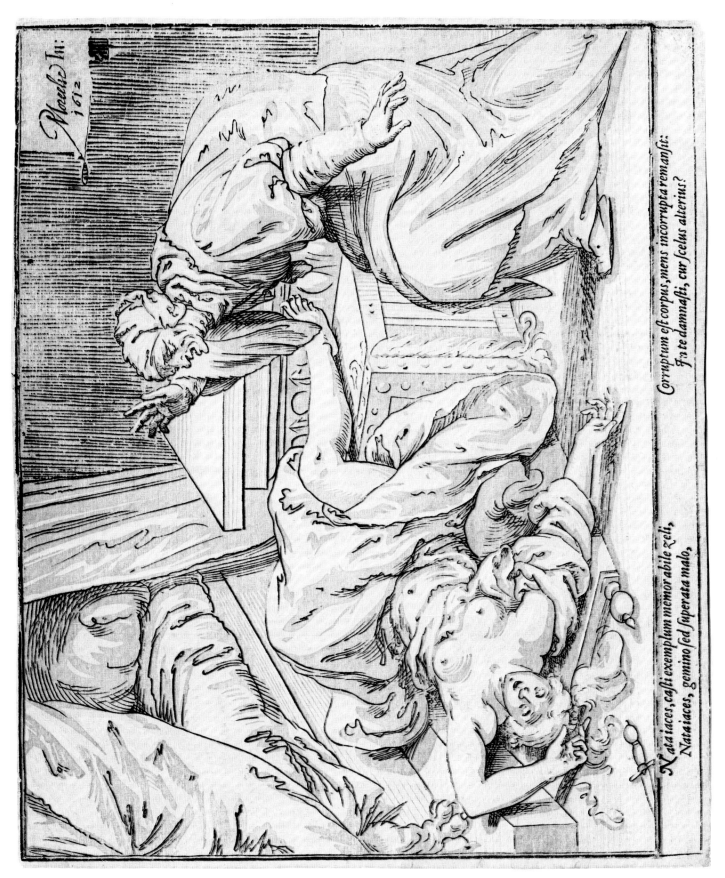

Casta iaces, casti exemplum memorabile zeli,
 Nata iaces, gemino sed superata malo,
Corruptum est corpus, mens incorrupta remansit:
 Fr te damnasti, cur scelus alterius?

153. Cupid Dancing with Two Nymphs

Imprinted: *P. Moreelse 1612*. Dated 1612.
237 x 290 mm.
H.2; DM.77; IN.261-262.
One line block; one tone block (shades of gray or of tan).
Watermark: Coat of Arms with a Diagonal Bar in the Escutcheon (Heawood 601).[1]

The text comprises a warning against frivolous living.

Boston (W. G. Russell Allen Collection), Cambridge, Cleveland, Munich,
New York (MM), *Oberlin* (Wolfgang Stechow Collection), Paris (BN),
Paris (IN), Rotterdam.

[1] Edward Heawood, *Watermarks, Chiefly of the 17th and 18th Centuries*, Hilversum, 1950.

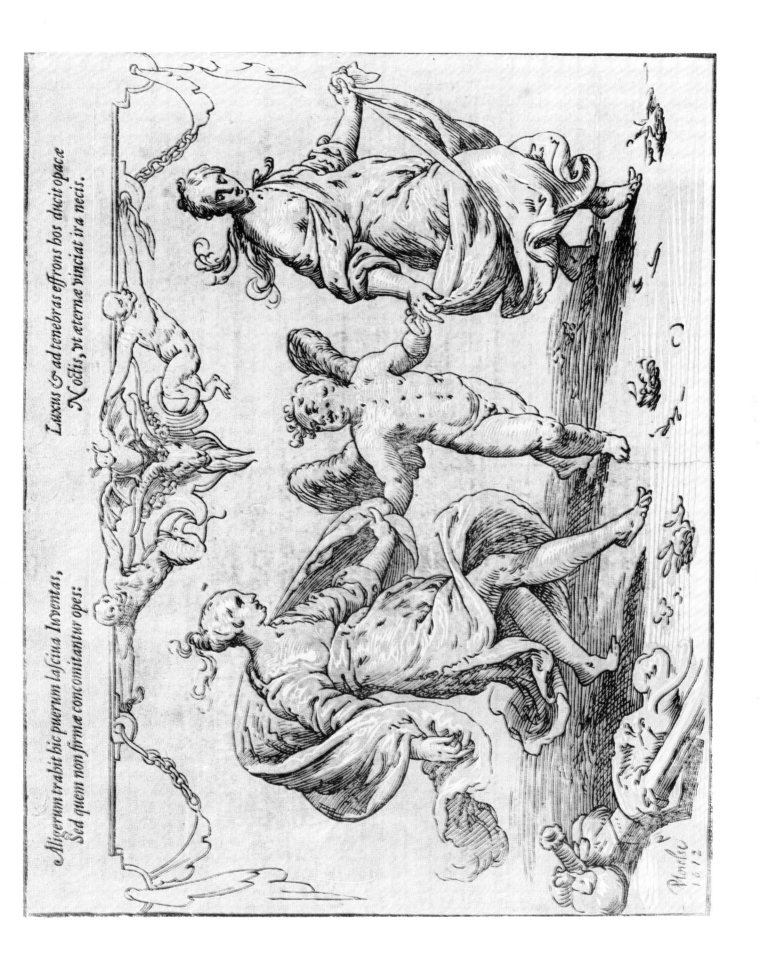

Aligerum trahit hic puerum lasciua Inuentas,
Sed quem non firmæ concomitantur opes:

Luxus & ad tenebras effrons bos ducit opacæ
Noctis, vt æternæ vinciat ira necis.

Ploelse
1612

CHRISTOFFEL VAN SICHEM II

Basel, 1581-1658, Amsterdam. Active in Leyden from 1602 to 1606, in Amsterdam from 1606 until his death in 1658. Although he is often called a student of Hendrick Goltzius, there is no documentary evidence to support this contention.[1] Van Sichem provided 797 Old Testament woodcut illustrations for the *Bibels Tresoor ofte der Zielen Lvsthof vytgebeelt in Figueren door verscheyden Meesters,* Amsterdam (Paets), 1646. These are copied from woodcuts and engravings by Dürer, Lucas van Leyden, Aldegraever, H. S. Beham, and others. He also issued single-sheet copies of Dürer's prints, including the "Apocalypse," "St. Anthony," and "St. Christopher." Van Sichem became a Mennonite in 1655.

154. Judith with the Head of Holofernes

Imprinted: *C V Sichem scul HG.* (Bottom left.) No date; circa 1630.
135 x 115 mm.
B.III, p. 126, No. 1; P. III, p. 471; LeB.12; Wu.16.

I. Line block only.
II. One line block; one tone block (sepia).
III. Copy in reverse. Imprinted HG only. Line block only, printed on blue paper.

Nagler[2] called this "a beautiful print, based on a drawing by Goltzius in the style of Lucas van Leyden." It can be dated in close proximity to five other woodcuts by van Sichem after Goltzius. Two of these, "Adoration of the Magi" and "Circumcision of Christ," are dated in the block 1629. This chiaroscuro print also served as the model for the woodcut illustration in *Bibels Tresoor* (p. 647) of 1646, but for this purpose it was copied onto a new block. The signature was moved to the bottom center for this edition.

Twenty-six biblical woodcuts by van Sichem, printed on blue paper, are contained in an Armenian edition, entitled: *Zamakardouthioun hasarakaj alotic,* Amsterdam, 1705.[3]

I. Paris (IN), Princeton.
II. Amsterdam, *Boston* (W. G. Russell Allen Collection); Cambridge, New York (NYPL; watermark: Viola), Paris (IN).
III. New York (NYPL; on blue paper; no watermark).

[1] H. F. Wijnman, "De Van Sichem-Puzzle," *Oud Holland,* 1929, p. 233.
[2] *Neues allgemeines Künstler Lexicon,* Munich, 1846, p. 349, No. 18.

[3] Joseph Heller, *Albrecht Dürer,* vol. 2, Bamberg, 1827, No. 346.

Thieme-Becker, xxx, p. 585.

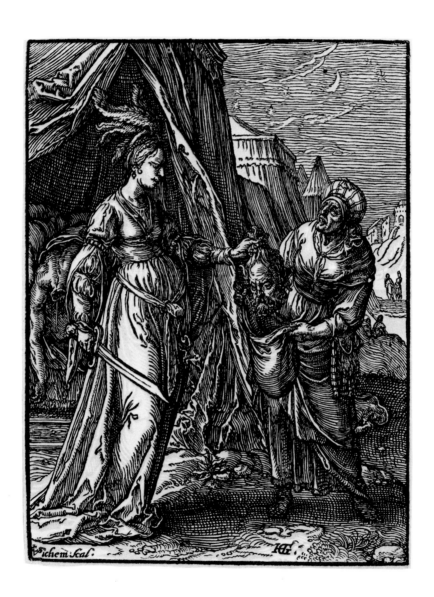

WERNER VAN DEN VALCKERT

Amsterdam[?], circa 1585-1630, Amsterdam[?]. Painter and graphic artist.
Reputedly a student of Hendrick Goltzius and probably influenced also by
Cornelis Cornelisz van Haarlem. Van Valckert was known to be active in Copenhagen
for a number of years. His attempt to move away from a purely linear quality to a
confluence of lines in order to achieve tonal effects in his woodcuts
anticipates the technique later used by Jan Lievens[1] (cf. Plate 162).

155. Plato

Imprinted: *W. V. V. inv.* Dated 1620.
Nagler, *Monogrammisten,* vol. V, p. 396; Bruillot, vol. II, No. 7769; Wu.14.
One line block; one tone block.

Companion piece of the following print. Plato's gesture of raking his beard with his fingers was a traditional one for wise men and philosophers.

Paris (BN), Rotterdam, Vienna.

[1] H. T. Musper, *Der Holzschnitt in fünf Jahrhunderten,* Stuttgart, 1944, p. 287.

Thieme-Becker, xxxiv, p. 53 (K. G. Boon).

F. W. Hudig, "Werner van den Valckert I," *Ood Holland,* vol. 54, 1937, pp. 54-56.

W.V.V.Inv. PLATO. 1620.

156. Charon

Without monogram. No date; circa 1620.
Nagler, *Monogrammisten,* vol. V, p. 396; Wu.15.

I. Line block only.
II. One line block; one tone block.

According to Greek mythology, Charon ferried the dead across the river Styx to Hades. Often a coin was placed under the tongue of the deceased to pay his toll. True to Virgil's description, Charon's beard is gray and unkempt, his eyes glow and stare, and his garment is tied to his shoulder by a knot (*Aeneid,* VI:298).

I. *Rotterdam.*

CHRISTOFFEL JEGHER

Antwerp, 1596-1652, Antwerp. Christoffel Jegher, reputedly of German descent, probably studied with Christoffel van Sichem. He is mentioned in the register of St. Luke's Guild of the Painters of Antwerp as "houte printsnyder" in 1627. From 1625 to 1643 he provided illustrations for the printing establishment of Plantin at Antwerp. Sometime after 1633 Jegher began producing elaborate woodcuts after designs by Peter Paul Rubens. These prints are distinguished by a softness of tone, exquisite lighting, and a remarkable coloristic effect.[1]

157. Christ in Half-Length

Imprinted: *Christopherus Iegher sculpat.* 1633.
395 x 262 mm.
Wijngaert 312; H.9.
One line block; one tone block (sepia).

This woodcut is based on Raphael, as indicated by the inscription beneath the print: *"Raphaeli Vrbinatis pencillo as sacrae vetustatis prototype expressan Eras-* *mus Quell delineabat, Christopherus Iegher sculpat."* For Erasmus Quellin, who provided the design, see also Plate 158.

Amsterdam (black on white with retouchings in brown brush), *London*, Rotterdam.

[1] Jegher's prints after Rubens are: "Silenus," "Hercules," "Susanna and the Elders," "Temptation of Christ," "Coronation of the Virgin," "Garden of Love" (two versions), "Ferdinand of Austria," "Ascension of the Virgin," "Flight to Egypt," "The Infant Christ and St. John," and "Giovanni Cornaro." Not all these exist in chiaroscuro.

Thieme-Becker, XVIII, p. 487. Adolph Rosenberg,

Die Rubensstecher, Vienna, 1888, pp. 158-62. Frank van Wijngaert, *Inventaris der Rubenschen Prentkunst,* Antwerp, 1940, pp. 61-3. Frank van Wijngaert and H. F. Bouchery, *P. P. Rubens en het Plantijnische Huis,* Antwerp, 1941. Mary L. Myers, "Rubens and the Woodcuts of Christoffel Jegher," *The Metropolitan Museum of Art Bulletin,* vol. 15, 1966, pp. 7-23.

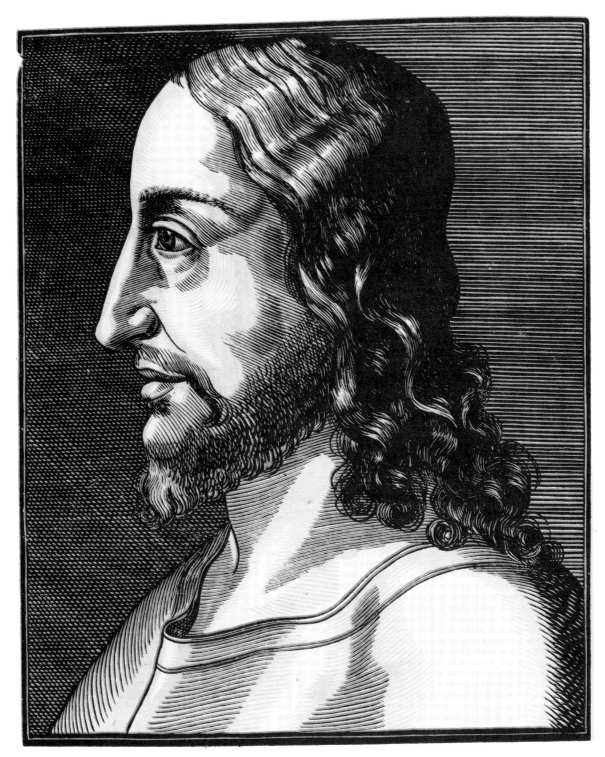

IESV DVLCISSIME, BENIGNISSIME, AMANTISSIME, CHARISSIME, POTENTISSIME,
DESIDERATISSIME, PRETIOSISSIME, AMABILISSIME, PVLCHERRIME,
QVANDO VENIAM, ET APPAREBO ANTE FACIEM TVAM? D. Augustinus in Meditationibus.

REVERENDISSIME IN CHRISTO PATER MVTI VITELLESCE GENERALIS, ET VOS SOCIETATIS IESV OMNES, VERE VIRI DE.
DEI-HOMINIS, *speciosißimi Regis, indeficientem contemplationem vobis, imò vniuerso populo Christiano, diuina hac imago offert; quæ in manibus, in osculis, in summâ veneratione S.*IGNATIO *Societatis vestræ Auctori fuit.* QVINTINVS CHARLARTVS, *tanti Patris amicus, deinde Filius, suspicienda veritatis tabulam (Deo simillimam esse, diuinorum participes pronuntiauerunt)* ROMA *in* BELGIVM *detulit: ac postmodum Matri sua dono dedit. apud heredes mansit, donec toto ferè vertente sæculo, in possessionem venit* Io. VVAVERI *Antuerpiensis*, *Equitis*, REGI CATHOLICO *à Consilijs: qui deuoto adfectu piorum amori venerabile cimelium consecrauit, & propter suum suáq; coniugis futurum sepulchrum viuus, sed morti intentus,* HALLIS *in æde* DEIPARÆ VIRGINIS *dedicauit.* M. DC. XXXIII.

Vrbanus ... Vrbinatis penicillo ad sacræ vetustatis prototypos cemelam, Erasmus Quell. delineabat, Christophorus ...

CHRISTOFFEL JEGHER

158. Three Roman Kings

Diameter: 165 mm.
H.201; Thieme-Becker, XVIII, p. 487; Wu.20.
One line block; one tone block (sepia).

An example of 144 medallions picturing the kings and emperors of Rome in the second edition of Hubert Goltzius' *Icones Imperatorum Romanorum, ex priscis Numismatibus ad vivum delineatae, et brevi Narratione Historica illustrae . . . Accessit modo Impp. Romano Austriacorlum Series, Stylo et Opera Casperii Gevartii . . .* Antwerp, Ex Officina Plantiniana Balthasaris Moreti, 1645 (also in French, *Les Images presque de tous les Empereurs de Rome,* Antwerp, 1645). Jegher prepared these illustrations, slightly larger than those of the original edition (cf. Plate 113) and added nineteen after designs of Erasmus Quellin. These additional designs probably date from circa 1631-32. One of Quellin's preparatory drawings remains at the Museum Plantin-Moretus in Antwerp.[1] A third edition was published in Antwerp in 1708, printed by Hendrick and Corneel Verdussen.

Boston (W. G. Russell Allen Collection).

[1] Wijngaert, 1941, Nos. 228, 229, 323.

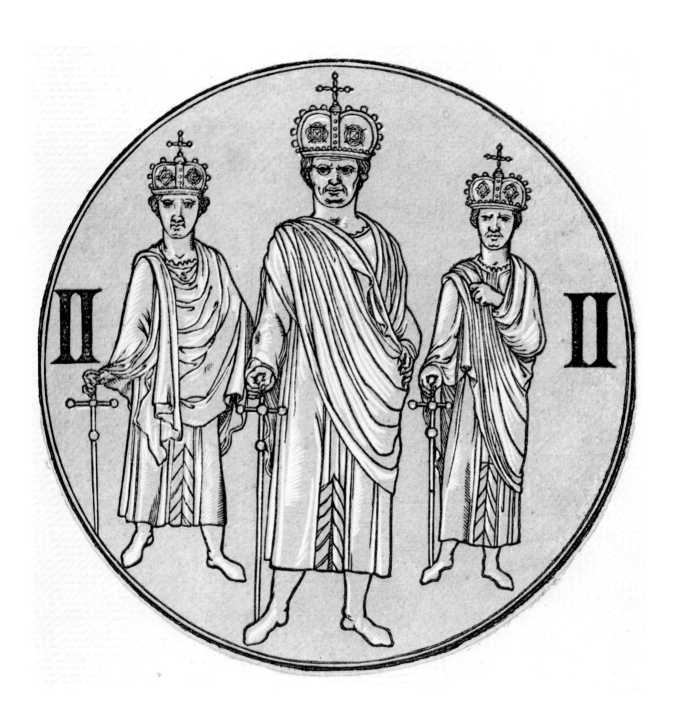

159. Portrait of Giovanni Cornaro

Imprinted: *P. P. Rubens del et exud., Christoffel Jeghers sculp.* No date.
284 x 219 mm.
R.92; H.20; LeB.17; Wu.16; Wijngaert 320.

 I. Line block only.
 II. One line block; two tone blocks.
 III. Without the address.

According to Le Blanc, this is perhaps a portrait of Rubens' brother.
Rosenberg[1] suggests it portrays Giovanni Cornaro, Doge of Venice.

 I. Amsterdam.
 II. Boston (W. G. Russell Allen Collection), Cambridge, London, Munich,
 New York (MM), Philadelphia, Rotterdam, *Vienna.*

[1] Rosenberg, 1888, p. 160.

CHRISTOFFEL JEGHER

160. Flight to Egypt

Imprinted: *c.i.P.P.Rub. delin. exec. CUM PRIVILEGIIS, C. Iegher sculp.* Circa 1635.
463 x 603 mm.
LeB.4; Wu.5; H.4; IN.251-255; Wijngaert 315.

 I. Line only.
 II. Trial impression before the address.
 III. See Plate 160A.
 IV. See Plate 160B.

 I. London, Rotterdam.
 II. *Amsterdam* (trial impression with corrections by Rubens hand; black/orange).
 III. See Plate 160A.
 IV. See Plate 160B.

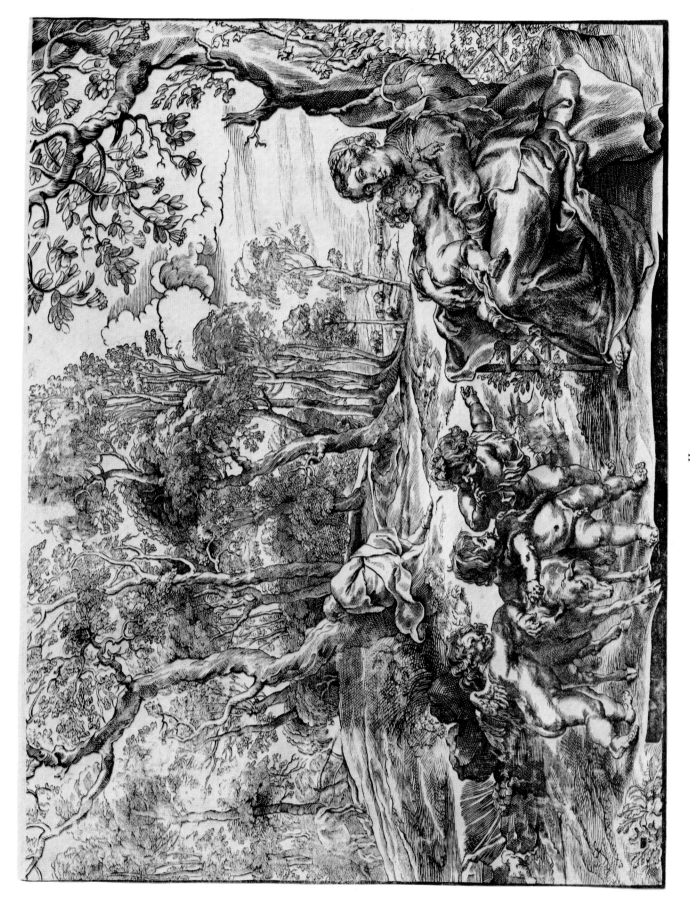

160A. Flight to Egypt

III. One line block; two blocks. Some lines removed from the sky.

Amsterdam, Antwerp, Cologne, London, New York (MM), Paris (BN), Paris (IN), Rotterdam.

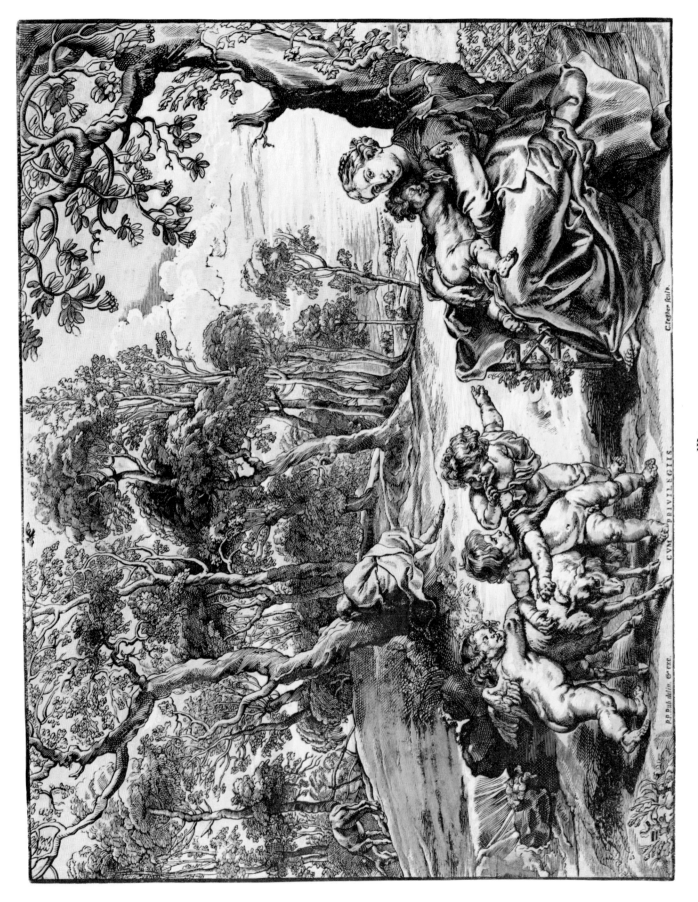

P.P. Rub. delin. & exc. CVM PRIVILEGIIS. C. Galle sculp.

III

160B. Flight to Egypt

IV. One line block; two tone blocks. Further lines and clouds removed
from the line block.

Amsterdam, New York (MM).

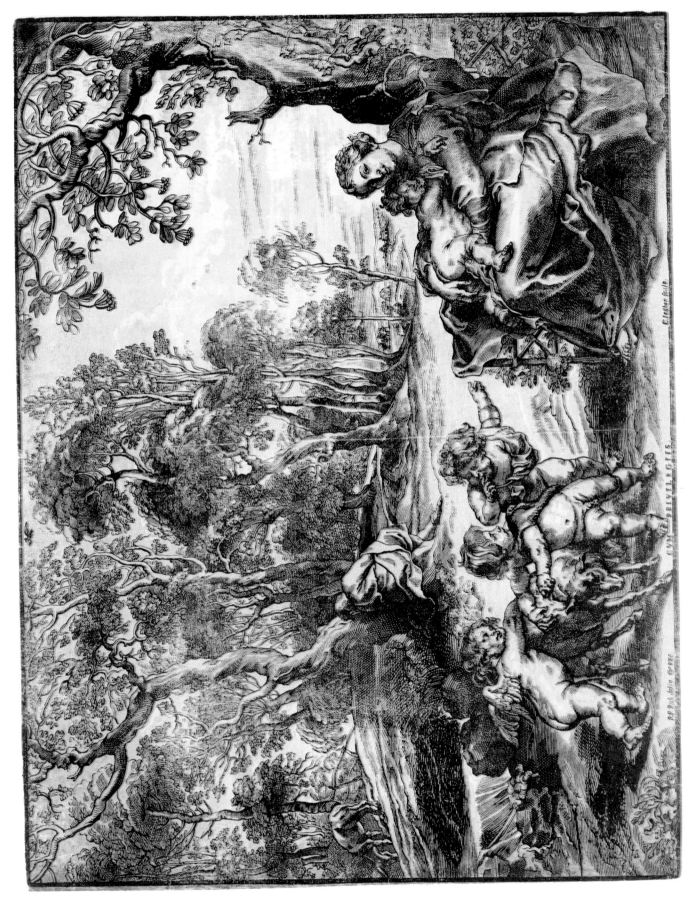

IV

161. The Infant Christ and St. John Playing with a Lamb

Imprinted: *P. P. Rubens delin. et excudit, C. Iegher sculp. CUM PRIVILEGIIS.* No date.
340 x 455 mm.
LeB.5; Wu.6; H.5; Wijngaert 316.

 I. Line block only; with corrections by Rubens.
 II. Line block only with Rubens' address. Watermark: the letter M.
 III. "Et excudit" eliminated.
 IV. One line block; one tone block.

Based on a painting by Rubens that exists in several versions, of which the best
is at the Palazzo Balbi in Genoa.[1]

 I. Paris (BN).
 II. New York (NYPL), Rotterdam.
 IV. London.

[1] Rosenberg, 1888, p. 159.

P. P. rub delin.
& excudit.
Cliquet sculp.

CVM PRIVILEGIIS.

IV

JAN LIEVENS

Leyden, 1607-1674, Amsterdam. Jan Lievens, one of the most talented artists
of the circle of Rembrandt, seems to have felt called upon, in contrast to Rembrandt,
to make use of the medium of woodcuts. These are remarkable for their nonlinear quality
and an emphasis on tonal values. A number of these woodcuts are closely akin
to the chiaroscuro woodcuts of Ludolph Büsinck.[1]

162. Head of an Old Man

Without monogram. No date.
178 x 136 mm.
Wu.70; R. p. 47; H.106.
One line block; one tone block (light green or light orange).

Musper[2] asserts that Lievens unquestion-
ably cut his own blocks, especially in view
of his innovative technique that dispenses
with strict lines, replacing these with frag-
mented surfaces of uneven shapes or poly-
gons. However, the impression of this
woodblock in London[3] is inscribed: *Johan-
nes Lievens pinxit, Francis du Sarp sculp.*,
contradicting Musper's theory. Although
this is the only true chiaroscuro print by
Lievens, there are some impressions of his
other woodcuts with faintly colored back-
grounds.

Boston (W. G. Russell Allen Collection; with some additional highlights in the tone block),
Chicago, London, Munich, New York (MM), Paris (IN), Rotterdam, Vienna.

[1] Wurzbach, vol. II, p. 47.
[2] H. T. Musper, *Der Holzschnitt in fünf Jahrhun-
derten,* Stuttgart, 1944, p. 280.
[3] H. Schneider, *Jan Lievens, sein Leben und seine
Werke,* Haarlem, 1932, p. 269 (cf. 2nd edition,
Amsterdam, 1972, with supplement by E. O. Ekkart);
D. Rovensky, *L'Oeuvre gravée des élèves de Rem-
brandt,* St. Petersburg, 1893, No. 70.

A. M. Hind, "The Woodcut Portraits of Jan Lie-
vens and Dirck der Bray," *The Imprint,* 1914, pp.
233-30. Carl Ernst Köhne, "Studien zur Graphik
von Ferdinand Bol und Jan Lievens," *Dissertation,*
Bonn, 1932.

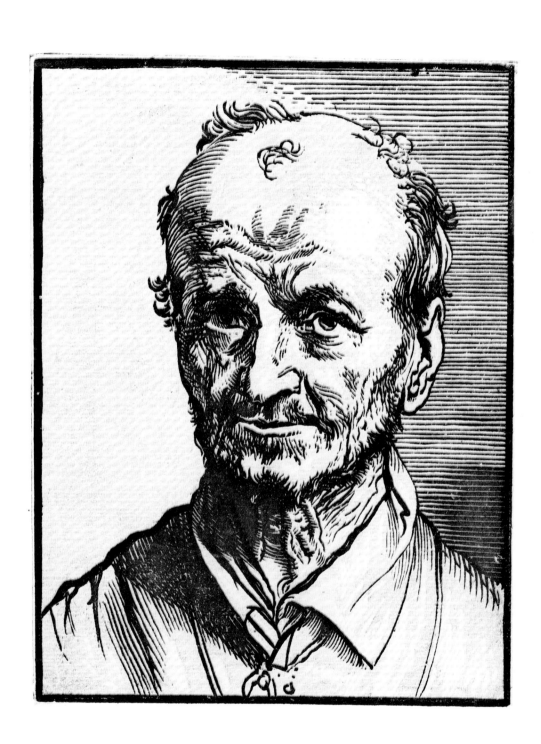

PIETER KINTS

Circa 1600-1660. Active in Brussels 1620; in Holland until 1635.

163. Death of St. Rochus

Imprinted: *A. Sallaert pinx. P. K.* Dated 1635.
225 x 150 mm.
Nagler, *Künstler Lexicon,* VII, p. 25; Nagler, *Monogrammisten,* IV, 3076; A.2; Wu.2; H.1.

I. Line block only. Printed on blue or brown tinted paper.
II. One line block; one tone block.

St. Rochus' life was devoted to healing those afflicted by the Plague. He is credited with effecting many miraculous cures. Accused of espionage, St. Rochus died in prison at Montpelier on August 16, 1327.

In this print, St. Rochus is pictured together with St. Christopher, St. Sebastian, and St. James (identified by his symbols, a pilgrim's staff and a shell).

Rotterdam (with highlights added in white chalk; from the J. Wünsch and the Dr. Bierens de Haan collections).

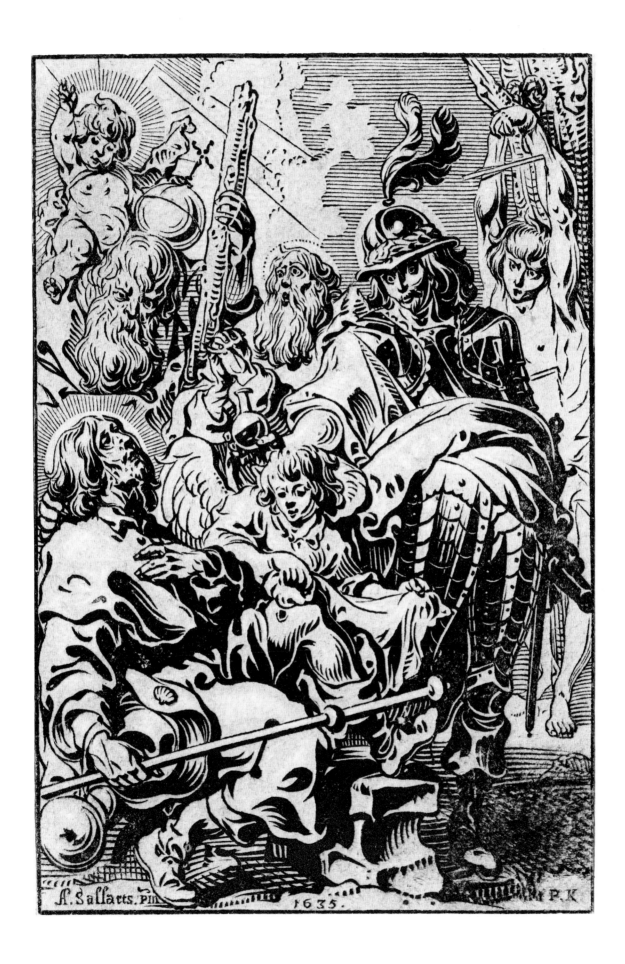

A. Sallaerts. *pin* 1635. P.K

FREDERICK BLOEMAERT

1610-1669.

Het Konstryk Tekenboek van Abraham Bloemaert (Abraham Bloemaert's Drawing Manual) was issued by Frederick Bloemaert, Abraham Bloemaert's youngest son, sometime before 1652. It went through several editions with variations in the number of illustrations, some of which were endowed with tone blocks.

LeB.35-155; Wu. vol. I, p. 112, No. 8; R.94; H.36-155.

1. *First edition:* no date. Imprinted below the illustration (cf. Plate 164) on the title page: *Prima Pars artis Apelles, liber studiosa juventus Aptata ingenio fert rudimenta tuo: Hoc duce carpe viam, membratim tota figura Discitur, his gradibus scandare as alta debit. Abraham Bloemaert inventor, Frederick Bloemaert fecit et excudit.*

 120 illustrations divided into six parts with subtitles. No date.
 Watermark: Crowned Escutcheon with Fleur-de-lis. London.

2. *Expanded edition: Oorsprongkelyk en Vermaard Konstryk Tekenboek van Abraham Bloemaert, Nicolaus Visscher excudit, cum Privilegium Ordinum Hollandiae et Westfrisiae.* Amsterdam.

 160 illustrations divided into eight parts with subtitles. No date, but printed after 1652.[1] Two additional chiaroscuros added (Nos. 170, 172).
 Watermark: Crowned Escutcheon with Fleur-de-lis. Paris (BN).

3. *Third edition:* Identical to II but imprinted, in addition: *Amsterdam, R. en J. Ottens, 1740.* Frontispiece added (No 171).
 Watermark: Coat of Arms with Cross and Dagger and the Roman Numeral VI.

4. *French edition:* Identical to III but with French section titles. New York (NYPL).

5. *Late edition:* Identical to III but only two chiaroscuros (Nos. 167, 172) in addition to the titlepage.

[1] Nicolas Visscher (1618-1709) took over the direction of his father's extensive printing and publishing establishment upon the death of Claes Jansz Visscher II (1586-1652).

THE
SKETCHBOOK
OF ABRAHAM
BLOEMAERT

164. The Artist and His Models

Imprinted: *Abraham Bloemaert inventor, Fredericus Bloemaert filius fecit, No. 1.*
308 x 225 mm.
LeB.35; R.94; H.36.
One line block; two tone blocks (brown/sepia).

The title page of Abraham Bloemaert's *Tekenboek*, it is patterned partly on the frontispiece of Odoardo Fialetti's *Il Vero Modo et Ordine Perdessignar Tutte Le Parti et Membra del Corpo Humano,* Venice (Sadeler), 1608.

Practicing drawing from plaster models was specifically recommended by Carel van Mander in *Het Schilderboeck,* Haarlem, 1604, *Den Grondt der edel fry schil-derconst,* fol. 8, ch. 2, par. 12:

"In regard to prints with a tone background adorned with highlights, you should look at those after the famous Parmens[1] and others. They will open your eyes and show how to draw with washes to give the effect of light and dark and of three-dimensionality. You can practice this by using good plaster casts for models."

Bennington (J. S. Held), Boston (W. G. Russell Allen Collection), Cambridge, Coburg, Chicago, London, Munich, New York (NYPL), Vienna.

[1] Francesco Mazzola [Il Parmigianino] (1503).

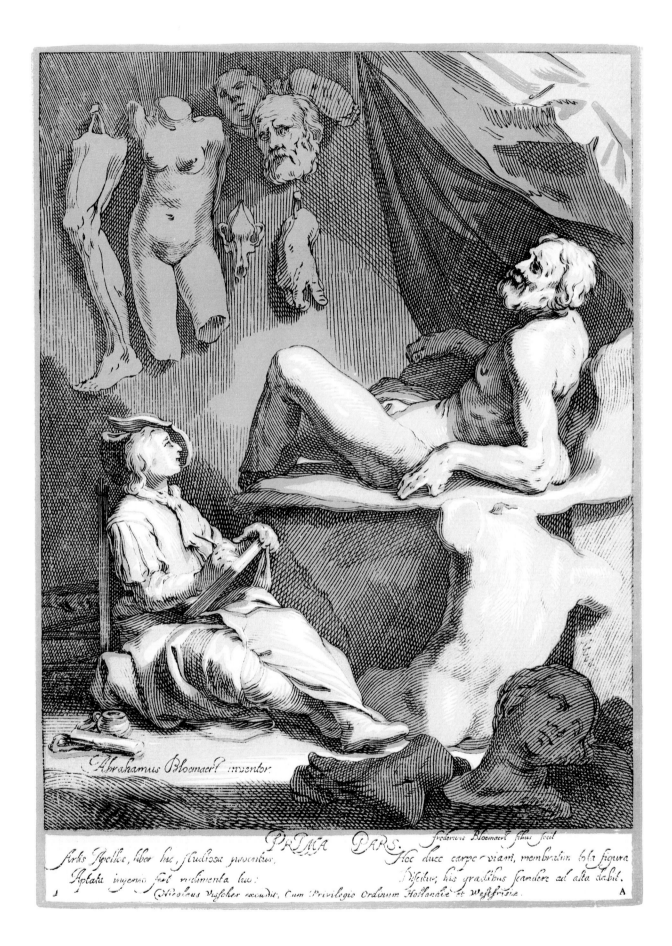

Abrahamus Bloemaert inventor.

PRIMA PARS. *Fredericus Bloemaert filius fecit*

Artis Apelle, liber hic, studiosa juventus. Hoc duce carpe viam, membratim tota figura

Aptata ingenio sert rudimenta tuo: Discitur; his gradibus scandere ad alta dabit.

Nicolaus Visscher excudit, Cum Privilegio Ordinum Hollandiæ & Westfrisiæ.

A

165. Kneeling Saint

Without monogram. No date.
184 x 145 mm.
One etched plate; one tone block (sepia).

Illustration in Abraham Bloemaert's *Tekenboek* (cf. Plate 164), Edition I, illustration No. 20; Edition III, illustration No. 91.

Bennington (Prof. J. S. Held), Leyden, Munich, New York (NYPL).

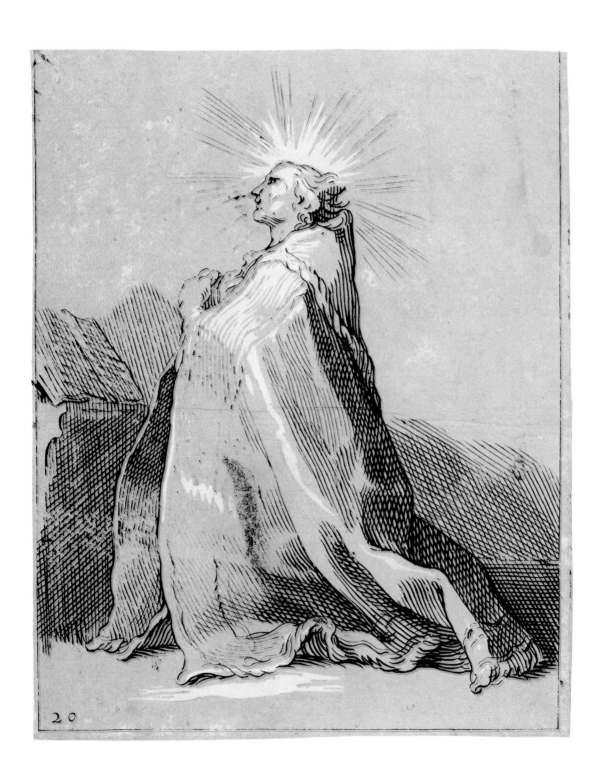

20

166. Mother with Three Children

Without monogram. No date.
184 x 145 mm.
R.95.
One etched plate; one tone block (sepia).

Illustration in Abraham Bloemaert's *Tekenboek* (cf. Plate 164), Edition I, illustration No. 74; Edition II, illustration No. 137.

Bennington (Prof. J. S. Held), Coburg, Munich, New York (NYPL), Vienna.

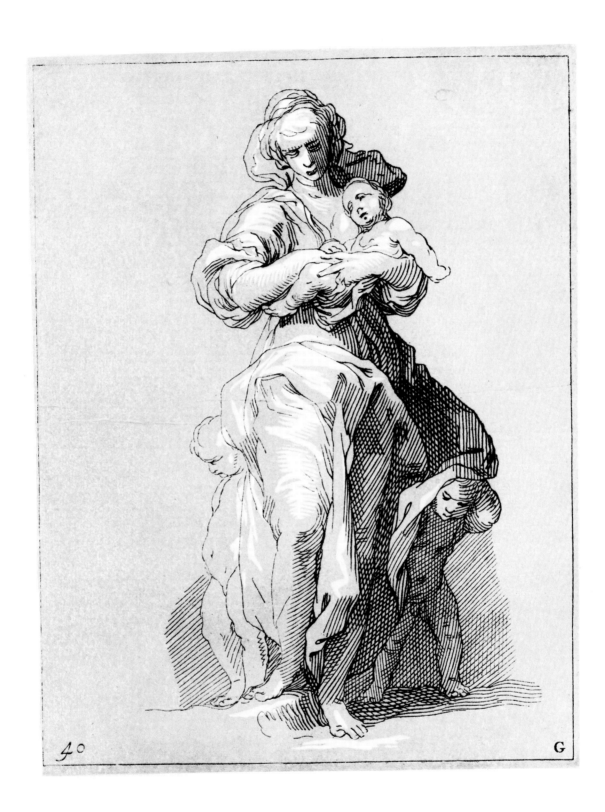

40 G

167. Mother and Child

Without monogram. No date.
218 x 172 mm.

I. Etched plate only. Edition III, illustration No. 95.
II. One etched plate; one tone block (sepia). Edition I, illustration No. 60;
Edition III, illustration No. 35.

Illustration in Abraham Bloemaert's *Tekenboek* (cf. Plate 164).

I. New York (NYPL).
II. Boston (W. G. Russell Allen Collection), Bennington (Prof. J. S. Held),
Leyden, Vienna.

60

168. Three Women Lamenting

Without monogram. No date.
184 x 152 mm.
One etched plate; one tone block.

Illustration in Abraham Bloemaert's *Tekenboek* (cf. Plate 164),
Edition I, illustration No. 74; Edition II, illustration No. 137.

Bennington (Prof. J. S. Held), Coburg, New York (NYPL).

74

169. The Holy Family before a Fireplace

Without monogram. No date.
216 x 175 mm.
LeB.75; R.96.

I. Etched line plate only. Edition III, illustration No. 144.
II. One etched plate; one tone block (sepia). Edition III, illustration No. 75.

Illustration in Abraham Bloemaert's *Tekenboek* (cf. Plate 164).

I. New York (NYPL).
II. *Basel,* Munich, Vienna.

170. Seven Men Struck Down by an Avenging Angel

Without monogram. No date.
204 x 163 mm.

 I. Etched line plate only. Edition III, illustration No. 46.
 II. One etched plate; one tone block (sepia). Edition III, illustration No. 145.

Illustration in Abraham Bloemaert's *Tekenboek* (cf. Plate 164).

 I. New York (NYPL).
 II. Bennington (Prof. J. S. Held), Cambridge, Coburg, New York (NYPL), Philadelphia.

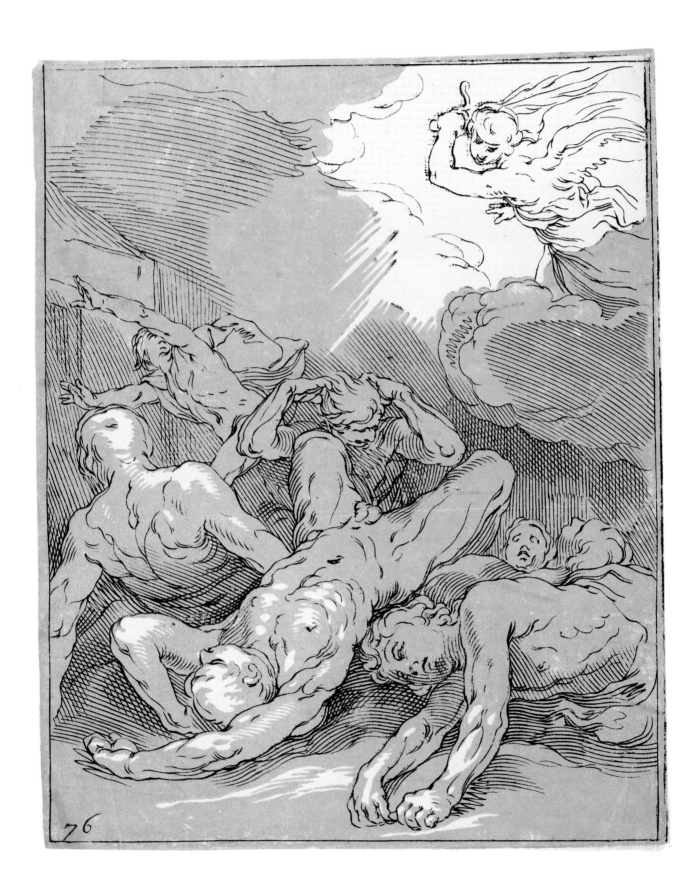

76

171. Portrait of Abraham Bloemaert

No monogram.
204 x 153 mm.
Wu. vol. I, p. 112, Nos. 3a and 3b; B.185; H.372.

I. Line only. Imprinted: *ABRAHAM BLOEMAERT PICTOR GORICOMIUS BATAVUS, AETAT XLIII, 1610, P. Morelsen pinxit ad vivum, J. Matham sculp. et. execud. cum privil. Sa Cae.M.*
II. One line block, one tone block (black on sepia). Imprinted: *ABRAHAM BLOEMAERT PICTOR GORICOMIUS BATAVUS, AETAT. XLIIII, 1611.*

It is not fully established whether Frederick Bloemaert simply added the tone block to Matham's portrait of Bloemaert, or also copied the line block. This portrait was used as frontispiece for the later editions of Abraham Bloemaert's *Tekenboek*.

I. London, Prague.
II. New York (NYPL; Stuart Collection) *Oberlin*.

172. Five Angels Holding an Empty Coat of Arms

Without monogram. No date.
218 x 164 mm.

 I. Etched line plate only. Edition III, illustration No. 106.
 II. One etched plate; one tone block (sepia). Edition III, illustration No. 108.

Illustration in Abraham Bloemaert's *Tekenboek* (cf. Plate 164).

New York (NYPL).

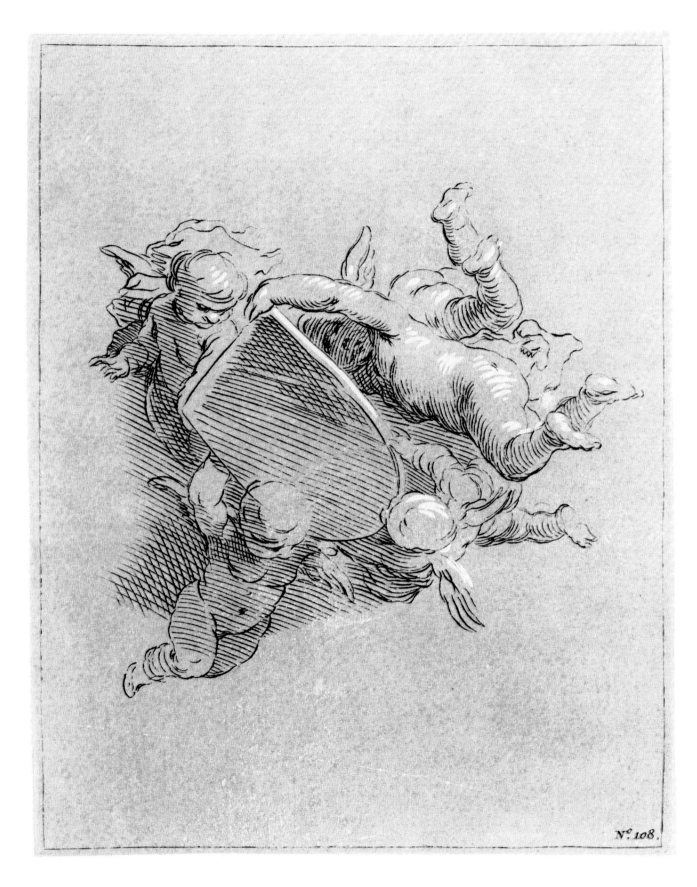

173. The Beggar

Imprinted: *Abraham Bloemaert inven. F. B. fecit, N. Visscher Excu.* No date.
127 x 81 mm.
Wu.5; H.156-185.
One line plate; one tone block.

This woodcut has not been previously described, except as part of a series of thirty scenes with beggars in black and white. The Visscher imprint indicates a late reprinting, similar to the second edition of Bloemaert's *Tekenboek* (cf. Plate 164).

Amsterdam, *Munich*.

1 Abraham, Bloemaert Inven f.B fecit.

Nudus, inops, mutilus, vili revolutus arenâ
Subsidium à populo prætereunte peto;
Tu quid, iners tremulam mentiris ad ostia vocem?
vah, tua non posset membra gravare labor.
Cultor agri pastorve gregis, mercede diurnâ
Contente, ô verè vita beata tibi.

N. Visscher Excu.

174. Study Sheet of St. John the Baptist, Preaching

Monogram: F.P. No date.
152 x 183 mm.
LeB. vol. 1, p. 373: A. Bloemaert, No. 16.
One line block; one tone block.

Based on a drawing by Francesco Mazzola (Il Parmigianino),[1] whose initials F.P. appear on the bottom of this print.[2] The central figure occurs also in A. M. Zanetti's chiaroscuro print "Seminude Young Man" (B.166.13) after Parmegianino.[3]

According to Dr. Russell Allen's notation on its mat at Boston, he attributed this print to Frederick Bloemaert. Although this is not conclusive, the style, color, and technique is closely akin to the chiaroscuro illustrations in Fredrick Bloemaert's edition of his father's *Tekenboek* (cf. Plate 144).

Boston (W. G. Russell Allen Collection), London (Inv. W.4-89 and 1851-3-8-1056), New York (MM; right portion trimmed off), Paris (BN; watermark: Coat of Arms).

[1] London, illustrated in A. E. Popham, *Catalogue of the Drawings of Parmigianino,* New Haven, 1971, No. 184.
[2] These initials occur, for example, on the chiaroscuro print illustrated in Caroline Karpinsky, ed. *Italian Chiaroscuro Woodcuts* (Bartsch, vol. 12), University Park, Pennsylvania, 1971, No. B.64.23.
[3] Illustrated in Karpinsky, B.12.166.13.

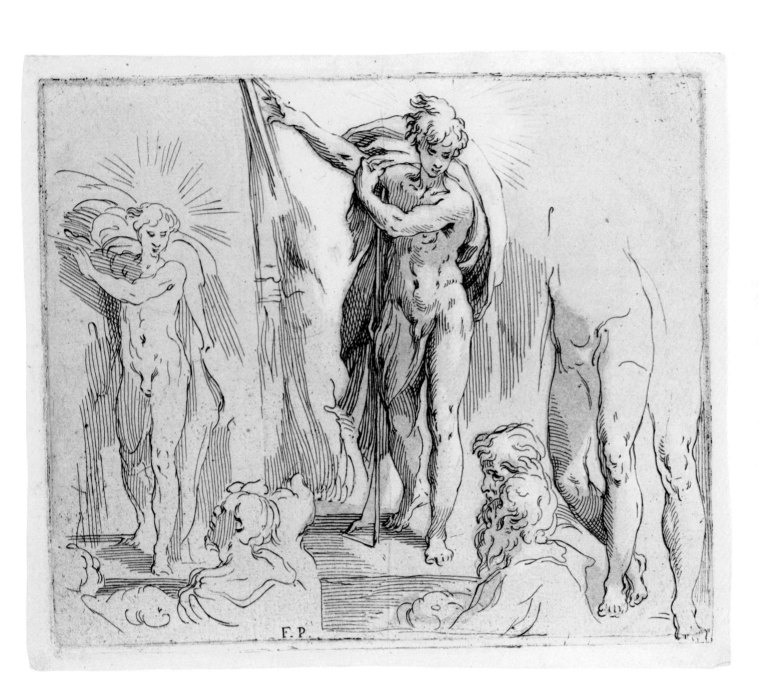

FREDERICK BLOEMAERT [?]

175. The Virgin; St. Joseph [on one sheet]

Monograms: *The Virgin: Bol; St. Joseph: F.P.* No date.
138 x 165 mm. (combined)
Watermark: Akin to Meder *(Dürer-Katalog)* No. 248 (used in Arnhem, circa 1606).
One line block; one tone block.

Identical in technique and color to the preceding print, although only St. Joseph seems clearly to be based on a design by Parmigianino, whose initials F.P. appear on the bottom of this subject. According to his notation on the mat, Dr. Russell Allen thought that "Bol" refers to Bolswert. It may, however, be the signature of an Italian artist (Francesco Primaticcio da Bologna?). Both subjects may have been transmitted by drawings by Abraham Bloemaert after Italian artists.

Boston (W. G. Russell Allen Collection), London (St. Joseph only),
Paris (BN; separated).

FREDERICK BLOEMAERT

176. St. Jerome in the Desert

Monogram: F.P. No date.
112 x 78 mm.
Wu.7.

I. Line only.
II. One line block; one tone block.

This print is similar in style and technique to the two precedings ones
(cf. remarks for the preceding prints).

I. London (A. Bloemaert), New York (NYPL).
II. *Boston* (W. G. Russell Allen Collection), Munich, Paris (BN).

177. Le Capitaine Raguet

No monogram. No date.
174 x 135 mm.
P. p. 124; R.83.
One line block; two tone blocks.
No watermark.

Passavant calls this print "a piece of Dutch humor, typical of the Netherlandish School of the sixteenth century." But his assertion that this print, like those of Dürer (Plates 1 and 2), was printed in chiaroscuro by Hendrick Hondius is incorrect, because the chiaroscuro impressions of Dürer's prints are by Willem Janssen.[1] Reichel suggests that this print may be by an anonymous French master because of the French inscription.[1] The constant French involvement in the Low Countries after the death of Charles the Bold may make a French satirical title for a Netherlandish print plausible. Freely translated, the title reads: Captain Scrub.

Paris (BN), *Vienna.*

[1] See remarks for Plate 138.

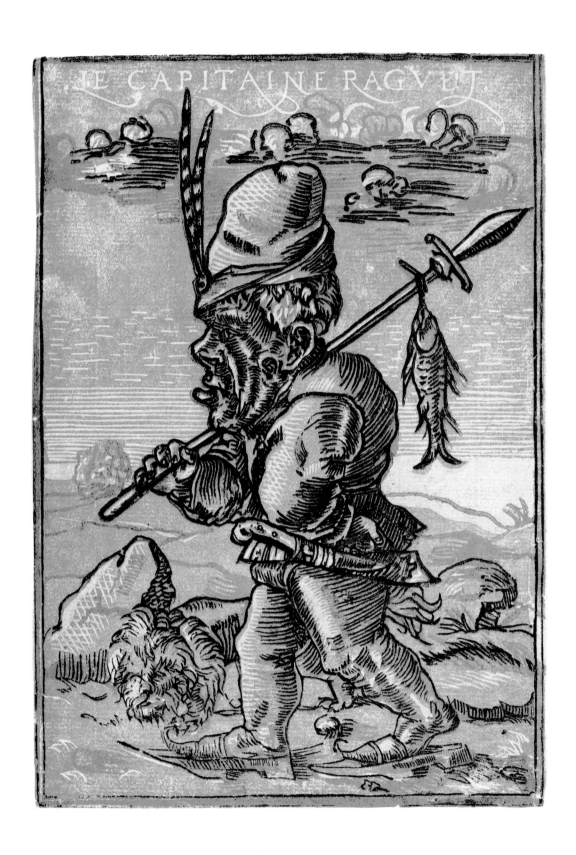

Appendix

42A. Ecce Homo, Man of Sorrows, Seated on the Cross

See remarks on page 82.

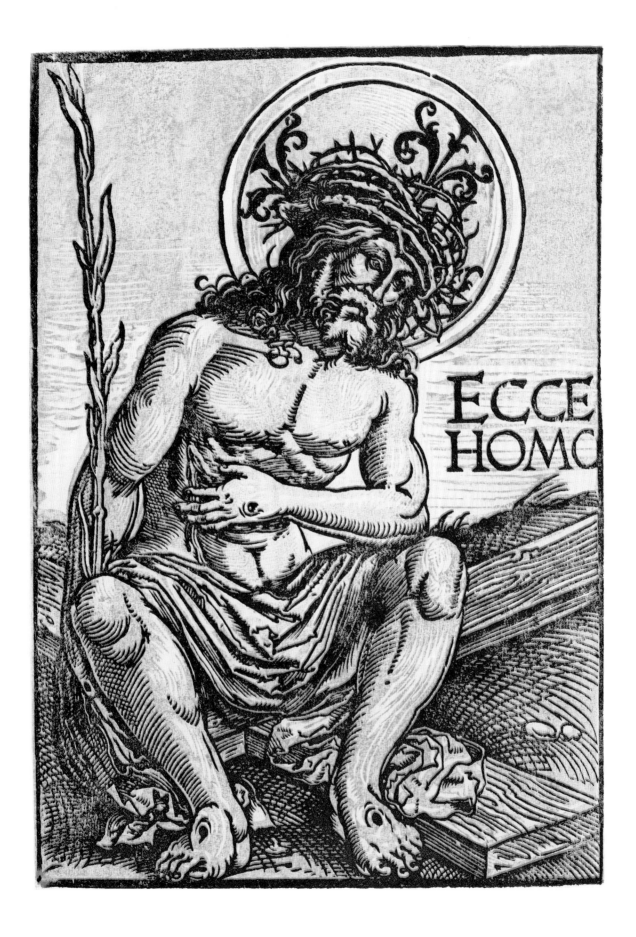

ECCE
HOMO

59A. Renaissance Structures Connected by a Wall

See remarks on page 118.

Der rö: kay: vnd khü: Statt
Freißhait: mit Nachzdür vberschür

61A. Renaissance Structure with Guard

See remarks on page 122.

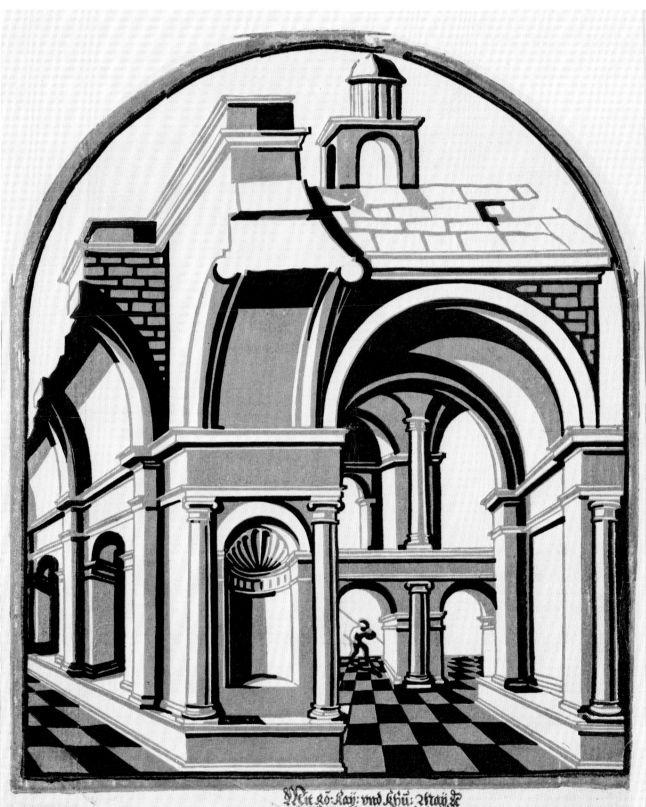

Mit Rö: Kai: vnd khü: May: &c
Freyhait: nit Nach zu drucken

62A. Renaissance Street with a Flight of Birds

See remarks on page 124.

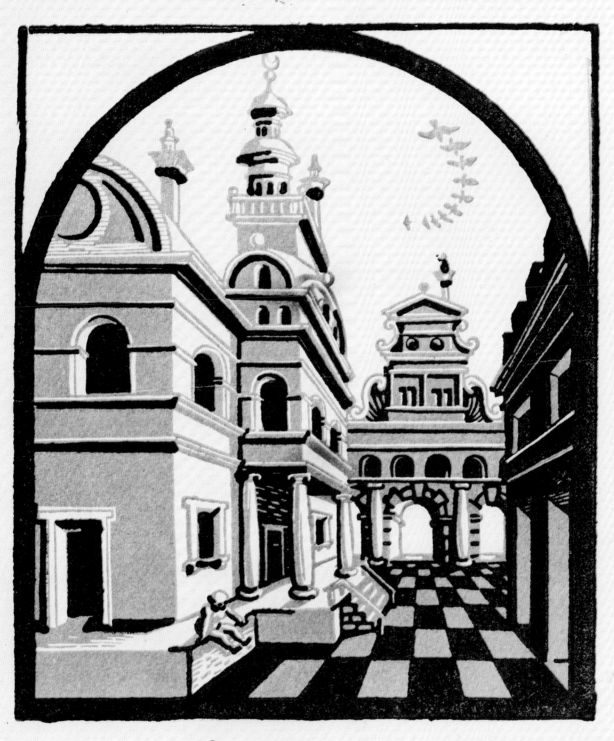

Mit Rö: Kay: vnd khü: May: &c
Freyhait: nit Nachzudruckhen

Exhibitions

1900 Galleria Nazionale, Rome. Reviewed: *L'Arte,* vol. III, 1900, p. 171.

1903 Ecole des Beaux Arts, Paris. Reviewed by Clément-Janin, *Mitteilungen der Gesellschaft für vervielfältigende Kunst,* Vienna, 1903, p. 9.

1912 Société de la Gravure sur Bois Originale, Paris.

1914 "Der Farbendruck," Kupferstichkabinett, Berlin.

1914 "Early Woodcuts and Chiaroscuro Engravings," R. Ederheimer Print Cabinet, New York.

1924 "The Collection of Dr. J. B. Ayer," Boston Museum of Fine Arts.

1928 "Exhibition of Woodcuts in Chiaroscuro and Color from the Collections of W. G. Russell Allen, Paul J. Sachs, Felix Warburg, the Pierpont Morgan Library," Metropolitan Museum of Art, New York City.

1932 "Chiaroscuros of Four Centuries, from the Collections of the Library, and of W. G. Russell Allen, Felix M. Warburg, Paul J. Sachs, and Philip Hofer," New York Public Library. Reviewed: *Art News,* vol. 33, May, 1932.

1937 "Chiaroscuro Woodcuts of Four Centuries from the Horace Swope Collection," Frederick Keppel & Co., New York City. (Now at the Fogg Art Museum, Cambridge, Mass.) Reviewed: *Art News,* vol. 35, February, 1937.

1939 "Chiaroscuro Woodcuts from the Collections of the Print Departments, and of Lessing J. Rosenwald, the Worcester Museum, and M. Knoedler and Co.," Boston Museum of Fine Arts.

1947 "Chiaroscuro Woodcuts, lent anonymously," National Gallery of Art, Washington, D.C. Reviewed: "Gravures sur bois et en mezzotint à la National Gallery, Washington," *Arts,* July, 1947.

1962 "Color in Prints," Yale Art Gallery, New Haven, Conn. Catalogue edited by E. Haverkamp-Begemann.

1965 "Clair-obscurs; gravures sur bois imprimées en couleurs de 1500-1800," Paris, Institut Néerlandais, and Rotterdam, Museum Boymans-van Beuningen." Catalogue by Carlos van Hasselt.

1967 "Die Kunst der Graphik V, zwischen Renaissance und Barock," Vienna, Albertina. Catalogue by Konrad Oberhuber.

1969 "Chiaroscuro," *Art in Prints,* No. 3, Kennedy Galleries, Inc., New York City. Catalogue with introduction, "The Chiaroscuro Print, a Brief History," by Maria Naylor.

1970 "Dutch Mannerism, Apogee and Epilogue," Vassar College Art Gallery, Poughkeepsie, New York. Catalogue with introduction by Wolfgang Stechow.

1972 Elvehjem Art Center, University of Wisconsin, Madison, Wisconsin.

1973 "Three Centuries of Chiaroscuro Woodcuts," the Pennsylvania Academy of the Fine Arts, Philadelphia. Catalogue by Ellen Jacobowitz.

Bibliography

AMES, WINSLOW. "Chiaroscuro Prints," *Parnassus*, vol. 9, February 1937.

————."Some Woodcuts by Hendrick Goltzius and their Program," *Gazette des Beaux Arts*, 1949, p. 425.

ANDRESEN, ANDREAS. *Der deutsche Peintre-Graveur*, Berlin, 1866.

BARTSCH, ADAM. *Le Peintre-Graveur*, Vienna, 1808.

BECKER, CARL. *Jost Amman*, Leipzig, 1854.

BENDEL, MAX. *Tobias Stimmer, Leben und Werke*, Zürich-Berlin, 1940.

BRUILLOT, FRANZ. *Dictionnaire des Monogrammes*, 3 vols., Munich, 1832-34.

BURKHARD, ARTHUR. "Meister der Graphik," XV, *Hans Burgkmair der Älterer*, Berlin, 1932.

BURT, C. G. E. "Chiaroscuro Woodcut, Precursor of the Colour Print," *Connoisseur*, vol. 108, December 1941.

CARTARI, VINCENZO. *Le Imagini degli dei Antichi*, Florence, 1571.

CHMELARZ, EDUARD. "Jost de Negkers Helldunkelblätter Kaiser Maximilian und St. Georg," *Jahrbuch der kunsthistorischen Sammlungen des allerhöchsten Kaiserhauses*, vol. 15, Vienna, 1894.

COLVIN, SIDNEY. "Le Portrait de Jean Baumgartner ou Paumgartner," *L'Art*, vol. 16, 1897, p. 221.

CURJEL, H. *Hans Baldung Grien*, Munich, 1923.

DELEN, A. J. J. *Histoire de la Gravure de Pays Bas et dans les Provinces Belges*, 2 vols., Paris 1934-35.

DODGSON, CAMPBELL. "Zu Jost de Negker," *Repertorium zur Kunstwissenschaft*, vol. 21, 1898, p. 377.

————. *Catalogue of Early German and Flemish Woodcuts in the British Museum*, London, vol. 1, 1903; vol. 2, 1911.

————. "The Earliest Works by Jost de Negker," *Print Collector's Quarterly*, vol. 22, 1935, pp. 9-17.

DUBIEZ, F. J. *Cornelis Anthoniszoon, zijn Leven en Werken*, Amsterdam, 1968.

EYE, A. VON. *Leben und Wirken Albrecht Dürer's*, Nördlingen, 1869.

FERN, ALAN M. "The Pembroke Album of Chiaroscuro Woodcuts," *The Quarterly Journal of the Library of Congress*, vol. 26, No. 1, January 1969.

FISCHER, O. *Hans Baldung Grien*, Munich, 1939.

FLECHSIG, EDUARD. *Cranachstudien*, Leipzig, 1900.

FOOTE, H. S. "Lucas Cranach the Elder's St. Christopher," *Cleveland Museum Bulletin*, vol. 16, July 1929.

FRIEDLANDER, MAX. *Die Holzschnitte des Hans Weiditz*, Berlin, 1922.

GALANIS, D. "De la gravure en bois de camaieu ou clair-obscur," *Art et Métier Graphiques*, January 1930.

GEISBERG, MAX. *Der deutsche Einblatt-Holzschnitte der ersten Hälfte der XVI Jahrhunderts*, 37 vols., Munich, 1924-30 (*The German Single Leaf Woodcuts 1500-1550*, ed. and rev., Walter L. Strauss, New York, 1973.)

————. "Holzschnittbildnisse des Kaisers Maximilian I," *Jahrbuch der preussischen Kunstsammlungen*, vol. 32, 1911.

GRIEFF, W. "Älteste deutsche Farbholzschnitte," *Zeitschrift für Bücherfreunde*, NF, vol. 1, 1910, p. 337.

HALLO, RUDOLF. *Das Kupferstichkabinett und die Bücherei der staatlichen Kunstsammlungen zu Kassel*, Kassel, 1931.

HASSELT, CARLOS VAN. *Gravures sur Bois Clair-obscurs 1500-1800*, Institut Néerlandais, Paris, 1965.

HAUSMANN, B. *Albrecht Dürer's Kupferstiche, Radirungen, Holzschnitte und Zeichnungen*, Hanover, 1861.

HEAWOOD, EDWARD. *Watermarks, Chiefly of the 17th and 18th Centuries*, Hilversum, 1950.

HELLER, JOSEPH. *Lucas Cranach, Leben und Werk*, Bamberg, 1821.

————. *Lexicon der Kupferstecher, Formschneider und Lithographen*, Bamberg, 1823.

————. *Das Leben und die Werke Albrecht Dürer's*, Bamberg, 1821.

HIND, ARTHUR M. *An Introduction to a History of Woodcut*, New York, 1935, 1963.

HIRSCHMANN, OTTO. *Verzeichnis des graphischen Werks von Hendrick Goltzius, 1558-1617*, Leipzig, 1921.

HOLLSTEIN, F. W. J. *Engravings, Etchings, and Woodcuts* [of German and Dutch Masters], Amsterdam, 1954-.

IVINS, WILLIAM M., JR. "Woodcuts in Chiaroscuro and Color, A Special Exhibition," *Metropolitan Museum of Art Bulletin*, vol. 23, 1928.

————. "On the Rationalization of Sight," *Metropolitan Museum of Art Papers*, No. 8, New York, 1938.

————. *Prints and Visual Communication*, Cambridge, 1953.

KAUFFMANN, H. "Dürer in der Kunst und im Kunsturteil um 1600," *Vom Nachleben Dürers*, Nuremberg, 1954. p. 38.

KEMP, WOLFGANG. "Die Höhle der Ewigkeit," *Zeitschrift für Kunstgeschichte*, vol. 32, 1969, pp. 133-52.

KENT, N. "Woodcut in Tone," *American Artist*, vol. 10, February, 1946.

KRISTELLER, PAUL. *Kupferstich und Holzschnitt in vier Jahrhunderten*, Berlin, 1905.

LE BLANC, CHARLES. *Manuel de l'Amateur d'Estampes*, Paris, 1854-90.

LEHRS, MAX. *Late Gothic Engravings of Germany and the Netherlands*, New York, 1969.

LINNIK, IRINA V. "A New Interpretation of a Set of Chiaroscuro Woodcuts by Hendrick Goltzius," The Hermitage, Leningrad, 1964, vols. 10-12, p. 3*ff*.

LINTON, W. J. *Masters of Wood-Engraving*, New Haven, Conn., 1889.

LIPPMANN, FRIEDRICH. "Farbenholzschnitte von Lucas Cranach," *Jahrbuch der preussischen Kunstsammlungen*, vol. 16, Berlin, 1895.

LÖDEL, HEINRICH. *Johann Wechtlin, genannt Pilgrim, Holzschnitte in Clair-Obscur in Holz nachgeschnitten*, Leipzig, 1863.

LOGA, V. VON. "Ein Jugendbildnis der Maria von Ungarn," *Jahrbuch der preussischen Kunstsammlungen*, vol. 10, Berlin, 1889.

LÜTZOW, CARL VON. *Geschichte des deutschen Kupferstichs und Holzschnitts*, Berlin, 1891.

MANDER, CAREL VAN. *Het Schilderboeck*, Haarlem, 1604.

MEDER, JOSEPH. *Dürer-Katalog*, Vienna, 1932.

MURR, CHRISTOPH G. VON. *Journal zur Kunstgeschichte und Litteratur*, Nuremberg, 1773.

MUSPER, H. T. *Der Holzschnitt in fünf Jahrhunderten*, Stuttgart, 1944.

NAGLER, GEORG KASPAR. *Die Monogrammisten*, vols. 1-5, Munich, 1879.

OBERHUBER, KONRAD, *Die Kunst der Graphic IV: Zwischen Renaissance und Barock, Ausstellung aus dem Besitz der Albertina*, Vienna, 1967-68.

ORTROY, F. VAN. *Biographie Nationale de Belgique*, Brussels, 1926-29.

OETTINGER, KARL, *and* KNAPPE, K. A. *Hans Baldung Grien und Albrecht Dürer in Nürnberg*, Nuremberg, 1963.

PANOFSKY, ERWIN. *Albrecht Dürer*, 2 vols. Princeton, 1943.

PAPILLON, J. M. *Traité de la Gravure en Bois*, Paris, 1766.

PASSAVANT, JOHANN DAVID. *Le Peintre-Graveur*, Leipzig, 1862.

PAULI, GUSTAV. *Hans Sebald Beham, ein kritisches Verzeichnis seiner Kupferstiche, Radierungen und Holzschnitte*, Strassburg, 1901.

PUYVELDE, LEO VAN. *La peinture flamande an siècle de Bosch et Brueghel*, Paris, 1953.

REICHEL, ANTON. *Die Clair-Obscur Holzschnitte des XVI, XVII und XVIII Jahrhunderts*, Zurich, 1926. English Translation: *The Chiaroscurists of the XVI, XVII, and XVIII Centuries*, Cambridge (U.K.), 1926; does not include the introductory text of the German edition.

RETBERG, R. VON. *Dürers Kupferstiche und Holzschnitte, ein kritisches Verzeichnis*, Munich, 1871.

REZNICEK, E. K. J. *Die Zeichnungen des Hendrick Goltzius*, Utrecht, 1961.

ROBINSON, F. W. "A Collection of Chiaroscuro Prints in the Cincinnati Art Museum," *Bulletin of the Cincinnati Museum of Art*, vol. 18, July 1937.

ROSENBERG, ADOLF. *Sebald und Barthel Beham*, Leipzig, 1875.

ROSENBERG, JAKOB, and SLIVE, SEYMOUR. *Dutch Art and Architecture, 1600-1800*, The Pelican History of Art, Baltimore, 1966.

ROSSITER, HENRY P. "Woodcuts in Chiaroscuro," *Boston Museum Bulletin*, vol. 37, October 1939; also in *Art News*, vol. 38, October 1939.

ROTTINGER, HEINRICH. "Hans Wechtlin und der Helldunkelschnitt," *Gutenberg Jahrbuch*, Mainz, 1942-43.

————. *Hans Weiditz, der Petrarca Meister*, Strassburg, 1904.

ROVENSKY, D. *L'Oeuvre gravée des élèves de Rembrandt*, St. Petersburg, 1894.

RUPPRICH, HANS. *Albrecht Dürers schriftlicher Nachlass*, Berlin, 1956-70.

SCHNEIDER, H. *Jan Lievens, sein Leben und seine Werke*, Haarlem, 1932.

SCHOTTENLOHER, K. *Die liturgischen Druckwerke Radtolts*, 1922, p. 28.

SEIBT, GEORG KAPL WILHELM. "Helldunkel," *Studien zur Kunst und Kunstwissenschaft*, vol. 5, Frankfurt, 1891.

SPRINGER, JARO. "Zur Geschichte des Farbendrucks." *Die Graphischen Künste*, vol. 16, 1893, p. 11*ff*.

STECHOW, WOLFGANG. "Ludolph Büsinck, a German Chiaroscuro Master of the Seventeenth Century," *Print Collector's Quarterly*, vol. 25, 1938, pp. 393-419; vol. 26, 1939, pp. 349-59.

————. *Dutch Landscape Painting of the 17th Century*, London, 1966.

————. "On Büsinck, Ligozzi, and an Ambiguous Allegory." *Essays in the History of Art Presented to Rudolf Witkower*, London, 1967, p. 193.

STECHOW, WOLFGANG, ed. *Dutch Mannerism, Apogee and Epilogue*, Vassar College Art Gallery, Poughkeepsie, 1970.

STRAUSS, WALTER L. "The Chronology of Hendrick Goltzius' Chiaroscuro Prints," *Nouvelles de l'Estampe*, No. 5, 1972, pp. 9-13.

THIEME-BECKER. *Allgemeines Lexikon der bildenden Künstler, von der Antike bis zur Gegenwart*,

Ulrich Thieme and Felix Becker, eds., vols. 1-37, Leipzig, 1907.

THÖNE, FRIEDRICH. *Tobias Stimmers Handzeichnunnungen*, Freiburg/B, 1936.

WALDMANN, EMIL. *Die Nürnberger Kleinmeister*, Leipzig, 1910.

WEIGEL, RUDOLF. *Der Strassburger Maler und Formschneider Johann Wechtlin*, Leipzig, 1863.

WEINBERGER, MARTIN. *Die Formschnitte des Katharinenklosters zu Nürnberg*, Munich, 1925.

WEITENKAMPF, FRANK. "Chiaroscuro Prints," *New York Public Library Bulletin*, June· 1916.

———. "Chiaroscuro Prints through Four Centuries," *New York Public Library Bulletin*, vol. 36, 1932.

WINKLER, FRIEDRICH. *Die Zeichnungen Albrecht Dürers*, Berlin, 1936-39.

———. *Albrecht Dürer, Leben und Werk*, Berlin, 1957.

———. "Hans Baldung Griens drei Hexen," *Jahrbuch der preussischen Kunstsammlungen*, vol. 57, 1936, p. 156.

WURZBACH, A. VON. *Niederländisches Künstler Lexikon*, 2 vols. and supplement, Vienna-Leipzig, 1906-11.

NOTE: At the Worcester (Mass.) Art Museum there are two bound notebooks in folio entitled *Vorarbeiten zur Geschichte des Farbendrucks* by S. R. Koehler, Part 1: "Helldunkel" (132 pages); Part 2: "Drucke in positiven Farben" (115 pages). Koehler, at that time, was the curator of the print room at the Boston Museum of Fine Arts. His notebooks comprise preliminary notes for a projected book on color prints based on Bartsch, Passavant, and Seibt. A separate notebook, in quarto, lists colored prints in the collections of the European cities Koehler visited during a trip (about 1895). (My attention was called to these manuscripts by the kindness of Prof. Egbert Haverkamp-Begemann.)

Index